mexican muralists

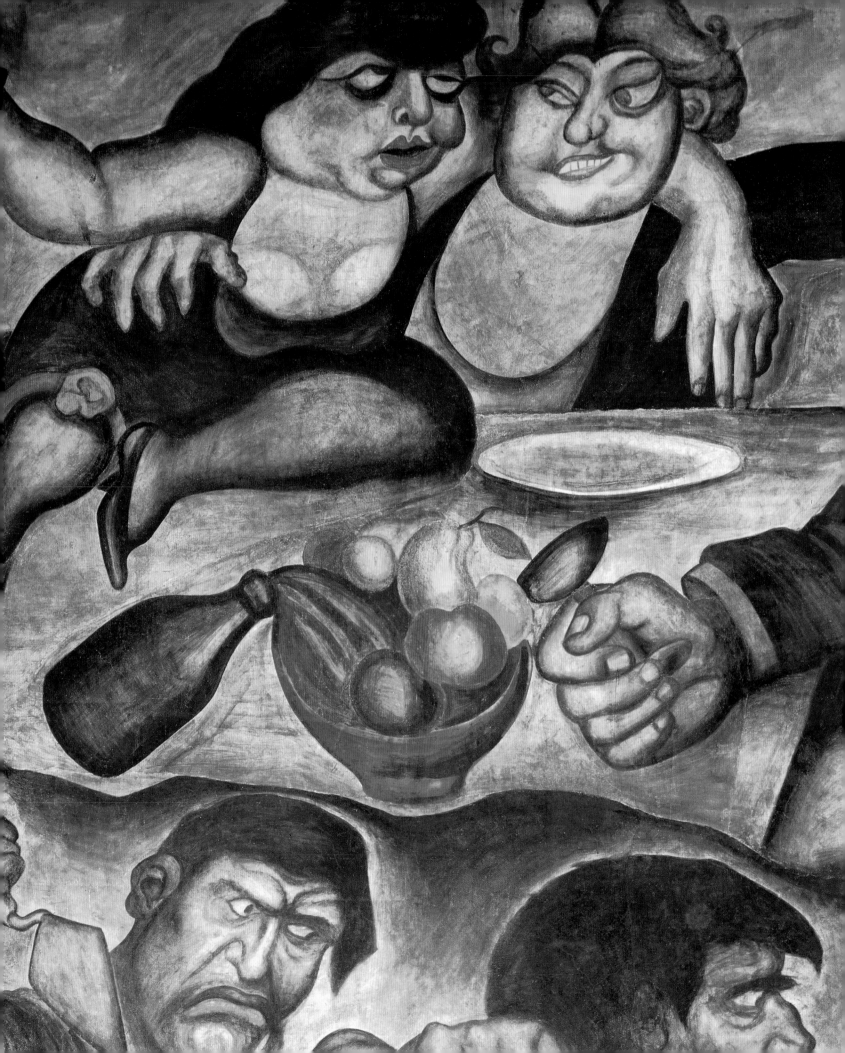

Desmond Rochfort

mexican muralists

OROZCO

RIVERA

SIQUEIROS

CHRONICLE BOOKS

SAN FRANCISCO

For Janie, Alexandra and Dominic

Frontispiece: Jose Clemente Orozco:
The Rich Banquet while the Workers Fight,
National Preparatory School, Mexico City

First published in the United States in 1998 by Chronicle Books

First published in Great Britain in 1993
by Laurence King Publishing

Cover design by Joseph Stitzlein
Book design by James Campus
Edited by Nicola Coleby
Additional research by Susan Bolsom-Morris

ISBN 0-8118-1928-0 pb

Library of Congress Cataloging-in-Publication Data available.

Printed in Hong Kong

Distributed in Canada by Raincoast Books
8680 Cambie Street
Vancouver, B.C. V6P 6M9

10 9 8 7 6 5 4 3 2 1

Chronicle Books
85 Second Street
San Francisco, CA 94105

Web Site: www.chronbooks.com

CONTENTS

INTRODUCTION

In 1951 the British art critic Herbert Read lamented what he considered to be the Soviet Union's failure, after more than thirty years of strenuous effort, to produce a new art on the basis of a new economy. In *The Philosophy of Modern Art* Read wrote

> We must wait, perhaps for a very long time, before any vital connection can be re-established between art and society. The modern work of art . . . is a symbol. The symbol, by its very nature, is intelligible only to the initiated (though it may appeal mysteriously to the uninitiated, so long as they allow it to enter their unconscious). . . . It does not seem that the contradiction which exists between the aristocratic function of art and the democratic structure of modern society can ever be resolved.[1]

Nearly three decades earlier, coinciding with the early years of Soviet society, the Mexican painter David Alfaro Siqueiros issued a manifesto on behalf of the Syndicate of Technical Workers and Sculptors, a newly created artists' trade union. The manifesto declared the coming of a new and revolutionary art in Mexico. In it, Siqueiros wrote

> We repudiate so-called easel painting and every kind of art favored by ultra-intellectual circles, because it is aristocratic, and we praise monumental art in all its forms, because it is public property. We proclaim at this time of social change from a decrepit order to a new one, the creators of beauty must use their best efforts to produce ideological works for the people; art must no longer be the expression of individual satisfaction (which) it is today, but should aim to become a fighting educative art for all.[2]

Between this radical proclamation of the young Mexican painters of the early 1920s and the later reflective scepticism expressed by Read lay a huge divide. It was a divide not of time, but of perception and recognition. Read had not recognized, despite what he considered to be the failure of Soviet art, and against the grain of much of what he claimed was the function of art in the democratic structure of modern society, that a vital connection had indeed been created in the twentieth century between art and society. The art in this case was a renaissance of public mural painting and the society that of post-revolutionary Mexico.

The presence of Mexican muralism in the history of twentieth-century culture is in many ways an anachronism in relation to the tenets of modernist aesthetics, practise and theory. Within this dominating Western perception of modern art history, the Mexican mural renaissance is seen as being 'in deliberate opposition to the course of modernist art as practised in Europe and the United States of America'.[3]

This opposition is in many respects deeply problematic. In standing outside and against the main thrust of modernist practice, Mexican mural painting has often become hostage to critical fortune. Arguments have prevailed for and against its self-proclaimed premise as a revolutionary art of substantive social function, of creative and aesthetic originality. Its adherents and supporters have interpreted it as a fundamental challenge to the concept of the avant-garde artist of modern Western art, who, as

Clement Greenberg wrote, 'Retiring from public altogether . . . sought to maintain the high level of his art by narrowing it to the expression of an absolute in which all relativities and contradictions would either be resolved or beside the point. "Art for Art's sake" and "pure poetry" appear, and subject-matter or content becomes something to be avoided like the plague'.[4] Furthermore, the whole project of Mexican muralism, particularly in its initial stages, was presented as a synthesis of art and the popular imagination, a concept described by the German playwright Bertolt Brecht as being 'intelligible to the broad masses, adopting and enriching their forms of expression, assuming their standpoint, confirming and correcting it . . . relating to traditions and developing them'.[5]

Critics of Mexican muralism have cast aspersions on its claim to occupy a central position within the story of modern Western art. Some have interpreted it as essentially a propagandist programme, placing it outside what they consider to be the essential characteristic of modern art, that of 'stylistic evolution'. In his essay on modernist painting, Clement Greenberg implicitly rejected any place for such a movement as Mexican muralism when he wrote that

It quickly emerged that the unique and proper area of each art coincided with all that was unique in the nature of the medium. The task of self-criticism became to eliminate from the effects of each art any and every effect that might conceivably be borrowed from or by the medium of any other art. . . . Realistic or illusionist art had dissembled the medium, using art to conceal art. Modernism used art to call attention to art.[6]

Against this canon of modernist aesthetics Mexican muralism represented in almost every sense the exact opposite of what Greenberg argued was '. . . the proper area of each art'. Not only was it a realistic and figurative movement, but it was one whose identity centred on the expression of public meanings. Furthermore, not withstanding the formal innovation that characterized Siqueiros' mural painting, the Mexican muralists' principal objective was not pictorial innovation, associated with so much of twentieth-century Western painting. The muralists' point of departure and primary concern was for a public and accessible visual dialogue with the Mexican people. Critical opinion over the last forty years has often neglected or marginalized Mexican muralism largely because, as the Mexican writer Luis Cardoza y Aragón has observed, such critical opinion could see no 'formally new, strictly pictorial contribution to the currents that interest them'.[7]

However, historical accuracy makes it imperative that the artistic achievements of the Mexican mural renaissance no longer be regarded as anything other than a contribution of equal significance to that of Western art during the twentieth century. Equally important to any claim of artistic recognition are the aims and ideas that lay behind the genesis and development of Mexican muralism. In the late twentieth century, when much of the thesis of modernism has been questioned by other discourses, Mexican muralism represents a significant challenge to the commonly accepted view of the role and position of the artist in Western society. That position is sometimes seen as one of intellectual and economic isolation, in which the primary function of the artist is a revelation of self expressed in a hermetic relationship formed by the will to create and the work created.

The Mexican muralists were neither artistically nor intellectually isolated from Mexican society. They played a central role in the cultural and social life of the country following the 1910–1917 nationalist revolution. Rather than a revelation of individual self, in the first instance the murals expressed a communality of national experience. The artists' murals could not be bought and sold, for they were created and commissioned as permanent fixtures in some of the most important public buildings of Mexico. As a public art, one of whose principal aims was to represent a notion of democratic cultural enfranchisement, the murals became a vital part of the patina of Mexican civic and national life for huge sections of the Mexican people.

The history of the Mexican mural renaissance, which started at the beginning of the 1920s during the administration of General Obregón, is in many senses a long and complex story, full of contradictions and paradoxes, myth and legend. For some, it was an art movement dominated by three artists of international renown, Diego Rivera, José Clemente Orozco, and David Alfaro Siqueiros, whose work came to define the essence of what the movement stood for. Others see it as part of a wider cultural

revolution that flowered in Mexico following the 1910 revolution, but whose roots predated the revolution.

From either perspective, the movement's emanation from the catharsis of the Mexican revolution has resulted in the construction of an entire mythology of revolutionary art. Together with its leading personalities, the movement has often been seen as the benchmark against which arguments concerning art and the people, society and revolution have been tested. During the worst period of the 1930s Depression in the United States of America, when the Roosevelt administration embarked on a policy of state-funded initiatives to alleviate hardship, supporters of the Federal Arts Project looked to the Mexican mural movement as a model for a new democratic, radical art. In May 1933 the artist George Biddle wrote to President Roosevelt

There is a matter, which I have long considered and which some day might interest your administration. The Mexican artists have produced the greatest national school of mural painting since the Italian renaissance. Diego Rivera tells me that it was only possible because Obregón allowed Mexican artists to work for plumbers' wages in order to express on the walls of the government buildings the social ideas of the Mexican revolution. . . . The younger artists of America are conscious as they have never been of the social revolution our country and civilization are going through; and they would be eager to express these ideals in a permanent art form if they were given the government's cooperation. They would be contributing to and expressing in living monuments the social ideals that you are struggling for. And I am convinced that our mural art with a little impetus can soon result for the first time in our history in a vital national expression.[8]

During the Depression, many other artists in the United States also found a spiritual nexus in the mythology of Mexican muralism which reflected their own aspirations. One such artist, Mitchell Siroporin, wrote

Contemporary artists everywhere have witnessed the amazing spectacle of the modern renaissance of mural painting in Mexico, and they have been deeply moved by its profound artistry and meaning. Through the lessons of our Mexican teachers, we have been made aware of the scope and fullness of the 'soul' of our environment. We have been made aware of the application of modernism toward a socially moving epic art of our times and place. We have discovered for ourselves a richer feeling in the fabric of the history of our place.[9]

In many respects the mythology surrounding Mexican muralism also became transformed into a kind of sanctification. Orozco observed that 'The highest, the most logical, the purest form of painting is the mural. It is, too, the most disinterested form, for it cannot be made a matter of private gain: it cannot be hidden away for the benefit of a certain privileged few. It is for the people. It is for ALL'.[10]

Such observations concerning the disinterested nature of the mural reinforced perceptions concerning the presumed democratic aim of the muralists, their publicly proclaimed intentions and their achievements. Rivera, for example, wrote that Mexican muralism had 'for the first time in the history of monumental painting ceased to use gods, kings, chiefs of state, heroic generals, etc. as central heroes. . . . For the first time in the history of Art, Mexican mural painting made the masses the hero of monumental art'.[11]

However, the democratic and revolutionary mythology surrounding the form, content and ideological intention of Mexican muralism has often served to obscure rather than to enlighten. Outside Mexico, the claims made upon muralism have been left largely unchallenged. Both critics and followers have served to fuel the myth. In *A Concise History of Modern Painting*, Herbert Read declined to include the works of Rivera, Orozco and Siqueiros on the grounds that 'like some of their Russian contemporaries, they have adopted a propagandist programme for their art, which seems to me to place it outside the stylistic evolution which is my exclusive concern'.[12]

Mexican muralism, and particularly the murals of its three leading artists, is too important to leave to mythology and unchallenged assumptions. Siqueiros claimed the 'fundamental aesthetic goal' of the movement was 'to socialize artistic expression and wipe out bourgeois individualism, to repudiate the practice of easel painting, to commit itself to the goal of a monumental public mural art, and to direct itself . . . to the native races humiliated for centuries; to the soldiers made into hangmen by their officers, to the peasants and workers scourged by the rich'.[13] It is therefore imperative that claims and achievements are tested and questioned and facts disconnected from the creation of the inevitable fiction in order to clarify our understanding of the real nature, aims and achievements of the Mex-

ican mural renaissance, and its place in the history of twentieth-century culture.

Were, for example, the complex dynamics of Mexican society during the revolution such that the birth of public muralism was largely a fortunate occurrence due to the commitment of one man, whose government post allowed for the initial realization of a few mural commissions? Or was it an inevitable consequence of the cultural, political and social reverberations following the ending of the Mexican revolution?

Were the radical aims and intentions of the movement, as articulated by its leaders in the first years of its existence, sustained throughout the decades that followed? Or did they, like the society from which the movement emanated, undergo such a transformation that the movement and its role in Mexican society became unrecognizable in relation to its original premises?

Does the mythology surrounding the Mexican mural movement, as a socially radical form of art, serve to hide divergent attitudes, intentions and artistic achievement, thereby questioning the whole idea of a singular aesthetic and ideological definition and the identity of Mexican muralism?

In what terms can the Mexican mural movement legitimately be discussed as revolutionary? Did it merely reflect the country's revolutionary society or did the murals, in a political sense, function as catalysts of change? Furthermore, to what extent were the murals really a public art for the masses? Were they in reality a form of state-institutionalized urban art, the intellectual preserve of the developing nationalist Mexican bourgeoisie?

Such questions are tools with which to begin unravelling and clarifying the important issues in relation to Mexican muralism. However, where we intervene in the history of this unique movement to begin such a task is in itself an important issue. Mexican muralism is often understood in terms of a common definition, and a common identity, a movement of coherence and singular purpose. In whatever way we understand that purpose, Mexican muralism was also the sum of its individual parts, the creation of many artists working over many decades. However, Orozco, Rivera and Siqueiros indisputably stand out, and form an essential point of departure in any attempt to understand the movement. Their murals have often been interpreted as giving the Mexican mural painting renaissance its singularity and identity. Yet as three profoundly individual artists, they have artistic and ideological divergences. This difference underlines the richness and breadth of their mural work, and the reasons for the outstanding achievement of the Mexican mural movement.

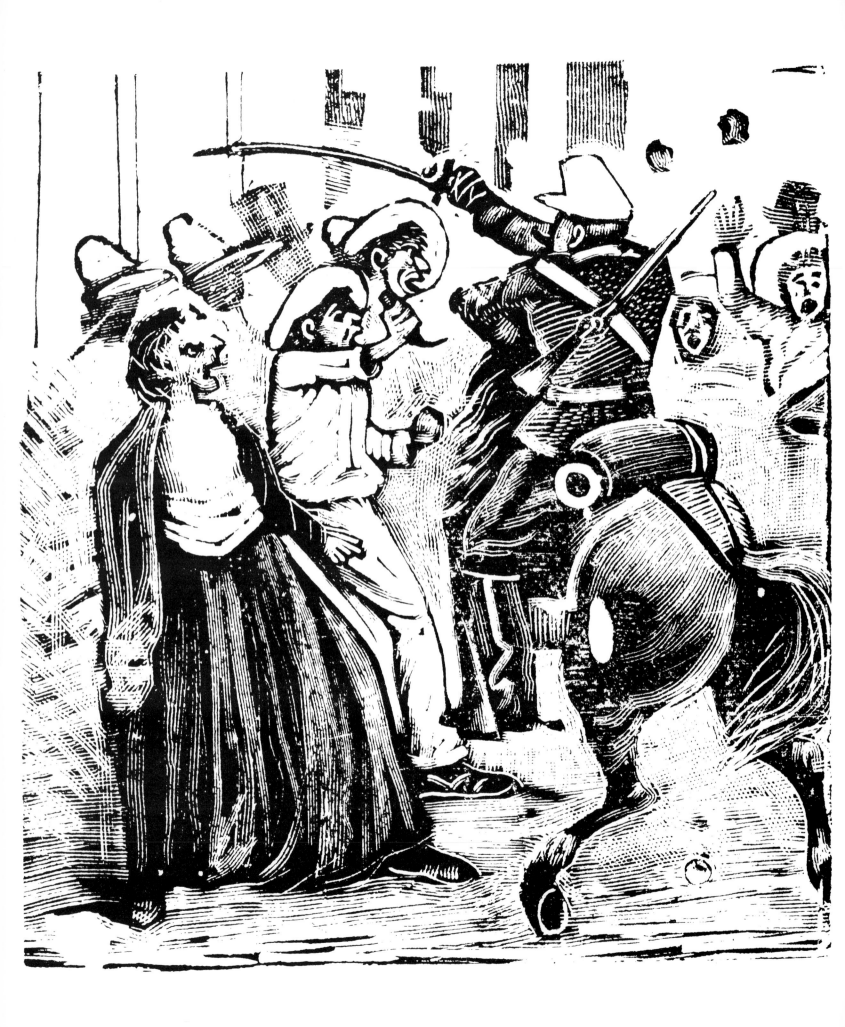

ONE

CULTURE AND REVOLUTION

THE POLITICS OF CONTEXT

The mural work of Orozco, Rivera and Siqueiros spans five decades from the early 1920s to, in the case of Siqueiros, the early 1970s. During that time Mexico underwent an enormous transformation from a mostly rural, semi-literate revolutionary nationalist society to a developed, largely industrialized and modern country. The murals of Orozco, Rivera and Siqueiros reflect the development of an extraordinary and arguably unique relationship between an art movement and a modern twentieth-century society. How the murals of these three painters reflected the changing realities of Mexico and its people, and how in turn the people perceived the murals throughout those changing decades feeds into the important wider question concerning the function that art can have within a modern secular society.

As contemporaries, Orozco, Rivera and Siqueiros grew up during the period of the 'Porfiriato'. This pre-revolutionary society, presided over by the dictator Porfirio Díaz for more than thirty years from 1876 to his eventual overthrow in 1910, influenced every facet of Mexican social life. It was a society marked by enormous divisions of wealth, property and power. In the countryside power was vested in a small class of landowners, whose hold over the land was such that by 1910, 90 per cent of the Mexican peasantry had been dispossessed of its land and forced to live under the iniquitous system of debt peonage.[1] Haciendas, the huge estates of Mexico's landed aristocracy, covered more than half the total area of the country. As if to reinforce the predicament of the mass of landless Mexican peasantry at this time, many of the country's landowners, or *hacendados*, were foreigners.

This colonizing of the land was mirrored in other areas of Mexican economic and industrial life. Díaz's rule was marked by a concerted effort to push Mexico into the twentieth century. To this end he encouraged massive foreign investment in Mexico, to be fed by a well of cheap and obedient labour. As a result, significant areas of Mexico's agricultural land as well as large parts of the country's economic and industrial infrastructure came under the control or influence of foreign owners, industrialists and speculators.

The degree to which Díaz allowed and encouraged this external control over his country's economic and industrial life was, paradoxically, fuelled by a genuine sense of national pride. He wanted Mexico to be dragged out of its backward past into the future. It was an attempt to secure for Mexico a place of pride, prestige and power from which it could begin to compete on equal terms with its much more powerful North American and Western European rivals. But it was a vain attempt, for the regime of Porfirio Díaz was a political culture controlled by a large group of positivist, Darwinist bureaucrats whom Díaz gathered around him. Known as the *Científicos* (scientific thinkers), they became 'the ideological backbone of the regime, whose emblem was "order and progress". But the order was equated with oppression and progress with the well-being of a few at the expense of a poverty-stricken rural population.'[2]

2
Porfirio Díaz (third from left) with
ministers and officials of his
government, *c.*1910.

12

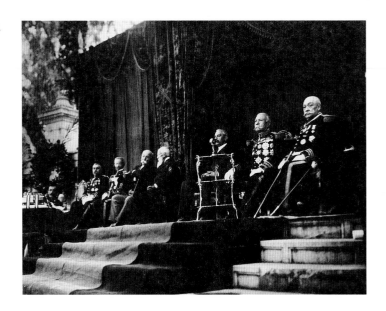

Headed by Díaz's main advisor, José Ives Limantour, the *Científicos* saw their positivist philosophy as a rational means to extricate Mexico from the poverty and backwardness of its past. However, the principal flaw in their project was their favouring of the white Mexican and the foreigner over the vast mass of the Mexican population which was either Meztizo or pure Indian. This belief prevailed amongst many of the bureaucratic élite of the Díaz regime and was exemplified by the attitudes of people such as Francisco Bulnes. A leading positivist intellectual of the time, Bulnes considered in his book *The Future of the Latin American Nations* (1899) that Indians, Africans and Asians were condemned to permanent inferiority by their environment and poor diet. For the *Científicos*, white European and North American modernity was the touchstone of Mexico's salvation and transformation into a modern industrial state, an attitude reflected in the economic and industrial policies of the dictatorship.

The main philosophical opposition to the dominance of the *Científicos* came in the form of an intellectual revolt which began with the creation of the *Ateneo de la Juventud* (Athenaeum of Youth) in 1907. This lecture and debating society was formed by a number of leading liberal intellectuals in Mexico who opposed the whole basis of the Díaz regime. Like most other countries in Latin America in the nineteenth and early twentieth century,

Mexico had a small élite group of intellectuals. Traditionally this élite generally supported the *status quo*. However, during the nineteenth century there were also a number of important radical individuals within this group. Figures such as Guillermo Prieto, Ignacio Ramírez and Ignacio Altimirano often manifested a deep social concern. This radical tradition was taken up by those who formed the Ateneo; its leading members, men such as Antonio Caso, Alfonso Reyes and perhaps most significantly José Vasconcelos, were all eventually to support the revolution and to take part in the forging of 'a new type of Mexican culture'.[3]

While the members of the Ateneo helped change the intellectual climate of the Porfiriato in the years immediately preceding the overthrow of the dictator, political and industrial opposition was simultaneously being felt across the country. In 1906 the group *Regeneración* led by Ricardo and Enrique Flores Magón issued a manifesto from exile in St. Louis, Missouri, calling for freedom of speech and the press, the suppression of political bosses, the secularization of education and the restoration of lands appropriated from the peasantry. In the same year the copper miners of Cananea went on major strike against their employers, the Green Consolidated Copper Company of America. The strike provoked a violent response from the company, which sent in a battalion of American Rangers to quell the industrial action.[4] A year later similar unrest hit the textile industry at Río Blanco, where demands by workers for recognition of labour organizations were put down in a bloody massacre. It was against this background that the revolution in Mexico grew.

The birth of the Mexican revolution is often cited as having begun in March 1908, when Porfirio Díaz, in an interview with James Creelman of Pearsons magazine, called for the emergence of an opposition party as 'proof of Mexico's ability to develop a true democracy'.[5] But as the old dictator's term of office drew to a close in the latter half of 1910 it became obvious that the proof would not materialize when, on 4 October, his unelected deputies once again declared him to have been re-elected President of the Republic.

In the same year that Díaz called for the emergence of an opposition party, Francisco Madero, a liberal democrat, issued a book entitled *The Presidential Succession*, in which he demanded

Francisco Madero, escorted by
Emiliano Zapata, during the
presidential election campaign of
June 1911, in Cuernavaca, Morales.

universal suffrage and no re-election of the president. But, as the main opposition candidate, Madero was imprisoned by Díaz on the eve of the 1910 presidential election. Escaping to the United States, Madero formally proclaimed a revolution against the Díaz government on 20 November in his Plan of San Luis Potosi. The news of Madero's proclamation spread quickly throughout the country. His influence on the Mexican masses began to take root, and everyone with a grievance against the Díaz regime saw in Madero the symbol of their hopes and dreams. On 14 Febru-

ary 1911 Madero crossed the United States' border into Chihuahua, where the conscript army sent to crush this revolution promptly deserted, joining his cause.

The downfall of Díaz was however more a dissolution than an insurrection by the masses. As Hans Greunig wrote, 'No violent upheaval overthrew Díaz. A stately edifice long admired from without for its magnificence and apparent stability unexpectedly crumbled. A disintegration had taken place in the body politic and social.'[6] Under pressure of events Díaz resigned on 25

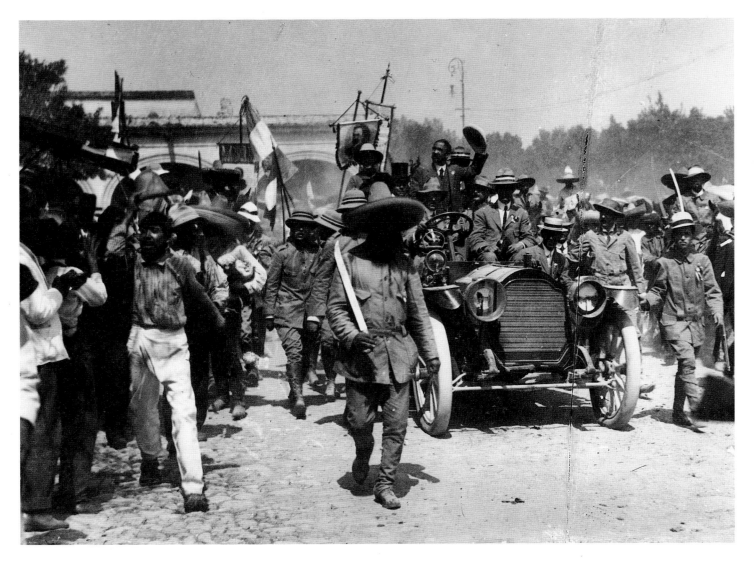

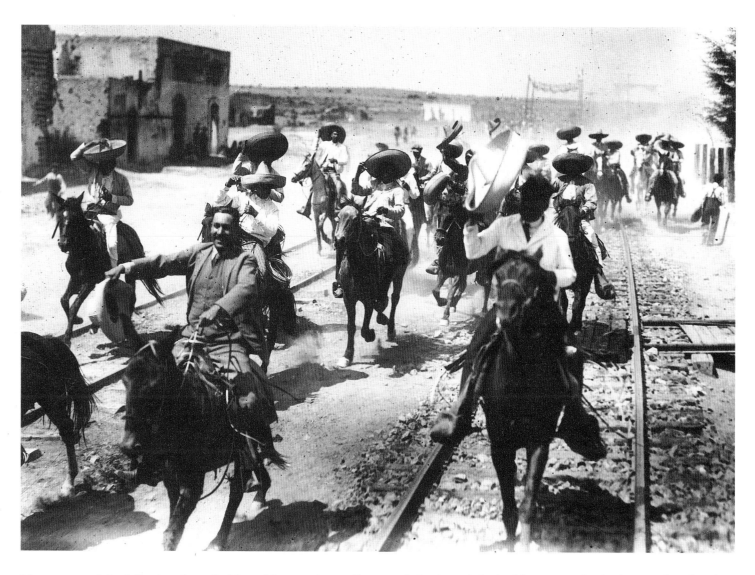

May 1911, and the following day sailed from Veracruz into exile in Europe.

Díaz's departure from Mexico eventually led to the outbreak of internecine warfare between former supporters of the old dictator and those opposed to him, as well as amongst the various revolutionary forces. This complex battle for power led to a protracted civil war which finally ended some ten years later. During that period over a million Mexicans lost their lives. In 1920, the constitutionalist army general Alvaro Obregón, who had been an important figure in the revolution, was elected President of Mexico. Obregón's short term of office marked the beginning of a long and difficult period in which the political process unleashed by the revolution would eventually come to be consolidated and institutionalized in the formation of a single ruling party, the PRI (Institutional Party of the Revolution). With the election of Obregón, Mexico not only swept away the dictatorship of Porfirio Díaz, but also consigned to history the country's old ruling class. Its powerbase in the church, the army

and the *hacendados* had been completely destroyed and with it, the dreaded yoke of debt peonage.

Although the old regime was eventually overthrown, the revolution itself was a complicated, bloody and often contradictory process. While Emiliano Zapata's cry of 'Land and Freedom' symbolized the struggle of the peasantry for land, Zapata's cause was surrounded by a crude and violent competition for power, in which many of the revolution's greatest heroes were murdered by their supposed allies. Such a tragedy is well expressed by Antonio Rodríguez, who wrote of

the shooting of Otílio Montano, one of Zapata's enlightened ideologists, by Zapata himself. Or that of Paulino Matínez, another ideologist, by Francisco Villa. . . . anyone who saw Zapata fall on the orders of Carranza, and Carranza by the orders of Obregón would look on the revolution as a blood bath, in which revolutionaries like Felipe Angeles, Villa, Zapata and many others died at the hands of their companions in arms.[7]

4
Supporters of Francisco Madero,
c.1911.

5
Banquet at the National Palace,
Mexico City in December 1914.
Seated, left to right, are José
Vasconcelos, Pancho Villa,
President Gutiérrez and Emiliano
Zapata.

The result of those chaotic years was to transform the country not into a communist or socialist state, but into one of revolutionary nationalism. This radical nationalism had its roots deep in the political history of Mexico's 300 years of Spanish colonial dependency and its aftermath. Mexico's struggle to break free

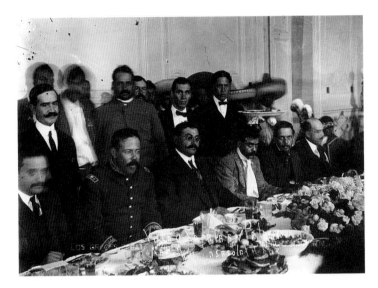

with its independence in 1821 was initially followed by the United States of America's occupation of the country and later, in a similar but much longer quest for colonial domination, by France in the 1860s. Despite these colonialist incursions, the country's tenuous grasp of its fragile independence was strengthened during the middle years of the nineteenth century by the period of the liberal reform under the presidency of Benito Juárez. In part this was because 'With both the independence and the republic faced with extinction, the liberals obviously had to appeal to ideals of collective sacrifice and civic duty rather than continue to insist on the primacy of self-interest of the individual. . . . At this decisive juncture the radical ideologues of the reform, Ignacio Ramírez and Manuel Altimirano, invoked the concept of the "patria".[8] Justo Sierra, Altimirano's foremost disciple, wrote that 'Liberty had triumphed; the great reforming revolution had become confounded with a war of independence and Patria, Republic and Reforma were henceforth the same thing.'[9]

With the advent of the revolution, intellectuals such as Molína Enríquez, Manuel Gamio and José Vasconcelos took the ideology of Liberal Patriotism and transformed it not only into an idea of Mexican nationhood but, as importantly, into the basis of a specifically Mexican nationalist theory. It was against this intellectual and political revolutionary backdrop that a tide of national demands and desires was released. Some of the demands were in opposition to everything that the positivist intellectuals of Díaz's *Científicos* had stood for. Others opposed the liberal capitalism of the United States. At a popular level, the nationalists of the revolution appealed 'to tradition and invoked myths and ideas already formulated during the wars of independence. Here was the origin of the prevalent "indigenismo" and the exaltation of the insurgent heroes. In this instance the revolution represented a revival and a revaluation of fading traditions and repudiation of the liberal positivist epoch.'[10]

This quest for national, cultural and intellectual self-expression and definition, which had begun to manifest itself long before the economic and political needs of the country finally provoked revolt, is significant. The development of Mexican muralism can be seen to grow out of a Mexican cultural renaissance, the roots of which were clearly present and developing before the revolution. This renaissance synthesized with the political revolution to form a unique relationship between a tide of radical national politics and a cultural rediscovery of national definition and identity that would in the end reach beyond the purely Mexican. As the celebrated Mexican art historian Justinio Fernández has written, 'the nationalist ideas went well beyond their limits and finally took on a humanistic character of universal scope. Nowhere is this better expressed than in contemporary mural painting. To understand this art is to consider and submerge oneself in the spiritual, social, political, philosophical, and historical problems of our time, not only in Mexico, but in the panorama of world culture.'[11]

The renaissance of twentieth-century mural painting in Mexico can be linked to a number of roots and cultural developments in the years leading up to the revolution. Of these, that which perhaps most obviously drew into focus the issues, ideas and personalities that would be associated with the eventual flower-

6 *above*
José Guadalupe Posada: newspaper engraving depicting a murder, 1910.

7 *below*
José Guadalupe Posada: newspaper engraving depicting a train accident, 1907.

16 ing of muralism, was an exhibition of indigenous Mexican art organized by the painter Gerardo Murillo (1875–1964; better known by his adopted Nahuatl name of Dr. Atl) at the Academy of San Carlos in Mexico City in September 1910. The exhibition was intended to present a nationalist response to the official government exhibition of contemporary Spanish painting sponsored by Porfirio Díaz to mark the centenary of Mexico's struggle for independence from Spanish colonialism. Atl's exhibition reflected the groundswell of nationalist feeling amongst the country's growing band of nationalist artists and intellectuals, for whom the official exhibition of Spanish painting typified the insufferably exclusive European cultural preoccupations of the nation's ruling classes.

Despite these preoccupations, a specifically Mexican art had already begun to emerge during the years preceding the outbreak of the revolution. History painting as a genre gradually developed, eventually including purely Mexican subjects, even though these were usually painted according to classical ideals of beauty.

Nineteenth-century artists such as Leandro Izaguirre, in his painting *The Martyrdom of Cuauhtemoc* (1892; Museo Nacional de Arte, Mexico City), and Felix Parra, in his depiction of the violence of the conquest in *Episodes of the Conquest* (1877; Museo Nacional de Arte, Mexico City), reflected the development of a sense of national consciousness in Mexican art. Indian painters, such as José Obregón and Rodrigo Gutíerrez, also began to emerge. The Mexican countryside became a central and significant theme in Mexican painting. José Maria Velasco, the most celebrated of Mexico's landscape painters, exemplified this dimension of national cultural consciousness in his panoramas depicting the central valley of Mexico. The growth of popular art also led to an explosion of work representing every and any subject that was Mexican, often by entirely unknown artists. But none represented the development of an indigenous Mexican art more than the popular engraver José Guadalupe Posada (1852–1913). Rodríguez describes Posada's work as

a regular register of events and a gallery of types which cannot have been equalled for range and variety anywhere in the history of engraving. Were it possible to collect all fifteen or twenty thousand wood-,

lead- and zinc-cuts as well as the lithographs produced by Posada between 1871 and 1913, one would have a comprehensive record of all the outstanding events in the history of Mexico, pictured as they occurred during a period of almost fifty years.[12]

But Posada's work, usually published in Vanegas Arroyas' street newspapers *Gaceta Callejera*, *El Bolletín* and *El Centavo Perdido*, was more than a mere catalogue of events. As a man of the people, Posada remained close to them all his working life. He was a rebel repelled by the injustices of the dictatorship of the Porfiriato. Prints such as *The Ruling Misery*, *The Ballad of Four Zapatistas killed by Firing Squad* and *The Horrible Crimes of the Landowners* show Posada as a political populist, championing the cause of justice and freedom.

The sense of national resurgence reflected in Atl's Mexican exhibition highlighted the radical nature of this cultural development, for many of the artists involved in the exhibition were either members of, or associated with, the Ateneo. Francisco de la Torre and Roberto Montenegro, for example, presented images of contemporary indigenous figures. Saturnino Herrán and Jorge Encisco depicted pre-Hispanic themes, in such works as *The Legend of the Volcanos* (by Herrán; 1910, Col. Pinacoteca del Ateneo Fuente de Saltillo) and *Anahuac* (by Encisco) in which 'the figure of the Indian stands as a symbolic and allegorical representation of spiritual and moral virtues in the race. . . . Encisco uses the pre-Hispanic Indian as a symbol of the nation, but it is his exalted attitude, his spiritualism that is the distinguishing principal characteristic.'[13]

Paradoxically, much of the work in the Mexican exhibition shared many common features with that of the Spanish painters in the government's official show. As Coleby has written,

Notwithstanding the nationalist implications that the (Mexican) exhibition assumed towards the painters of the old capital, the painters in both exhibitions shared common roots. Painting in the Spanish exhibition was characterized predominantly by 'costumbrista' themes. . . . Equally in the Mexican exhibition, the predominance of national, above all 'indegenista' themes corresponded to the characteristics of costumbrismo and modernism.[14]

However, Atl's Mexican exhibition was more than simply a nationalist project. It also promoted, as Atl himself had done in the years preceding it, a view of art that was anti-academic and, in Mexican terms, modernist. Notions of modernity amongst Mexican artists had been vigorously promoted in the years leading up to the 1910 Mexican exhibition through the journal *Savia Moderna*. The group of artists associated with *Savia Moderna*, amongst whom was Diego Rivera, took a stand against the analytical and objective realism which they saw as a reflection of the prevailing ruling ideology of scientific positivism of the Díaz dictatorship. They opposed art produced at the Academy, which they saw as mirroring this philosophy, promoting in its place a view of art that was essentially spiritual and symbolist. Indeed, one of the principal aesthetic currents of these years was the reaction against academic realism.

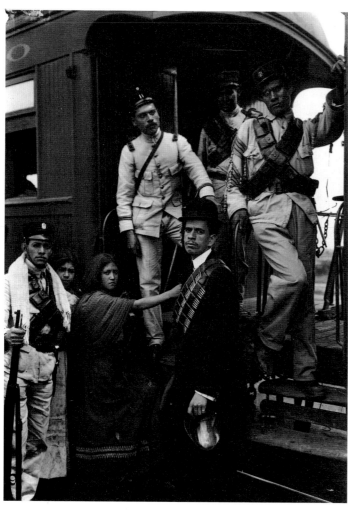

Atl is often seen as the ideological precursor and theoretical proponent of Mexican muralism. In the early years of the twentieth century he was one of the leading proponents of the idea of the creation of a national art that would be based on the aesthetic 'spiritualistic' concepts of *modernismo*, as expressed by the artists surrounding *Savia Moderna*.[15] His demand for a national art was inspired by the idea of creating in Mexico, through the revelation of universal values, a school of modern painting, on equal terms with that of the Europeans.

Atl was a politically rebellious figure and stimulating teacher at the Academy of San Carlos. He had travelled extensively in Europe in the 1890s and early 1900s, and, returning to Mexico in 1903, brought to the attention of the young artists around him the importance of the murals of the Italian renaissance. Orozco recalled how Atl spoke 'in his easy insinuating, enthusiastic tone of his travels in Europe and his stay in Rome. When he spoke of the Sistine Chapel his voice took fire.'[16] Atl was also a fervent radical and political nationalist. At the academy he became a focal point of reference for the young students, who were stimulated by his anti-colonialism and his proselytizing of

revolution and a new Mexican culture. Orozco wrote that during

nightly sessions in the Academy, as we listened to the fervent voice of that agitator Dr. Atl, we began to suspect that the whole colonial situation was nothing but a swindle foisted on us by international traders. We too had a character, which was quite the equal of any other. We would learn what the ancients and the foreigners could teach us, but we could do as much as they or more. It was not pride, but self confidence that moved us to this belief, a sense of our own being and our destiny.[17]

Atl's admiration for the murals of the Italian renaissance was based not so much on the notion that they represented the model for a new social art, but more on his belief that they reflected his conception of the 'spiritual' in art. Atl admired the frescoes of Michelangelo and Leonardo for their spiritualism and spontaneous energy. Indeed, it was this dimension that he considered to be the basis for the creation of a Mexican *modernismo*.

Following the success of his 1910 Mexican exhibition, Atl formed what he came to call his *Centro Artístico* (Artistic Centre). The aim of this centre, in which Orozco participated amongst others, was to find walls of public buildings on which to paint murals. Significantly, Atl conceived of this idea not in terms of a visual social polemic, but in terms of decoration, an approach that was much in keeping with his view of art as essentially spiritual and symbolist. Though his ideas for mural painting did not envisage the kind of social radicalism that was to become identified with the mural movement after the revolution, the method he intended to employ certainly foreshadowed the radical collectivist team work that Siqueiros sought to develop during the 1930s. For example, in 1910 Atl gained permission from Justo Sierra, Minister of Education under Díaz, to paint the walls of the Bolivar Amphitheatre in the National Preparatory School in Mexico City, a project which the newspaper *El Imparcial* reported was to be created by members of the Artistic Centre who had agreed 'to collaborate together on a single project'.[18]

Atl's artistic position was not, as the nationalist groundswell of feeling at the time might suggest, simply anti-European. He did oppose the belief that European art was innately superior to Mexican art but, like many artists of this period, he was also

10
Girl soldier, 'soldadera' of the
Mexican revolution.

11
Soldiers of the Federal army, 1915.

12
Wounded Federal soldier, 1915.

particularly interested in developments that were occurring in
Europe. In this respect, the *Modernista* movement in Mexico,
championed in the pages of the magazine *Revista Moderna*, was of
notable significance. Works by Rodin and Beardsley were
illustrated in the magazine, and Japanese art, art nouveau and
the symbolist concept that art was another reality and not just an
allusion to something were all promoted.

The theme of 'Human Evolution' proposed by Justo Sierra for
the mural on the walls of the Bolivar Amphitheatre thus held
particular appeal for Atl and his fellow artists of the *Centro
Artístico*. They saw the theme as being essentially symbolist, as
much connected to their current thinking concerning the
development of modern Mexican art as it was to its European
counterpart.

Atl's influence on the development of Mexican muralism was
one derived essentially from his presence as a political figurehead
and mentor, first as a teacher and then, during the revolution, as
the Director of the Academy of San Carlos. Atl's powerful rad-
icalism was perhaps as much an influence as anything else on the
young painters who would eventually create the Mexican mural
movement after the revolution. His approach towards the teach-
ing and practice of art and the institution of the Academy was
particularly significant. In his nomination speech as the Director
of the Academy, Atl said 'Being the foe of academic institutions,
how can I present a plan for reform, suggest a curriculum for a
set-up that I judge pernicious?'[19] Atl urged his students and
fellow artists to create a national art which would be monumen-
tal in form and public in its accessibility, and to adopt the use of
workshops and group work in the teaching of art and creative
production. At his nomination he also spoke of his dilemma of
'whether to propose that the school be scrapped, or else con-
verted into a workshop geared for production like any industrial
workshop of today, or like all workshops of all epochs when art
flowered vigorously'.[20]

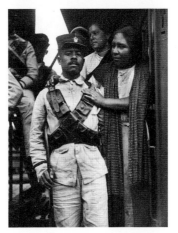

Following his closure of the open-air Santa Anita School of
Painting, which his predecessor Alfredo Ramos Matínez had
opened on the outskirts of Mexico City following a student strike
in 1911 against the rigidity of the teaching methods employed at
the Academy by the current Director, Antonio Rivas Mercado,
Atl stated that

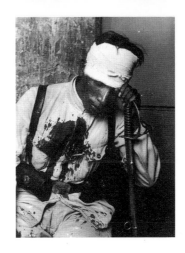

13
Diego Rivera (third from left) and
José Vasconcelos (second from left)
at a political meeting in
Chapultepec Park, Mexico City,
1923.

20 Architects, painters and sculptors should not work with an exhibition or a degree in mind, but rather to make or decorate a building. . . . Reform must come at the same time in the political, administrative, military and artistic orders. If in this moment of universal renovation the Mexican artists, pleading the serenity of their sacerdocy, remain inert, refuse to play a conscious virile part in the struggle, if they let others do their job and fail to leaven the national upsurge with the purity of their good will and the thrust of their energy, then the rolling avalanche is sure to leave them behind, in a heap of debris.[21]

Atl therefore not only opposed the academicism of the Academy but also what he termed the asocial character of the Santa Anita School. Both seemed for him in their own ways to deny the presence and impact of the turbulent revolution going on throughout the country outside the walls of these institutions. Atl's radicalism at this time was such that he saw the joining of the art institution to the social and political revolution as a fundamental principle. Indeed, during his time in Paris in 1913 on his second stay in Europe, before returning to Mexico to take up the directorship of the Academy, Atl had founded a magazine entitled *L'Action d'Art* in which he declared that the role of art was to reflect life and act as a determining force in society. In his formal letter of acceptance to the post of Director, Atl wrote that 'It is my intention to definitively reorganize this training establishment, in what I would refer to as its material structure in terms of its teaching methods. I intend to make of the National School of Fine Arts an institution of the most elevated moral character, with exclusively utilitarian ends.'[22]

The foundation of Atl's position was his idea that the artist participate in the revolutionary struggle. The influence of this ideological position was clearly felt when in 1914 he persuaded Siqueiros, Orozco and other Academy students to join with him in supporting Carranza and his constitutionalist army in their evacuation of the capital, and to move to the southern town of Orizaba. There, Atl, who had taken with him most of the printing presses owned by the Academy, set up a propaganda centre in support of Carranza using the newspaper *La Vanguardia*, for which Siqueiros acted as military correspondent and Orozco drew a whole series of biting cartoons and illustrations. Siqueiros later wrote of Atl's influence that 'We owe him the first direct militancy of Mexican artists in the ranks of the revolution . . . It

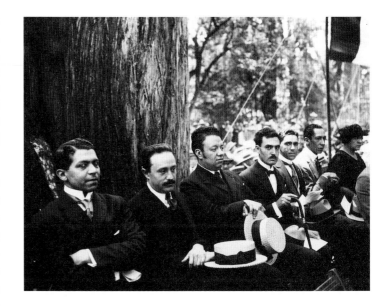

is evident that his participation in organizing the workers of the capital into the red battalions was an incentive to the ex-students of the school of Fine Arts and the striking students of the school to participate in the political and military life of modern Mexico.'[23] Atl's profound influence on the young painters of this period makes his presence integral to the story of the birth of Mexican muralism.

Similarly, nothing can be written about Mexican mural painting without mentioning the crucial presence of José Vasconcelos. As one of the major intellectuals of Mexico's revolutionary cultural renaissance, Vasconcelos became one of its key inspirational figures. As the Secretary of State for Public Education in Mexico from 1921 to 1924, he used his ministerial position to implement an educational and cultural policy for Mexico, the effect of which was to facilitate and set in motion, through the auspices of the state, a tide of intellectual and artistic creativity that was to give Mexico a special prominence in the modern culture of the twentieth century.

In 1915 Vasconcelos joined the provisional government of Eulalio Gutíerrez as Secretary of Education. In 1920, under the administration of General Alvaro Obregón, he was made Rector of the National University in Mexico City. In his inaugural address, he announced that he had come as a delegate of the

revolution and that a revolution should now also take place in education. In 1921, Obregón promoted him to Secretary of State for Public Education, giving his ministry more than twice the amount of money previous office holders had had at their disposal.

During Vasconcelos' term of office, books and magazines were published and distributed in their thousands. Those who could scarcely read or write before the revolution were given access to the world of literature through his public education programmes. But his most radical and, at the time, not always popular policy was that of commissioning young Mexican artists to paint murals on the walls of some of the state's most prestigious buildings. 'One of the imperatives of our programme', Vasconcelos said later, 'was to put the public in contact with great artists rather than with mediocrities'.[24] In the mural paintings he commissioned he wanted to see 'An art saturated with primitive vigour, new subject-matter, combining subtlety and the sacrifice of the exquisite to the great, perfection to invention.'[25]

Vasconcelos closely involved the artists who had gathered around him in his extensive building programme. It was not always a popular move but, as he later said, it was his firm conviction that 'many of our present and modest endeavours will be remembered thanks to the painters who have decorated them. Architects should feel elated at their good fortune at working in the midst of an artistic renaissance.'[26]

In the context of Mexico's political upheavals, Vasconcelos' radicalism was quite unlike that of his colleagues and many of the painters he commissioned. As Jean Charlot has observed, Vasconcelos never felt committed to the revolution in the same terms as his fellow reformers. His views were coloured by a philosophy that owed much to his belief in Pythagoras. His book, *Pythagoras, A Theory of Rhythm*, which he wrote in 1915 while in political exile, proposes the existence of two different conceptual views of reality. On the one hand there is the realm of science and economics, and on the other, the world of art and disinterested contemplation, which is arrived at by intuition. For Vasconcelos, the universe was essentially a musical concept, in which he believed that men were more 'malleable when approached through their senses, as happens when one contemplates beautiful forms and figures, or hears beautiful rhythms and melodies . . . (Pythagoras) decreed that the initiation should be through music, since melodies and rhythms possess therapeutic properties to cure the passions and routines of men.'[27]

Vasconcelos combined cunning and daring with his philosophic idealism, paying little heed to his own political and personal fortunes. In the face of sceptical colleagues and, as often as not, a hostile and uncomprehending public, Vasconcelos camouflaged the commissions that he awarded to painters under more acceptable headings.[28] Siqueiros, for example, was appointed to the position of Eighth Teacher of Drawing and Manual Crafts, with a salary of 3.30 pesos per day, while Jean Charlot recalled that Vasconcelos employed him to assist Diego Rivera on his first mural under the guise of Inspector of Drawing in the Public Schools of Mexico City Transferred to the Jurisdiction of the Ministry of Public Education.[29]

Vasconcelos' philosophical position was above all one in which freedom of expression was a principle not to be compromised by the determinations of revolutionary and transient political requirements. As Octavio Paz observed, for this reason Vasconcelos 'imposed no dogmas, either aesthetic or ideological, on the artists.'[30] It was one of the paradoxes of his time that this great philosophical idealist would help bring into being a movement in which the artists would eventually spurn his idealism in favour of a partisan and often didactic art.

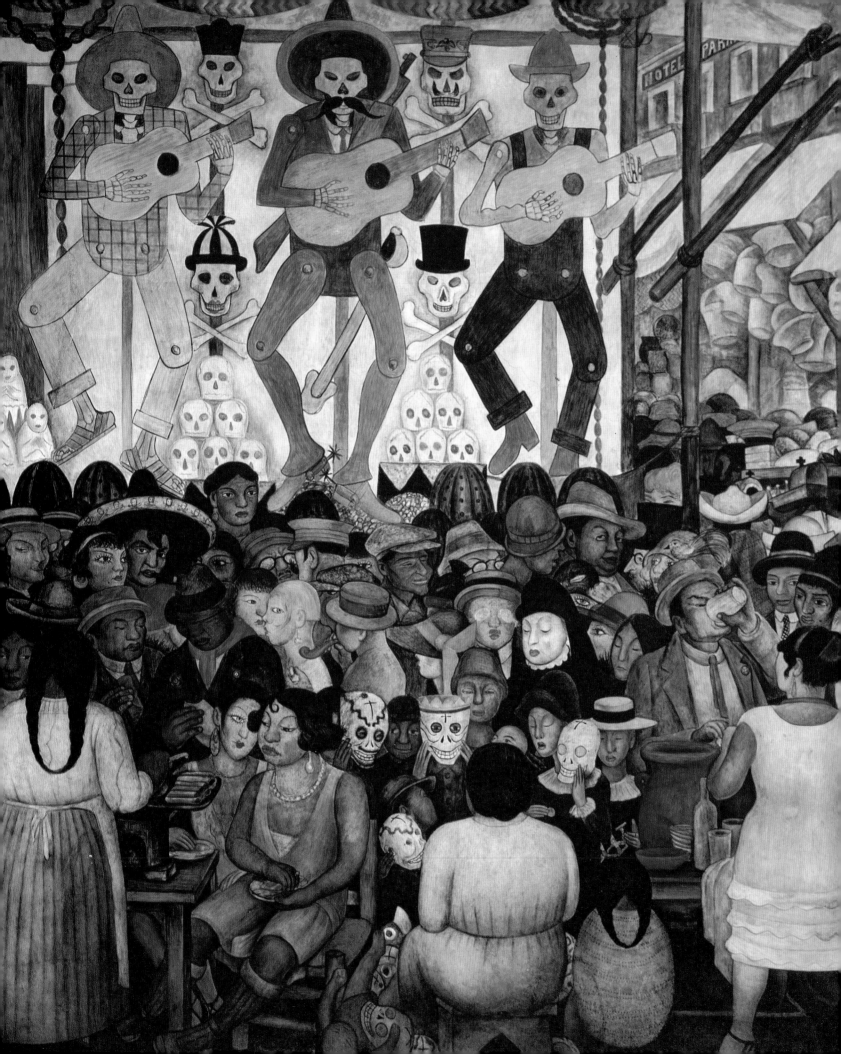

Diego Rivera: *The Day of the Dead*
(detail). Fresco, 1923–4. South wall,
Court of the Fiestas, Ministry of
Education, Mexico City.

TWO

EARLY BEGINNINGS

The Mexican mural movement began in 1921 with a burst of activity. The first murals commissioned by Vasconcelos as Secretary of Public Education were in the chapel of San Pedro y San Pablo, and among the artists commissioned were Dr. Atl, Roberto Montenegro, Xavier Guererro and Jorge Enciso. Mural commissions for the patios of the National Preparatory School, the Bolivar Amphitheatre and the Colegio Chico, all in one building in the centre of Mexico City, followed soon after. The patios of the National Preparatory School were decorated by José Clemente Orozco, Jean Charlot, Fermín Revueltas and Ramón Alva de la Canal; in 1922, Rivera began his work on the Bolivar Amphitheatre and later that year Siqueiros was commissioned to paint murals in the Colegio Chico.

When Rivera started work in the Bolivar Amphitheatre, he was already 36 and an artist of maturity, wide experience and considerable reputation. Like many Mexican painters of his generation, he trained at the Academy of San Carlos. He enrolled there in 1908, spending seven years undergoing a rigorous academic training that emphasized a thorough grounding in life-drawing and technical expertise. During this time, he was taught and influenced by many different painters, including Félix Parra, who introduced him to the art and culture of Pre-Columbian Mexico, Santiago Rebull and the landscape painter José María Velasco, who taught him landscape.

Of the many artists that influenced Rivera during his formative years, few did more than the Mexican engraver José Guadalupe Posada. Posada's prolific output of prints represented for Rivera the vitality of Mexico's rich traditions of popular art and the most penetrating views of Mexican social life in the years before the revolution, and later influenced the imagery that Rivera used in his murals depicting the revolutionary struggles of the people through their popular traditions of folklore and political and religious festival.

Rivera's influences were not, however, exclusively Mexican. Like several other Mexican artists of the time, he travelled to Europe. With the assistance of a scholarship awarded to him by the governor of Veracruz, Teodoro Dehesa, Rivera arrived in Spain in 1907. He first went to the Madrid studio of the Spanish painter Eduardo Chicharro, an introduction made under the auspices of Dr. Atl.

Whilst in Spain, Rivera visited the Prado Museum, making copies of paintings by Goya, Velázquez, El Greco, Bruegel and Bosch. In 1909 he left Spain to travel through France, Belgium and England. In the summer of that year he visited London where he studied the work of Constable, Blake and Turner. He also visited the capital's notorious East End, making drawings of its slums, street life and factories.

In November 1910, Rivera returned briefly to Mexico for an exhibition of his work as part of the official centennial celebrations for the War of Independence against Spanish colonial rule. He stayed only a short time, leaving Mexico in June 1911 to return once more to Paris.

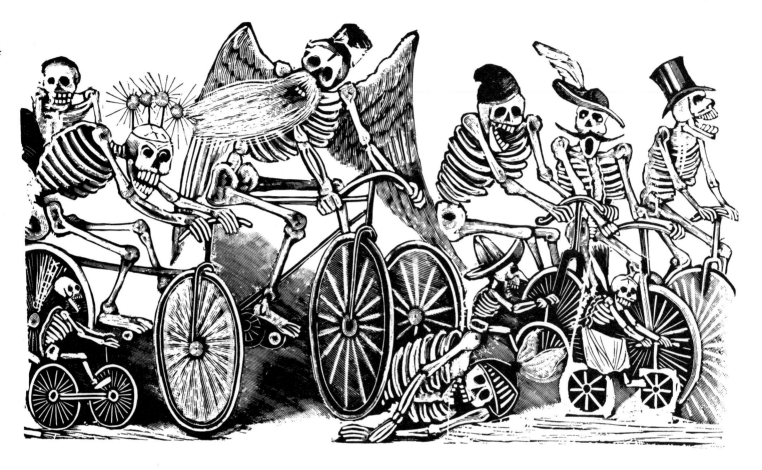

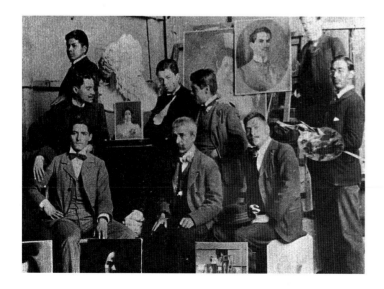

Although Rivera travelled widely in Europe during the years that he lived there, Paris and later Italy were the centres of art that most influenced his intellectual and aesthetic development. During the first two decades of the twentieth century, Paris was the centre of European artistic innovation. Not only was it at the heart of the Cubist revolution, but it also functioned as a cultural intersection where nearly all the leading intellectual, artistic and political figures of the period lived or visited. Europe's own cultural revolution engaged him artistically and intellectually in ways that had a profound influence on his development as a mural painter.

The impact of Cubism on Rivera was immense. For four years, influenced by the examples of Picasso, Braque and Juan Gris, Rivera immersed himself in the movement, contributing much to its diversity of style. Although he never forgot the lessons of

15
José Guadalupe Posada:
Newspapermen depicted as bicycling
skeletons, c.1890.

16
Rivera (third from left, back row) as
a student at the San Carlos
Academy of Art.

Cubism, the movement ultimately proved inadequate for Rivera's need to express the social and political realities that were increasingly engaging his attention. His famous *Zapatista Landscape* painting of 1915 (Museo Nacional de Arte, Mexico City) to some extent successfully combined avant-garde Cubist language with Mexican revolutionary and landscape imagery. But the unresolved contradictions that arose from this attempted synthesis made change inevitable. In his own words, Rivera ceased to paint using Cubist techniques because 'of the war, the Russian revolution, and . . . the belief in the need for a popular and socialized art. It had to be a functional art related to the world and the times, and had to help the masses for a better social organization. In Cubism there are many elements that do not fit this specific need.'[1]

Rivera's move away from Cubism was sudden and signalled the reaffirmation of a more traditional and classical approach in his art. Cézanne, then Ingres, Renoir and Gauguin became the focus of his attentions. The portrait of *The Mathematician* (1918; Col. Dolores Olmedo), the drawings of *Chirokof* (1917; Worcester Art Museum, Massachusetts), *Angeline Beloff* (1917; Museum of Modern Arts, New York) and the painting of *The Grape Picker* (1920; private collection) reflect the dramatic break with Cubism. The paintings of these years also parallel Rivera's own political and intellectual development. The art critic Elie Fauré, the realities of the First World War and the combined political and social influence of Russian and Mexican émigré friends on Rivera, with their first-hand accounts of political developments in both countries, helped to radicalize and politicize the ideological and aesthetic framework of Rivera's thinking. Thus, when Rivera met Siqueiros for the first time in 1919, the ideological terrain on which he held discussions with Siqueiros on the future course of Mexican art had already begun to be formed in his thinking.

Persuaded by Alberto Pani, the Mexican Ambassador to Paris, and José Vasconcelos, Rector of the University of Mexico, to study the frescoes of the renaissance, Rivera travelled to Italy in 1920. Like Siqueiros' own pilgrimage in the same year, the visit formed a final and most significant stage in Rivera's development in the years preceding the birth of Mexican muralism.

Rivera spent seventeen months in Italy studying Byzantine, Etruscan and renaissance art. The frescoes of the renaissance occupied most of his attention, and of these and many other works Rivera created over 300 sketches and drawings. He also continued to explore what for him was by then a growing concern: the concept of a public and socialized art, an idea championed by Elie Fauré. It was also a subject that had occupied many of the conversations that Siqueiros and Rivera had held in Paris the previous year, concerning the profound implications the Mexican revolution would have for the future of Mexico's culture and the important role visual artists could play in that culture.

When Rivera returned to Mexico in 1921 to take part in Vasconcelos' programme of public mural commissions, he had spent the best part of fourteen years abroad. Except for the short period when he had returned to Mexico in 1910–1911, he had witnessed nothing of the tumultuous events of the revolution that had so changed his country.

By contrast, José Clemente Orozco had seen much of the revolution at first hand. Born in Zapotlán el Grande, in the state of Jalisco, in 1883, Orozco was the oldest of '*los tres Grandes*'. Like Rivera, he trained at the Academy of San Carlos, enrolling there in 1906. Under the regime set by the Academy's director, Antonio Fabrés, Orozco 'thrived . . . on a stiff academic diet, zealously copied plaster casts and photographs, and trained his hand and eye to the inhuman objectivity of a camera.'[2]

During his years at the Academy, Orozco was exposed to a wide variety of artists and influences. Through Julio Ruelas, 'the painter of cadavers, satyrs, drowned men and suicidal lovers', Orozco was introduced to Symbolism. While the widely influential and much-read art journal *Revista Moderna* (1898–1911) championed Symbolism, it also contained illustrations of the work of many leading European modernists of the time and was one of the few sources in which Mexican artists could see the new work being produced in Europe.

One of the most decisive influences on Orozco in the early pre-mural period of his career was Dr. Atl, whose championing of renaissance art for its spiritual qualities coincided with Orozco's interest in Symbolism. In his autobiography, Orozco later recalled the profound impression made on him by the character of Dr. Atl as one of his tutors at the Academy.

26 In 1912 Orozco set up his first studio, moving away from the world of academic training to embark on a series of drawings and watercolours of prostitutes which became known as *The House of Tears*. 'I opened a studio in Illescas street', he wrote in his autobiography,

in a neighborhood plagued with luxurious houses of the most magnificent notoriety, which sheltered 'embassies' from France, Africa, the Caribbean, and North and Central America. Out in the open air the Barbazonians were painting very pretty landscapes, with the requisite violets for the shadows and Nile green for the skies, but I preferred black and the colours exiled from Impressionist palettes. Instead of red and yellow twilight, I painted the pestilent shadows of closed rooms, and instead of the Indian male, drunken ladies and gentlemen.[3]

In addition to the *House of Tears* series, Orozco also made a number of drawings of young girls, as well as numerous studies on paper of popular street life.

Apart from the powerful tragic and expressive work of his brothel scenes, during this period Orozco also produced political and social caricatures. The influence of Posada is unmistakable in these. Orozco spoke of the importance of Posada when he wrote how, as a young man, he would pass by the printer's workshop and see Posada working 'in full view, behind the shop window, and on my way to school and back, four times a day I would stop and spend one or two enchanted minutes in watching him. . . . This was the push that first set my inspiration in motion and impelled me to cover paper with my earliest figures; this was my awakening to the existence of the art of painting . . .'.[4] The cartoons and social caricatures that Orozco created during this period also reveal the profound iconoclasm present in so much of Orozco's work. He drew biting satires for the two anti-Madero newspapers, *El Imparcial* and *El Hijo del Ahuizote*. One caricature, printed in *El Ahuizote* in 1913 and entitled *Congressional Cinema*, satirized Madero politicians and depicted Madero himself as a chick-pea.

In November 1914, with the competing armies of Francisco Villa, Emiliano Zapata and Eulalio Gutiérrez about to enter the capital, Orozco left Mexico City, with other student colleagues from the Academy, to follow Dr. Atl to the town of Orizaba, a move prompted by General Carranza's decision to evacuate the city and go south to the state of Veracruz to set up his headquarters. Atl, a fervent supporter of Carranza (Carranza had appointed him Director of the Academy in 1913), had decided to lend support and live and work in Orizaba, where he edited the Constitutionalist army newspaper *La Vanguardia*. While in Orizaba, Orozco made drawings and cartoons for *La Vanguardia*, which was produced in a church and 'distributed by its staff from troop trains that shuttled endlessly in darkness from bivouac to battlefield to hospital to bivouac.'[5]

Although Orozco was not directly involved in combat during the revolution, he nevertheless witnessed its ravages firsthand, which provoked a mass of contradictory reactions in him. In his autobiography he claimed 'no part in the revolution. I came to no harm, . . . and I ran no danger at all. To me the revolution was the gayest and most diverting of carnivals.' Later, however, he would record more accurately the tragedy he witnessed:

Trains back from the battlefield unloaded their cargoes in the station of Orizaba: the wounded, the tired, exhausted, mutilated soldiers, sweating . . . in the world of politics it was the same, war without quarter, struggle for power and wealth, factions and subfactions were past counting, the thirst for vengeance insatiable. . . . Farce, drama, barbarity . . . A parade of stretchers with the wounded in bloody rags, and all at once the savage pealing of the bells and a thunder of rifle fire.[6]

The drawings and the cartoons of this period reflect the impact of the tragedy that Orozco witnessed. His tone was caustic and uncompromising. On the front cover of *La Vanguardia* of 10 May 1915 he drew the face of a laughing girl with a dagger and a knife in front of her face and with the caption 'I Am The Revolution, The Destructor'. Another image depicted the failure of the reform parties, with 'No Re-election' invited by 'Effective Suffrage' to join him and all the other revolutionary ideals in a common grave.

In 1916 Orozco left the ravages of the battlefields in Orizaba and returned to Mexico City. There he took part in a group exhibition intended by Carranza to tour the United States with 'the double purpose of introducing Mexican culture to foreign parts, and to open a market for the exhibitors.'[7] Though the exhibition never toured, its private showing brought an enthusiastic response to Orozco's work from Raziel Cabildo, who wrote that Orozco's art was the 'most discussed and least appreciated. . . . That this artist displeases is natural, his idiosyncrasies being at odds with the well-worn clichés revered by a public bred to the cult of prettiness.'[8] Orozco also had a one-man show of his work in the *Librería Biblos* in September. However, Mexico City in 1916 was no place for an artist, dislocated as it was by battles of the revolution. Furthermore, despite Cabildo's apparently positive remarks, Orozco was disillusioned with the overall negative response to his work: 'I have supported patiently the flood of epithets which the public let loose upon my head on account of that hapless exhibit', he wrote, 'but when in a widely read newspaper I am insulted in such fashion, I cannot remain quiet longer. . . .'[9] The following year, finding no real prospects in Mexico, Orozco went to the United States, first to San Francisco and then to New York.[10] In San Francisco he worked for a while as a sign painter. While in New York, living in extreme poverty, Orozco earned a meagre wage painting dolls' faces.

Orozco returned to Mexico City in 1920, where he set up a studio in Coyoacán, and worked as a newspaper cartoonist. He was still disillusioned and largely ignored as a painter. In a later article written for *International Studio* in 1923, the art critic Walter Pach stated that 'Orozco gave up his life work because he sadly realized that . . . he meant nothing to a public hopelessly incapable of appreciating his gifts.'[11] However, both Walter Pach and the poet Juan Tablada were highly enthusiastic about Orozco, and their ringing public endorsements of his talents as an artist were largely responsible for bringing Orozco back into the public eye and to the attention of José Vasconcelos.

For whatever reason, whether because Orozco was regarded more as a cartoonist, or because of his political opposition at one time to Madero, whom Vasconcelos fervently supported, Vasconcelos did not initially include him in the programme of public mural commissions. Orozco's eventual commission was largely due to the support of Tablada. At an important farewell gathering given by the Cultural Board of Mexico City for Tablada in February 1923, prior to his departure for the United States, the poet had called publicly on the Mexico City council to commission Orozco to decorate a wall in the reception room of the City Hall.[12] Although the mayor did not take up the idea, Vasconcelos did, and on 7 July 1923 Orozco began his first murals on the walls of the central patio in the National Preparatory School.

By the time Orozco embarked on his first mural commission, David Alfaro Siqueiros had already completed his first mural for José Vasconcelos on the walls of the Colegio Chico. The youngest of '*los tres Grandes*', Siqueiros was born in 1896 in Chihuahua. Like Rivera and Orozco, Siqueiros also undertook his early training at the Academy of San Carlos. He entered the Academy in 1911, when the revolution was already a year old and Francisco Madero still held the reins of power. In this context, the circumstances of Siqueiros' training were quite different to those of his two predecessors.

Although Siqueiros was only fifteen when he entered the Academy, both its teachers and the teaching methods employed there left an indelible impression upon him. Siqueiros was subjected to an antiquated, rigid academic teaching environment. There were long periods of drawing from the nude and clothed figure, endless still-life projects and hours of copying classical Greek plaster casts. The system employed at the time under the director, Antonio Rivas Mercado, was modelled after the French academician Pillet.[13] The academic teaching methods soon became subject to opposition. Amongst those the students criticized most was the professor of anatomy, Dr. Vagare Lope.

Lope's particular 'crime' was to require students to buy and then copy mimeographed sheets that had been traced from the pages of Richter's *Anatomy*. Petitioned by the students to put a stop to this practice, Rivas Mercado refused. What had started as a purely intercurricular problem soon escalated into political confrontation, and on 28 July 1911 the students declared a strike, demanding the director's resignation.

The extent of Siqueiros' involvement in the strike at the Academy, which lasted a year, is difficult to assess. He was still a young teenager, and by his own admission he appears only to have 'throw(n) a few stones at things, or people, and little else'.[14] Of the strike itself, Siqueiros noted 'It is not very important that this activity was mainly destructive and devoid of integral solutions, because at the time the important objective was the destruction of the old system, which had ruined so many generations. . . . so that the way could be prepared for a new progressive system of art teaching.'[15] The strike at the Academy resulted in the closing down of the institution. The students were partly successful in their demands, for eventually their favourite figure, Alfredo Ramos Martínez, was appointed director in place of Rivas Mercado. Martínez transformed the teaching methods and at the same time opened up the famous open-air school in the suburb of Santa Anita. Siqueiros attended these open-air classes briefly, but the neo-impressionism taught at this time was less important for him than the groundswell of thinking among many artists and intellectuals for Mexican subject-matter. Siqueiros wrote that

The young painters Herrán and Francisco de la Torre on the one hand and Tellez on the other began to exercise a powerful influence of 'nationalist' thinking in us. Herrán and De la Torre started to employ exclusively local themes. . . . we used to speak of the Mexicanization of the plastic arts in our country. . . . We discussed the necessity of depicting Mexican landscape, Mexican types and even to depict the problems of Mexico.[16]

Like Orozco, Siqueiros was profoundly affected and influenced by the personality of Dr. Atl. Siqueiros first came into contact with Atl when he was appointed director of the Academy in 1914. In his *Memorias*, Siqueiros recalled how influential Atl's ideas on Italian renaissance art had been for him, as well as his striving to introduce new teaching methods.

Atl's crucial role in influencing the students of the Academy to join with him in the military and political struggle of the Mexican Revolution when he moved to Orizaba in 1914 was also largely instrumental in leading Siqueiros to enlist in the military forces of the constitutional armies and eventually to fight in one of the bloodiest civil wars of this century. Initially Siqueiros helped to edit Atl's newspaper *La Vanguardia*, as well as acting as its military correspondent.

Though it is uncertain whether Siqueiros actually took part in any combat while he was in Orizaba with Dr. Atl – he eventually transferred to Veracruz, where Carranza had moved to set up his headquarters – his military career was one of rapid promotion. In only two years he rose from private soldier to the rank of second captain in General Díguez's western division. He took part in several important campaigns during the revolution, such as that against Francisco Villa and the battles of Guadalajara, Trinidad, Lagos de Morena, Leon and the eventual capture of Aguascalientes. During this period he witnessed summary executions and terrible sufferings. In addition to the psychological effects these experiences had on Siqueiros, he considered that they added considerably to his understanding of

The Indian, the Spanish and popular tradition of the country, of the human beings that lived together, that worked together, fought together in our land, that is the labouring masses, workers, peasants, artisans and Indian tribes. . . . It led to a direct reflection of the immense cultural traditions of our country, particularly with regard to the extraordinary Pre-Colombian civilizations . . . we did not realize in reality the real measure of the values that our nation contained. . . .[17]

When Siqueiros returned to Mexico City in 1918 and started to paint again, the way in which his art would develop stylistically was foretold by Raziel Cabildo in an article in which he wrote that Siqueiros was 'an opulent colorist, master of an ample and vigorous technique. He wraps his personages in harmonies of audacity not free from extravagance. . . . The dancers of Siqueiros are a whirlwind of limbs and maddening drapes of painted flesh disjointed and with incredible foreshortenings.'[18] In addition to this, the drawings that Siqueiros produced at the time began to indicate an approach to subject-matter that reflected a more political and social content. Cabildo highlighted the

18 *above*
Encampment of the Federal army,
1913.

19 *below*
Passing food to Federal soldiers on
their way to fight, 1913.

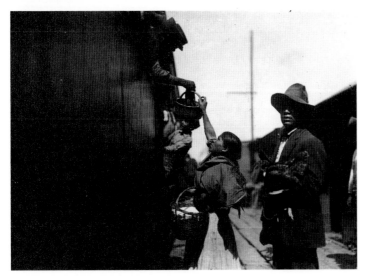

drawing of *El Señor Verano*, in which Siqueiros depicted a black Christ on a cross flanked by armed Zapatistas praying. The critic also remarked on the use of contrasting images in the drawing *Sugar Skulls* in which Siqueiros depicted a bourgeois girl with her skipping rope next to a squatting Indian selling his wares on the Day of the Dead.[19]

Though indications of more direct social content appeared in Siqueiros' work during this period, it seems that in terms of his

development as a painter the years of the revolution were ones of absorption – of ideas, experiences and influences. This absorption ultimately provided the basis for a theoretical and ideological understanding of a new revolutionary art, rather than for any contemporary depiction of it.

This particular aspect of the revolution's influence on Siqueiros was reflected in his thinking during 1919 in Guadalajara, where he went to live after leaving Mexico City. There he came into contact with a radical group of painters who had taken part in the revolution. They were collectively known as the *Centro Bohemio* and their studio became a meeting place for discussion. The discussions that Siqueiros held there on the future role and direction of art in the revolutionary Mexican society were of seminal importance for they formed a large part of the ideological framework for the mural artists' activities during the 1920s. Siqueiros recalled how he and his colleagues asked themselves 'For whom are we going to produce art? What object should it have? Was it to be a work of use to a laboratory, that would later be of service to us in some way? No, we knew that we were not going to do that any longer. Above all we knew that we were going to make a change.'[20]

Arising out of these discussions, Siqueiros and other artists of the *Centro Bohemio* published their ideas concerning the role of art in a revolutionary society in the journal *El Occidental*. Many of the ideas closely paralleled those which Dr. Atl had formulated some years earlier, in particular, the importance of a state art. The examples they cited included ancient Greece, Egypt, China, Peru, Central America and Mexico. Religious art was seen as another case in point, the aim of which was transmitting ideas, concepts, philosophic thoughts and political ideologies. They argued that such precedents formed a model which should be followed by artists in the new Mexican revolutionary society. The reality of Mexican society, however, was such that there were no governmental means or even sympathy for the practical realization and development of these ideas. In addition, Siqueiros and his fellow artists in Guadalajara had little firsthand experience of much of the art they were presenting as the model for their revolutionary aesthetic; they had been, as Siqueiros put it, 'practically disconnected from the outside world'.[21]

The influence that the Mexican revolution had on Siqueiros cannot be separated from the three years he spent in Europe from 1919 to 1921. These experiences formed a final pattern of thinking that culminated in the publication of his historic manifesto, 'Three Calls to American Painters: Detrimental Influences and Tendencies', in the Barcelona magazine *Vida Americana* in 1921.

Siqueiros left Mexico in 1919 with the aid of a government scholarship and the appointment of a minor diplomatic post, primarily to see the art of the Italian renaissance. However, he first came into contact with modern French art. In Paris, the Catalan painter Pruna and the Castilian Escalera, with whom Siqueiros struck up a friendship, became important sources of introduction to leading French artists of the time, of whom the painter Fernand Léger was to prove an enduring influence. Siqueiros met Léger on many occasions, often in Siqueiros' own studio in the Impasse de Rouet. Léger and Siqueiros had shared the experience of fighting in wars at parallel moments in history. While Siqueiros had experienced combat in the Mexican revolution, Léger had been with the French army during the 1914–1918 War in Europe. Their reactions to their common experiences were remarkably similar,[22] and with Siqueiros eager and receptive to modern French painting, it was natural that Léger would exert an influence on the young Mexican. Although Siqueiros admitted that their friendship did not exclude frequent private controversies, mostly provoked by Siqueiros' calls for a return to public art and his sarcasms against easel painting, nevertheless through these conversations he developed his lasting interest in the aesthetic of the machine. This later manifested itself in Siqueiros' Barcelona manifesto, 'Three Timely Calls to American Painters' in which the artist stated 'Love the modern machine, dispenser of unexpected plastic emotions, contemporary aspects of our daily life, our cities in the process of construction, the sober and practical engineer of our modern building.'[23] Although the passage has striking similarities to the rhetoric of the Futurists, Siqueiros himself claimed that it was Léger as much as the Futurists who was responsible for his preoccupation with the machine aesthetic.

Although there is little extant work from his period in Paris, Siqueiros appears to have been much absorbed by Cubism. However, by 1919 Siqueiros had noted that Rivera, with whom he was now in close and frequent contact, had begun to move away from Cubism and to return to a descriptive figuration, based on a more solid, classical approach to the human form. In this, Siqueiros seemed to see a connection between the solidity contained in the images of Cézanne and the images of the machine in the paintings of Léger. The example of Cézanne struck a powerful chord with Siqueiros, for to him Cézanne's work appeared closely to parallel the monumentality that characterized the Italian renaissance murals that Dr. Atl had spoken of in 1914. Siqueiros found in Cézanne solidity and a modern realization of monumentality that Impressionism had scattered into fragments of light and Cubism into fragments of form. It was inevitable, therefore, that with Cézanne in mind, in his manifesto Siqueiros would later write of 'the great primary masses: the cubes, cones, spheres, cylinders, pyramids, which should be the scaffolding of all plastic arts. . . . The fundamental basis of a work of art is the magnificent geometric structure of form and concept of the interplay of volume and perspective, which combine to create depth, to create spatial volumes.'[24]

Besides the significance of Cézanne, Léger and Cubism, Italian Futurism was especially important during this period for Siqueiros. Although he disagreed with many Futurist attitudes, particularly Marinetti's wish to 'destroy the painting of the museums',[25] he was particularly struck by the group's theoretical proposals concerning the nature of movement and its realization in pictorial form. His identification with the Futurists' concern for the depiction of movement, their preoccupation with the machine aesthetic and the clearly agitational nature of their manifestos anticipates much of the work, both theoretical and practical, that he would undertake in the 1930s when he established the foundation of his radical aesthetic.

Siqueiros left Paris in 1920 to visit Italy, principally to see what the Futurists had so disdained: the great paintings of the Italian renaissance and the Baroque. Of the paintings he saw, those which most impressed him were the frescoes of Masaccio, and he made studies of those in the Brancacci chapel in Florence. The Italian master's extraordinary realism, his sobriety of gesture, narrative power and the solidity of his forms represented for Siqueiros the monumentality that Atl had spoken of in 1914.

Although Siqueiros was probably unaware of its importance at the time, he also observed the way in which Masaccio had achieved 'the added power to control the onlooker's attention gained through the use of several points of view within a single composition.'[26] Siqueiros was also deeply impressed by the paintings of the Baroque. Their use of optical illusion, particularly in connection with the creation of 'architectural space', emerged in his later murals, where he employed the dynamics of architectural space to create his own extraordinary optical illusions and multi-angular perspectives.

The initial links between Siqueiros and Rivera were forged in Europe. Although the relationship between the two artists frequently went through periods of open hostility and antagonism in later years, the discussions between them in Paris in 1919–20 were vital to the development of Mexican muralism, influencing the thinking of both artists. Siqueiros later wrote as a result of these meetings and exchanges 'Afterwards it was possible for me to express myself theoretically in the manifesto that I published in Barcelona in 1921.... Though inarticulate, it constituted the first publication of what we had spoken about in Mexico over many years. It was also the result of what I had gained in Europe. The fusion in effect of the material that Rivera and I exchanged.'[27]

The manifesto that Siqueiros wrote in Barcelona has become part of the folklore of the Mexican mural renaissance. Paradoxically, for all its notoriety, in many ways its proposals were rather vague. The manifesto contained not a single reference or call for a public art, nor for an art of social and political content. Rather, it extended 'a rational welcome to every source of spiritual renewal from Cézanne onwards', referring specifically to Cubism and Futurism, as well as stressing the importance of the classical canons of painting.[28] The obvious identification with European modernism in the first 'call' was reiterated in the second, entitled 'The Preponderance of the Constructive Over the Decorative'. Siqueiros wrote of a formal aesthetic based on construction and solidity, linked to the art of the primitives and of Africa: 'Our physical proximity to (the Pre-Columbian societies) will help us to absorb the constructive vigour of their work, in which there is evident knowledge of the elements of nature.... We must become *universal*; our *racial* and *local* elements will inevitably appear in our work.'[29]

In a broad sense, the Barcelona manifesto was, as Siqueiros later admitted, a theoretical cocktail, a synthesis of his own and Rivera's respective experiences and thoughts which they had exchanged and developed in Paris. It was perhaps only coincidentally significant for the beginnings of the Mexican mural movement. Its publication in May 1921 in the only issue of *Vida Americana* to be published, coincided with the first mural commissions handed out by Vasconcelos as Minister of Education. An article in the July edition of *El Universal*, entitled 'The Painter Siqueiros in Barcelona', reported that Siqueiros was the director of the 'important magazine *Vida Americana* published in Barcelona'. The article failed to give any details of the manifesto. The importance of the manifesto must thus be limited to its representation of Siqueiros' initial ideas rather than a defined focus of action for mural painting around which the nascent mural movement in Mexico gathered.

Indicative of this fact are the delays and excuses Siqueiros made to Vasconcelos about returning to Mexico from May 1921 until his eventual return in August 1922. As late as November 1921, when Rivera was already back in Mexico and about to begin his first mural in the Bolivar Amphitheatre, the Mexican Minister to the Honduras, Juan Dios de Bojórquez, wrote a letter on Siqueiros' behalf to Vasconcelos, indicating Siqueiros' eagerness to remain longer in Europe.[30]

Siqueiros eventually returned to Mexico, but only after repeated urgings by Vasconcelos. In a letter sent shortly before his return, he wrote to Vasconcelos that 'I find myself in total agreement with your basic idea: to create a new civilization extracted from the very bowels of Mexico, and firmly believe that our youth will rally to this banner.... (I owe my desire to return) specifically to your own intelligent initiative concerning art....'[31] In September 1922 Siqueiros heeded the calls of the Minister for Public Education and returned home to Mexico. Three months later he finally began work on his first murals in the Colegio Chico.

20
Diego Rivera: *The Burning of the Judases* (detail). Fresco, 1923–4. West wall, Court of the Fiestas, Ministry of Education, Mexico City.

THREE

THE MURALS OF THE 1920s

FESTIVAL, REVOLT AND TRADITION

The murals commissioned by Vasconcelos in 1921 were perhaps the principal component of the unique process of national cultural renewal that took place in Mexico in the early part of the twentieth century. The revolution had been the catalyst for this renewal, but the reassertion of the rich traditions of Mexican culture after 400 years of colonial subjugation preceded it. Even under Porfirio Díaz, the intellectual momentum of radical and popular cultural nationalism had asserted itself, to be synthesized by such key figures as the anthropologist Manuel Gamio in his seminal work of 1916, *Forjando Patria* (Forging the Fatherland). Groups such as the *Ateneo de la Juventud* had become a focus for the country's radical nationalist intellectuals, many of whom figured prominently in the vanguard of the cultural renaissance of the 1920s.

The murals painted by Rivera, Orozco and Siqueiros during the 1920s can be divided into two groups. The first consists of works commissioned by Vasconcelos and completed before the end of his term of office in 1924, and which seem to mirror the ideological and aesthetic framework of his own particular philosophical vision. The second group are works – some of which were commissioned by Vasconcelos and even executed during his tenure as Minister of Education – with themes and styles that moved away from his vision towards a more overtly didactic, political and populist art, with which the Mexican mural movement has come to be popularly associated.[1]

Rivera's first mural, *Creation*, is typical of the first group.

Painted at the Bolivar Amphitheatre between early 1922 and January 1923, it exhibited many of the uncertain and apparently contradictory beginnings of the Mexican mural movement. Like the other early murals, neither its theme nor its style was conceived within any popular or radical Mexican tradition. Instead, it was created within an intellectual and aesthetic framework characterized by 'the moral imperatives of Judeo-Christian religion and the intellectual standards of Hellenic civilization; in the latter case in particular the premise of the astronomer-philosopher Pythagoras . . .'.[2] Whether it was due to the influence of Vasconcelos' highly individualistic philosophical idealism or to the weight of experience derived from his European past, Rivera's first mural – like the initial ones painted by Orozco and Siqueiros – had yet to cross the divide separating that past from the world of Mexico's revolutionary present.

Assisted by the painters Jean Charlot (1898–1980), Xavier Guerrero (1896–1974) and Amado de la Cueva (1891–1926), Rivera presented an allegory in his *Creation* that is stylistically characterized by Italian and Byzantine influences. Antonio Rodríguez described *Creation* as a 'poetic and philosophical medley of Christianity and paganism; symbols of knowledge and wisdom, constellations, haloes and angels' wings alternate in it with muses and the three cardinal virtues'.[3] The mural expresses the idea of creation as the product of the dual aspects of male and female in the human race, and the natural elements of earth and water, air and fire. Although the Italianate character of the

composition displayed Rivera's debt to Italian fresco painting, the mural did not escape entirely from the influence of cultural nationalism that was sweeping the country at the time. The features of the women are clearly those of the Mexican *Mestizo*, a significant anticipation of Rivera's later concentration on essentially Mexican subject-matter.

This shift towards a more emphatic Mexicanism was articulated more explicitly in the recessed central area of the mural. Rivera conceptualized the imagery here quite differently from that of the foreground area. Set against the Italianate and Cubist imagery of the main wall area, the luxuriantly tropical hue of this portion of the mural, with its abundant plant life, exotic animals and indigenous figures, was, as Jean Charlot has described it, a 'stylistic duality. . . . but inasmuch as it tells the story of the artist's change of heart, it remains valuable as an index to Rivera's Mexican evolution'.[4]

The transformation in Rivera's vision from an exclusively European aesthetic to one rooted in the spirit of Mexican nationalism was in large part the result of the influence of both Vasconcelos and the painter Adolfo Best Maugard. Rivera's dis-

covery of the indigenous character and nature of his country was stimulated to a considerable extent by Best Maugard's lectures on Mexican art. Maugard's influence, as Vasconcelos noted, 'inclined (Rivera) towards national themes'.[5] But for all his philosophical idealism, Vasconcelos also had nationalist credentials and beliefs. His desire to send Rivera to Tehuantepec in the southern part of Mexico at the end of 1922, for Rivera to familiarize himself with his country after such a long absence from it, became a key component in the changes that afterwards occurred in Rivera's work. Tehuantepec proved to be something of a revelation for the painter, who previously had known nothing of the exotic southern areas of Mexico. As Jean Charlot has written, Rivera began to look 'his own country in the face and find her beautiful and his Italian memory gradually faded'.[6] As a result, he returned to Mexico City with a different spirit, clearly reflected in the nature of his imagery.

Rivera's *Creation* was inaugurated in March 1923 to widely differing opinions. Some praised it, considering it to be a nationalist work. Orozco, however, was among those who were sceptical of its worth. 'Incomprehensible', he wrote, 'are those

21
Diego Rivera: *Creation*. Encaustic
and gold leaf 1922–3. Bolivar
Amphitheatre, National Preparatory
School, Mexico City.

22
David Alfaro Siqueiros: *The Elements*
(detail). Encaustic, 1922. Colegio
Chico, National Preparatory School,
Mexico City.

pseudocubistic pictures done according to so-called scientific recipes imported from Paris. No-one understands such painting, not even he who makes it. Some verses are spelled very nicely and polished magnificently, yet they are worth a peanut. Some paintings boast of the golden proportion and that famous cubistic technique; they are worth another peanut.'[7]

At the end of 1922, a few months before the inauguration of Rivera's first mural, Siqueiros, who had returned from Europe in September, began his decoration of the walls in the Colegio Chico, Vasconcelos having given him the choice of where to paint. His choice was hardly auspicious, selecting as he did a rather small and badly-lit staircase. Like Rivera's *Creation*, the mural was painted in encaustic, and depicted a bulky, apparently

foreshortened, winged angel figure. Painted onto the ceiling panel of the staircase, its imagery was derived more from Siqueiros' European experience and memories than anything intrinsically Mexican. *The Elements*, as Siqueiros entitled his first mural, later reminded Rivera 'of a somewhat Syrio-Lebanese Michelangelo'.[8] One critic reacted to the work by linking Siqueiros with Rivera as the importers 'of the latest European trend and as a result the good tradition'.[9]

Siqueiros himself was later decidedly more self-critical about his first attempt, and recorded the difficulties of creating public art in post-revolutionary Mexico. 'For my part', he wrote

I painted the elements: Fire, earth, water etc., inspired by the figure of an angel, more or less in a colonial style. You can imagine the chaos – but it was a chaos appropriate to a world in which public art, 'art for everyone' had disappeared. There was no one to tell us 'Do this and now do that'. We wanted to help the Mexican revolution, but we were doing a very bad job of it. What we were doing as public art might well have been interesting from the point of view of general culture, but from the point of view of what we were going through at the time it was hopeless.[10]

The contemporary comments on Siqueiros' work as an importation of 'the latest European trend' also pointed to the cultural uncertainties and contradictions surrounding the birth of the mural movement that Vasconcelos had brought into being. Such uncertainties affected not only the choice of imagery used by the painters in their first murals, but also, as in the case of Rivera and Siqueiros, the medium in which they executed their work.

The encaustic employed in Siqueiros' first work was not exclusively in response to Rivera's impressive handling of the same difficult medium. It was also in part linked to attitudes held at the time by Vasconcelos. In the months preceding the paintings of Rivera's *Creation*, discussions among the painters concerning the most appropriate medium for use in mural painting were intense. Attempts to translate from an old copy of a volume on the techniques of Italian fresco painting written by Cellino Cennini had proved to be problematic, particularly since many of the mentioned ingredients were unknown to the Mexican painters. Rivera argued that encaustic was, in his view, more durable, a

36 position that many of his colleagues accepted, particularly on seeing his impressive handling of the medium in *Creation*.

However, Vasconcelos' own attitudes influenced the techniques adopted, for he had quickly grown impatient with the fruitless researches of the painters into the fresco recipes of Cennini, arguing with a perverse sense of Mexican cultural nationalism that since Cennini had never been to Mexico, his techniques must be inferior. Rivera decided to adopt the encaustic medium, despite it being no more Mexican than the classic Italian fresco techniques of Cennini and this paved the way for some of the other painters, including Siqueiros, to follow suit.

The encaustic medium was eventually abandoned by Rivera in favour of the much easier fresco technique. However, he did so only after Xavier Guerrero, while assisting Rivera with his first panels in the Ministry of Education in 1923–4, helped develop a fresco technique that his father had used, discovering through trips to the pre-Columbian site of Teotihuacan that it was similar to techniques employed in the ancient Toltec society. In the highly charged nationalistic climate of the time, this simple technical development was taken up by the press who, in a classic example of distortion and wild embellishment, publicized it under blazing headlines, such as 'Diego Rivera Discovers a Secret of the Mexica', presenting it as 'the process used by ancient Mexicans to produce their splendid frescoes, such as those we admire at San Juan Teotihuacan'.[11] Despite the somewhat distorted history behind the more widespread adoption of the classic fresco technique, the nationalistic embellishments nevertheless served to legitimize the use of the medium and technique, during a period when the climate of cultural *indigenismo* was at its most passionate.

Orozco's first murals, begun at the National Preparatory School in 1923, displayed the same contradictions as those painted earlier by Rivera and Siqueiros: images created amidst the climate of revolutionary optimism and nationalist fervour, but reflecting little of either. In his autobiography, Orozco described this period as 'a time of preparation, during which much trial and error went on and the works produced were purely decorative, with only timid allusions to history, philosophy and other themes'.[12] From the start, the cultural nationalism which was

now becoming more fully synthesized within the work of artists such as Rivera, already at work on his second mural commission in the Ministry of Education building, was viewed by Orozco with great suspicion. 'True nationalism', he wrote

cannot reside in this or that theatrical wardrobe, in this or that folk song of most doubtful worth, but rather in our scientific, industrial, or artistic contribution to civilization at large. For example a painter who works within the Italian tradition of the fifteenth or sixteenth century can be more 'nationalistic' than some other artist tickled silly at the sight of our Mexican pots and pans, which are fit for the kitchen, but not for the drawing room, and even less for the library or laboratory. Such thoughts led me to eschew once and for all the painting of Indian sandals and dirty clothes. From the bottom of my heart I do wish that those who wear them would discard such outfits and get civilized.[13]

True to this view, Orozco's first mural images firmly avoided any hint at indigenous Mexico and its culture.

None of the first murals painted by Orozco remain, with the exception of the panel of *Maternity*. A draft outline of his plan of decoration gives an impression of what he had in mind:

Decoration of the north wall of the courts respectively called the 'Colegio Grande' and 'Pasantes' in the National Preparatory School. General Theme: The Gifts of Nature to Man.

It includes seven secondary themes as follows:

1. Decoration of the door of the hall known as 'El Generalito' and on the left wing of the corridor: *Virginity*, physical integrity and spiritual integrity. Cool harmony, with horizonal and vertical lines predominant; tranquillity, calm. Minor composition: *Adolescence*.
2. Decoration of the central area: *Youth*, allegory of the Sun and a group of schoolgirls; in very warm harmony; lines of movement; large masses very dynamic and ascendant.
3. Decoration of the main door and of the left wall panel: *Grace*. Warm harmony; feminine predominance.
4. Decoration of both sides of the corridor called 'Pasillo': *Beauty*. Warm harmony; masculine predominance.
5. Decoration of the library door: *Intelligence*. Cold and deep harmony.
6. Decoration of the central area of 'Pasantes': *Genius*. Very warm harmony, lines of movement ascending and very dynamic.

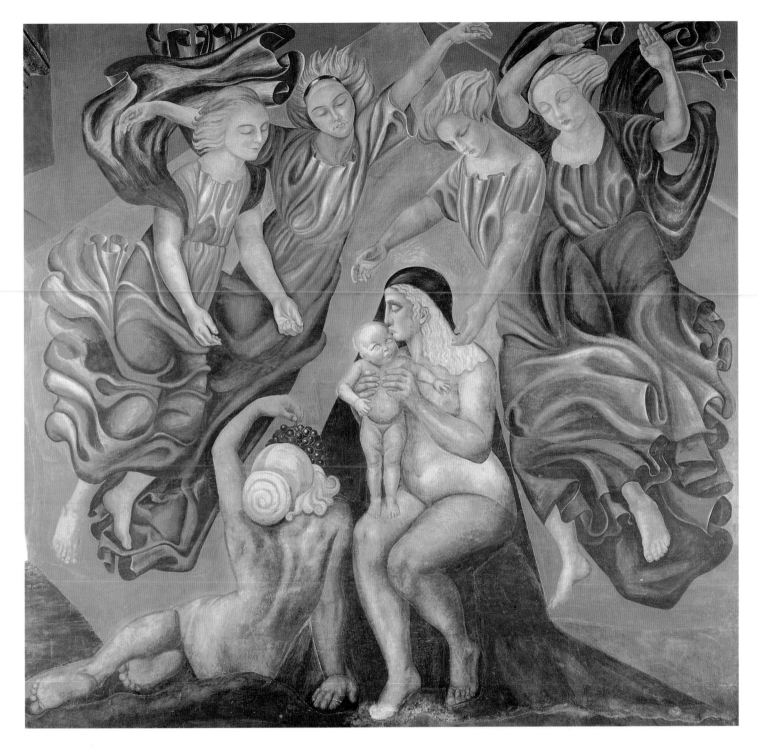

7. Decoration of the right wing: *Force*. Warm harmony. Great dynamic masses. Predominance of horizontal and vertical lines.
The decoration has been planned within the same modules and rhythm that characterize the architecture of the building, and in such a way that complete solidarity between both will be achieved. The technique used is classical fresco.[14]

Despite the fact that most of the original scheme of this plan was never carried out as described, the draft still reflects the spirit of Orozco's approach. The photographs of those panels that he did create, together with the one remaining panel of *Maternity*, reveal a synthesis of the styles of Dr. Atl and Michelangelo. As Laurence Hurlbert has noted

The influence of Atl's work and his eloquence for the cause of Michelangelo can be unmistakably seen, if only partially and awkwardly digested, in Orozco's first *Preparatoria* murals, in the superhumanly muscled nudes in 'Youth'. . . . and in the colossal figures of 'Tzontemec'

and the human in the 'Two Natures of Man'. Moreover Atl's use of abstract decorative forms in his murals such as 'The Rain' may also have been a source of inspiration for Orozco.[15]

The character of Orozco's first murals can also be explained by his view that so-called 'great art' or mural decoration could never be associated with nationalism as expressed by minor folk arts. Whatever the reason, Orozco eventually chose not just drastically to change his original intentions, but even more radically, to destroy images that he had created, replacing them in 1923–4 with his celebrated 'revolutionary' images, such as *Destruction of the Old Order*, *Revolutionary Trinity*, *The Strike*, *The Trench* and *The Rich Banquet while the Workers Fight*.

The one remaining panel of the first series that Orozco painted, *Maternity* (reworked from his panel of *Youth* as envisaged in his original outline), depicts a Botticelli-like image of a young mother caressing a baby surrounded by angels. The fresco aptly fits Orozco's description of this initial period as a time of preparation with much trial and error. In a country whose people are predominantly dark skinned, and within a cultural climate of fierce searching for a sense of nationalism, the blonde-haired, white-skinned female figure and child surrounded by accompanying angel figures represents an anachronism.

The existing frescoes by Orozco in the National Preparatory School, which date from late 1923 to 1926, can perhaps best be described in the groups formed by their location. These are the panels along the walls of the ground and second floors depicting the themes from the revolution; the panels along the first floor dealing with social criticism; and finally, the paintings on the inner stairwell dealing with the conquest. For the most part, they all stem from the political and social developments that began to unfold from late 1923, even if they were not always directly related to them. These developments pushed Orozco away from his metaphysical and philosophical beginnings to a monumental and powerful rendition of the social, political and historical realities of his country.

In late 1923 the Obregón government was confronted by a rebellion from conservative sections of the military and the political nationalists, under the leadership of Adolfo de la Huerta. Although the uprising was short-lived, its violence reflected the still unresolved tensions of the revolution. In January 1924 the socialist governor of the Yucatán state and champion of the peasantry, Felipe Carrillo Puerto, was assassinated by supporters of de la Huerta. Shortly afterwards, following a call for revenge from the labour leader Luis Morones, who demanded direct action against politicians who supported de la Huerta, a de la Huerta senator, Field Jurado, was murdered. This provoked Vasconcelos to tender his resignation from Obregón's government. Although his departure was postponed for a while, Vasoncelos' political star was waning fast, as he had been revealed as less than supportive of the radical Obregón. His refusal to side with the barbarity of the revolutionary struggle marked him as an increasingly conservative figure. The influence of his active radicalism in his position as Secretary of Public Education faded, and with it his support and ability to protect the mural painters whose work he had commissioned.

In the wake of the de la Huerta rebellion, and following the increasing radicalism of both industrial and agricultural workers, in 1923 Mexico found itself caught, as Antonio Rodríguez has written,

between two fires: on one side the Left as we will call it, with the workers' movement and the most radical adherents of the revolution, who wanted to continue the 1910–1917 struggle to its final conclusion, and on the other the reactionary forces, with the spiritual and well-organized support of the clergy.... Obregón had the sense to lean on the most progressive forces of the country – the workmen, the advanced intellectuals, the painters, who again rushed into the fray to defend Obregón.... This explains to a great extent how painters and other intellectuals became radicals.... There were other factors. Among these ... were ... the ever-increasing influence of the October revolution in Russia.... A further factor in the radicalization of the painters was their grouping into 'cooperatives', 'syndicates' and the staffs of journals; some of them affiliated to the communist party.[16]

The syndicates alluded to by Rodríguez refer to the famous trade union of artists at work on the public commissions handed out by Vasconcelos. Formed at the end of 1922 by Siqueiros, Rivera and Xavier Guerrero, the Syndicate of Technical Workers, Painters and Sculptors, as it became known, is significant not only for its ability to defend and promote the interests of its members, which in the main it was singularly unsuccessful at doing, but

because it was a collective, organized manifestation of the increasing political and ideological radicalism of the painters involved in the commissions from Vasconcelos.[17] The Syndicate was also important in that it became the vehicle for the manifesto on mural painting issued by the painters, and for its production of the union newspaper *El Machete*. The paper was edited by Siqueiros and Guerrero, and they and Rivera wrote articles for it, while Orozco produced some memorable cartoons.[18]

The Syndicate's manifesto was drawn up by Siqueiros in 1922 and launched on 9 December 1923 in response to Adolfo de la Huerta's coup against the Obregón government. It was published in 1924 in the seventh issue of *El Machete* and was signed by the large majority of the mural artists. Its opening preamble declared:

> The Syndicate of Technical Workers, Painters and Sculptors directs itself to the native races humiliated for centuries; to the soldiers made into hangmen by their officers; to the workers and peasants scourged by the rich; and to the intellectuals who do not flatter the bourgeoisie.

Further on, the manifesto explicitly outlined its artistic and aesthetic principles and goals:

> our fundamental aesthetic goal must be to socialize artistic expression and wipe out bourgeois individualism.
>
> We *repudiate* so-called easel painting and every kind of art favoured by ultra-intellectual circles, because it is aristocratic, and we praise monumental art in all its forms, because it is public property.
>
> We *proclaim* that at this time of social change from a decrepit order to a new one, the creators of beauty must use their best efforts to produce ideological works of art for the people; art must no longer be the expression of individual satisfaction which it is today, but should aim to become a fighting, educative art for all.[19]

Antonio Rodríguez wrote of this historic manifesto that after its publication 'mural painting ceased being a vague aim, an indefinite longing, and became a conscious aspiration, based on ideological as much as on artistic motives. It ceased to be one of many ways of painting and became fundamentally and theoretically identical with Mexican painting as such.'[20] Although Orozco was somewhat cynical of the Syndicate, refusing to take part in its meetings and questioning its ability to protect its

25
José Clemente Orozco: *The Destruction of the Old Order*. Fresco, 1926. National Preparatory School, Mexico City.

26
José Clemente Orozco: *The Trench*. Fresco, 1926. National Preparatory School, Mexico City.

40 members, around the time of the manifesto's publication he nevertheless clearly identified with the principles of the mural as a public medium. Later, in 1929, he wrote that 'The highest, most logical, purest and most powerful type of painting is mural painting. It is also the most disinterested, as it cannot be converted into an object for personal gain, nor can it be concealed for the benefit of a privileged people. It is for the people. It is for ALL.'[21]

Of the political and social events surrounding the period beginning in late 1923, none caused or explained the dramatic change that occurred in the frescoes of Orozco and Siqueiros, or the less sudden but no less fundamental change in Rivera's work, following their initial incursions into the medium of the public mural. Some of the events predate the changes; some are coincident with them. Certain events, such as the murder of Carrillo Puerto, which seems to have been the inspiration for the final version of Siqueiros' mural *Burial of the Sacrificed Worker* in the Colegio Chico, completed in 1924, relate directly to the change. However, taken together they form a context in which it is possible to see how the philosophical idealism that inspired Vasconcelos' unique educational and cultural project during the presidency of Obregón, together with the aesthetic metaphysics that informed the first mural commissions, collided with, were taken over and subsequently transformed by a political culture created by the revolution. It is perhaps not an exaggeration to say that the first murals were created in the creed of Vasconcelos. Indeed, by the time of his resignation in July 1924, his attitude towards his progeny had become less than wholehearted in its commitment. For him, the painters 'had got out of hand', as Charlot observed. They had 'refused to work along the line of pure art so fairly offered them . . . instead of lifting the masses to the Pythagorean level of unhampered delectation (they) had dragged painting wilfully down to function as a Newtonian cog'.[22] From their hesitant beginnings, the murals now charted a course increasingly derived from the realities and demands of a country whose identity and culture were being reborn from the dynamics of a suppressed history liberated by popular revolt and revolutionary struggle.

The change in Orozco's images was particularly striking. From executing essentially apolitical and metaphysical European

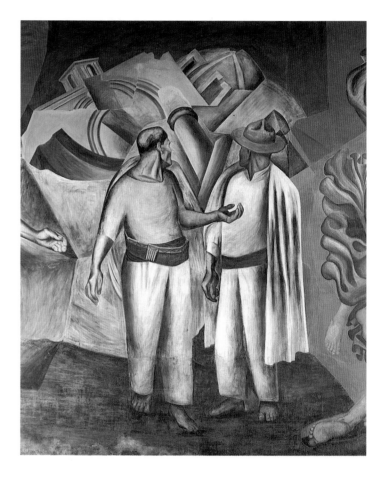

imagery in the National Preparatory School in mid-1923, Orozco evolved to create along the walls and inner stairwell of the National Preparatory School a series of monumental, powerful, often tragic images relating to the subject of the revolution, the corruption of justice and the hypocrisy of false moralities, and the spiritual conquest of Mexico by the Spanish. Along the ground-floor patio corridor walls Orozco created his famous depictions of *The Trench*, *The Destruction of the Old Order* and *The Strike*, replacing the early images he had destroyed. Completed in 1926, following a period when his work was unceremoniously interrupted by the hostile reaction to some of his earlier murals, the three huge panels have entered the iconography of Orozco's penetrating vision of human tragedy and pathos. Antonio Rodríguez described the panel of *The Trench* thus:

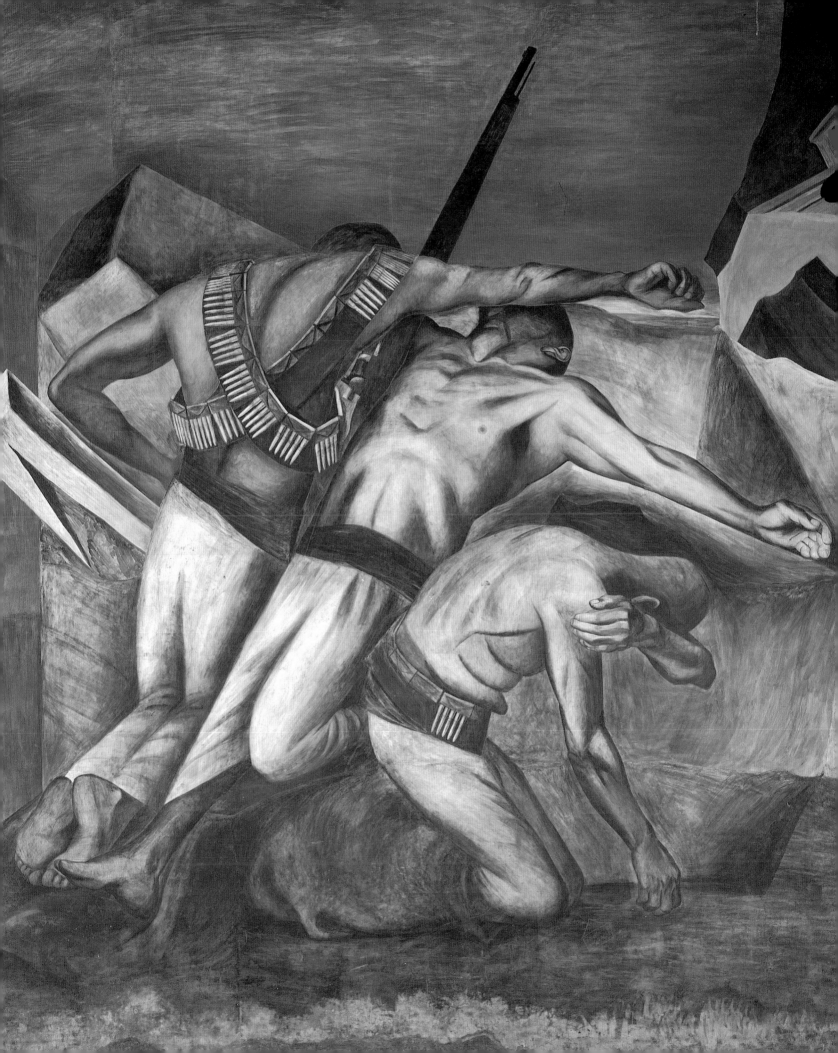

27
José Clemente Orozco: *Revolutionary Trinity*. Fresco, 1923–4. National Preparatory School, Mexico City.

28
José Clemente Orozco: *The Rich Banquet while the Workers Fight*. Fresco, 1923. National Preparatory School, Mexico City.

42

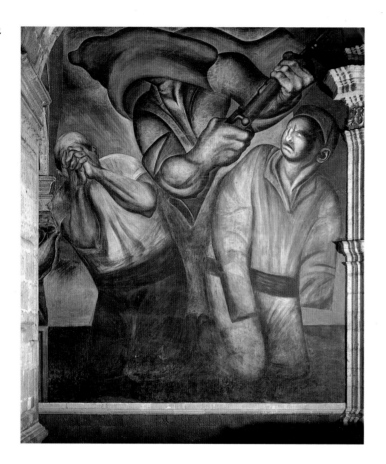

In *The Trench* there are no stirring hymns to drive heroes towards enemy bayonets, no waving standards to enthuse the timid. Here everything is dignified like death or like fire which, having consumed and purified, resolves in ashes . . . two men have fallen, one on his back, the other with hands crossed in front of him, a third kneeling, hides his face in his hand: a rifle lying diagonally, cutting space like a spent bullet. . . . No lyric passion, no lamentation. There is no enthusiasm, nor is there despair.[23]

Perhaps more than any of the other frescoes that he created during the 1920s, *The Trench* was the confirmation of what an extraordinary and powerful painter Orozco would turn out to be. Like *The Trench*, the two adjacent panels of *The Strike* and *The Destruction of the Old Order* reveal Orozco as the creator of an eerie stillness, in which the implicit violence of movement is frozen in time by monumentalism. Orozco increasingly

abandoned such stillness in his later murals of the 1930s and 1940s, in which his compositions and painterly style were characterized by violent fractures of compositional structure and gestural paint work.

The earlier panels, which Orozco painted in late 1923 and 1924 along the same stretch of wall, and entitled *The Rich Banquet while the Workers Fight* and *Revolutionary Trinity*, were both the caustic comments of Orozco the caricaturist and the first examples of the tragic pessimism manifested in his work of the 1930s. *The Trinity* was a particularly telling indictment of revolutionary idealism betrayed by its own zeal. The central figure of the panel depicts a revolutionary blinded by the red Jacobin hat of the revolution, brandishing a rifle. The right-hand figure, its hands severed from the wrists, watches helplessly as the figure on the left prays for salvation. Orozco transformed the figures at the sides from their original, more optimistic stance, in which they hold the instruments of measurement, science and calculation, to their present postures of utter despair and helplessness, a telling comment on the development of Orozco's sceptical view of the success of the revolution. This scepticism was expressed more powerfully in his denunciation of false leadership of 1936 in his mural at the University of Guadalajara.

The *Banquet* panel, a monumentalist caricature in which workers fight among themselves to benefit only the rich and the powerful is similar in tone to those images that he created in 1924 along the first-floor corridor walls on the theme of social criticism. Awkward, clumsy and rapidly conceived, these huge, haphazard cartoon-like images provoked enormous criticism, leading Orozco to further bouts of biting satire, no less pictorially successful than those which had provoked the original outcry. The titles of these panels, *Reactionary Forces*, *The Money Box*, *Political Junk Heap*, *Liberty*, *The Last Judgment*, and *Law and Justice*, reflect Orozco's typical penchant for lambast and satire against the pretensions of authority and morality, and his sceptical view on the claims to the ideal made by the world of *realpolitik*. In *Political Junk Heap*, the Jacobin cap with which he blindfolded the central figure in *Revolutionary Trinity* lies among the discarded flotsam of political chicanery, the fasces of Italian fascism, the swastika, crowns etcetera. In other panels, grotesque aristocratic women pass by a begging hand, backs are stabbed,

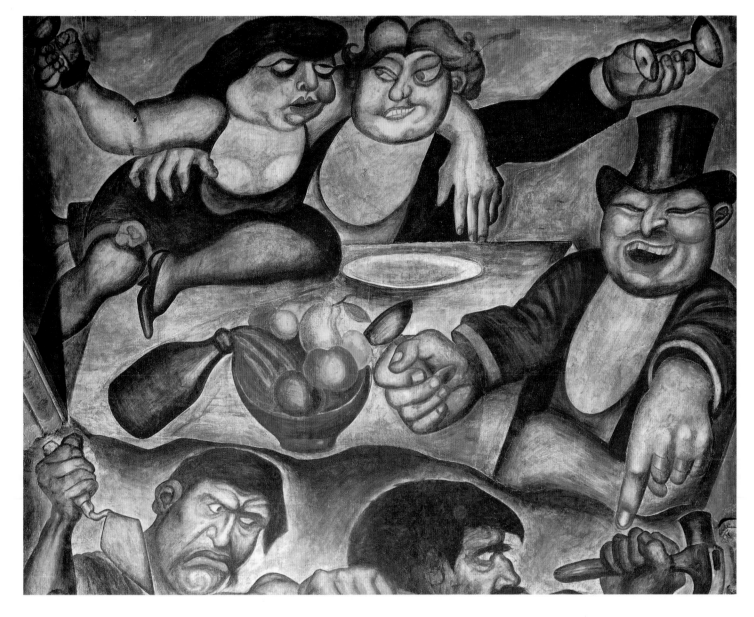

and hideous male and female figures cavort stupidly with the scales of justice.

The murals on the first floor together with those created in late 1923 on the ground floor were the target of intense criticism and fury by conservative groups. During de la Huerta's uprising against Obregón, the famous '*Damas Católicas*' and conservative students defaced the murals. Petitions to Vasconcelos protesting against the paintings resulted in Vasconcelos ordering both Orozco and Siqueiros to cease painting. A report in the newspaper *El Excelsior* on 26 June ran the story

Decoration Stopped – Acceding to the terms of a petition presented by students, Sr. José Vasconcelos, Secretary of Public Education, decreed yesterday that the pictorial decoration now in course in the building of the Escuela Nacional Preparatoria (National Preparatory School), under the supervision of Don Diego Rivera, be stopped.

The Secretary also decreed that one of the painters working under Sr. Rivera be dismissed, when it became known that he had instigated the students to exercise direct action by destroying one of his own pictures.[24]

Certainly the paintings that Orozco had created were hardly popular. Salvadore Novo described them as 'repulsive pictures, aiming to awaken in the spectator, instead of aesthetic emotions, an anarchistic fury if he is penniless, or if he is wealthy, to make his knees buckle with fright.'[25] In *The Plumed Serpent* D. H. Lawrence wrote

They were caricatures so crude and so ugly that Kate was merely repelled. They were meant to be shocking but perhaps the very deliberateness prevents them from being so shocking as they might be. They were ugly and vulgar. Strident caricatures of the Capitalist and the Church, and the Rich Women, and of Mammon, painted life-size and

OMNI-CIENCIA

PINTADO POR
JOSÉ CLEMENTE OROZCO
POR ORDEN DE SU
GRAN ADMIRADOR
FRANCISCO SERGIO ITURBE
AÑO DE 1925

29
José Clemente Orozco: *Omniscience*. Fresco, 1925. Casa de los Azulejos (now Sanborns Restaurant), Mexico City.

30
José Clemente Orozco: *Social Revolution*. Fresco, 1926. Industrial School (now the Centre for Workers' Education), Orizaba, Mexico.

Revolution is a dynamic and rhythmic composition depicting revolutionary soldiers as builders of a new society. Below, in a more sombre vein, Orozco depicted what he must have witnessed so often during the revolution when he was stationed in Orizaba with Dr. Atl: the grieving women, the *soldaderas* (girl soldiers) and their children. The images anticipate the series of frescoes he created shortly afterwards along the top floor of the National Preparatory School on the theme of the agrarian revolution.

The frescoes that Orozco painted on his return to the Preparatory School include those on the ground-floor patio passageways, which have already been discussed, those on the stairwell and the cycle on the second floor. The murals that Orozco painted on the stairwell of the school's inner courtyard are particularly significant in that they deal with the theme of the conquest. In one sense, nearly every mural painted by Orozco, Siqueiros and Rivera within Mexico contains and reflects aspects that in some way or another derived from the consequences of the Spanish Conquest of Mexico. But Orozco was the first of the three painters directly to hint at the consequences visited on the nation by colonialist intervention. On the walls of the inner stairwell he painted a series of frescoes which includes his celebrated portrayals of *Cortez and Malinche* and *The Franciscan and the Indian*.

The *Cortez and Malinche* fresco was the first direct reference by the Mexican muralists to one of the most significant results of Spanish colonialism in Mexico, that of the miscegenation or *mestizaje* of the indigenous population. The union between the male Spanish European conquistador and his female Indian mistress was an incontestable historical fact. Presented to Cortez by Tabascan chiefs, Malinche was a slave girl, whose knowledge of both the Mexica language and its dialects became a vital asset to Cortez in communicating with the Aztecs. First interpreter, then secretary to Cortez, Malinche became his mistress and bore him a son, Don Martín Cortez.[28] In Orozco's portrayal, the couple are joined hand in hand in an act of union. This union, however, is seemingly contingent upon Cortez's subjugation of the Indian, represented in the fresco by a prone and naked figure under the Spaniard's right foot. Cortez's left arm both prevents an act of supplication for the Indian on Malinche's part and acts as a final

as violent as possible, round the patios of the grey old building where the young people are educated. To anyone with a spark of human balance they are a misdemeanour.[26]

Orozco's dismissal from the Preparatoria in June 1924 resulted in an absence from the building of nearly eighteen months. But in 1926 he was recommissioned, this time under the auspices of Alfonso Pruneda, Rector of the National University. In the intervening period, Orozco painted two further murals. The first, entitled *Omniscience*, on the main staircase of the Casa de los Azulejos (House of Tiles) in Mexico City, was a return to the static monumentalism so reminiscent of his first and now destroyed Italianate murals on the ground floor of the National Preparatory School. Even the theme, featuring figures representing inspiration, force and intelligence, was a return to the apolitical; 'a philosophical statement, rather than a revolutionary exhortation or horror scene', as Bernard Meyers described it.[27]

The second mural of the intervening period was quite different. Painted in 1926, just prior to Orozco's return to the National Preparatory School, in what is now the Workers Education Centre in Orizaba in the state of Veracruz, the fresco *Social*

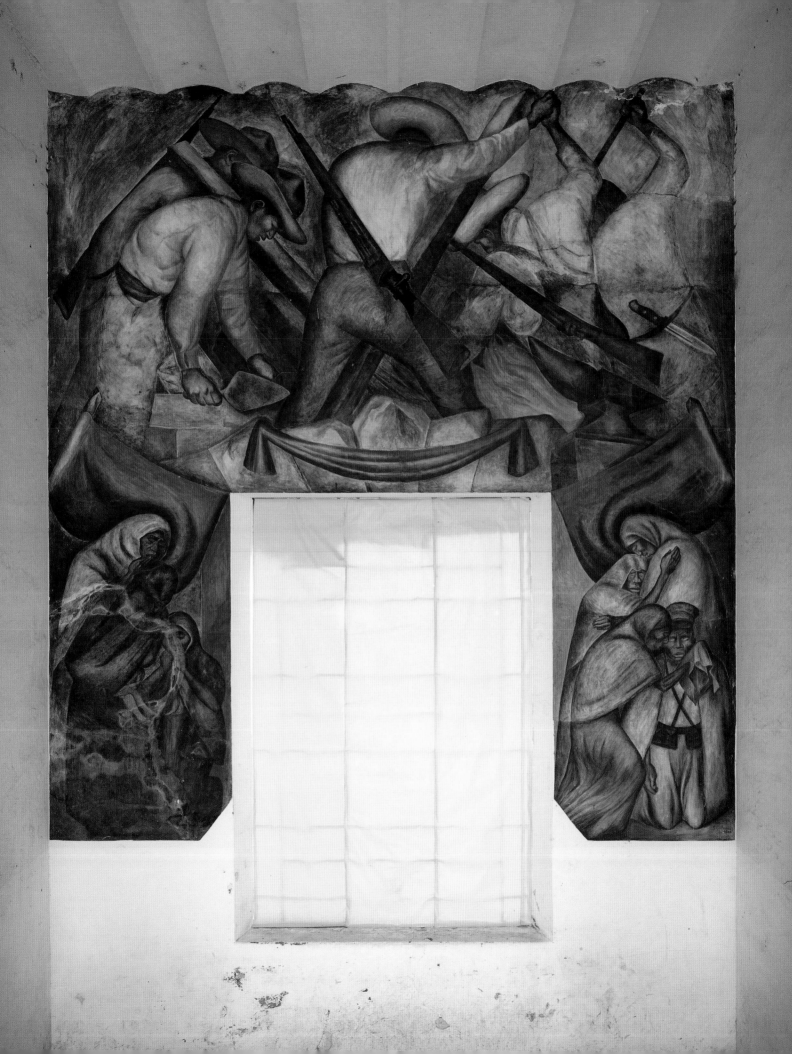

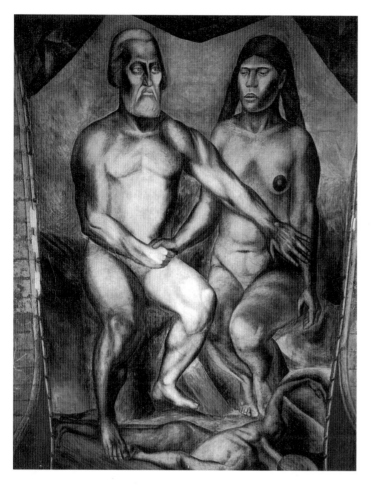

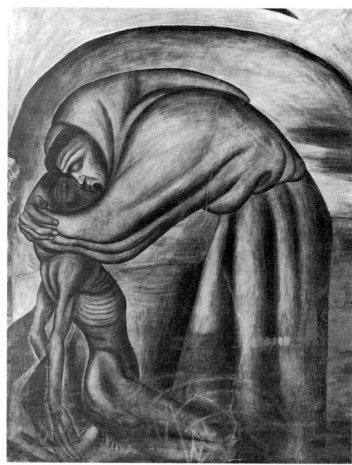

separation from her former life. The image of Cortez and Malinche symbolizes synthesis, subjugation and the ambivalence of her position in the story of the nation's history of colonial intervention.

The panel of *The Franciscan and the Indian* is an image equally infused with ambivalence and synthesis by its act of bringing to the metaphorical foreground the consequences of Catholic imperialism in one of its spiritually most effective endeavours. The spiritual 'capture' evoked in the claustrophobic embrace of the naked Indian by the clothed Franciscan, symbol of Spanish Catholicism, is a direct parallel to the physical miscegenation expressed in the image of *Cortez and Malinche*. However, the ambivalence of Orozco's image is expressed here in the implication of salvation and redemption, power and subjugation. It is one that simultaneously summons up the story of Fray Bartolomé de Las Casas, and the *Requerimiento* (The Summons). The former staunchly defended the Indian, arguing that conversion should be by peaceful means and not demanded as a tribute of conquest.[29] The *Requerimiento*, on the other hand, was a statement of principle read to Indians, whose territory was laid claim to by the Conquistadors. It declared Mexico to have been assigned by God to the Catholic kings of Spain, and that reli-

gious men accompanying the army would teach the Catholic religion, which, if it was accepted, would allow the Indians to keep their land subject to the laws of Christianity and the Spanish monarch. Failure to accept, however, would result in war being declared against them.

With these two panels and others in the series entitled *Conqueror Builder* and *The Indian Worker* and *The Old Warrior Racers*, as well as with other images of Franciscans, Orozco placed the conflicting interpretations surrounding the reading of the conquest in the pictorial foreground. Such conflicting readings were characterized by the *Hispanistas* on one side, who saw the Spanish conquest as the freeing of Mexico, representing its absorption into Christendom and therefore civilization, and by the *Indigenistas* on the other, who saw the conquest as nothing more than the genocide and plundering of the native indigenous populations and their rich and ancient cultural traditions. Orozco's views on this dilemma were controversial and often contradictory, but whichever side of the polemic he saw himself on, he seldom waved banners for one side or another.[30] Rather, as these fresco images testify, he had an unnerving ability to choose, conceptualize, and express subject matter that lay at the very heart of the conflicting identities of modern Mexico.

31
José Clemente Orozco: *Cortez and Malinche*. Fresco, 1926. National Preparatory School, Mexico City.

32
José Clemente Orozco: *The Franciscan and the Indian*. Fresco, 1926. National Preparatory School, Mexico City.

33
José Clemente Orozco: *The Mother's Blessing*. Fresco, 1926. National Preparatory School, Mexico City.

34
José Clemente Orozco: *The Mother's Farewell*. Fresco, 1926. National Preparatory School, Mexico City.

The final images in the National Preparatory School on the theme of the agrarian revolt which Orozco painted on the second floor express a special pathos. The titles indicate the mood: *The Grave-Digger*, *The Mother's Blessing*, *Return from Work*, *The Mother's Farewell*, *The Family* and *Return to the Battlefields*. In these poetic and tragic images, now sadly in somewhat delapidated condition, Orozco depicted the revolution as a sombre, wearying experience, in which farewells and death itself recur again and again in a constant return to the struggle of battle. The concluding panel, *Return to the Battlefields*, anticipates what would become a leitmotif for Orozco, the idea of struggle as a continuum, a never-ending process of pushing back the tides of oppression only to find them returning to overtake mankind's quest for the ideal, for liberation.

When Orozco completed his frescoes at the National Preparatory School, the reaction to his work was undeservedly negative. Disillusioned, and with the country in the throes of a Catholic-inspired uprising against the anti-clerical laws of President Calles, Orozco left Mexico and went to the United States. Nearly eight years elapsed before he painted another mural in Mexico.

The political events and developments from late 1923 also formed an important context for Siqueiros within which his work changed from his early mural attempts. Undoubtedly Siqueiros' membership of the Mexican Communist Party and his leading role in setting up the mural painters' Syndicate and its newspaper *El Machete* were significant factors in the change.

When Siqueiros began his mural commissions in the Colegio Chico in late 1922, a glaring contrast existed between his publicly professed political preoccupation with an ideological art as reflected in the Syndicate's manifesto and the actual images that he created in the mural panels of both *The Elements* and his collaborative piece *The Myths*.[31] Two things are clear about this incongruity. First, Siqueiros' political experience had been lived almost exclusively in Mexico. Politically, he was the product of a radical and revolutionary Mexican nationalist experience. His subsequent adoption of the European Marxist tradition added to and even embellished, but did not substitute for, his pre-existing national radicalism. Secondly Siqueiros' artistic education – his absorption of styles, images and ideas on art – was taken, like

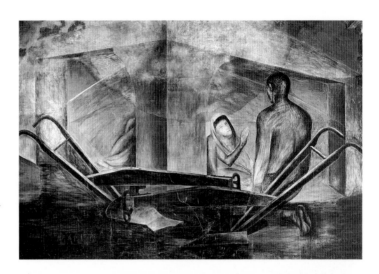

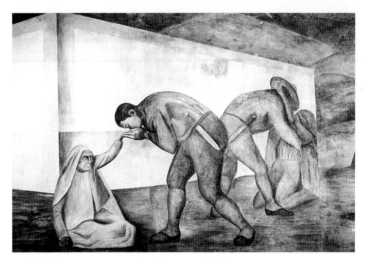

Rivera's, from European models and sources. Such pictorial sources and influences were added to during his visit to Europe from 1919 to 1921. Although his nationalist leanings helped him identify with Mexico's pre-Columbian heritage, he lacked the maturity to synthesize his largely European artistic experience with his Mexican political experience.

The beginnings of this synthesis began to occur with his panel *Burial of the Sacrificed Worker*. The significance of this work is far greater than is suggested by its awkward and unfinished state, for it marks the point at which Siqueiros consciously

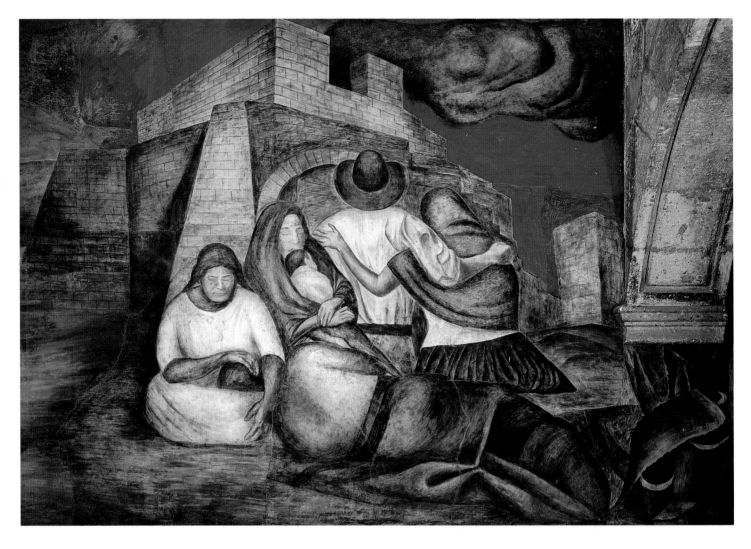

decided to abandon 'symbolic, cosmogenic, sentimental, abstract folkloric terms', as he put it, in order to create works with political and social content. In his memoirs, Siqueiros stated that this was largely the influence of the Syndicate. In reality, the political turmoil that erupted at the end of 1923 with de la Huerta's coup against Obregón was responsible for revealing the disjuncture between Siqueiros' rather tame, apolitical beginnings as a mural painter and the urgency of Mexico's fraught political realities.[32] Not only the subject matter of the *Burial* but also the pictorial embellishments to the panel as a whole show how these events acted as a catalyst, transforming the subject matter of Siqueiros' mural work. The embellishments included the painting of an obviously symbolic hammer and sickle on the top side of the coffin, together with Siqueiros' dedication of the panel to the memory of Carrillo Puerto, whose murder was announced shortly after work on the painting was started.[33]

In addition, the *Burial of the Sacrificed Worker* expresses an almost religious sentiment. This feature was an aspect shared by all three muralists at this time. Orozco movingly incorporated religious sentiment in his panel of 1926, *The Trench*, while Rivera created images that were strikingly similar to the religious cycles of Italian renaissance painting many times in his huge cycle in the Ministry of Education. Antonio Rodríguez commented on this important aspect in the early work of the muralists when he wrote that 'Siqueiros merely portrays that attitude of a working class which still has more confidence in the church than in the unions, and still prefers to listen to a sermon rather than a harangue of a leader.'[34]

Siqueiros' position as a painter on the public payroll came to an end in the middle of 1924. His increasing opposition towards the government, frequently articulated in the pages of *El Machete*, resulted in his dismissal by Vasconcelos' successor as Secretary of Public Education, Puig Cassauranc. Considerably less tolerant of the radicalism of the mural painters than Vasconcelos was even at the end of his term of office, Cassauranc issued an ultimatum to the Syndicate, demanding that either they cease publishing *El Machete*, with its systematic attack on the government, or the

35
José Clemente Orozco: *The Family.*
Fresco, 1926. National Preparatory
School, Mexico City.

government would suspend all their contracts. Siqueiros' reaction decided the matter: 'If they snatch from us the walls of the public buildings, we have in the pages of *El Machete* movable walls for our great mural painting movement. . . . *El Machete* must be continued and must be continued better in its graphic form . . . we should make an effort to quintuple its production.'[35]

This reaction, together with Cassauranc's hostility and the public disquiet over many of the murals being painted in the National Preparatory School, resulted in the termination of Siqueiros' contract.[36] With the ending of his mural commission in the Colegio Chico, and with no other work available, Siqueiros moved to the city of Guadalajara. Guadalajara was a most appropriate place for him: not only had he begun to formulate the basis of his strategy for a revolutionary art in Mexico there in 1919 in his discussions with the painters of the *Centro Bohemio*, but also by 1924 the governor was Guadalupe Zuño, one of the original members of the *Centro Bohemio*. Zuño was a political radical and decidedly more sympathetic towards the muralists than the central government.

Siqueiros' decision to move to Guadalajara was initially prompted by an invitation from his old friend and fellow *Centro Bohemio* colleague, Amado de la Cueva, to join him on a state mural commission there. De la Cueva had been engaged by Zuño to execute a mural commission in the former chapel of the city university. As an enterprise in collective work, the mural carried out by the two artists is considerably more significant than credited by either Siqueiros or other writers. It was perhaps the first really successful collective mural painting to have been realized in the Mexican mural renaissance. Powerful egos, material difficulties, undisciplined approaches to work and involvement in politics had all previously conspired to prevent the realization of real creative collaboration. In Guadalajara, de la Cueva and Siqueiros managed successfully to synthesize their different styles and approaches. Zuño, in the journal *La Bandera de Provincias*, commented how 'Worthy of praise is the capacity of these two young men at work in mutual coordination, to subject their personal styles to a central formula. . . .'[37]

Although Siqueiros claimed that he worked for de la Cueva only as a labourer, the pictorial evidence left by the work suggests a much greater creative and collaborative involvement.

This collective achievement has been described as a '. . . proletarian aesthetic, of epic simplicity, with a pictorial manifesto that avoids facile prettiness and pleasures to express a definite political calling.'[38] The themes of this mural are *Work* and *Rebellion*. The subjects of the panels, all painted into the architectural subdivisions of the building, illustrate the revolutionary character of their theme. The subjects in the north part of the building are peasant and agrarian: *Cultivation of the Maize*, *Sugar Cane*, *Agriculture*, and *Unity of the Peasant and the Worker*. At the southern end of the building the images are of industrial workers and their machines: *The Miner*, *The Potter*, *The Electrical Worker*. Over the entrance to the building are panels depicting *The Legend of Zapata* and *The Triumph of the Revolution*.

At first glance it appears that Siqueiros did subordinate all his artistic conceptions to those of de la Cueva, for instead of the spatially dynamic character that he had begun with his panel *Burial of the Sacrificed Worker* in the Colegio Chico, in this joint mural hieratic, solid and immovable images are employed. The monumental figures are silent and at rest. There is no sense of the penetration of pictorial space that he had begun to play with in his *Burial* panel. Instead, a flatly depicted figuration conceived in an overall tonality of reds dominates the whole work, simulating the spirit of a Byzantine church painting in its spatial conventions. Yet even if Siqueiros was at odds with the surface decorativism of de la Cueva's approach, there are nevertheless aspects of the work that are clearly influenced by Siqueiros, connected to developments in his own work at this time. As Zuño observed, 'At first sight one confuses the work done by the two painters, but overall close observation reveals the figures done by Alfaro, angular, reconstructed, more ample than Amado.'[39] Indeed the economic monumentality of Siqueiros' figures, as opposed to de la Cueva's more flatly delineated ones, echo not only the figures in the *Burial* panel, but foreshadow the large canvases he painted in Taxco five years later, such as *Peasant Mother* (1929) and *Proletarian Mother* (1930).

An important additional characteristic of this Guadalajara work is its closeness in spirit to the atmosphere of medieval church painting. The work as a whole seems to have been conceived very much in these terms. The simplicity of the whole conception not only achieves a pictorial unity between the two

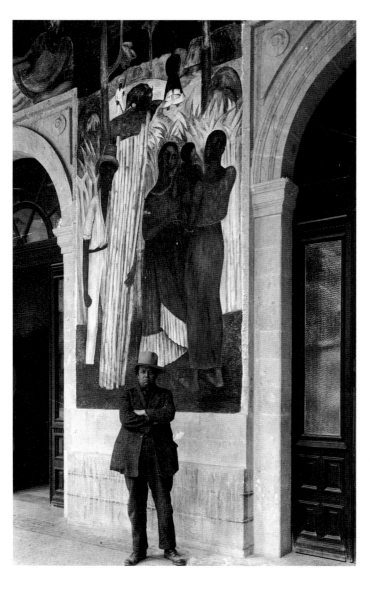

36
Rivera posing in front of one of his
murals at the Ministry of
Education, c.1924.

painters of very different artistic temperaments and style, but also visually communicates its theme in a manner seemingly designed for a popular audience. This 'religious' iconographic conception closely reflects the assertions made by Siqueiros as to the collective and communicative power of the early Christian art, an assertion that he had seemed strongly to identify with in his earlier discussions concerning the need to create a revolutionary art for the masses held at the *Centro Bohemio*.

Siqueiros' involvement in this project is reflected in his design and carving of the huge wooden doors to the building. The simple hieratic imagery of the mural inside is echoed in the doors with their organization of rectangular panels depicting revolutionary images of Marx and Lenin, the clasped hands of solidarity and pre-Columbian-type figures. These carved doors are unique in the work of Siqueiros, and are particularly significant because they are a three-dimensional extension of the massive sculptural forms he was beginning to achieve in his paintings.

He re-explored this approach some thirty years later with his huge *bas-relief* works on the façade of the Automex factory and the National University in Mexico City.

Further collaboration with de la Cueva was halted when the latter was tragically killed in a motorcycle accident. De la Cueva's untimely death served as a pretext for Siqueiros to break his commitments to Guadalupe Zuño in order to devote himself to full-time political work among the trade unions of Jalisco.[40] Nevertheless, he had achieved much in artistic terms in the short period between his return to Mexico from Europe in 1922 and his decision to apply himself full-time to political work in 1925. Although the mural work he had created in Mexico City was by no means as impressive as Orozco's or as prolific as Rivera's would be throughout the 1920s, his innumerable writings and manifestos and his ideas on collective work would all be consciously rehearsed in the 1930s, when he would begin to create and develop a political aesthetic for his mural painting that would increasingly be characterized by invention and innovation. He was to develop a thematic approach that would transform the slightly religious aspects of his first murals into a direct assertion of political content reflective of political and urban modernity.

Unlike Orozco and Siqueiros, Rivera weathered the storm of Vasconcelos' resignation and the tide of criticism against the murals which built up towards the end of 1923 and into 1924. He also made his peace with Puig Cassauranc, who not only allowed Rivera to continue with his work in the Ministry of Education building but also seemed keen to encourage him.

By the time *Creation* was completed in April 1923, Rivera had already made a substantial impact. Impressed by his protégé's work, Vasconcelos duly appointed Rivera to the post of Head of the Department of Plastic Crafts at the Ministry of Education. This title was in effect a commission awarded to Rivera to undertake the decoration of Vasconcelos' new Ministry of Education building in the centre of Mexico City. The building, the construction of which sought to give architectural expression to the radical education policies of Vasconcelos, became the site of Rivera's first great achievement as a mural painter.

Although Orozco had created an undeniably powerful and memorable cycle of images in the National Preparatory School

and Siqueiros' works in the Colegio Chico had begun to hint at future developments, the murals executed by Rivera in the Ministry of Education and in the National Agricultural School at Chapingo between 1923 and 1928 represent the most significant stage in the development of the Mexican mural movement as a radical national public art. His work at the Ministry signified his move away from the exclusivity of his largely European educational past and experience, which until then had for the most part inhibited the full expression of the social and political reality of Mexico in his work. In the murals at the Ministry, the concept underlying post-revolutionary Mexican nationalism – the idea that the nation's culture was both the product and the possession of the people – became part of Rivera's political and visual aesthetic. This in turn stimulated much worldwide interest in the development of Mexican mural painting in the 1920s.

The populist dimensions of Rivera's Ministry of Education murals were rooted in the same circumstances as those which effected the changes in Orozco and Siqueiros' work at the National Preparatory School, that is, the radical atmosphere surrounding the Obregón government at the end of 1923. Constantly pressurized by the strength of the country's growing labour movement, the Government tended to side with the forces of the left. Plutarco Calles, Minister of the Interior and in 1924 successor to Obregón as President, declared that 'the people's wishes can no longer be silenced by gunfire . . . it is the unavoidable duty of rulers to respect and guarantee the free exercise of rights – such as the right to strike – to all citizens.'[41]

Although Rivera was often the target of the violent verbal attacks against the murals after Vasconcelos had resigned, paradoxically his murals remained unscathed, leaving him free to carry on working and to consolidate his position as the leading painter in the movement. Against this background, together with the formation of the painters' Syndicate by Rivera, Siqueiros and Guerrero, and their collective membership of the Mexican Communist Party, Rivera's adherence to socialist politics took on a very public display, and became steadily infused into the visual and thematic texture of the murals he painted.

By the time Rivera completed his work at the ministry in 1928, he and his assistants had painted 235 individual fresco panels, of

which 116 were principal works. Together they covered an area of 15,000 square feet. In his book *My Life, My Art*, Rivera wrote that it was his aim 'to reflect the social life of Mexico as I saw it, and through my vision of the truth to show the masses the outline of the future.'[42]

The murals are divided according to the architectural subdivision of the building. Based on the colonial model, it was designed with two adjacent courtyards, each with two floors. On the ground floor of the first courtyard, which he entitled 'The Courtyard of Labour', Rivera painted images depicting themes of labour characteristic of the different geographical regions of Mexico. On the first floor are smaller images, mostly monochromatic, symbolizing intellectual labour such as medicine and technology. The second floor shows images symbolizing the arts and sciences, together with the great heroes of the revolution.

In the second courtyard, which Rivera called 'The Courtyard of the Fiestas', he painted frescoes on the themes of Mexican traditions of popular religious and political festivals. On the first floor, painted almost exclusively by his assistants, Rivera designed escutcheons for the different Mexican states, while on the top floor he executed murals illustrating the famous *Corridos* of the *Agrarian and Proletarian Revolutions*. In addition to these, Rivera also painted views of the Mexican landscape on the stairwell of the Labour Courtyard, representing the evolution of the country's political and social life.

38
Diego Rivera: *The Dyers*. Fresco,
1923. North wall, Court of Labour,
Ministry of Education, Mexico City.

39
Diego Rivera: *The Sugar Refinery*.
Fresco, 1923. North wall, Court of
Labour, Ministry of Education,
Mexico City.

40 *opposite*
Diego Rivera: *The Embrace*. Fresco,
1923. East wall, Court of Labour,
Ministry of Education, Mexico City.

52

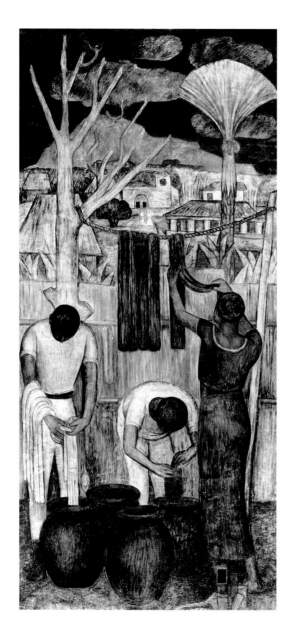

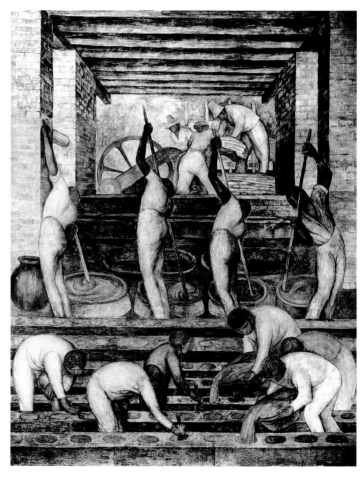

Rivera began his cycle on the ground floor of the Labour
Courtyard.[43] Rivera developed his own highly individual manner
of social expression here in the eighteen principal fresco panels
depicting the industries and agriculture of the different regions
of Mexico. The influence of his 1922 visit to Tehuantepec
remained with him in the first images he executed. Along the
north wall and in the small vestibule of this part of the courtyard
he painted *The Dyers* and a series of frescoes on the theme of
The Tehuanas, showing the industries of the southern, largely
Indian region of Mexico. The atmosphere, the colour and the
generally decorative tone of these panels celebrate the indi-
genous culture, reflecting the climate of cultural *indegenismo* at
the time.[44]

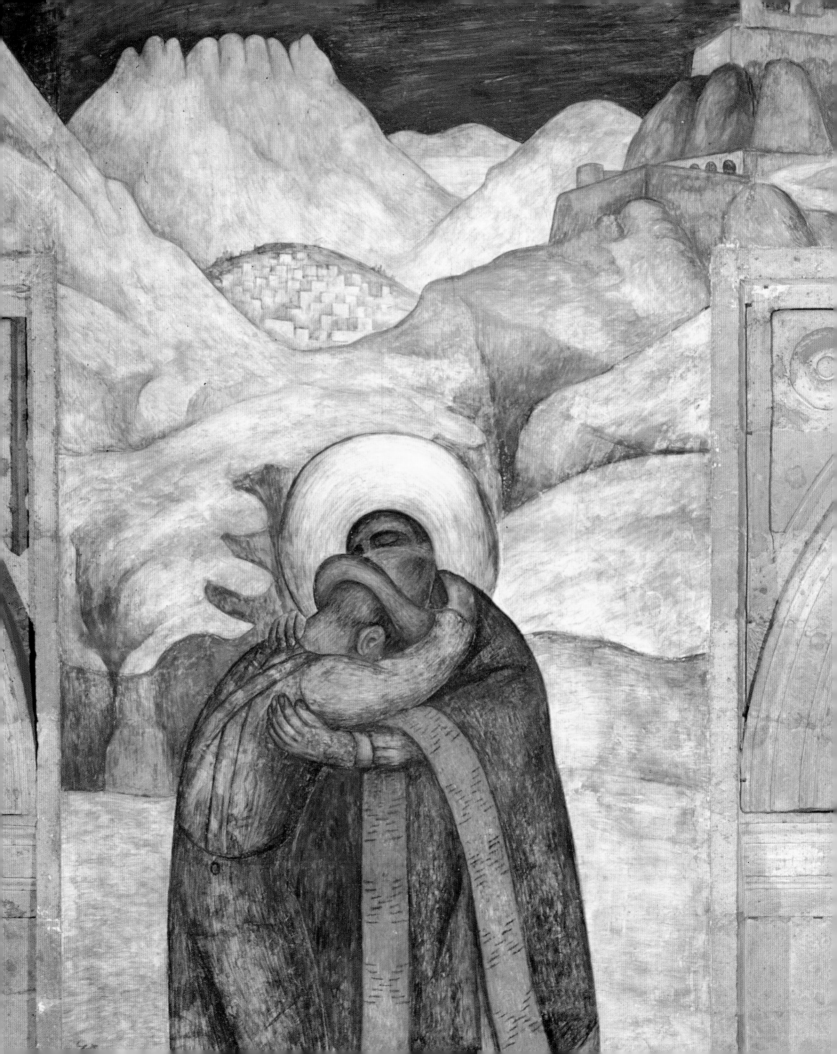

41
Diego Rivera: *Entry into the Mine*.
Fresco, 1923. East wall, Court of
Labour, Ministry of Education,
Mexico City.

42
Diego Rivera: *Exit from the Mine*.
Fresco, 1923. East wall, Court of
Labour, Ministry of Education,
Mexico City.

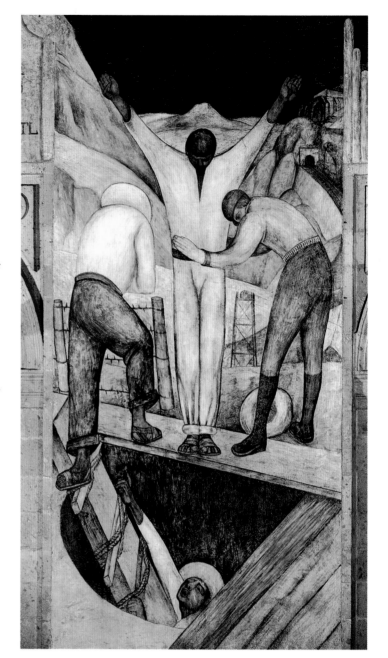

54 After the decorative and rather exotic panels of *The Tehuanas*,
Rivera began to introduce a quite different character. In such
panels as *The Sugar Refinery* and in a further series of panels on
the south wall depicting the iron and surface mining industries
of northern Mexico, his frescoes became more rhythmical,
monumental and much less folkloric. Rivera avoided the use of
visual rhetoric in these images of industrial labour to express the
toil and hardship that the workers endured. Along the east wall,
Rivera went so far as to express a political identification with his
subject matter. Here, in images depicting the agriculture and
mining and pottery industries of western Mexico, he synthesized
his national subject matter with his knowledge of Italian renais-
sance religious painting to create extraordinary images full of
pathos and tragedy. His approach draws heavily on the moving
spirituality of Christian Mexico. In the panel *Entry into the Mine*,
the miners carrying pickaxes, shovels and pit props over their

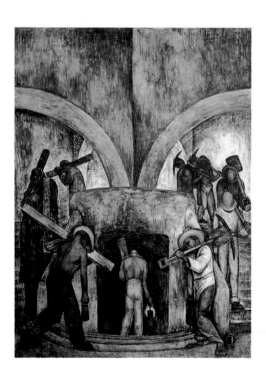

shoulders echo the Biblical story of the road to Calvary. In the
adjacent panel, *Exit from the Mine*, the crucified stance of the
miner being searched by a mine official evokes the Crucifixion
sacrifice.[45] Further along the wall, in the panel *The Embrace*, the
unity expressed in the embrace of the peasant and industrial
worker, with the peasant's sombrero resembling a halo and his
serape a religious cloak, conveys all the religious passion of a
secular annunciation, visiting the two figures in a spirit of
human brotherhood. The fusion in these images of the labour,
exploitation and solidarity of the Mexican worker with allusions
to the passion of Christ represents one of the most striking and
poetic elements in Rivera's artistic vocabulary.

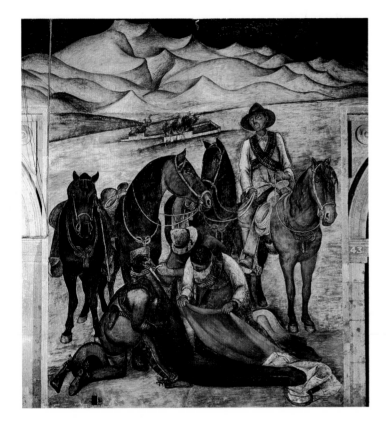

43
Diego Rivera: *The Liberation of the Peon*. Fresco, 1923. South wall, Court of Labour, Ministry of Education, Mexico City.

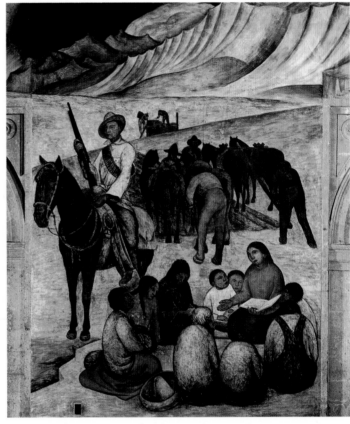

44
Diego Rivera: *The New School*. Fresco, 1923. South wall, Court of Labour, Ministry of Education, Mexico City.

Rivera continued to use images alluding to the Passion in his fresco *The Liberation of the Peon*. Here, the allusion is to the descent from the cross and the lamentation, which Rivera employed to express the tragic freedom of death when the peasant is finally released from his life of drudgery and exploitation. By contrast, an adjacent panel entitled *The New School* expresses the notion of a different kind of freedom, gained through revolution. *The New School* openly alludes to the rural schools created by Vasconcelos in his drive to bring literacy to the countryside.

Apart from the very first frescoes which he painted on the north wall, Rivera had depicted the life of the Mexican worker as one of toil. As he moved into the second courtyard, the 'Courtyard of the Fiestas', his mood changed. He described the atmosphere expressed here as one in which 'the people turned from

their exhausting labors to their creative life, their joyful weddings, and their lively fiestas: The Burning of the Judases, The Dance of the Deer, The Dance of the Tihuanas, The Dance of the Ribbons, The Corn Harvest Dance'.[46] Rivera's murals in the second courtyard mark both the point at which a certain distance and even antagonism began to occur between himself and the other mural painters, and the development of his position as the movement's leading figure. To some extent this distancing was illustrated by his treatment of fellow artists. While working as assistants on the first courtyard, de la Cueva, Guerrero and Charlot had also been given the task of decorating some areas of the second. This reflected the ethos of the Syndicate, which aimed to share out work collectively. However, in his capacity as Head of the Department of Plastic Crafts at the Ministry of Education, Rivera found the efforts of his fellow painters

Diego Rivera: *The Festival of the
Distribution of the Land*. Fresco,
1923–4. South wall, Court of the
Fiestas, Ministry of Education,
Mexico City.

56

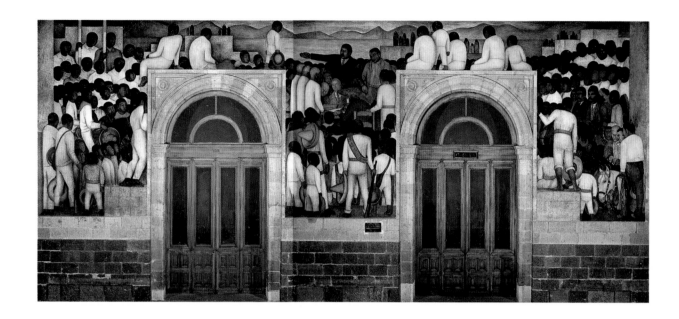

46
Diego Rivera: *The Festival of the First of May*. Fresco, 1923–4. West wall, Court of the Fiestas, Ministry of Education, Mexico City.

47
Diego Rivera: *The Market*. Fresco, 1923–4. North wall, Court of the Fiestas, Ministry of Education, Mexico City.

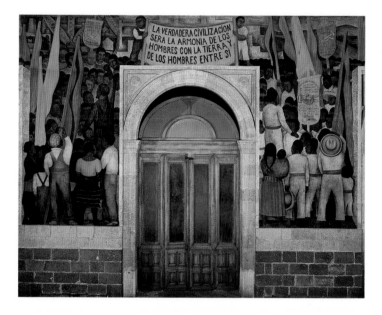

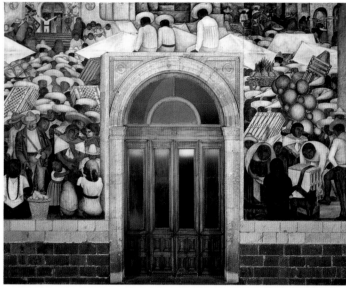

unsatisfactory. Complaining that their work was technically inadequate and would not integrate with his own scheme, he summarily dismissed them and assigned them the menial task of painting the escutcheons on the floor above. Furthermore, when he finally entered the second courtyard to start his own painting, Rivera decided to chip from the wall two of Guerrero's frescoes and one of Charlot's on the grounds that they interfered with his own plans.[47] In addition to this, Rivera's support for his fellow colleagues in the Syndicate was less than forthright when their murals were being attacked at the National Preparatory School. He dismissed the attacks as a tiny scandal. On 11 September 1924 *El Machete* announced: 'Diego Rivera resigned from the Syndicate of Painters and Sculptors in July because of a difference of opinion concerning a majority decision relating to the protest made public at the time against the destruction of mural paintings at the National Preparatory School.' Whereas Siqueiros and Orozco were dismissed from their work at the School, Rivera was able to continue working, enjoying the support of Vasconcelos' successor, Puig Cassauranc.

Although Rivera adopted the same layout in the Fiesta Courtyard as he had employed in the Labour Courtyard, dividing his themes geographically in accordance with the direction each wall faced, his compositional style was markedly different. In the Labour Courtyard, his compositions had tended to be grand, sometimes monumental, employing only a few figures. In the Fiesta Courtyard, on every available wall space, between the entrances to the offices, even over the doorways, Rivera painted hundreds of figures, as though he was creating a vast portrait of the Mexican people.

This and the general air of celebration that permeates the twenty-four principal frescoes of the second courtyard is typified in the middle sections of each of its three walls. Here, Rivera painted *The Festival of the Distribution of the Land*, *The Festival of the First of May* and *The Market*. In the first two, Rivera expressed decidedly political themes. However, his tone here was not critical, as it was in the Labour Courtyard, where his images by implication seemed set in pre-revolutionary Mexico. Instead, the murals exude an air of revolutionary optimism and idealism, creating visual eulogies to the gains of the revolution with its new atmosphere of political liberation. The compositions are made up of compacted groups of predominantly Indian figures and seem to represent Rivera's attempts to give expression to what he saw as an authentic, indigenous national image. This idea is underpinned by the way in which Rivera constructed the

THE MURALS OF THE 1920S

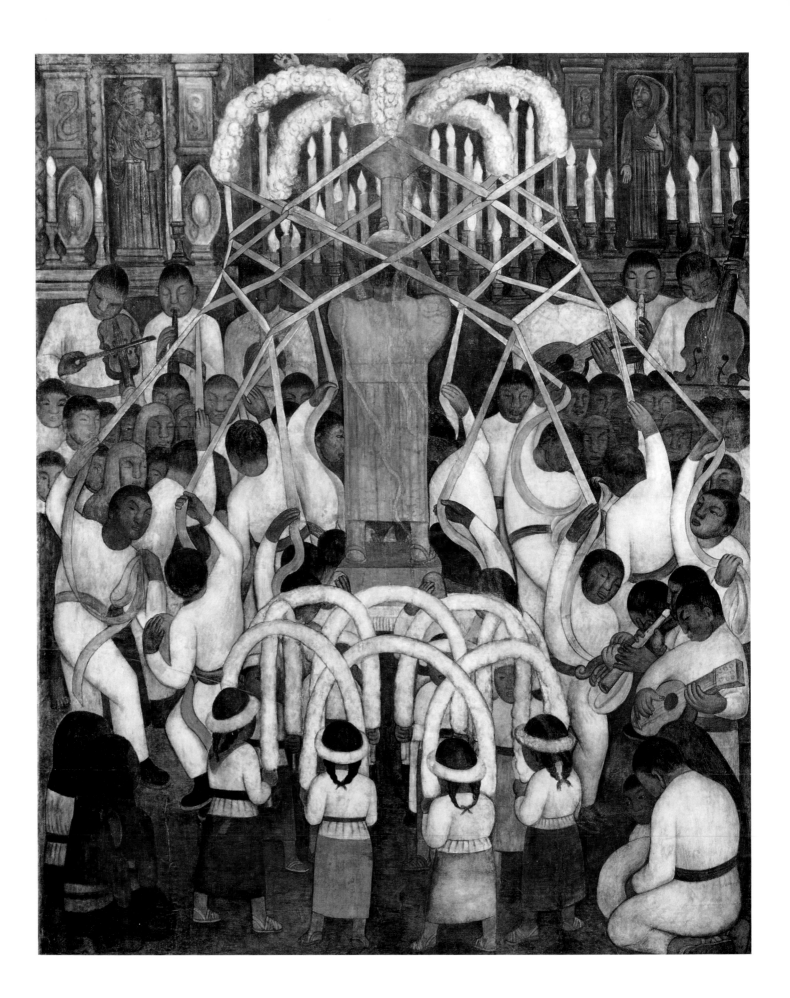

48
Diego Rivera: *The Ribbon Dance.*
Fresco, 1923–4. North wall, Court
of the Fiestas, Ministry of
Education, Mexico City.

49
Diego Rivera: *The Burning of the
Judases*. Fresco, 1923–4. West wall,
Court of the Fiestas, Ministry of
Education, Mexico City.

50
Diego Rivera: *The Corn Festival.*
Fresco, 1923–4. South wall, Court
of the Fiestas, Ministry of
Education, Mexico City.

59

compositions: lack of background space, together with a tiered arrangement of figures echoing the pictorial method of the Aztecs and Mayans before the conquest.[48]

The reverence with which Rivera depicted the Indian and the peasant can be clearly seen in the three panels with the theme of the Day of the Dead. In the panel depicting the festival in its urban setting, *The Day of the Dead – City Fiesta*, Rivera treated his subject satirically, depicting it essentially as a raucous, even drunken celebration. In its rural setting, entitled *The Day of the Dead – The Offering*, the peasants celebrate the festival in traditional manner, with prayers and offerings of food at the graveside. Similarly, *The Day of the Dead – The Dinner* is a quiet yet unmistakable eulogy to peasant life.

Rivera continued the spirit of comment and satire in an adjacent panel entitled *The Burning of the Judases*. From the early 1900s, this festival had become an occasion at which effigies of unpopular political figures were stuffed with explosives and set alight. In Rivera's mural, three exploding puppets, representing the politician, the church and the army sway above a mass of gyrating figures. This trilogy of Judases symbolizes the pre-revolutionary institutional oligarchies' betrayal of Mexico and its people.

However, Rivera's use of satire and political critique is rare in the ground floor murals in the Fiesta Courtyard, for his enduring theme is the celebration of the life and traditions of the Indian peasant. The frescoes showing these traditional customs and festivals, such as *The Deer Dance*, *The Corn Festival*, *The Ribbon Dance* and *La Zandunga* are particularly intriguing in this respect, since they focus on the image of the Indians, presenting them as the quintessence of the real Mexico.[49]

He continued his decoration of the Ministry with the cycle of murals painted in the stairwell adjacent to the Courtyard of Labour. From the ground up to the second floor, Rivera presented what he described as

an interpretative painting of the Mexican landscape rising from the sea to hills and plateaus and mountain peaks. Alongside this representation of the ascending landscape was an accompanying view of the progress of man. Allegorical figures personified the ascending stages of the social evolution of the country from primitive society through the peoples' revolution to the liberated and fulfilled social order of the future.[50]

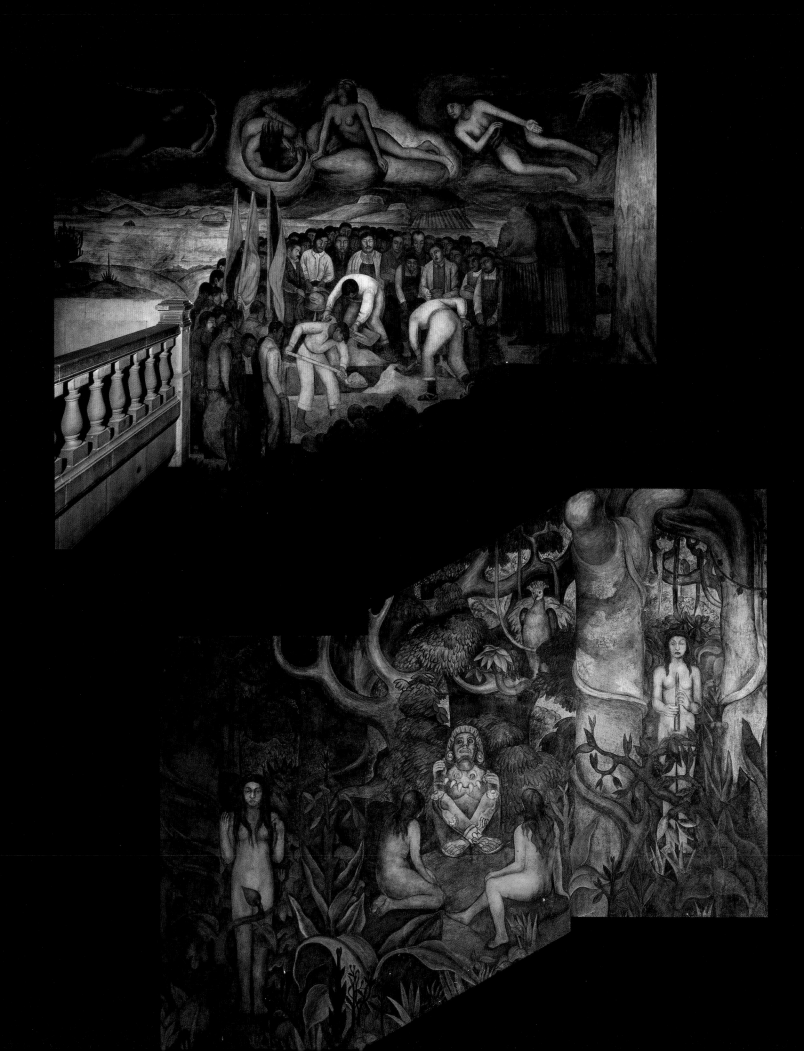

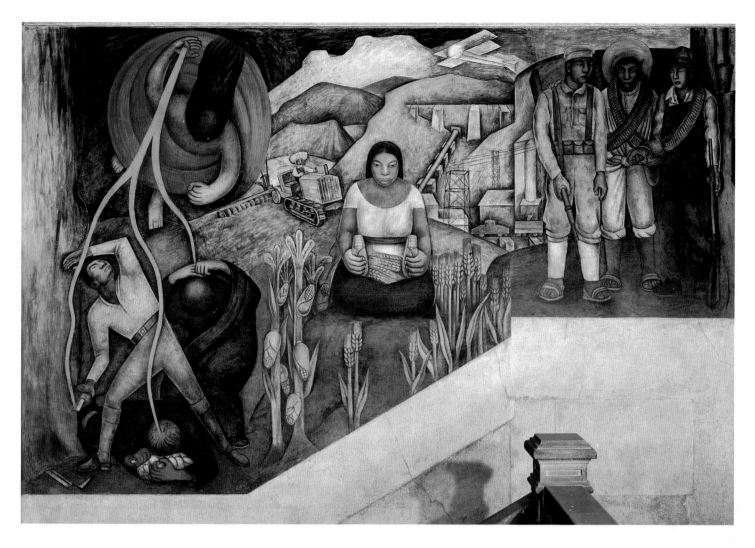

51 *opposite top*
Diego Rivera: *The Burial of the Revolutionary*. Fresco, 1926. North wall stairwell, Court of Labour, Ministry of Education, Mexico City.

52 *opposite bottom*
Diego Rivera: *Tropical Mexico* and *Xochipilli and his Votaries*. Fresco, 1926. North wall stairwell, Court of Labour, Ministry of Education, Mexico City.

53 *above*
Diego Rivera: *The Mechanization of the Country*. Fresco, 1926. North wall stairwell, Court of Labour, Ministry of Education, Mexico City.

In contrast to the exotic and somewhat idealized representation of southern Mexico on the lower levels of the stairs, Rivera painted scenes of Mexico's agricultural centre and north on the top floor of the stairwell. This is the Mexico of the hacienda, of the landlord, of exploitation and revolution. On one wall, in a panel entitled *The Mechanization of the Country*, a goddess-like figure swathed in red strikes down the landlord and his cohorts with a triple-headed lightning bolt. In *The Burial of the Revolutionary* on the adjoining wall, Rivera presented one of his most moving and significant themes: heroic sacrifice in the revolutionary struggle. The image highlights the synthesis of European religious painting with Mexican reality. The references to Giotto's *Lamentation* at the Arena Chapel in Padua (1305–08) and perhaps more significantly to El Greco's painting of *The Burial of Count Orgaz* (1586; Santo Tomé, Toledo), which Rivera had seen during his travels in Spain, are unmistakable.[51]

THE MURALS OF THE 1920S

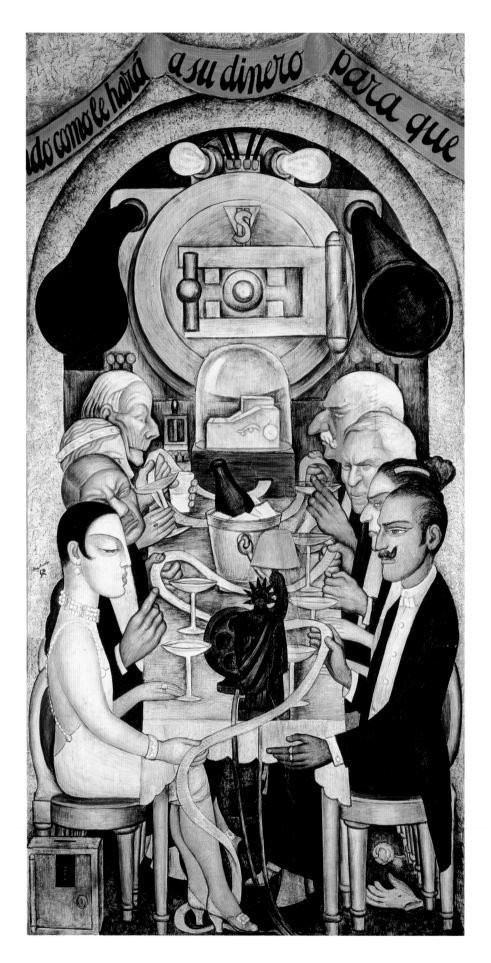

54
Diego Rivera: *Wall Street Banquet.*
Fresco, 1928. North wall, Courtyard
of the Fiestas, Ministry of
Education, Mexico City.

55
Diego Rivera: *Our Bread*. Fresco,
1928. South wall, Courtyard of the
Fiestas, Ministry of Education,
Mexico City.

56
Diego Rivera: *Night of the Poor*.
Fresco, 1928. North wall, Courtyard
of the Fiestas, Ministry of
Education, Mexico City.

57
Diego Rivera: *The Learned*. Fresco,
1928. North wall, Courtyard of the
Fiestas, Ministry of Education,
Mexico City.

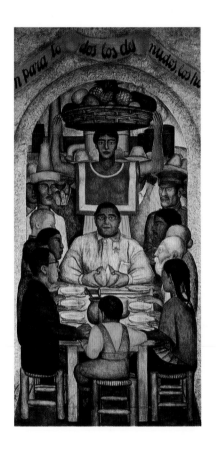

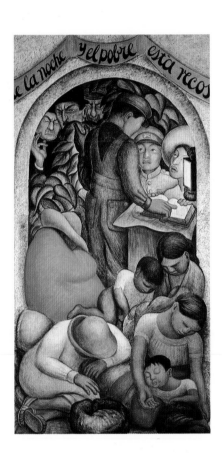

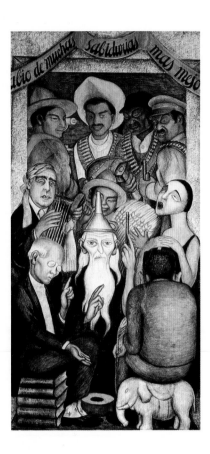

The final frescoes in the Ministry of Education, along the corridors of the second floor of the Courtyard of the Fiestas, include twenty-six panels illustrating the stanzas from three revolutionary *corridos* or popular songs: *The Ballad of Zapata, The 1910 Mexican Agrarian Revolution*, which was written by José Guerrero, and *Así Será La Revolución Proletaria* (That is How the Proletarian Revolution Will Be), written by Martinez.[52] Although the two agrarian *corridos* frescoes were painted nearly two years before the proletarian *corrido*, which Rivera completed following his trip to the Soviet Union in 1928, all the illustrations are characterized by a recurring *motif*: the contrast between a eulogy of the revolution, its ideals and achievements, and biting criticism of its opponents and detractors.[53] In the three panels illustrating the theme of the supper, Rivera contrasts the plutocracy with the popular masses. In the *Wall Street Banquet*, he painted a group of American industrialists and their wives seated at a dinner table examining the gold ticker-tape of the stock exchange. Among the assembled figures are recognizable caricatures of John D. Rockefeller (top left of the table), J.P. Morgan and Henry Ford. In the panel entitled *Capitalist Dinner*, Rivera continues his satire of the rich's obsession with money by picturing those assembled around the table staring at dinner plates full of coins, and sporting expressions of infinite stupidity. In contrast to both these panels, *Our Bread*, illustrating the theme of the proletarian or revolutionary supper, is strongly eulogistic, and alludes to the Christian miracle epitomized in the figure of the revolutionary at the head of the table breaking bread.

THE MURALS OF THE 1920S

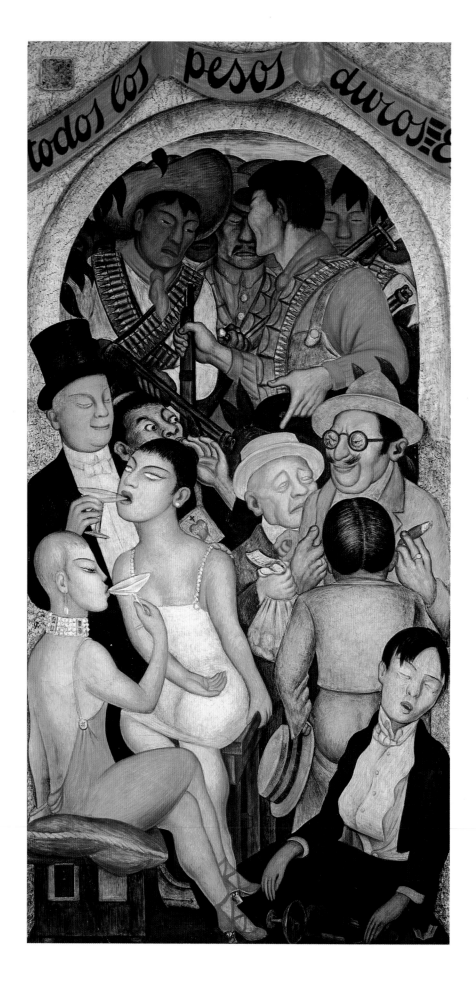

58
Diego Rivera: *Night of the Rich*.
Fresco, 1928. North wall, Courtyard
of the Fiestas, Ministry of
Education, Mexico City.

59
Diego Rivera: *Death of a Capitalist.*
Fresco, 1928. South wall, Courtyard
of the Fiestas, Ministry of
Education, Mexico City.

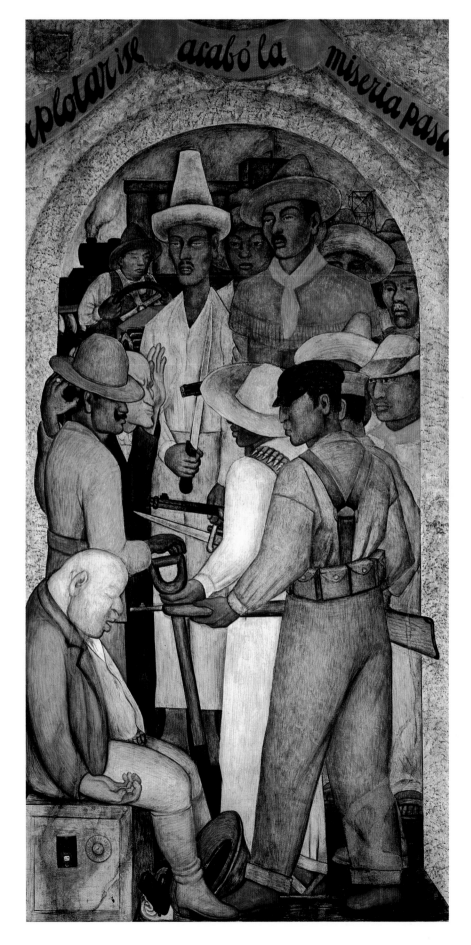

60
Diego Rivera: *He Who Wants to Eat Must Work*. Fresco, 1928. South wall, Courtyard of the Fiestas, Ministry of Education, Mexico City.

61
Diego Rivera: *The Trench*. Fresco, 1928. South wall, Courtyard of the Fiestas, Ministry of Education, Mexico City.

62 *below*
Diego Rivera: *The Protest*. Fresco, 1928. West wall, Courtyard of the Fiestas, Ministry of Education, Mexico City.

63 *opposite*
Diego Rivera: *Distribution of the Arms*. Fresco, 1928. South wall, Courtyard of the Fiestas, Ministry of Education, Mexico City.

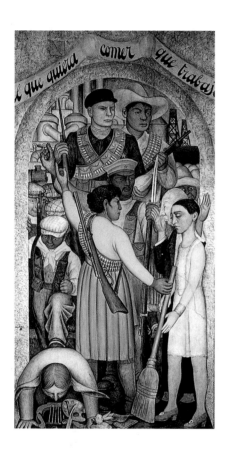

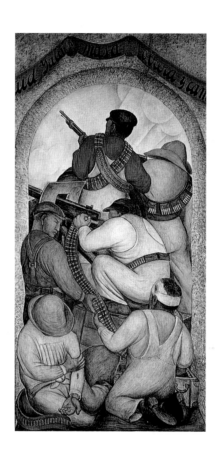

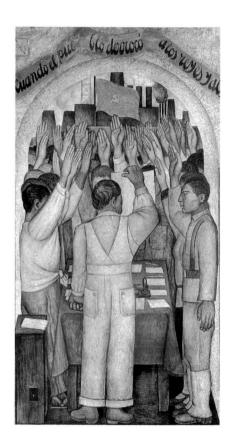

Rivera continued this theme of contrasts with two further panels called *Night of the Rich* and *Night of the Poor*. He indulged in one of his most biting satires in the panel of *The Learned*, picturing a group of bourgeois intellectuals among whom Rivera depicted none other than José Vasconcelos (with his back to the viewer), the one man who above all else had been responsible for bringing into being the Mexican mural movement, in which Rivera was now playing the leading role. However, in the wake of the failed de la Huerta coup, Vasconcelos was now viewed as an increasingly conservative figure, publicly disenchanted with the revolutionary murals which his original patronage had inspired. Vasconcelos now criticized the mural artists for having fallen 'into the abjection of covering walls with portraits of criminals'.[54]

Rivera focused on the theme of revolutionary justice in the *Corrido of the Proletarian Revolution* with panels that included *He Who Wants to Eat Must Work* and *Death of a Capitalist*. He contrasted these with utopian, highly idealized visions of revolutionary struggle and achievement in such panels as *The Trench*, *Distribution of the Arms*, *To Work*, *The Protest*, *Learning the ABC*, *The Cooperative* and *United Front*.[55]

By the time Rivera completed his vast cycle of frescoes at the Ministry of Education in 1928 he had created an epic portrait of the Mexican people. Notwithstanding accusations that he had indulged in the falsification of reality in his eulogistic depictions of the revolution's achievements, Rivera acknowledged in his *Corrido* illustrations the great debt he owed to Posada. He had created a pictorial synthesis of the rich traditions of Mexican

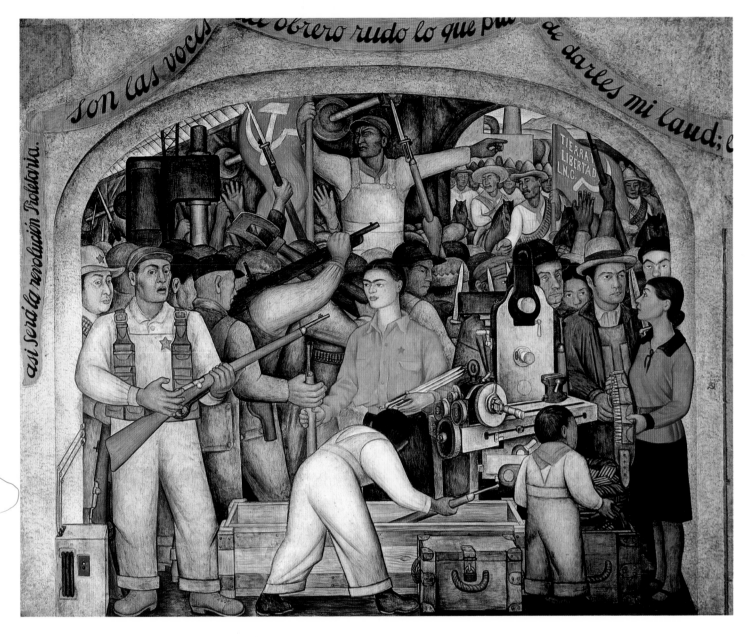

popular culture from Posada's ballads of hope and love and his popular images of satire and social criticism. Rivera also consolidated his style and narrative purpose in the cycle, both of which he went on to develop further in his later work and which profoundly influenced many North American artists during the 1930s, who saw Rivera's public murals as breaking down the barriers separating art from propaganda.

If Rivera's frescoes at the Ministry of Education represent an extensive social and political panorama of the Mexican people, then the cycle of murals he painted in the chapel and administrative building at the National Agricultural School at Chapingo in the state of Mexico in 1925–26 represents a particular aspect of that panorama, that of Mexico's agrarian revolution.

The agrarian revolution and the issue of land reform and ownership was central to the character of Mexico's 1910 revolution. As a subject it thus had particular resonance and significance. For Rivera the theme of the land also represented a link to the historical, cultural and political origins of the Mexican Indian and peasant, whom he had depicted with increasing frequency in the Labour and Fiesta Courtyards of the Ministry of Education as the personification of the true nature of Mexican identity.

The land and buildings of Chapingo, situated just outside Mexico City, were owned by a former president of Mexico and were nationalized after the revolution and turned into an agricultural school. Using the theme of the land, Rivera based his cycle on Emiliano Zapata's dictum 'Here it is taught to exploit the land not the man'.

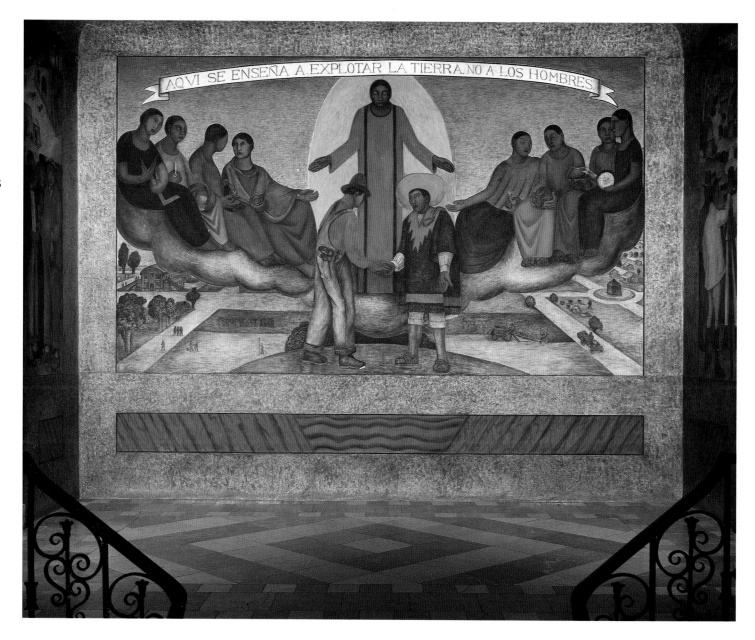

AQVI SE ENSEÑA A EXPLOTAR LA TIERRA, NO A LOS HOMBRES

64 *above*
Diego Rivera: *Alliance of the Peasant and the Industrial Worker*. Fresco, 1924. North wall, second floor foyer, administrative building, Autonomous University of Chapingo, Mexico.

65 *opposite*
Diego Rivera: *Partition of the Land*. Fresco, 1924. Second floor foyer, administrative building, Autonomous University of Chapingo, Mexico.

The frescoes begin in the entrance to the building at the foot of the main staircase, with images depicting the *Men and Women of Tehuantepec*. These figures are reminiscent of those Rivera had used two years earlier in the Courtyard of Labour at the beginning of his cycle in the Ministry of Education. In the body of the stairwell, he painted scenes of cultivation and harvest in monochrome, while on the first floor, on either side of the staircase are panels representing good and bad government. The panel of *Bad Government* illustrates scenes of the cruel excesses of pre-revolutionary Mexico, with peasants shown being horsewhipped and lynched. *Good Government* is a contrasting image of the land in which abundance and cultivation are reality. Scenes of construction and education and the dual

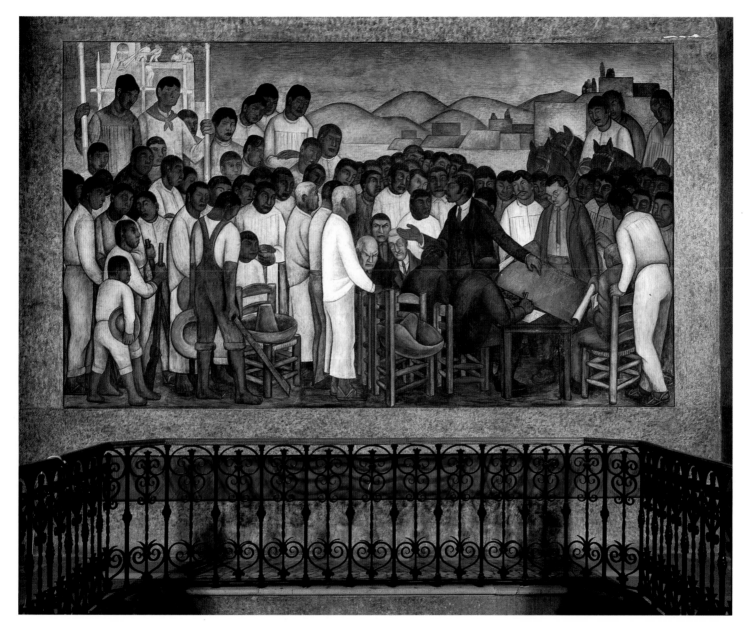

portraits of President Obregón and de Negri, Secretary of Agriculture under Obregón, make this an unmistakable eulogy to the ideals and achievements of the revolution.[56] In the two panels facing each other at the head of the stairs, *The Alliance of the Peasant and Industrial Worker* and *The Partition of the Land*, Rivera closely echoed the format of frescoes that he had painted with similar titles and themes in the Courtyard of the Fiestas at the Ministry of Education.

Rivera achieved his most explicit and poetic expression of the agrarian theme in the chapel itself when he returned to it in 1926. The decorative scheme of the chapel has both paradox and irony: on the one hand, it is a visual 'shrine' to the materialist philosophy and politics of revolution and to the earth's fecundity, yet on the other, the images evoke an essentially Biblical atmosphere. In part, this association is made apparent by the architecture of the chapel, to which Rivera faithfully adhered in planning the location and form of the murals. Simultaneously some of the imagery also evokes a Biblical atmosphere, through its reference to some of the great works of Italian renaissance painting. The choice of colour, with its deep golden hues and earth tones, echoes the atmosphere of mediaeval church painting.

At one level, the decoration of the chapel of Chapingo can be seen as a hymn to the earth. However the narrative is quite didactic. The spirit of the work is movingly expressed on a panel within the chapel in an inscription which reads

66 *top left*
Diego Rivera: *Men and Women of Tehuantepec under Wind and Cloud Symbols*. Fresco, 1924. East wall entrance, administrative building, Autonomous University of Chapingo, Mexico.

67 *top right*
Diego Rivera: *Men and Women of Tehauntepec in Mountain Landscape with Sunburst*. Fresco, 1924. Entrance, administrative area, Autonomous University of Chapingo, Mexico.

68 *bottom left*
Diego Rivera: *Bad Government*. Fresco, 1924. North wall, second floor foyer, administrative building, Autonomous University of Chapingo, Mexico.

69 *bottom right*
Diego Rivera: *Good Government*. Fresco, 1924. South wall, second floor foyer, administrative building, Autonomous University of Chapingo, Mexico.

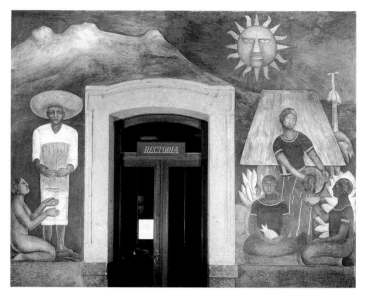

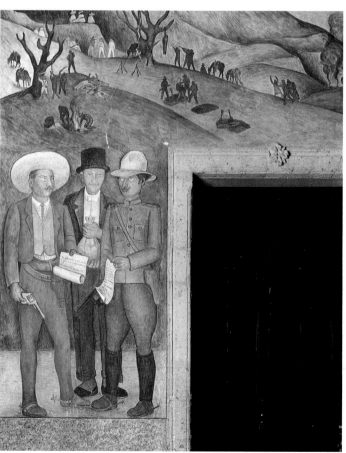

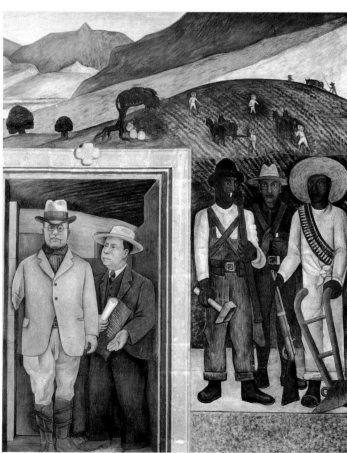

MEXICAN MURALISTS

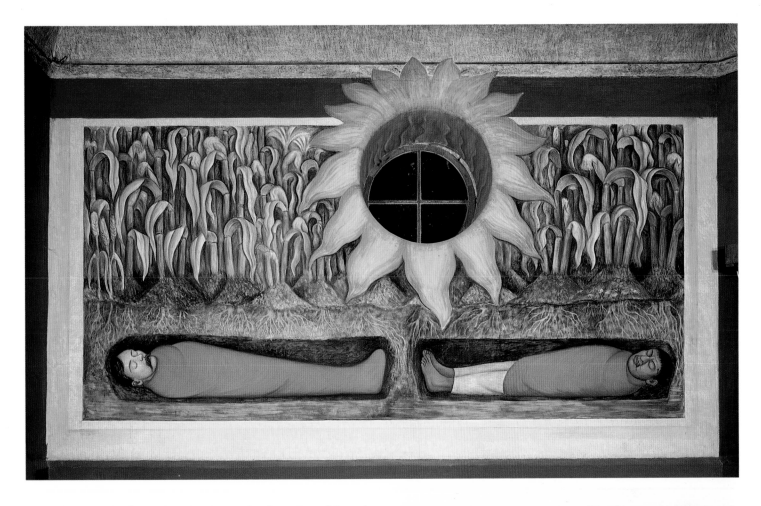

To all those who fell and to the thousands who will yet fall in the fight for the land and to all those who make it fruitful by the labour of their hands. Earth manured with blood, bones and flesh! To commemorate all those who sacrificed themselves to it. This work is dedicated to them by all those who took part in it: Juan Rojano, Efigemio Tezlez, stonemasons, Ramón Alva Guadarrama, Maximo Pacheco and Pablo O'Higgins, assistants, and Diego Rivera painter.[57]

The left-hand side of the chapel contains a series of fresco panels depicting the revolutionary transformation of the ownership of the land. On the right-hand side of the chapel and acting as a thematic mirror to the images, Rivera presents the biological and geological evolutionary cycles of the earth. The social and political revolution is therefore presented as the counterpart to the process of the natural evolution of the earth.

The theme of the political and revolutionary transformation of the ownership of land is introduced by Rivera in two panels at either side of the chapel entrance. On the left is a didactic panel entitled *The Agitator*, while on the right is a moving image entitled *The Blood of the Revolutionary Martyrs Fertilizing the Earth* depicting the two martyred heroes of the agrarian revolution, Zapata and Montaño. The juxtaposition within the second panel of Zapata and Montaño's death with the abundant harvest of maize that

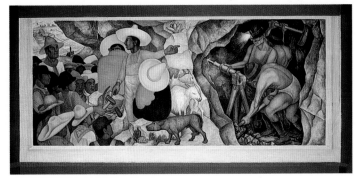

70 *top*
Diego Rivera: *The Blood of the Revolutionary Martyrs Fertilizing the Earth*. Fresco, 1926. Chapel, east wall, Autonomous University of Chapingo, Mexico.

71 & 72 *above and overleaf*
Diego Rivera: *The Agitator*. Fresco, 1926. Chapel, west wall, Autonomous University of Chapingo, Mexico.

THE MURALS OF THE 1920S

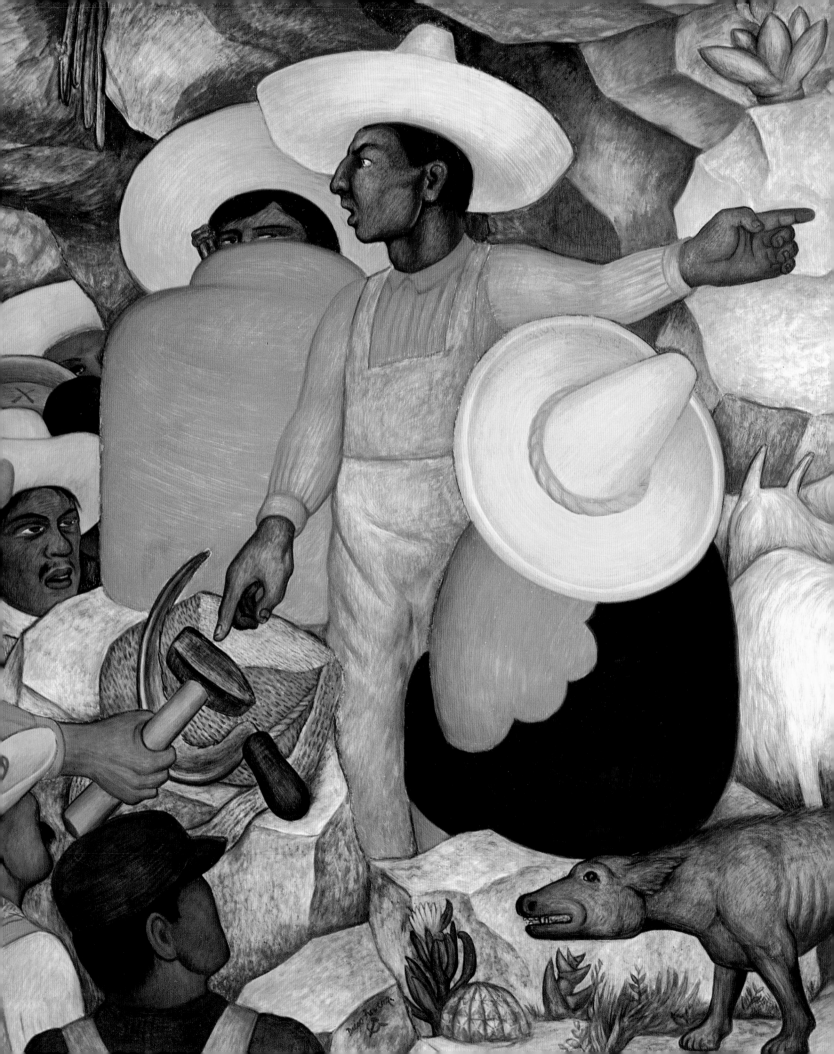

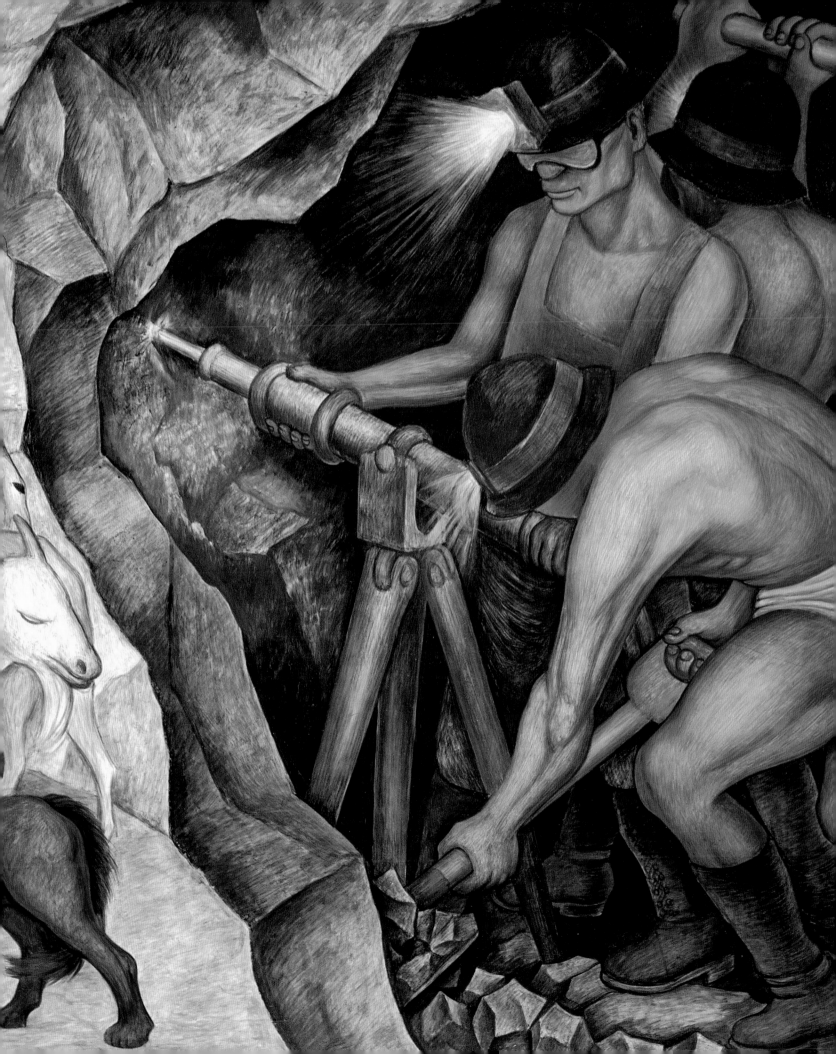

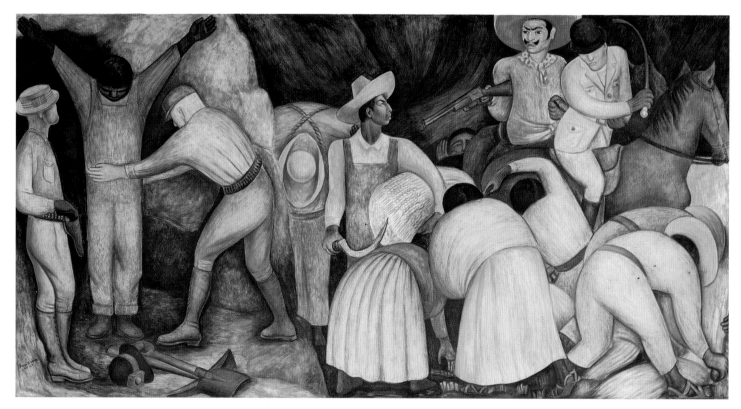

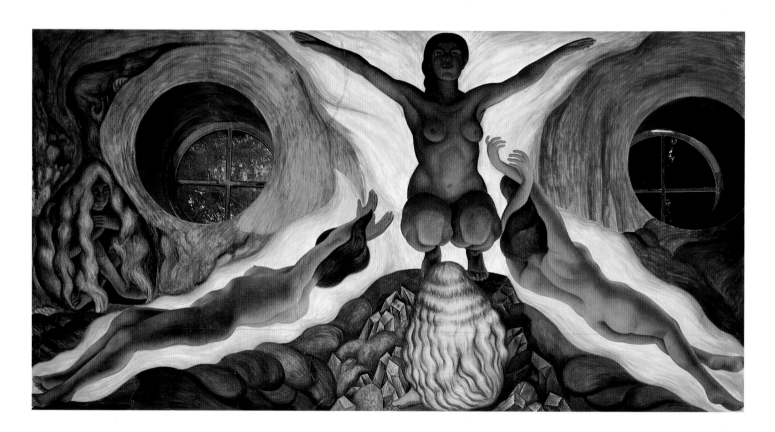

MEXICAN MURALISTS

73 *opposite top*
Diego Rivera: *The Exploiters*. Fresco,
1926. Chapel, west wall,
Autonomous University of
Chapingo, Mexico.

74 *opposite bottom*
Diego Rivera: *Subterranean Forces*.
Fresco, 1926. Chapel, east wall,
Autonomous University of
Chapingo, Mexico.

75 *below*
Diego Rivera: *The Earth Enslaved*.
Fresco, 1926. Chapel, upper west
wall, Autonomous University of
Chapingo, Mexico.

76 *above*
Diego Rivera: *The Flowering*. Fresco,
1926. Chapel, east wall,
Autonomous University of
Chapingo, Mexico.

77 *below*
Diego Rivera: *Germination*. Fresco,
1926. Chapel, east wall,
Autonomous University of
Chapingo, Mexico.

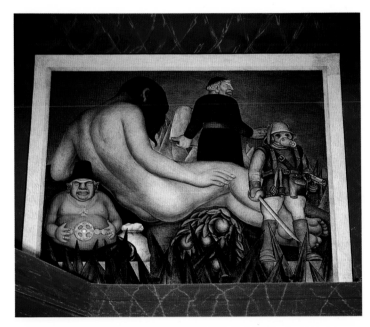

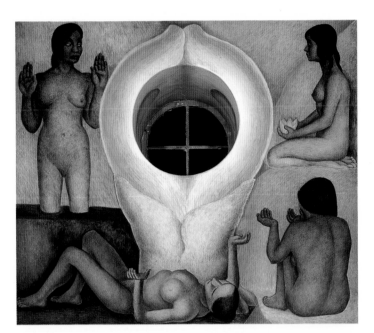

grows above them introduces the dualities of life and death and
of social revolution and natural evolution, both of which are at
the heart of the cycle in the rest of the chapel.

Within the main body of the chapel the duality begins with a
theme of Biblical chaos. The panel of *The Exploiters* on the left-
hand side, and that directly above it, *The Earth Enslaved*, depict the
land and the worker in the grip of vicious dictators and greedy
landlords. In the upper panel Rivera ingeniously suggests that
the image of the seated nude is a representation of the Mexican
nation, for her body outline closely resembles that of Mexico
itself. She is depicted surrounded by tormentors, represented by
three grotesque figures symbolizing the church, the army and
capitalism.[58] On the opposite side of the aisle, the theme of
natural evolution begins with the panel *Subterranean Forces* in
which anthropomorphic female figures swim up through the
chaos of the earth's fire.

Further along the aisle, the two panels of *Germination* and *The
Flowering* are mirrored on the opposite wall by those of *The
Formation of the Revolutionary Leadership* and *The Blood of the
Martyrs*. Here Rivera returns to his theme of sacrifice (death) for
the revolution, this time expressing it as a process of perpetual
contribution and renewal. As in his panel *Burial of a Revolutionary*

79 *top left*
Diego Rivera: *The Organization of the Agrarian Movement*. Fresco, 1926. Chapel, west wall, Autonomous University of Chapingo, Mexico.

80 *bottom left*
Diego Rivera: *The Abundant Earth*. Fresco, 1926, Chapel, east wall, Autonomous University of Chapingo, Mexico.

81 *top right*
Diego Rivera: *Triumph of the Revolution*. Fresco, 1926, Chapel, west wall, Autonomous University of Chapingo, Mexico.

78 & 82 *opposite and bottom right*
Diego Rivera: *Revolution – Germination*. Fresco, 1926. Chapel, west wall, Autonomous University of Chapingo, Mexico.

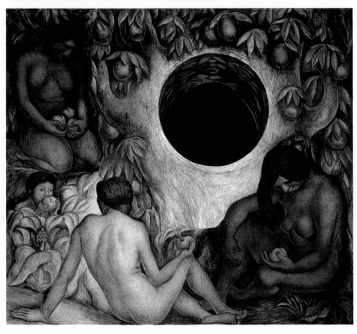

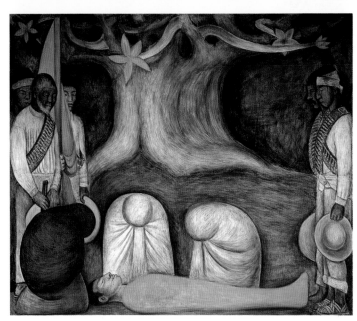

THE MURALS OF THE 1920S

83
Diego Rivera: *Revelation of the Way*.
Fresco, 1926. Chapel, ceiling bay,
Autonomous University of
Chapingo, Mexico.

84 *below*
Diego Rivera: *The Land's Bounty
Rightfully Possessed*. Fresco, 1926.
Chapel, ceiling bay, Autonomous
University of Chapingo, Mexico.

85 *opposite*
Diego Rivera: *The Liberated Earth
with the Natural Forces Controlled by
Man*. Fresco, 1926. Chapel, north
wall, Autonomous University of
Chapingo, Mexico.

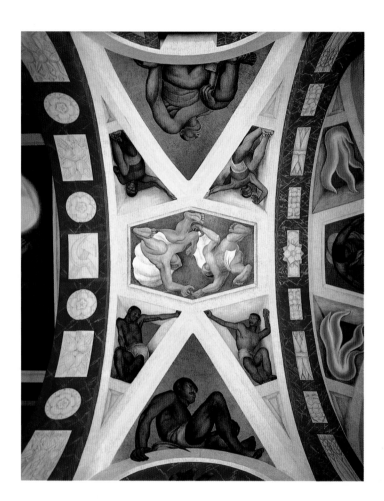

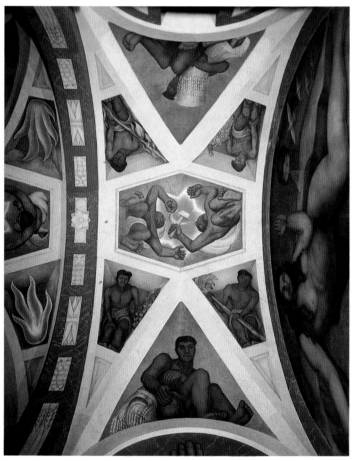

on the stairwell of the Labour Courtyard, Rivera made a pictorial reference to Italian renaissance painting, specifically in this instance to a panel in Giotto's fresco cycle in the Arena Chapel in Padua.

Leading on from *The Blood of the Martyrs*, Rivera concluded the left-hand side of the chapel with the panel *Triumph of the Revolution*. In an image which refers to the sacraments, Rivera pictured the trinity of revolution: the soldier, the peasant and the worker, each giving to and consuming with their families the full fruits of their labour, born out of the struggle of the revolution. Opposite this image of revolutionary fulfillment an abundant harvest is depicted in the panel *Fruits in Season*.

The Liberated Earth with the Natural Forces Controlled by Man

painted on the huge altar wall of the chapel stands as a glorious conclusion to the portrayal of revolutionary transformation and natural evolution. Painted after Rivera's wife Guadalupe Marín, who was then pregnant with their first child, the monumental and voluptuous nude reclines, representing the fertile earth. Attending her are the forces of nature, fire, wind and water. Water is represented by a woman who sits in front of a giant hydro-electric tube which enters the labia of the earth in a symbolic act of penetration.

Panels in the vaulted ceiling complement the ones below with images of men clutching hammers and sickles and sheaves of corn emphasizing the idea of the socialized transformation of the land. High up in a large arched panel directly opposite the altar

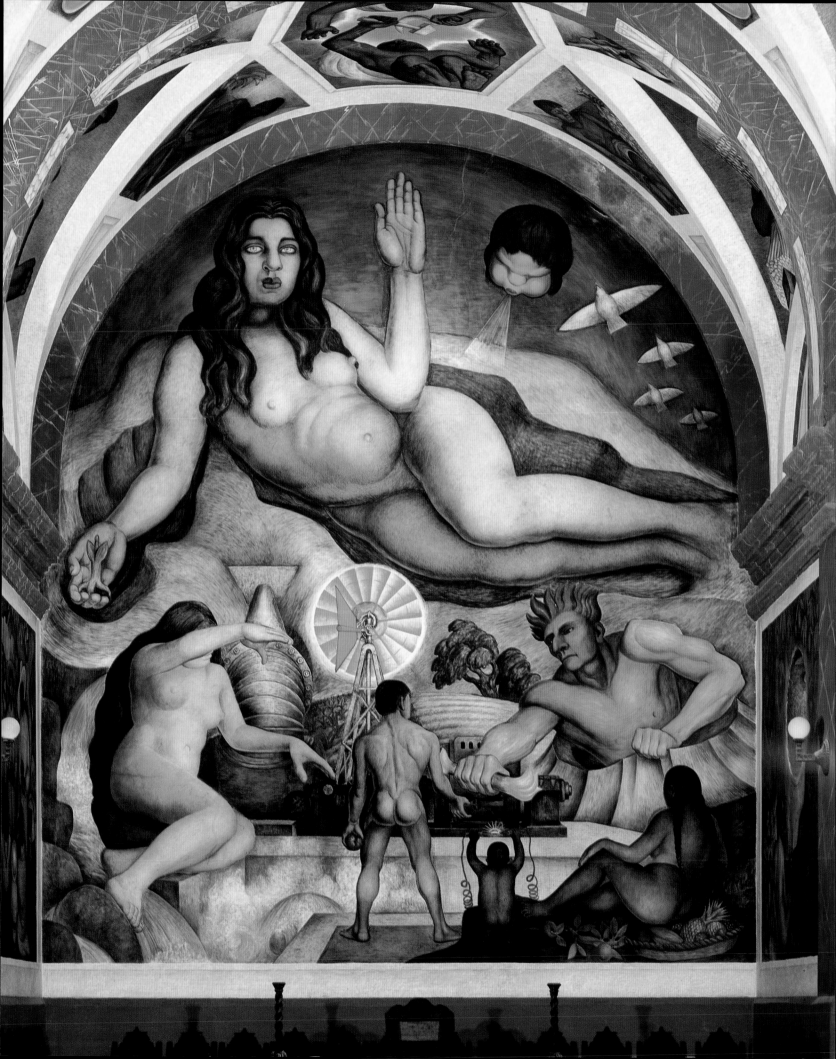

80

wall the fertility of the land is symbolized by the beautiful and erotic image of a female nude. Entitled *The Virgin Earth*, she shields a young cactus in her open palm.[59]

Like Siqueiros' and de la Cuevas' collaborative work in Guadalajara, Rivera extended this cycle to include the carving of the wooden doors to the building. An interesting parallel can be drawn between the doors of the Extemplo de la Universidad in Guadalajara and those at Chapingo. Although the styles are quite different, both are attempts to extend by way of three dimensionality the painted themes inside into an integration of painting, sculpture, and architecture. The three-dimensional work at Chapingo extended to the interior of the chapel, where the benches, altar table and accompanying chairs were carved with revolutionary emblems echoing those painted in the ceiling area above.

The chapel of Chapingo represents one of Rivera's outstanding achievements. As a poetic narrative of revolutionary impulse and national texture, it has few equals, either within Rivera's own mural work or within the work of Orozco and Siqueiros. Rivera created a pictorial synthesis in which he fused into a visual poem an awareness of his country's agrarian revolution and that of its long and deeply rooted agrarian culture. The sentiments that permeate this secular work reflect the religious and spiritual traditions of the Mexican people. The influence of Italian renaissance painting that pervades so many of the images points not only to Rivera's artistic sources but also indicates the presence of European Christian culture in Mexican history. Simultaneously, Rivera's use of symbolic figures, for instance in the panels *Subterranean Forces* and *Germination*, is rooted in the use of similar figures in pre-Columbian cultures. Despite these references, the work at Chapingo is unmistakably contemporary. Its subject is the revolutionary struggle of the present to right the injustices of the past, and the chapel is '. . . the first of the great works of art born of socialist and agrarian materialism'.[60]

Together with the frescoes at the Ministry of Education, the cycle at Chapingo represents the earliest definition of the general characteristics of the Mexican mural movement during the 1920s. Beside these works, the murals painted by Rivera at the Ministry of Health in Mexico City in late 1928, based on images

of nudes symbolizing *Life*, *Health*, *Fortitude*, *Knowledge*, *Purity* and *Conscience*, represent only an interlude before he turned his attention to his next great epic of Mexican history and his grandiloquent visions of the industrial and technological modernity of North America.

The conclusion of Rivera's work at Chapingo and the Ministry of Education, together with the murals that Orozco and Siqueiros had painted, marked the end of the first stage of Mexico's mural renaissance. Under the auspices of Vasconcelos it had started at the beginning of the decade with a blaze of impassioned idealism but only a hesitant grasp of its pictorial, ideological, cultural and aesthetic agenda. During the 1920s social and political developments in Mexico formed the basis on which the painters evolved a public art, with images that were more emphatically drawn from the deep well of national idealism and experience than their first hesitant works had ever been able to reflect. The themes of revolution, the land and the cultural traditions of the people emerged in the murals of Rivera, Orozco and Siqueiros. The work created by the three painters during the following decades would be fundamentally different from these populist beginnings.

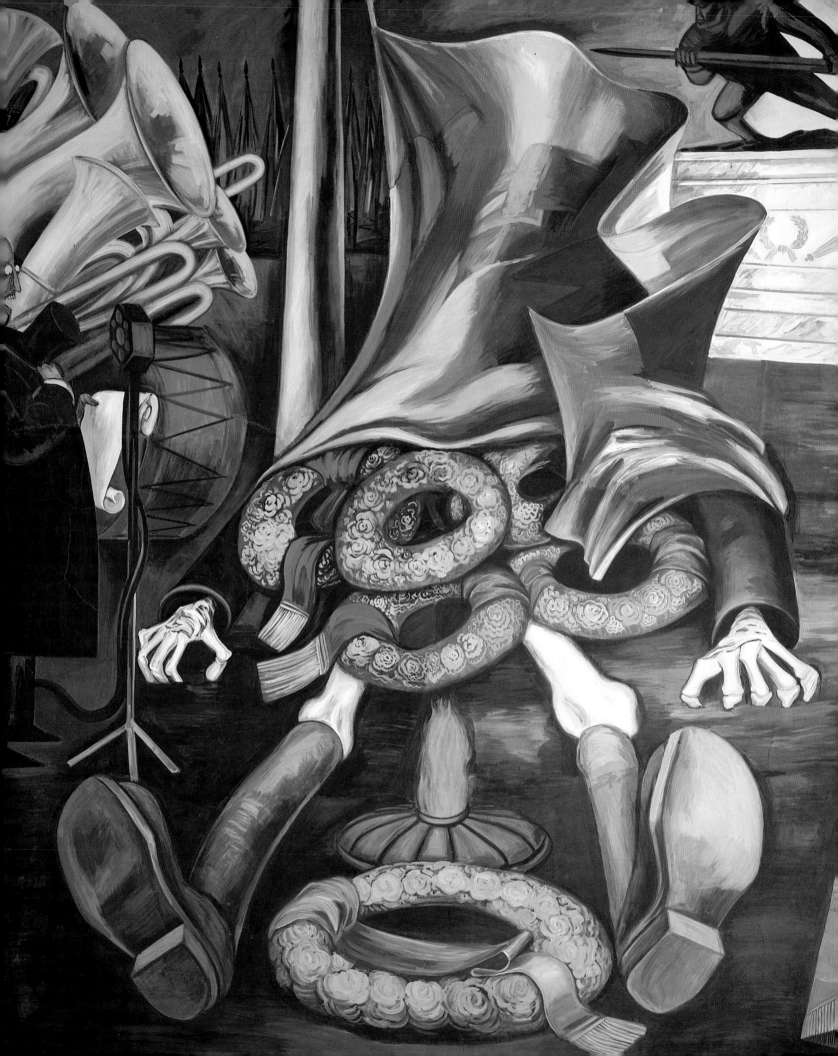

José Clemente Orozco: *American
Civilization – Modern Human Sacrifice*
(detail). Fresco, 1932. Post-
Cortesian section, Baker Library,
Dartmouth College, New
Hampshire.

FOUR

RIVERA AND OROZCO IN THE 1930s

RE-ENVISIONING NATIONHOOD

'The claim to a national culture in the past does not only rehabilitate that nation and serve as a justification for the hope of a future national culture. In the sphere of psychoeffective equilibrium it is responsible for an important change in the native. . . . colonialism is not simply content to impose its rule upon the present and the future of a dominated country. By a kind of perverted logic it turns to the past of the oppressed people, and distorts, disfigures and destroys it.'

Frantz Fanon: *The Wretched of the Earth*

Mexican muralism in the 1920s was characterized by attempts to create an image of the people as they emerged from the turmoil of the revolution. Metaphysical beginnings had been superseded by the realities of populist experiences and concerns, which formed the dominant imagery in the murals of Rivera, Orozco and Siqueiros by the mid-1920s.

By the end of that decade, the national cultural focus began to shift from the local and immediate concerns of the revolution towards an interrogation of the national past, a redefining of the nation's identity in the aftermath of its independence and national revolution. The re-envisioning of the country's sense of itself through a vision of its epic historical experience formed the basis for the visual exploration of Mexican national identity. Simultaneously, the industrialized and technological modernity of the nearby United States of America was in turn used by the painters to confront and question the contemporary world beyond Mexico. Mexico and the United States were the arenas in which all three painters found themselves during the 1930s, and both countries provided stimuli for the creation of some of their most significant works.

The political dynamics governing the formation of the new nation state at the end of the 1920s led to a reassessment of Mexico's history throughout the following decade. The ideological discourse underlying this process, which pre-dated the revolution, formed the basis for a fresh national and cultural identity for Mexico.

In 1925, after stepping down as Minister of Education, Vasconcelos published a book entitled *La Raza Cósmica* (The Cosmic Race). In it, he argued that the *mestizo* represented the true essence of Mexican nationality. He went on to argue that because of their fusion of pre-Columbian and European ancestry, the *mestizos* would become the chosen race of the future, the fifth great race of humanity, a final synthesis distilled from all the great races that had gone before them.[1] By putting forward such theories on the nature of Mexican identity, Vasconcelos and his theoretical predecessors helped to legitimize the political and ideological framework within which the *mestizo* was seen as embodying national consciousness.

The dynamics of political power in Mexico at the end of the 1920s were such that the contending forces of the revolution were beginning to coalesce. Political authority and power

became centralized in the form of the *Partido Revolucionario Institucional*, which began to rule and organize on a national scale.[2] For many Mexicans, the creation of the PRI, as it is known, coincided with the point at which it became possible to view their nation not so much as a simple geographical context in which revolutionary struggle and bloodshed seemed the only reality, but as a country with a past, a present and a future.

For all factions within the Mexican state at the time, the acknowledgment of this comprised the basis on which a defence of the country against the disruptive incursions of modern imperialism could be forged and a definition of nationhood created. The defence of nationhood was highly significant for the radical left, as they saw it as a protection of what they considered to be one of the central planks of the 1910 National Democratic Revolution. For the others who had forged the new state after the revolution – the *mestizo* middle class, the *rancheros* and the remnants of the old pre-revolutionary élites – such a defence was necessary in order to protect the base on which they could consolidate their own political and financial interests within a highly centralized state, free from the interference of external influences such as the United States.

During the 1930s, against the backdrop of this political dynamic, Diego Rivera and José Clemente Orozco created a series of epic mural cycles on the theme of Mexican history. The central characteristic of these cycles is not a simplistic nationalist promotion of a preconceived Mexican national identity, but a re-appropriation and reassembly of the nation's past into a usable history. The public discourse of these epic cycles provided the opportunity to explore and promote the layers of different national meaning derived from a past fashioned out of the domination and absorption of an indigenous peoples and their culture by Europeans. Such meanings were often conflicting and contradictory, expressed in ways both utopian and tragic. Nevertheless, the visual image of a modern Mexican cultural identity emerged for the first time in these murals.

Two of the four mural cycles created during the 1930s dealing with the epic of Mexican history were painted by Rivera and two by Orozco. Rivera's involvement with his two great cycles on the history of Mexico began in 1929. Following the completion of his frescoes in the Ministry of Education, he was commissioned first

by the Mexican government to paint a history of Mexico on the main stairway of the National Palace, and then by the American Ambassador to Mexico, Dwight Morrow, to paint a mural on a similar theme in the Cortez Palace in Cuernavaca.[3]

The highly prestigious locations of both these commissions, one in the seat of national government, and the other in the very building that Cortez had built for himself following the defeat of Cuernavaca, signalled the real beginnings of the institutionalization of the Mexican mural movement. Throughout the 1920s, many murals, particularly those of Rivera, had been imbued with the pictorial rhetoric of leftist politics. Indeed, Rivera's particular achievement during those years had been to create a visual image of a revolutionary and popular culture, which previously had existed in Mexico only in the realm of memory or in the broadsheets, *ex-voto* church paintings or working men's *pulqueria* drinking houses. Rivera had carefully crafted a popular vocabulary of social images and themes drawn from these sources to appeal to a public that extended beyond the confines of the country's bourgeoisie, with its narrowly exclusive literary culture. As a result, he managed to create a foundation on which to convey to this much wider audience the sense of continuity with a forgotten past and a feeling of participation in a historical process that had been largely ignored in the history of the country's colonial experience.

By the end of the decade, the political nationalists who dominated the Mexican state in the newly constituted ruling party began to sense in the public murals of Rivera a means of substantiating culturally their own role in Mexico's revolutionary development. Murals commissioned or encouraged by the state and its institutions could reflect an interpretation of Mexican history in which their own role could be made to appear highly significant. The ground was thus laid for the development of an officially sanctioned nationalist vision of Mexico's rebirth from the tragic consequences of its past.

Nowhere was the dual process of cultural institutionalization and emergent national identity more keenly articulated than in Rivera's mural *The History of Mexico*, begun in 1929. Commissioned by the central government, at a time when Rivera's reputation in Mexico as well as abroad was reaching its peak, the fresco was also the first of the murals to place the Mexican

89
Diego Rivera: *The History of Mexico*.
Fresco, 1929–35. National Palace,
Mexico City.

revolution within some kind of historical perspective. In so doing, it presented for the first time a history that could in some senses be recognized from within a framework of shared national experiences and values. In particular, it set out to present judgments on past events in national history.

The mural was monumental in scale and painted on three adjoining walls in the National Palace, overlooking the imposing colonial building's main staircase.[4] Rivera subdivided the overall theme in relation to the architectural disposition of the walls. The largest of the three walls, the central one, displays the part of Mexican history that Rivera regarded as more widely and objectively known, namely the period from the Spanish conquest of Mexico in 1519 until up to and including the revolution. On the two adjoining walls, Rivera painted other periods of Mexican history. On the right, he depicted the pre-Columbian world, while on the left he painted a panorama of modern-day Mexico as he saw it. Physically, the two side walls act as thematic prologue and epilogue to the main historical drama of the dominating centre wall.

Rivera's utopian social vision is evident on the right-hand wall, depicting the world of pre-Columbian Mexico. The legendary god-king of the pre-Hispanic world, Quetzalcoatl, creator of culture, civilization and learning, sits serenely amidst his subjects.[5] Images of crop cultivation and the carving of stone sculptures surround him, symbolizing indigenous culture and civilization. Rivera also included another view of this indigenous world, one characterized by conflict and slavery: the human sacrifice to the gods. An Aztec priest is seen brandishing an obsidian dagger, while in another area Indians are locked into the combat of inter-tribal conflict. Yet Rivera's depiction of this unattractive face of the pre-Columbian world is strangely mute. Rivera expressed the legendary myth and superstition that permeated this civilization and which contributed to its downfall only in incarnations of Quetzalcoatl, in forms other than his human one.[6] In the upper background he appears as a feathered serpent rising out of a volcano in tongues of flames, while to the right he appears riding the serpent boat in which he left the Indian world, expelled by the very Indians to whom he had brought civilization and learning. In Rivera's hands, pre-Columbian myth and superstition form a strange world in which culture and conflict, agriculture and slavery are treated with equal importance, assuming no rank or hierarchy. Unlike Orozco, Rivera chose to suspend all sense of judgment in the face of such a reality. The ethics of a European culture, brutally imposed on this ancient world by the Spanish, cannot seemingly be applied to or be part of this existence, so unrelated was it to the make-up and social values of the European culture that usurped it. Rivera instead chose to present the components of a reality unhindered by the trappings of contemporary moral or political assertion. It is a golden age. Only a hint of its demise, resulting from overburdening superstition, internal dissension and disintegration, is expressed.[7] When the disintegration and

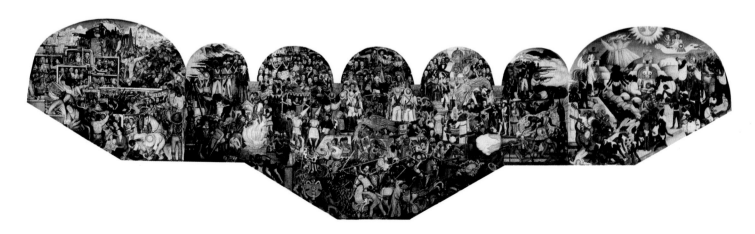

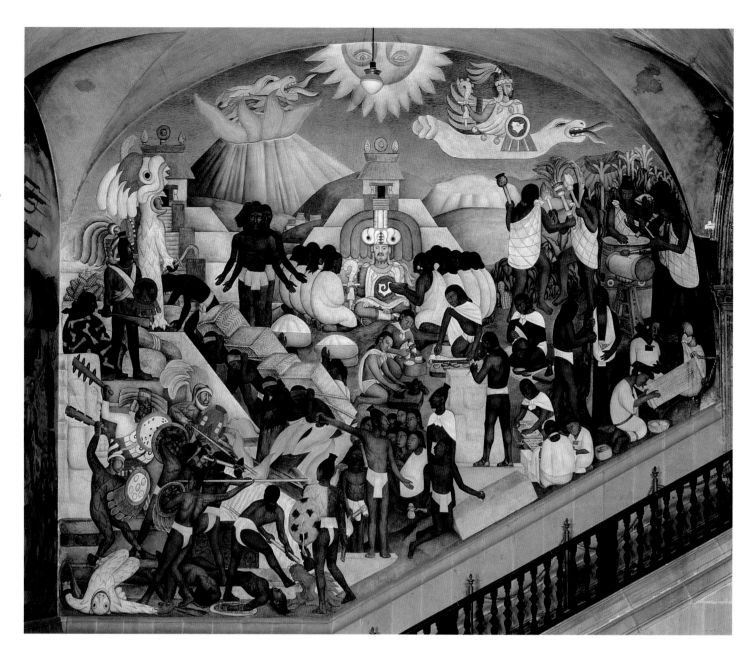

MEXICAN MURALISTS

90
Diego Rivera: *The History of Mexico –
The Ancient Indian World*. Fresco,
1929–35. North wall, National
Palace, Mexico City.

91
Diego Rivera: *The History of Mexico*.
Fresco, 1929–35. West wall, detail
of central arch, National Palace,
Mexico City.

subjugation eventually arrives, conversely it is seen as being imposed, both metaphorically and literally, from outside. For, against the evidence of history, the disintegration of the Indian world is shown, in the adjacent central wall, as being exclusively the result of the Spanish conquest.[8]

The history configured by Rivera on the central wall is a two-dimensional one, shorn of many of the complexities of the historical transformation of Mexico after the demise of the pre-Columbian world. Rivera starkly rendered the positive and negative aspects of his nation's history. He reduced the past to actions that conformed a heroic history and others that comprised one of betrayal and oppression. The images are cast as invitations to the spectator to pass judgment upon events in Mexican history. Rivera depicted the good and the heroic as synonymous with the defence of Mexico from exterior violation; by contrast, the bad is unmistakably associated with invasion, subjugation and exploitation.

The compositional structure through which Rivera conveyed his complex narratives is the key to the mural's meaning. The ideological premise of the centre wall is that Mexican national revolutionary history arises out of the conquest. The surrounding narratives either mirror or resist the legacy of this foundation. The conquest is depicted centrally in the lower section of the mural, Rivera using the position of the image within the composition to reflect the role he had assigned to it in national history.

The images depicted on the central wall stretch across the whole of its length. The wall is crowned by five arches. Rivera placed a complex of figures identified with the centuries of struggle and resistance to colonial subjugation and dictatorship in an ascending chronology directly under the central arch. The placement of these symbols of resistance ensures their reading as the central core of Rivera's historical interpretation. At the very centre of the mural lies the Aztec symbol of an eagle with a serpent in its mouth. This is Rivera's symbolic national heart.

The chronology assembled in this central area begins at the bottom with the image of the Aztec prince Cuauhtemoc in combat with Cortez the conquistador.[9] This passage synthesizes the twin concepts of resistance and the heroic. Cuauhtemoc's

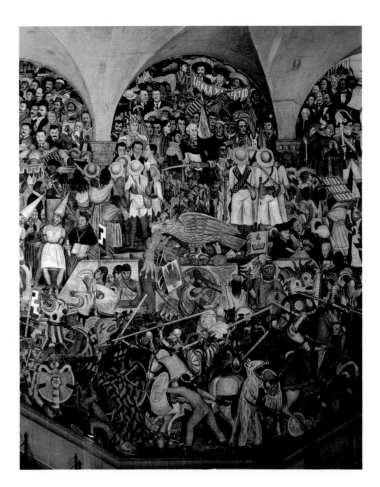

87

battle with Cortez and the invading conquistadors represents the first struggle against the outsider. The Aztec's portrayal also symbolizes disbelief in the myths and superstitions that mistakenly led Aztec priests to believe that Cortez represented the returning incarnation of their god Quetzalcoatl, a belief that in no small way facilitated the conquest of the Aztec kingdom.[10]

In the sequences above, Rivera isolated other significant moments of resistance and heroism in the prominent images of the priests Hidalgo and Morelos, the father figures of Mexican independence in the nineteenth century.[11] Above them, at the apex of the central arch and acting as a thematic and ideological 'crown' to the whole cycle are Obregón and Calles, the political leaders of the revolution and its aftermath. Carrillo Puerto, the

92
Diego Rivera: *The History of Mexico*.
Fresco, 1929–35. West wall, left
inner arch, National Palace, Mexico
City.

93 *below*
Diego Rivera: *The History of Mexico*.
Fresco, 1929–35. West wall, right
inner arch, National Palace, Mexico
City.

94 *opposite*
Diego Rivera: *The History of Mexico*.
Fresco, 1929–35. West wall, detail
of right inner arch, National Palace,
Mexico City.

88

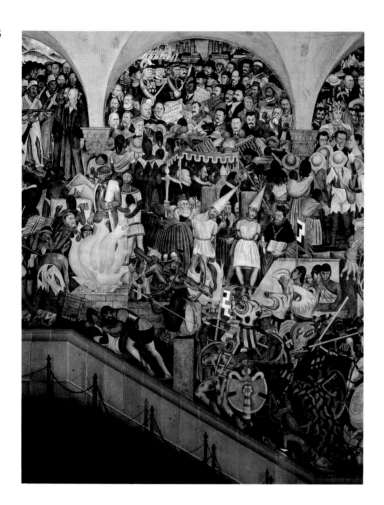

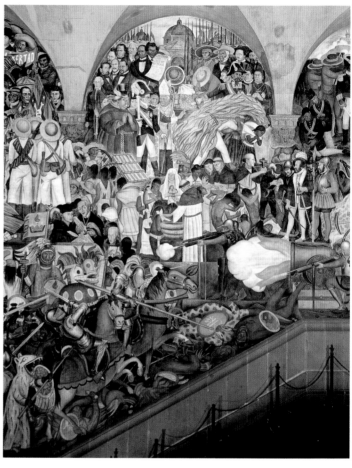

Indian socialist governor of Yucatán, Francisco Villa and Luis Cabrera, the assassinated communist agrarian leader, are also portrayed, standing behind the famous standard of the revolution, with its words of *Tierra y Libertad* (land and freedom) symbolizing the spirit of the agrarian revolt of the peasantry.

The secondary vertical tiers of the composition are located under the two arches on either side of the centre, and contain scenes representing the positive and negative aspects of the great political struggles of the nineteenth and early twentieth centuries. On the right, the period of *La Reforma* is represented with the prominent display of Benito Juárez, Mexico's first Indian president, whose liberally democratic regime foreshadowed many of the policies and aims of the 1910 revolution. In contrast,

the regime of Porfirio Díaz is shown under the arch to the left of the centre. Protagonists to the confrontation of Díaz, figures such as Zapata, Otilio Montaño, Carranza, Vasconcelos and others, are set against a backdrop at the top of the arch containing imagery of oil drilling rigs. The rigs form an ambivalent setting, symbolizing the modernity that Porfirio Díaz sought during his dictatorship, the annexation of that modernity by foreign powers against which in part the revolution fought, and the idea of the modern epoch, which the revolution itself heralded. Careful scrutiny of these two areas of the mural reveals an important continuity of the positive and negative theme. Moving upwards through the tiers of the right inner arch, Rivera intended a link to be drawn between the arrival of the

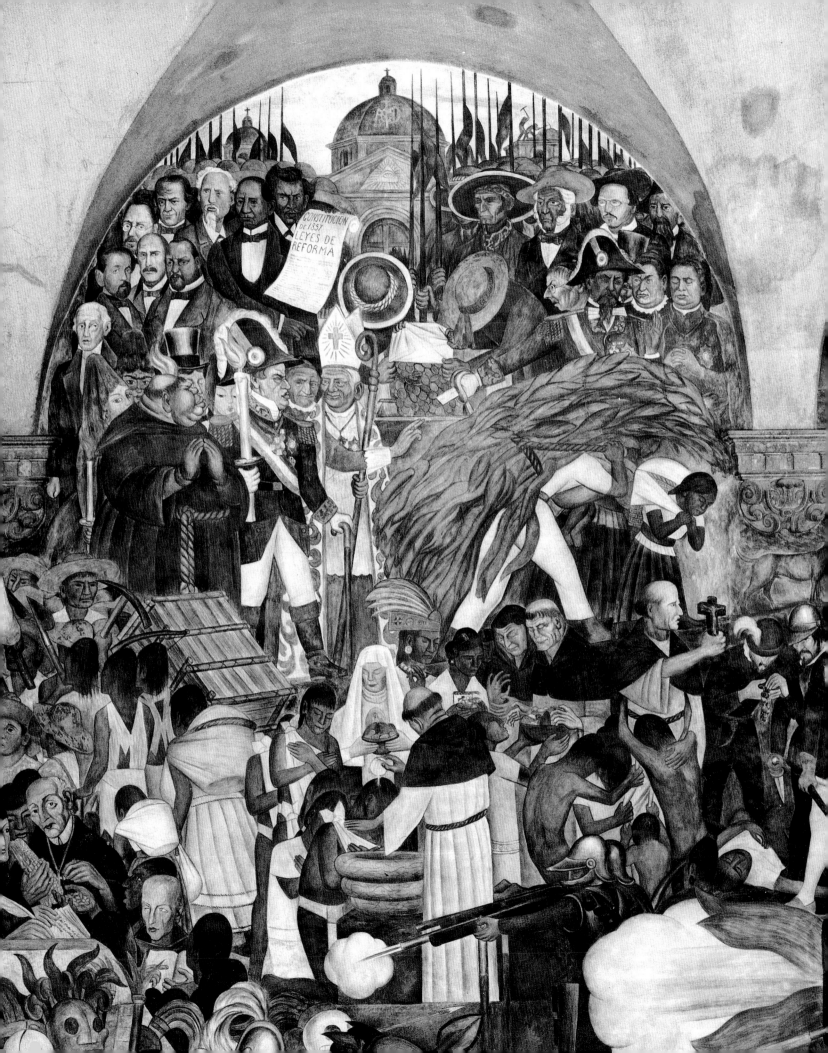

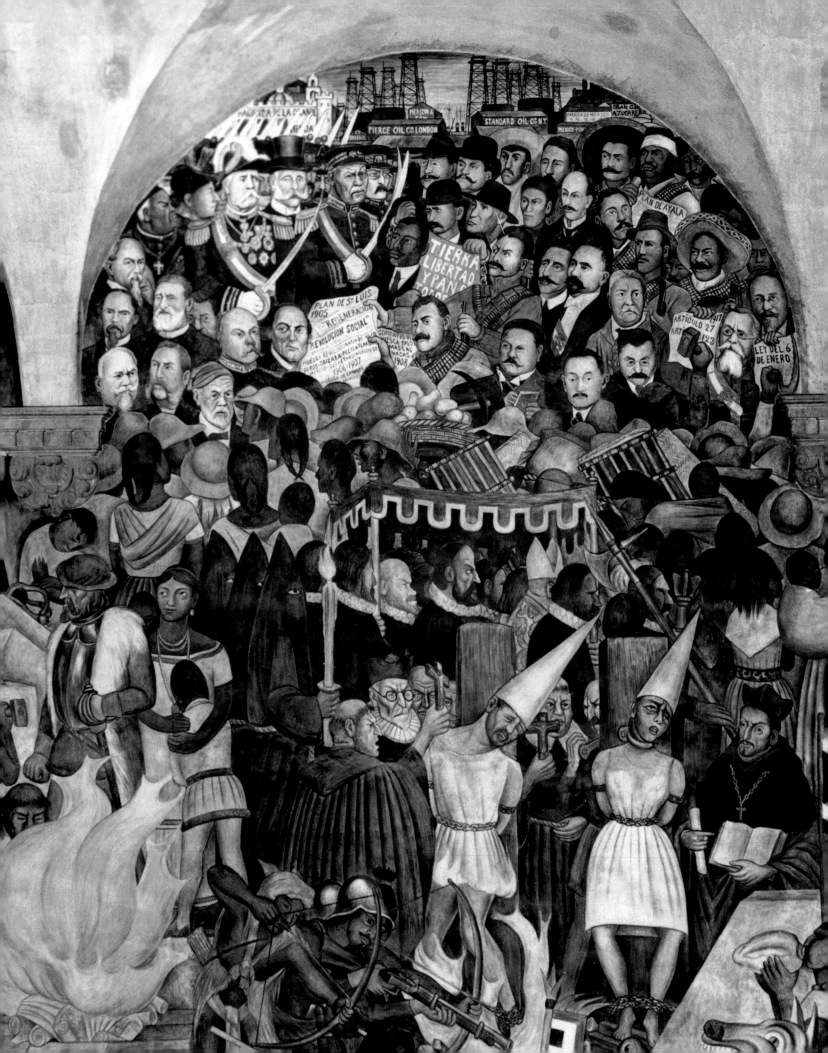

95 *opposite*
Diego Rivera: *The History of Mexico*.
Fresco, 1929–35. West wall, detail
of left inner arch, National Palace,
Mexico City.

96
Diego Rivera: *The History of Mexico*.
Fresco, 1929–35. West wall, left
outer arch, National Palace, Mexico
City.

97
Diego Rivera: *The History of Mexico*.
Fresco, 1929–35. West wall, right
outer arch, National Palace, Mexico
City.

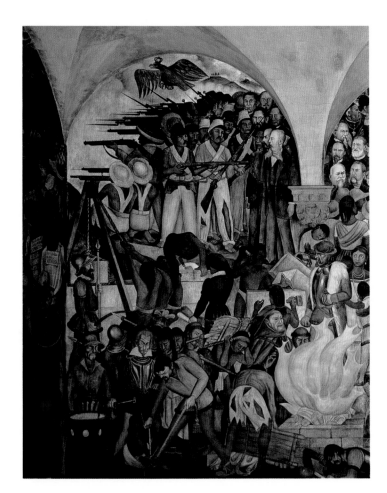

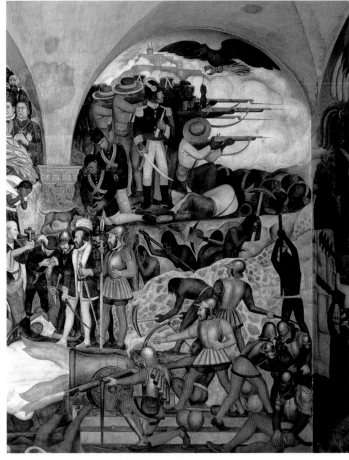

Franciscans during the conquest and the inheritance of their influence in the guise of the liberal Benito Juárez. Likewise, under the left inner arch, the equation between the conquest, the spiritual terror of the inquisition and the dictatorship of Porfirio Díaz is unmistakable.

Much of the intended reading of the narratives in the mural is determined by what Rivera chose to portray along the bottom and outer edges of the wall. Here he depicted the invasions and violations experienced by Mexico from the conquest to the revolution. The image of the conquest runs from right to left in a vast assemblage of interlocking scenes along the entire length of the lower section of the wall, symbolizing the political and social foundations from which arises the modern Mexican history

depicted above. In these images, Rivera expresses the conquest not merely as an armed incursion, but as a process of total cultural, physical and spiritual subjugation and transformation. The introduction of Catholicism depicted on the right-hand side transforms the superstitious spirituality of the Indians and their nature gods, while on the left, the cruel arm of this religious conversion is pictured in images of the Spanish Inquisition, juxtaposed with images of the branding and slavery of Indians.

Rivera continued the theme of external violation under the outer arches of both the right- and left-hand sides of the central wall. Scenes of foreign domination and invasion are pictured. On the right, the Mexican-American war of 1847, during which Mexico was occupied by the United States, is shown, while on

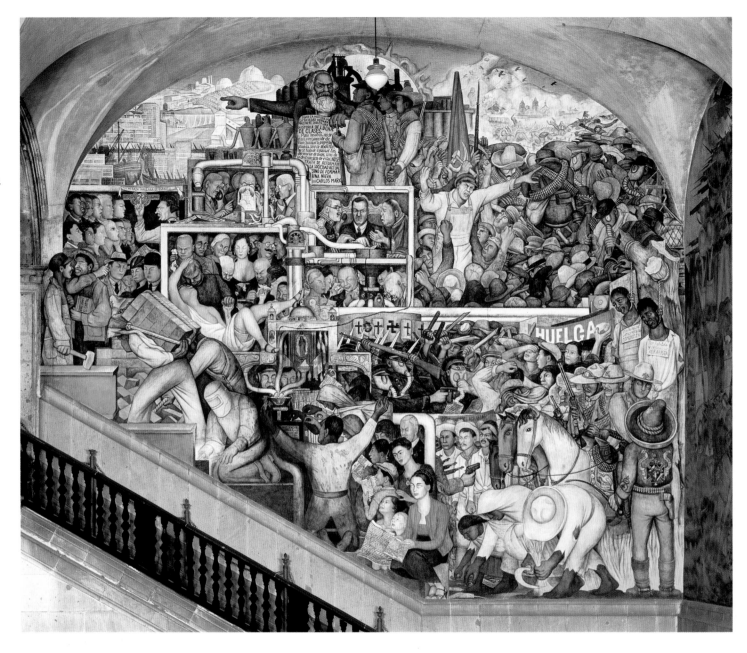

the left the French occupation of Mexico in 1861 and the rule of the puppet Austrian emperor Maximilian are portrayed.[12]

Together with the images of the conquest, these outer flanking scenes precondition the idea of the heroic tradition of resistance portrayed at the core of the mural. Rivera shows the struggle taking place in a country whose people have been totally and irrevocably transformed by three centuries of colonial rule. His epic configuration of Mexican national history is thus primarily about the heroic struggle to rid the nation of the shackles of colonial legacy. In the aftermath of the revolution, these struggles became the catalyst for the spiritual endeavour to 'excavate' parts of the pre-colonial and indigenous roots from which the new nation was derived.

As with much history painting, Rivera's mural renders into the realm of myth every event and every personage connected to the nation's history. He promulgated the idea of the hero, a noble and untarnished being, in whose name politics are created, causes followed and around whom history is configured into meaningful constructions. Like all heroic constructions of history, the reality often conspires to disrupt the heroic expression, stripping it of its lustre. In Rivera's hands, the heroic conclusion to this massive central panel is negated by the realities of the revolution and its aftermath. The political context in which Rivera painted this mural was one characterized by greed, corruption and oppression. The influence of the former Mexican leader, Plutarco Calles, on Mexican political life had transformed

98 *opposite*
Diego Rivera: *The History of Mexico –
The World of Today and Tomorrow.*
Fresco, 1929–35. South wall,
National Palace, Mexico City.

99
Diego Rivera painting the west wall
of *The History of Mexico – Mexico
Today and Tomorrow,* 1935.

93

Rivera's portrayal of Marx sustains itself by suggesting the communist ideal as the final act in this national struggle, concluding the historical transformation of Mexico. But just as he had done with his portrayal of Quetzalcoatl on the opposite wall, here too Rivera was forced to depict Marx and the world he proclaimed as a golden age to which Mexico would return, mirroring Quetzalcoatl's idyllic world. As with the great Aztec kingdom, the Marxist domain lay beyond any real experience to which Rivera could be a witness. He could therefore do nothing but paint it as a utopia.

Rivera's creation of a visual mythology of post-revolutionary Mexican nationalist politics remains his most questionable, as well as his most significant, cultural contribution. More than any other of the great public murals in Mexico, the National Palace mural represents a synthesis of Mexican nationalist politics and the post-colonial cultural renaissance that sustained them ideologically. It is a work that echoes the thrust of nationalist assertions and definition based on the concept of the *mestizo*, and has become the artistic reflection of what Rodríguez has described as the birth of 'a new society, later to become the Mestizo of our times'.[13]

Rivera's other mural on Mexican history, commissioned by the American Ambassador to Mexico, Dwight Morrow, for the Cortez Palace in Cuernavaca was begun shortly after he had started work on the cycle in the National Palace. The acceptance of this commission, like that of the other, was steeped in controversy and political irony. In 1928 Morrow, the American capitalist, had persuaded the Mexican president, Plutarco Calles, to amend informally legislation affecting Mexican oil rights to favour the interests of American investors. He was now commissioning the world's most celebrated Marxist painter of nationalist, anti-imperialist murals.[14] However, the commissioning of the Cuernavaca mural was part of an exercise in American diplomacy: Morrow had recently taken up residence in the town of Cuernavaca, and the commission was a gesture of good will.[15]

Rivera's mural at Cuernavaca was considerably smaller than the one at the National Palace. Painted along three walls of an open corridor on the second floor of the palace, the chosen theme was *The History of Cuernavaca and Morelos.* Unlike the work at the National Palace, Rivera constructed his composition by

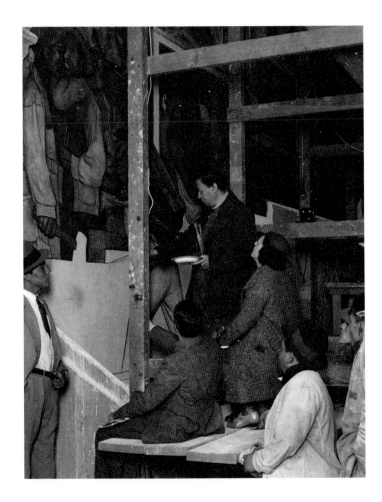

the radical and heady days of the early 1920s into a regime of power-seeking corruption. Rivera's configuration of a heroic national ancestry thus provided a convenient contemporary mythology which Mexican leaders then and now were and are able to claim as their inheritance. However, in the concluding left-hand panel, painted by Rivera in 1935 following his return from the United States, he portrayed the absorption of the Mexican working classes into Mexican history by including the image of Karl Marx and the Communist and Workers' Movement. The mythology of the mural is continued in this panel. By picturing the revolutionary struggles of the workers' movements together with the portrait of Karl Marx, Rivera presents contemporary political struggles as part of the national heritage.

100

Diego Rivera: *The History of Cuernavaca and Morelos*. General view along the corridor site in the Cortez Palace, Cuernavaca, Mexico.

102

Diego Rivera: *The History of Cuernavaca and Morelos – Crossing the Barranca*. Fresco, 1929–30. Detail, Cortez Palace, Cuernavaca, Mexico.

94

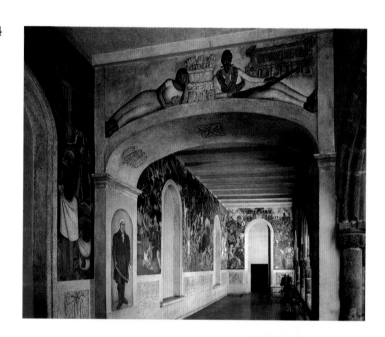

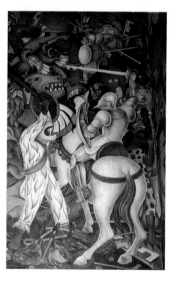

101

Diego Rivera: *The History of Cuernavaca and Morelos*. Fresco, 1929–30. Detail, Cortez Palace, Cuernavaca, Mexico.

means of a linear, horizontal sequence of images running from right to left. Using the story of Cuernavaca as a metaphor for the conquest of Mexico, Rivera portrayed the history of Mexico in a chronological sequence. The different divisions within the linear composition were dictated by the presence of arched niches interrupting the length of flat wall surfaces on which Rivera painted his fresco, and which he used to segment the narrative into sequences. The narrative begins on the right, around the entrance to the passageway. Rivera arranged the combatants at either side of the arched doorway. On the right, Spanish knights fire their guns at their Indian adversaries, who are pictured on both sides of the doorway. Rivera included the figure of Cuauhtemoc, portrayed in the same pose as at the National Palace. Above the doorway, Rivera depicted an Aztec pyramid temple, on the summit of which a human sacrifice is being performed, a gesture to the brutal realities of that time which he chose not to include in the National Palace mural. This section of the mural, which extends on to the long main wall, is one of the finest passages of painting in Rivera's murals. Its most striking quality is the extraordinary exuberance of colour, which highlights not only the decorative quality of the exotic clothing of the Aztec warriors, but also the icy grey-blue of the Spanish conquistadors' steel armour, emphasizing the technical dominance in warfare of Spanish invaders over their Indian adversaries. This contrast is vividly expressed in the large image of a Spanish knight on a white horse brandishing his sword at an Aztec warrior, who fights back with a barbed wooden club. The battle dress of the combatants covers their whole body, but whereas the mounted Spaniard is dressed entirely in steel, the Indian fights unshod and on foot; he wears a plumed pink costume with a birdhead mask. The exoticism of the Indian confronts the technologically superior European in a struggle between two very different cultures.

A striking feature of this first part of the fresco is the way in which Rivera uses pictorial sources and references to underscore the extent of cultural absorption that the act of conquest represented. His skilful incorporation of the influence of Italian renaissance compositional form represents an eloquent aesthetic metaphor for the conquest of Indian America by European renaissance man.[16]

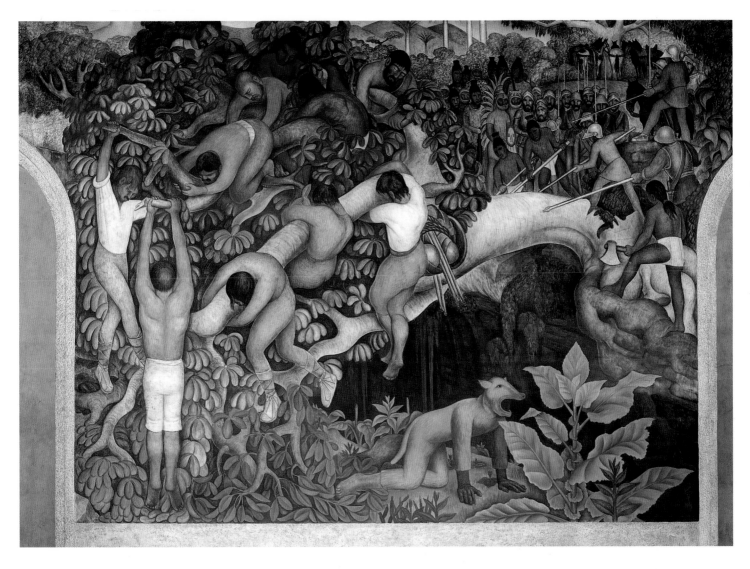

From the opening sequence, the narrative of the images moves leftwards along the main corridor walls. Initially, the scenes refer directly to the taking of the town and lands of Cuernavaca by the Spanish. This is followed by images depicting the construction of the Cortez Palace by the defeated Indians. From here, the narrative develops into a picture of the Indians as labourers and sugarcane cutters for the colonial state of Morelos. These three sequences give way to portrayals of the spiritual conversion of the Indian by the Catholic priests at the end of the cycle. The Catholic crusade to convert the Indians is seen as both gentle and forgiving, and cruel and despotic. Mirroring the Aztec sacrifice depicted in the opening sequences of the work, above the doorway at the end of the cycle Rivera portrayed the burning of heretics during the Spanish Inquisition, as well as the hanging and horsewhipping of Indians by their Spanish masters. The images represent the exchange of one culture's cruelty for that of another, but the final, imposing image of Zapata, accompanied by his white horse, symbolizes liberation from the colonial shackles of conquest, from landlordism and the restrictions of an imposed faith.

Running along the length of the Cuernavaca mural is a frieze-like grisaille. Like the great frescoes of the Italian renaissance, this grisaille contains monochromatic narrative imagery paralleling the theme above it, and is another example of Rivera's use of historical sources. Apart from the obvious reference of the grisaille to Italian renaissance painting, Rivera used the device as a support for his exhaustive study of the Sahagún Codex.[17] The Codex seems to have influenced Rivera to produce a faithful record of events and costumes of the time. The stylization of the Codex illustrations is visible not only in the grisaille panels, but also in some of the painted sequences in the main body of the fresco. The sequential and episodic treatment of this fresco underlines the influence of this source, and Rivera's attempt to narrate the story of Mexican history in these terms contrasts strongly with the overlapping narratives of the National Palace mural.

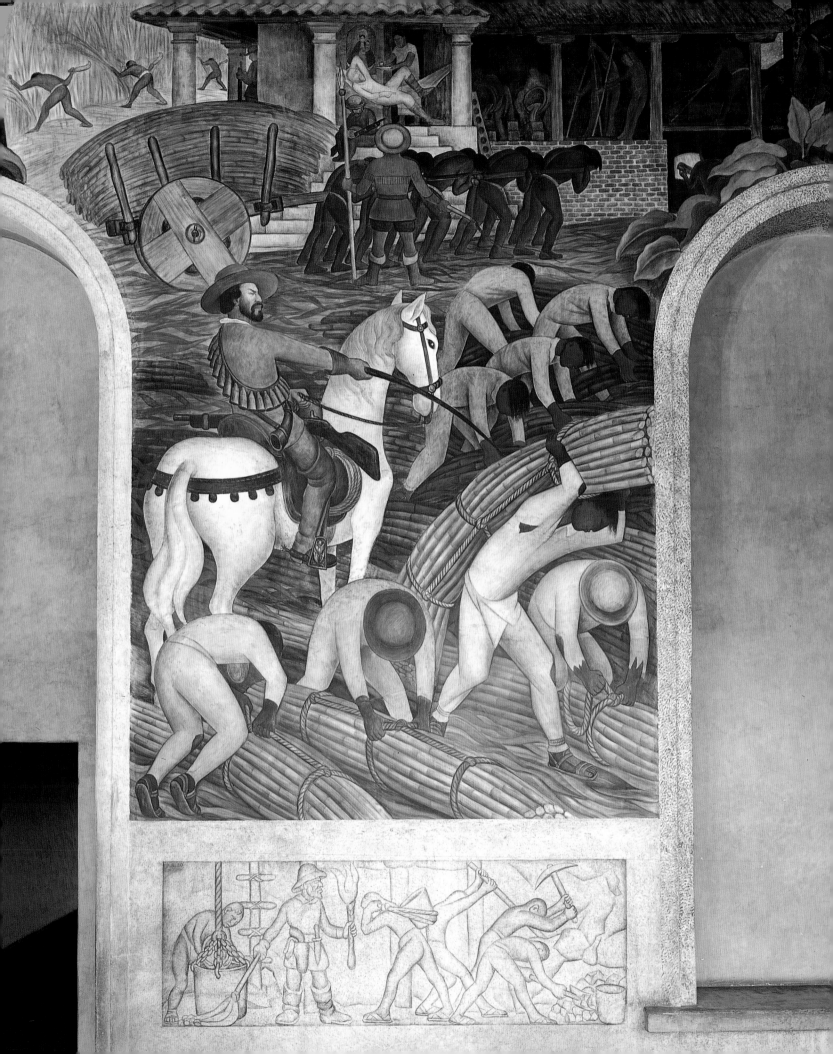

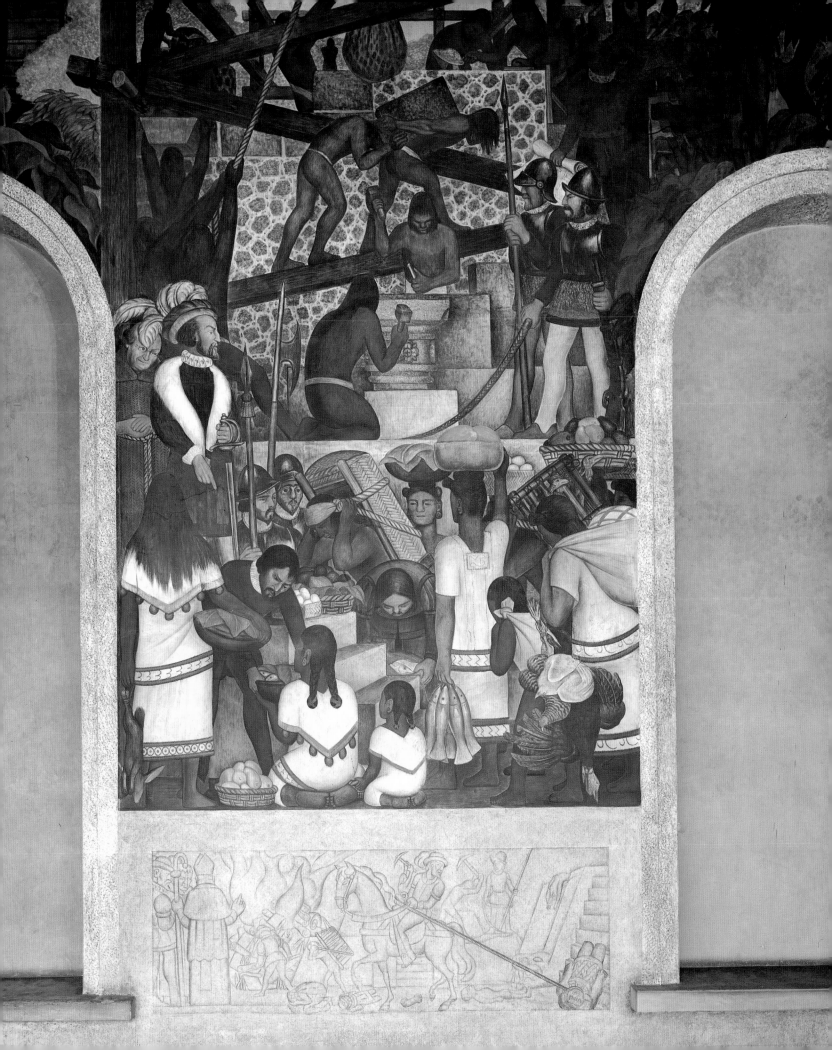

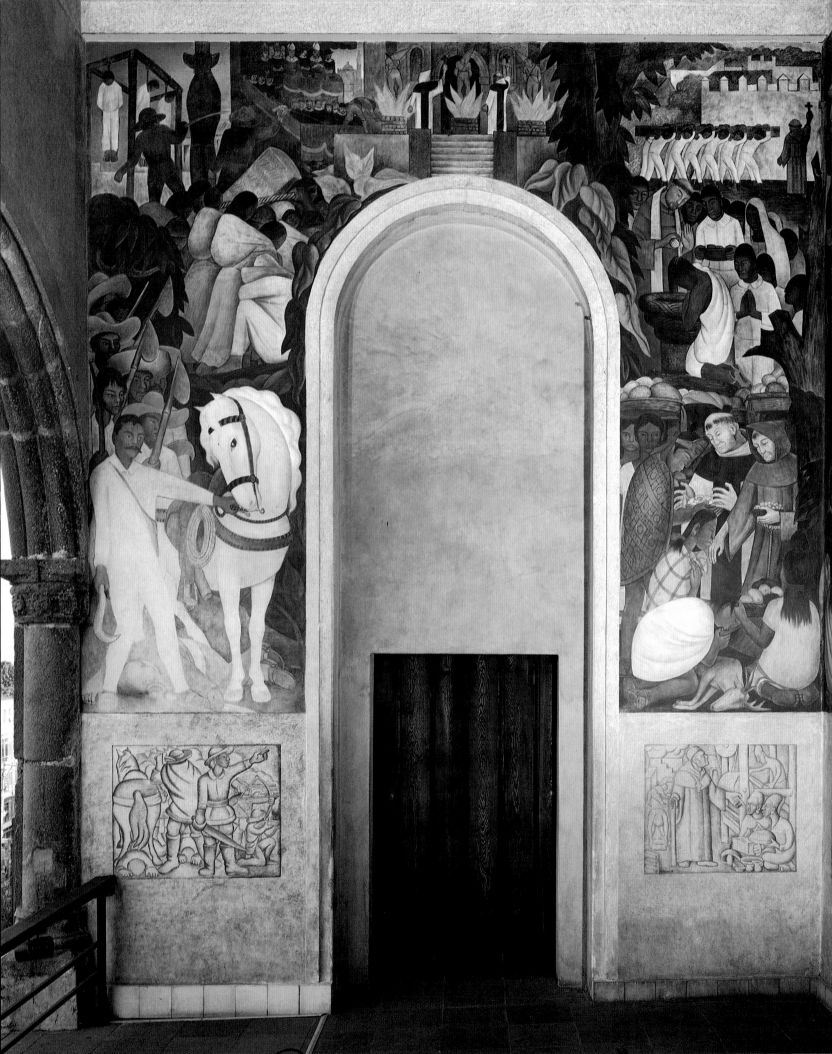

103 *previous pages*
Diego Rivera: *The History of Cuernavaca and Morelos – The Enslavement of the Indian* and *Constructing the Cortez Palace*. Fresco, 1929–30. Detail, Cortez Palace, Cuernavaca, Mexico.

104 *opposite*
Diego Rivera: *The History of Cuernavaca and Morelos – The Conversion of the Indian*. Fresco, 1929–30. Detail, Cortez Palace, Cuernavaca, Mexico.

105 *below*
José Clemente Orozco: *Revolution and Universal Brotherhood – Ghandi, Imperialism and Slavery*. 1931. New School for Social Research, New York.

106 *bottom*
José Clemente Orozco: *Revolution and Universal Brotherhood – Socialism (Yucatan), Socialism (Lenin)*. 1931. New School for Social Research, New York.

Despite its references to the harshness of the pre-Columbian world, the murals of this period at Cuernavaca and the National Palace largely idealize that world and its culture. Rivera's idealization is, of course, deliberate, contrasting starkly with the world he has portrayed of the European colonialists, in order to suggest a concept of Mexican national integrity. This is rooted in the idea of resistance, against the violation of the country both by outsiders, and by dictators from within. Rivera therefore places emphasis on the Indian past and the Indian in general as being the true representative of that identity. For Rivera, the pre-Columbian past represents a time in Mexican history when the nation was able to determine its direction free from outside domination. In Rivera's hands, the indigenous world thus becomes a powerful nationalist symbol.

The conceptual and historical paradigms provided by Rivera were very different from those painted by Orozco in the 1930s. Like Rivera, Orozco also became engaged during this period with confronting and interrogating the epic of history. The mural cycles that he painted on the history of America at Dartmouth College in the United States and of Mexican history at the Hospicio Cabañas in Guadalajara remain among his greatest achievements.

For Orozco, the struggles and events of history were all part of a single conflict in which the possibilities of progress vie with the pressing forces of reaction, greed, power and corruption in a never-ending circular sequence, in which no single construction or narrative can be dominant. Orozco was thus profoundly opposed to the mythologizing and utopian constructions of national history that were so characteristic of Rivera's murals.

Orozco's first engagement with the historical epic was undertaken not in Mexico but in the United States, at Dartmouth College in Hanover, New Hampshire. Orozco arrived at Dartmouth College on 2 May 1932. His presence at the prestigious east-coast university was the result of a prolonged effort by both faculty and administration to bring him there. The efforts of the Rockefeller family, whose son Nelson was studying at Dartmouth in 1930, had been especially influential.[18] Orozco had been in the United States since 1927, where he went because 'there was little to hold me in Mexico in 1927 and I resolved to go to New York'.[19] Since then, with the support of Alma Reed, whose cultural and literary salon, the Ashram, he had joined, he had continued working, exhibiting his celebrated series of gouache, pen and ink drawings on the theme of Mexico in revolution, and producing a number of important easel paintings.[20]

In 1930 he travelled west to Pomona College in Claremont, California, where he created his first murals in the United States. Here, at the south end of the college's refectory, Orozco painted *Prometheus*, in which the theme, composition and colour anticipated the expressive texture of his murals in Guadalajara, which he would paint in the latter half of the decade. Later that year, Orozco returned to New York where he carried out another group of murals, this time in the New School for Social Research on the theme of *Revolution and Universal Brotherhood*, an allegory of ideal human social orders.

107
José Clemente Orozco: *Prometheus*.
Fresco, 1930. Pomona College,
Claremont, California.

108
José Clemente Orozco: *American
Civilization – Ancient Human Sacrifice*.
Fresco, 1932. Detail, pre-Cortesian
section, Baker Library, Dartmouth
College, New Hampshire.

100

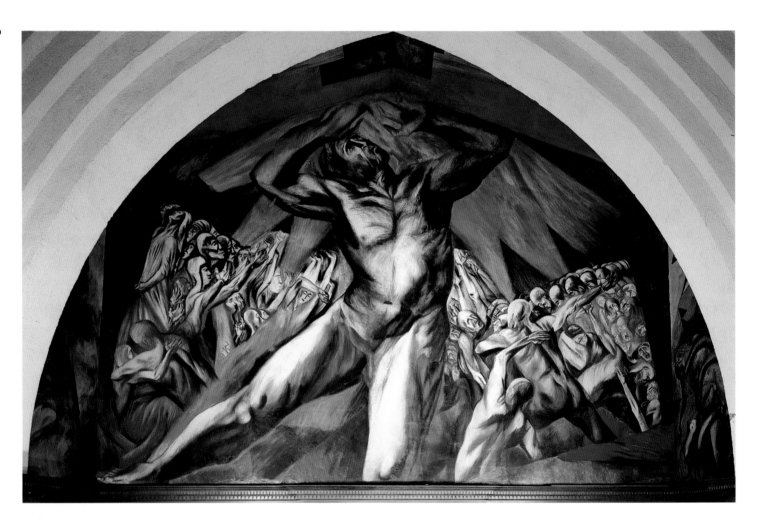

Orozco's Dartmouth mural was an enormous undertaking. Measuring 150 feet in length, it was painted in the reserve room of the Baker Library. Orozco had been particularly struck by the location on a previous visit to the college. 'These are the walls for my best mural, my epic of America', he had commented when he saw them for the first time.[21] The fresco cycle that he painted there was not strictly speaking a history of Mexico. Rather, as implied by his statement, Orozco wished to confront not a specifically national history so much as a North American one. As Laurence Hurlbert noted, Orozco's intention was to 'paint his conception of the development and current state of civilization in *America, the "New World"*.'[22]

Although described by Orozco as one of the best examples of liberalism in the north, Dartmouth College was in fact a bastion of white Anglo-Saxon educational privilege. Yet the college had had very different beginnings and intentions, and was founded in the late eighteenth century specifically for the purpose of providing education for the North American Indian. The indigenous ancestry of the college in part anticipated Orozco's approach to the thematic concept of his mural. Ernest Hopkins, the University President, made note of Orozco's comment that 'the resolution of your college is in line with its traditions that connect it with the Indian races of America.'[23] The mural was thus conceived not as a historical narrative in a simple sequential sense,

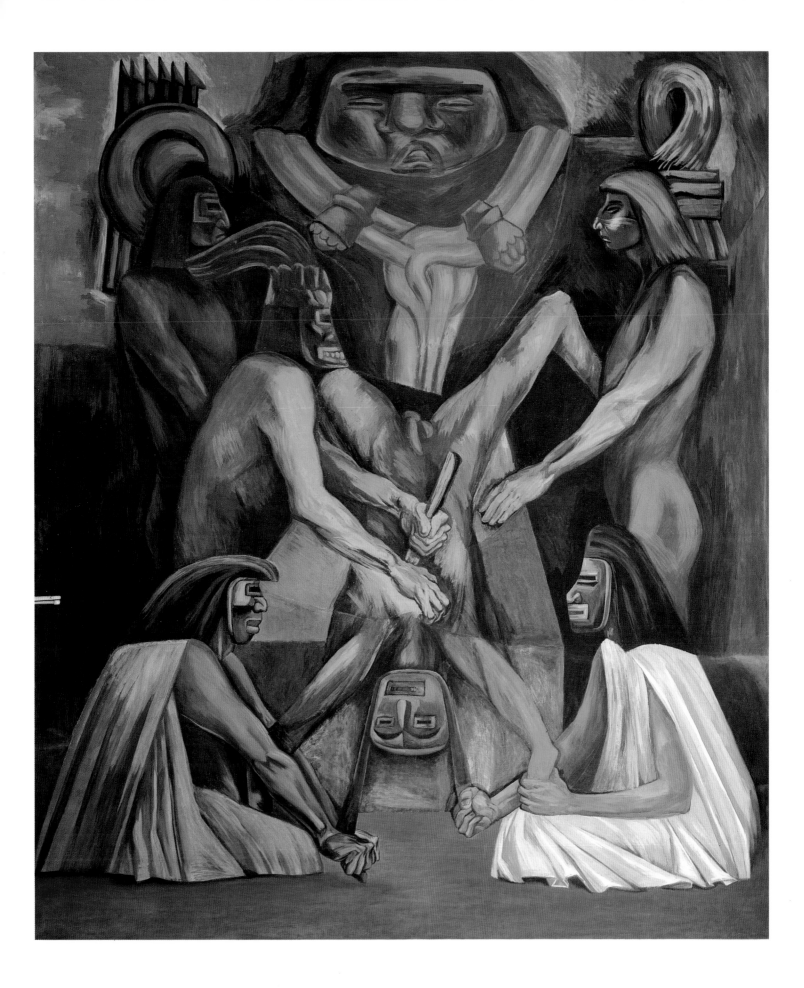

109
José Clemente Orozco: *American Civilization*. Fresco, 1932. Overview, pre-Cortesian section,
Baker Library, Dartmouth College, New Hampshire.

110
José Clemente Orozco: *American Civilization*. Fresco, 1932. Overview, post-Cortesian section,
Baker Library, Dartmouth College, New Hampshire.

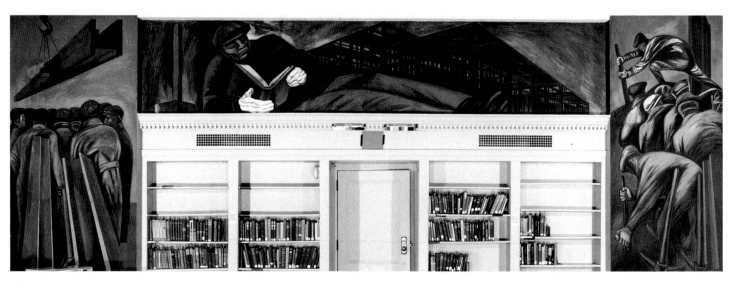

111
José Clemente Orozco: *American Civilization – Modern Industrial Man*. Fresco, 1932. Detail, post-Cortesian section,
Baker Library, Dartmouth College, New Hampshire.

MEXICAN MURALISTS

but as the conceptualization of a historical idea. In this case it was an idea concerning America, a continent characterized by the dualities of Indian and European historical experience. As Orozco wrote

In every painting, as in any other work, there is always an *idea, never a story*. . . . The important point regarding the frescos of Baker Library is not only the quality of the idea that initiates and organizes the whole structure, it is also the fact that it is an American idea developed into American forms, American feeling, and as a consequence into an American style.[24]

Orozco's concept centred on what he termed the 'living myth' of Quetzalcoatl, which, as Laurence Hurlbert has described, was fundamental to Orozco's 'depiction of the indigenous civilizations and their relationship to European culture transported to this continent in the early sixteenth century'.[25] For Orozco, the myth of Quetzalcoatl was the basis of his grand ideological vision of the American idea, in which he believed that

The America continental races are now becoming aware of their own personality as it merges from two cultural currents, the indigenous and the European. The great American myth of Quetzalcoatl is a living one, embracing both elements and pointing clearly by its prophetic nature, to the responsibility shared equally by the two Americas of creating here an authentic American civilization.[26]

Orozco's visualization at Dartmouth of this idea of America was conceived in two main parts. He painted the first part, representing the period of America's pre-Columbian civilization, along the western section of the long wall in the library's reserve room. He painted post-Cortez America along the other half of the wall, starting with the conquest and ending with a portrayal of contemporary America formed by the constituent parts of its Hispanic and Anglo-Saxon experience.

Unlike Rivera, Orozco did not conceive this historical visualization as a rhetorical call of nationalist or continentalist liberation and identity. Rather, he saw the idea of the American experience not only as a duality, but also as a base on to which he could map the important question of humanity's endless struggle to realize its greatest aspirations and ideals and its simultaneous frustration by its innate fallibility. For Orozco, this dichotomy of the human character was tragically repetitive and could not be

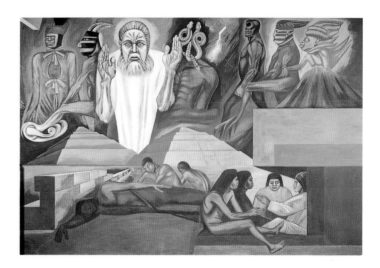

conveniently located within specific geographical areas, historical times, races and cultures. The duality of the American experience, with the intrusion and subjugation of one people's culture by another, was thus the perfect ground on which to reveal such divisions.

Orozco's mural at Dartmouth is therefore a thematic layering of meanings and narratives. The dual nature of the continent's histories, made up of indigenous and European ancestries, is conceived as a grand sequence of an indigenous world and its culture being superseded and transformed by the intrusion of another. Beneath this grand sequence is a distinctly circular or revolving history, in which events are seen merely as different backdrops against which Orozco expressed the dilemma of the human ideal thwarted by human fallibility.

He began his cycle on the west wall with the dawn of American history in his panels of *Ancient Migration* and *Ancient Human Sacrifice*.[27] The latter, depicting the ritual sacrifice of an enemy warrior to Huitzilopochtli announces the advent of Aztec civilization, in which Orozco saw death as one of the central components of culture.[28] At the beginning of the library's long central north wall, Orozco painted the first of three interconnecting images depicting the age of Quetzalcoatl. The sequence begins with *Aztec Warriors* and ends with the image of Spanish knights dressed in armour. The age of Quetzalcoatl is pictured in three parts. The first, *The Arrival of Quetzalcoatl* depicts the Aztec

113
José Clemente Orozco: *American Civilization – The Departure of Quetzalcoatl*. Fresco, 1932. Detail, pre-Cortesian section, Baker Library, Dartmouth College, New Hampshire.

114
José Clemente Orozco: *American Civilization – The Prophecy*. Fresco, 1932. Detail, pre-Cortesian section, Baker Library, Dartmouth College, New Hampshire.

104

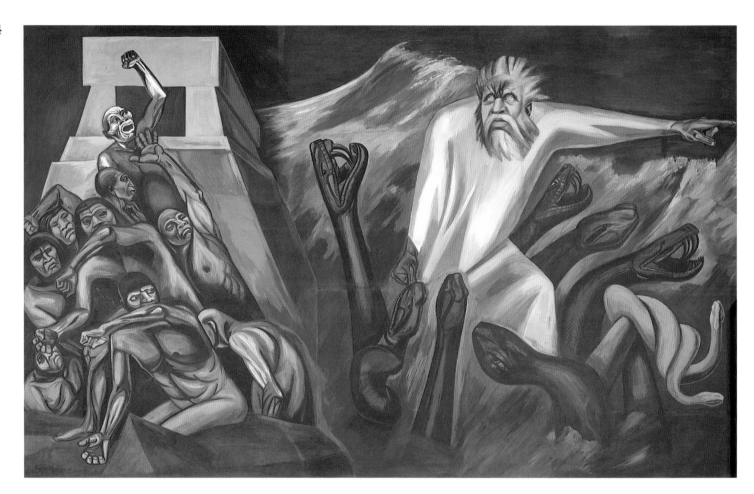

god commanding the Indian world to set aside greed, superstition, magic ritual and militarism in favour of civilization, where learning and culture triumph over barbarity and darkness. Orozco's use of colour in these passages is transformed from sombre greys and browns to strident blues and yellows. Images of the great pyramids, the cultivation of maize, stone carving and science speak of the great achievements of the Toltec and Mayan civilizations. These positive images unfold towards the centre of the long central wall with Orozco's insistent theme of the endless struggle caused by the duality of human nature revealing itself in the return of barbarity, cruelty and superstition. Quetzalcoatl is expelled by evil sorcerers from his kingdom on a raft of serpents, with the triumph of darkness and the fall

of the nation that has rejected his teachings prophesied by his departure.[29] Quetzalcoatl's prophecy of doom, demise and return is announced as a new age, that of the advent of the white man, the enslavement of the Indian and the epoch of Spanish colonialism.

Unlike some of the images that he would paint in his great historical cycle a few years later in Guadalajara, Orozco depicts the arrival of Spanish colonialism with the utmost pessimism. Cortez's arrival on the shores of Mexico is presented as a kind of punishment for the Aztec world's rejection of Quetzalcoatl, a turning away from the achievements of their golden age of civilization. Cortez is seen as an enslaver, whose presence ushers in an epoch characterized not by the great achievements of

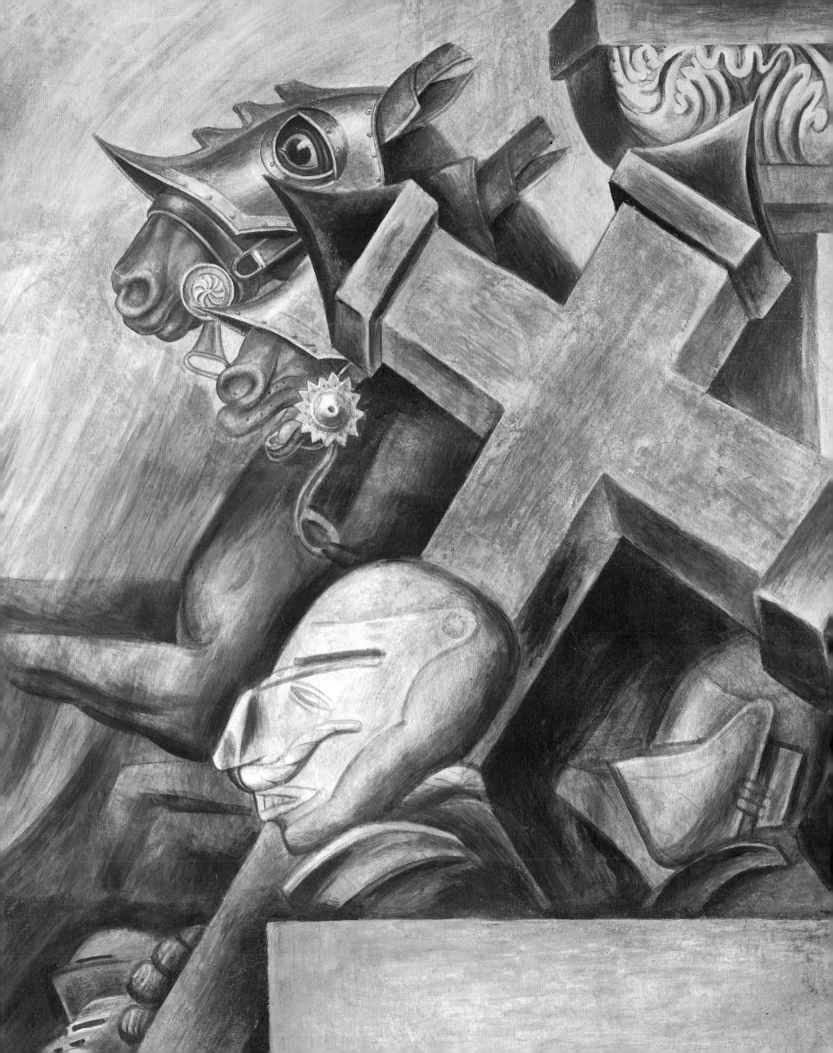

115
José Clemente Orozco: *American Civilization – Cortez and the Cross*. Fresco, 1932. Detail, Baker Library, Dartmouth College, New Hampshire.

116
José Clemente Orozco: *American Civilization – Anglo-America*. Fresco, 1932. Detail, post-Cortesian section. Baker Library, Dartmouth College, New Hampshire.

117 *opposite*
José Clemente Orozco: *American Civilization – Latin America*. Fresco, 1932. Detail, post-Cortesian section, Baker Library, Dartmouth College, New Hampshire.

106

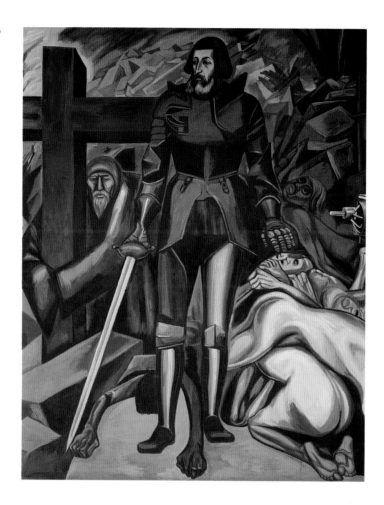

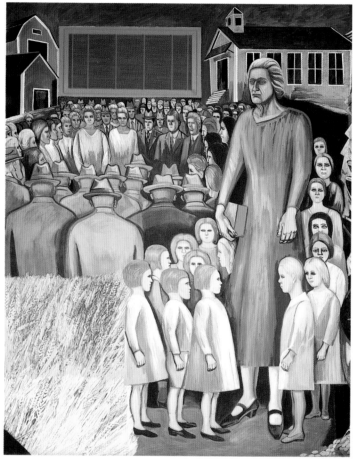

European art and culture but by a technological superiority that brings with it a mechanical underworld. It is a world dominated by giant pieces of machinery in which human presence and spirit are conspicuous by their absence.

From this frightening world, Orozco moves on to his celebrated panels depicting modern America. The first, *Anglo-America*, is a world of conformity. Children stand obediently around their strait-laced teacher, while behind them a mass of adults gather at a town-hall meeting. The expressive sameness of their features speaks tellingly of a democratic political process (despite it being in part greatly admired by Orozco) transformed into a rigid conformity and agreement, in which polite orderliness eschews all sense of questioning. By contrast, *Hispanic America* or *Latin America* is a world scarred by corruption, greed and chaos. Its background is a mesh of fallen and destroyed buildings, reminiscent of Orozco's earlier National Preparatory School panel, *Destruction of the Old Order*. Corrupt politicians and generals hoard money. At the centre, however, stands the Latin American rebel, Emiliano Zapata. Zapata is portrayed as the personification of Latin American idealism. As Orozco himself said about this image,

The best representation of Hispanic-American idealism, not as an abstract idea but as an accomplished fact would be, I think, the figure of a rebel. After the destruction of the armed revolution (whether against a foreign aggressor or local exploiter or dictator) there remains a triumphant ideal with the chance of realization. If there is any need for

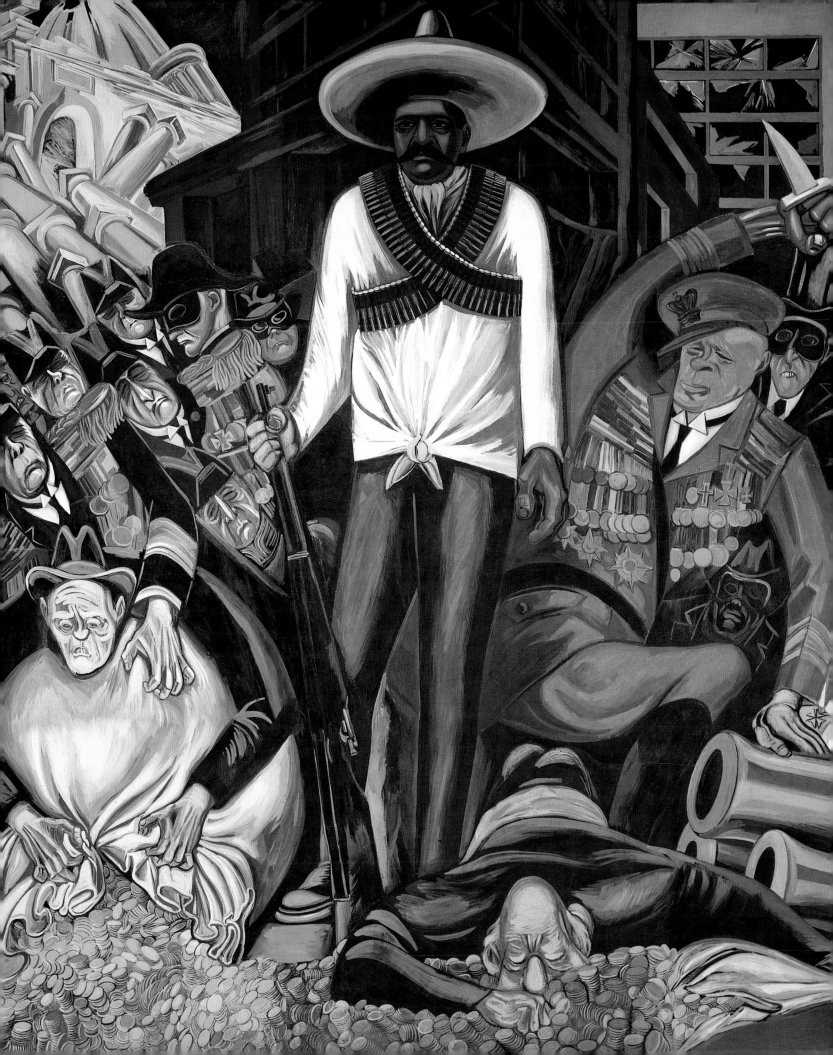

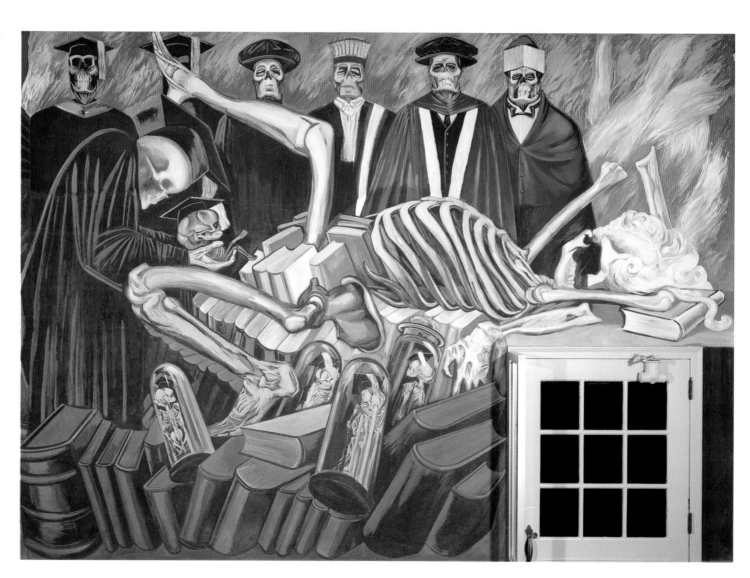

118
José Clemente Orozco: *American Civilization – The Gods of the Modern World*. Fresco, 1932. Detail, post-Cortesian section, Baker Library, Dartmouth College, New Hampshire.

expressing in just one sentence the highest ideal of the Hispanic-American hero, it would be as follows: 'justice whatever the cost'.[30]

However, Orozco depicts Zapata as being stabbed in the back by a North American general. The general is pictured with a motley crew of accomplices – businessmen, foreign armies and, even more tellingly, a collection of Zapata's own countrymen. Such people are viewed by Orozco as loathsome demons, whose lack of principles is equalled only by their greed.

Education is the subject of the following sequence, the last of the compositions on the long central north wall. In his panel of *The Gods of the Modern World*, Orozco created one of his most powerful images. Unlike the panel depicting the American teacher, where learning is expressed as attention and obedience, *Gods of the Modern World* pictures education as a nightmare of futile learning and sterile knowledge. These purveyors of false knowledge, portrayed by Orozco as skeletons dressed in

119
José Clemente Orozco: *American
Civilization – Modern Human Sacrifice*.
Fresco, 1932. Detail, post-Cortesian
section, Baker Library, Dartmouth
College, New Hampshire.

academic robes, attend the birth of false knowledge: a prone skeleton giving birth to a skeletal foetus.[31] It seems that Orozco was intent, in part, on providing a searing critique of the 'ivory tower' method of education, where the pursuit of knowledge undisturbed by any need to apply its conclusions to the real, external world leads to complacent self-importance. Above all, this passage is a stinging attack on the indifference to the crisis of modern civilization, implicitly expressed in the flaming background of the composition, a motif first featured in the earlier image of Cortez's arrival in Mexico.

The circularity of Orozco's historical treatment becomes apparent in the two panels painted on the far end of the west wall. In the first, *Modern Human Sacrifice*, Orozco painted a mirror image of the horrific ritual of the ancient Indian world. Here is modern American civilization's equivalent: nationalism. Young men are sacrificed on the altar of the modern battlefield for the advancement of this cause and for its defence. Orozco denounces this phenomenon in a tragic image, picturing the dead torso of an unknown soldier, whose body lies over a burning candle and whose head is draped with a flag which bears a composite of the emblems of various national flags. Around this figure are apologists for this gratuitous sacrifice: a wreath of remembrance and a figure reading a funeral sermon.

The concluding panel of the mural cycle at Dartmouth, the *Modern Migration of the Spirit*, is a judgmental image on the history that Orozco has presented of the American continent in the preceding panels. The image is a deliberate play on the prophecy of Quetzalcoatl, who vowed on departure to return to build another civilization. Orozco's use of the monumental Christ figure in this final panel, returned to earth only to hack down his cross in condemnation of all that he sees as having been done in his name, is likewise a replaying of the Quetzalcoatl theme of the condemnation of his people's worship of false gods. This time the worship is of false knowledge, money and power, and the violence of blind nationalism. The junk heap of the weapons of war and the trash of industrial culture in the background of the composition reinforce Orozco's deeply pessimistic view of the modernity arrived at by contemporary American civilization.[32]

Orozco configured the history of the American continent as a

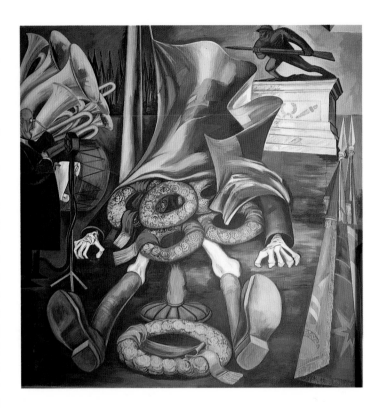

109

series of composite images in his fresco cycle at Dartmouth, which can be broken down further. The images are not merely allusions to historical fact, but rather represent visualizations of what Orozco perceived to be the essence of a period. Looking down the whole length of this work, Orozco's methodology becomes apparent. His use of sequential images forms a loose chronology of events. However, the specific themes embedded in each of the images underscores Orozco's lack of faith in the notion of progress with time. Orozco brilliantly unifies the past with the present, but his intention was not, as was Rivera's, to construct a heroic pedigree of struggle against oppression and injustice that could form a definable identity towards which his nation could strive. The unity that Orozco creates is that of a mirror in which events of the past reflect themselves in the present and vice versa. Thus, in Orozco's mind, the Aztecs' ancient sacrificial ritual is replayed in the sacrifice of the young, unknown soldier on the altar of war and nationalism. Quetzalcoatl's judgment on the worship of false gods is no

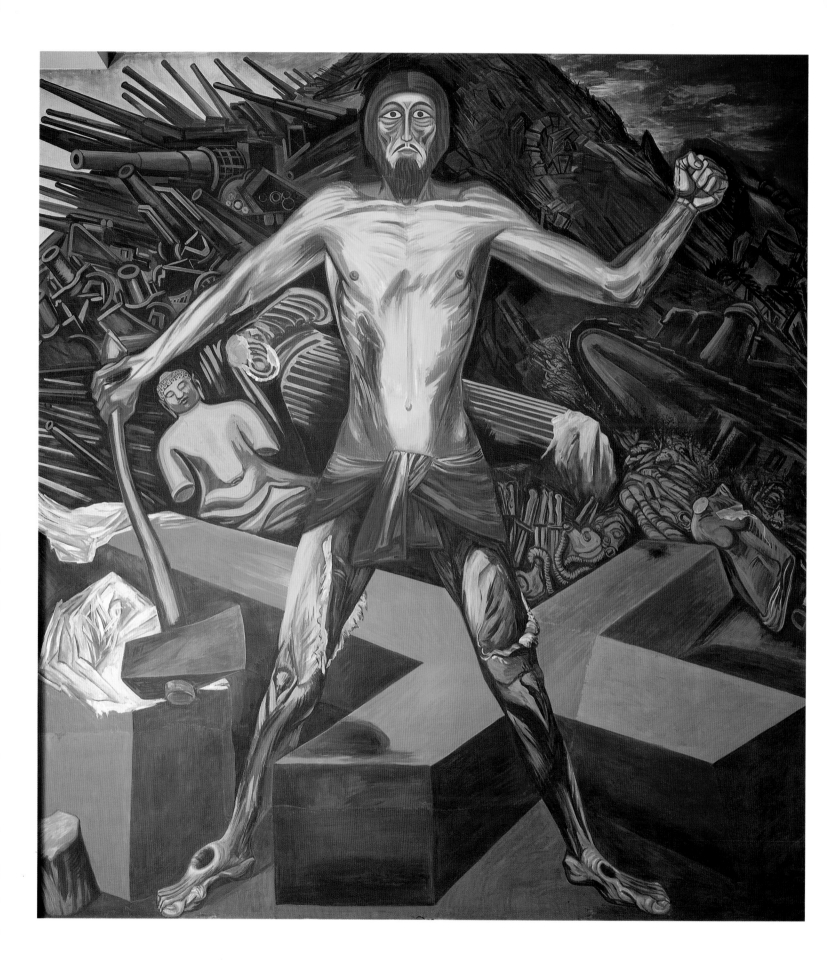

120
José Clemente Orozco: *American Civilization – Modern Migration of the Spirit*. Fresco, 1932. Detail, post-Cortesian section, Baker Library, Dartmouth College, New Hampshire.

121
José Clemente Orozco: *The Spanish Conquest of Mexico*. The *Mechanized Masses* and *Despotism* can be seen in the foreground. Fresco, 1938–9. Hospicio Cabañas, Guadalajara.

different from that of the modern Christ returned to cut down his cross in anger. The materialistic militarism of the conquistador is in essence the same as the spirit of the modern mechanical world wrought by the aggrandizing sentiments of modern industrial capitalism. Likewise, the golden age of the Aztecs is identified with the purposeful spirit of the rebel who strives to liberate and cast light where only the darkness of corruption reigned before. For Orozco, the struggles and events of history are part of a single conflict in which the possibilities of progress vie with the pressing forces of reaction, greed, power and corruption. Orozco's bi-focal view of American civilization is one in which the instances have changed with time but the conflict remains the same.

Such a view is also present in the configuration of the history that Orozco was to paint six years later in the Hospicio Cabañas in Guadalajara.[33] When Orozco returned to Mexico from the United States in 1934, he was a mature painter at the height of his career. His cycle at the Hospicio Cabañas in 1938 was the final work in a series of murals that he had painted in the city over the previous two years at the behest of the governor of Jalisco, Don Everado Torpete.

Although Orozco had set out with the express intention of conveying a historical idea of continental American civilization at Dartmouth, many of his images, particularly those pertaining to the pre-Columbian era, as well as those featuring Cortez, had specifically Mexican connections, as opposed to ones that were generally American. Whether this was mere convenience is not certain. For whatever reason, the Mexican connection creates a reading that is particularly significant, presenting the idea of an American identity rooted in Mexican and, by association, indigenous ancestry.

Many agree that the monumental fresco cycle at the Hospicio Cabañas is Orozco's greatest work. Here, in a deconsecrated church, the fifty-five-year-old artist created his cycle of *The Spanish Conquest of Mexico*.

Unlike his work at Dartmouth, here Orozco avoided an exclusively polarized view of the conquest and its consequences. He did not, for example, unquestioningly embrace the cause of pre-Hispanic Mexico, as Rivera implicitly had done. Nor did he view the Spanish conquest in an unremittingly negative light.

Rather, he sought to synthesize his preoccupation concerning the polarity of the positive and negative aspects of history with his idea of Mexican history.

Orozco expressed this duality in composite images of the conquest in the vaulting, transept and aisle of the building. Through visual metaphor and simile, he evoked what he saw as the essence and character of each of the stages and consequences of the colonial subjugation and subsequent transformation of Mexico. Taken as a whole, the images that Orozco created in the transept and aisle panels fall into four sections. Within each section, Orozco ordered the images so as to represent the character of a particular aspect of transformation in the evolution of Mexican history.

In the east and west transepts Orozco painted five images evoking the cruel and barbaric world of ancient Indian Mexico with its bloody sacrifices and macabre dance rituals of appeasement to the god of war, Huitzilopochtli. With additional images

122
José Clemente Orozco:
Huitzilipochtli. Fresco, 1938–9.
Hospicio Cabañas, west transept,
vault, Guadalajara.

123 *opposite*
José Clemente Orozco: *The Spanish
Conquest of Mexico – Philip the Second
of Spain* (detail). Fresco, 1938–9.
Hospicio Cabañas, south nave, right
vault, Guadalajara.

of Franciscan priests, Indian and Spanish warriors, Orozco introduced the crucial historical moment of an Indian world about to be transformed by military and spiritual means. He continued and expanded the dual aspect of this impending transformation on the vaulted panels along the length of the nave. Here, Orozco sought to express the character of the Spanish conquest at its harshest. The Indian world is crushed and transformed by white European renaissance man at his most aggressive, acquisitive and violent. The subjugation of the Indian appears total and final. Each image in the vaulted panels is an image of plunder and transformation. A huge portrait of Philip the Second of Spain, dominated by a dark cross with the monarch's crown, evokes the monarchical Catholicism that lay at the spiritual heart of the Spanish colonial enterprise. Ensuing panels focus on what was an impressive technological force of conquest in contrast to the bare-fleshed Indian warriors portrayed by Orozco. In the two panels in the south and north naves, depicting the *Twin-Headed Horse* and *Portrait of Cortez*, imagery conveys the conquest as a symbol of modern war in both man and animal.[34] The portrait of Hernán Cortez pictured in armour, his body constructed of nuts, bolts and pistons, takes on the appearance of a machine. As Salvador Echavarria has observed, these human and animal images transformed into demonic machines portray the 'engine age in its prime, the first product of the rising science of the renaissance, which made the conquest possible'.[35] Orozco extended this visual metaphor in the image of the mechanical horse by depicting the conquering animal as a modern battle-tank. Upon its grotesquely mechanical body, the image of the heraldic lion and tower of Castille, closely resembling the turret of a tank, appears on a banner. In this threatening and monstrous apparition, Orozco created a sinister caricature of Quixote's Rozinante, whose rider follows not the noble cause of justice but that of death and destruction.

Other evocations of the subjugation of Indian Mexico are complemented in the nave by images of the subsequent cultural and spiritual transformation of Indian Mexico. In a reworking of the earlier Preparatory School fresco panel of the *Franciscan and the Indian*, Orozco shows an imposing portrait of a Franciscan priest holding a crucifix, the edges of which are

sharpened like a sword, over the head of a kneeling Indian. At the priest's side is a banner carrying the first letters of the European alphabet which, together with the sword-like crucifix, express the character of the conquest as one that was simultaneously ruthless and harsh, but charitable and forgiving.

In the side walls of the building's nave and transepts, Orozco depicted what he saw as the positive effects and benefits of European colonialism. Portraits of El Greco and Cervantes symbolize the introduction of European art and culture. The portrait of Bishop Ruíz de Cabañas, the founder of the city's orphanage, evokes the charity and help for the poor that was the legacy of the Franciscan monks. Another fresco panel explores the transformation of Indian culture into that of colonial and Mestizo culture, expressed in images of architecture.

In a deliberately iconoclastic fashion, Orozco counterposed these positive images of the colonial legacy with opposite and adjacent panels depicting the contemporary despotism of the twentieth century. This theme is condensed into panels displaying sharp satires on modern political demagogy. In deathly grey colours, modern demagogues gesticulate menacingly and people march in a faceless, spiritless mass against a foreground of barbed wire, presided over by a torso carrying a whip. For Orozco, these pessimistic views of the modern world, which can be seen in part as a thematic repetition of the concluding panels in his Dartmouth cycle, are a comment on a legacy of

124 & 125 *previous pages*
José Clemente Orozco: *The Spanish Conquest of Mexico – Portrait of Cortez* and *The Franciscan*. Fresco, 1938–9. Hospicio Cabañas, north nave, right vault and south nave, left vault. Guadalajara.

126 *below*
José Clemente Orozco: *The Spanish Conquest of Mexico – Twin-Headed Horse*. Fresco, 1938–9. Hospicio Cabañas, Guadalajara.

127 *opposite top*
José Clemente Orozco: *The Spanish Conquest of Mexico – The Wars of the Conquest*. Fresco, 1938–9. Hospicio Cabañas, north nave, central vault, Guadalajara.

128 *opposite bottom*
José Clemente Orozco: *The Spanish Conquest of Mexico – The Mechanical Horse*. Fresco, 1938–9. Hospicio Cabañas, north nave, left vault, Guadalajara.

despotism that seems to extend back through the power-seeking aggrandizement that inspired the conquest, and, before that, promoted human sacrifice to the gods of war. Indeed, these images seem to underline the antithesis of the picture Orozco conveyed of the charity and benediction, culture and learning of the colonial world. It is important to stress here that the positive view of the colonial experience that Orozco chose to convey in these images is counterbalanced by his powerful and terrifying images of the despotism of the Spanish conquest.

Orozco's arguably greatest achievement and his apotheosis in the Hospicio Cabañas is the fresco in the cupola entitled *Man of Fire*, a typically personal statement on the history configured below. The image is a metaphor for the theme of social struggle as well as representing the chimera of the ideal. The *Man of Fire* is also the resurrected Christ at Dartmouth. The use of such imagery is an essential part of Orozco's powerful vocabulary,

symbolizing the yawning gulf between the world of lived experience and the domain of the ideal. Unlike Rivera's notion of the ideal, Orozco's images are separate from, not an extension of, the trajectory of history.

Like Rivera's fresco cycles at the National Palace and the Cortez Palace in Cuernavaca, Orozco's mural at the Cabañas was painted during a particularly significant period in the development of post-revolutionary Mexico. The latter half of the 1930s under the presidency of Lazaro Cárdenas could be characterized as a spirited revisiting of the egalitarian and nationalist thrust of the revolutionary appeal. Cárdenas' nationalization of the oil industry in 1938, for example, marked 'the highest point of our revolution. Mexico became of age before the world by making sure that its sovereign rights would be respected, securing the basic principles of the constitution from outside attack.'[36] In the context of the political times in which it was painted, Orozco's cycle in the Hospicio Cabañas, with its ambivalent and

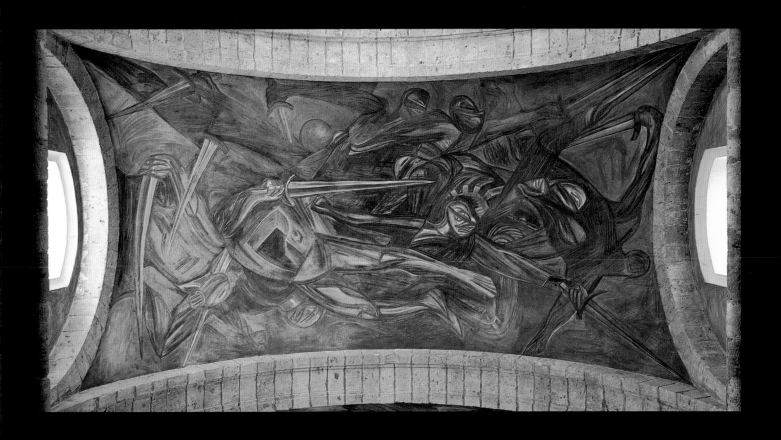

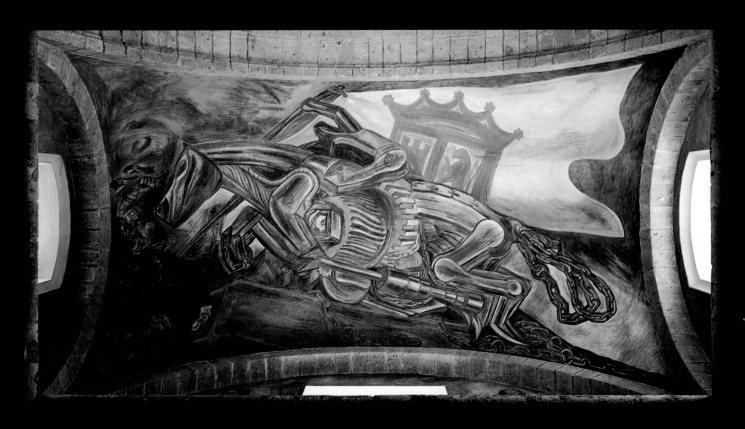

129
José Clemente Orozco: *Man of Fire.*
Fresco, 1938–9. Hospicio Cabañas,
cupola, Guadalajara.

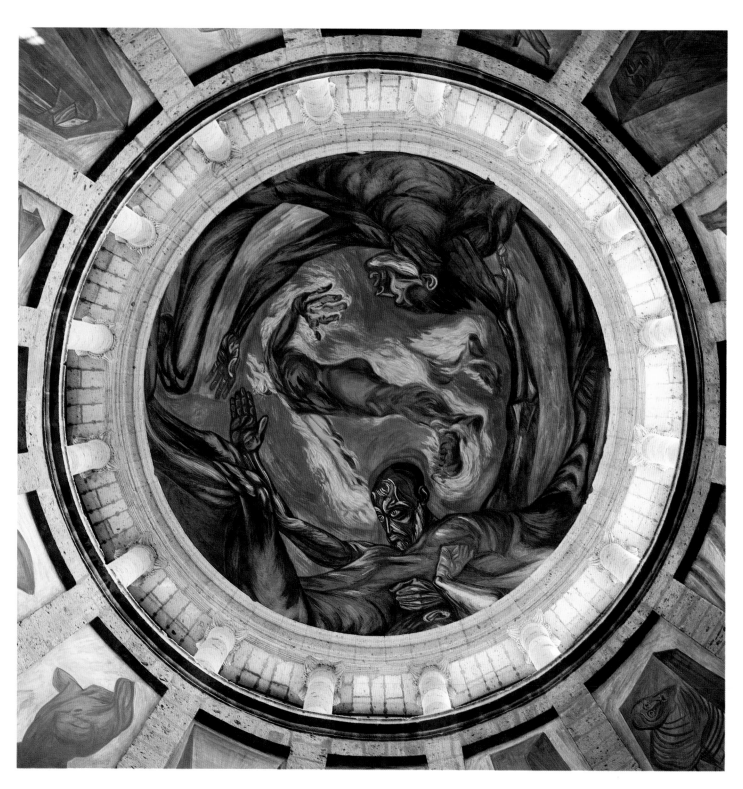

MEXICAN MURALISTS

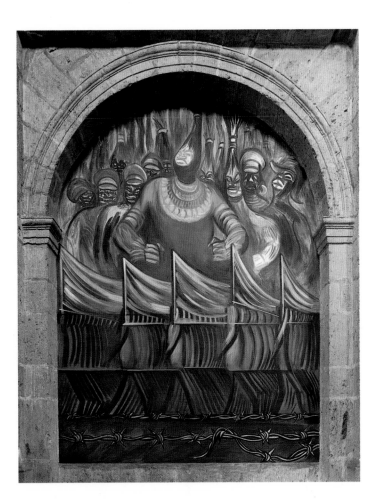

130
José Clemente Orozco: *The Dictators*.
Fresco, 1938–9. Hospicio Cabañas,
south nave, east side, south wall,
Guadalajara.

sombre vision of the contemporary world, suggests a deliberately powerful rebuttal of leftist nationalist rhetoric. Likewise, the duality of the national heritage, so vividly expressed in Orozco's images, in which both the pre-Columbian past and Spanish colonialism are unequivocally charged in negative and positive terms, cuts through Rivera's one-dimensional way of constructing a framework in which Mexican national history can be seen and presented for official sanction. For Orozco, at Dartmouth but more specifically in Guadalajara, the identity of Mexican history and, by association, of the country itself, was a complex dialectic, an elusive and continually evolving process.

Both Orozco and Rivera incorporated a utopian dimension into their national vision of Mexico or the continent's history. For Rivera, the utopia was concrete: Quetzalcoatl, Cuauhtemoc, Hidalgo, Zapata, Marx and the world of the Communist revolution. For Orozco, on the other hand, the figure of Christ at Dartmouth and the man in flames at Guadalajara represented a utopian ideal that was purposely not part of the collective realization of historical experience. In Orozco's eyes, human purpose had proved too fallible for such symbols to be seen as realizable. In this sense, Orozco's vision of his country was a penetrating construction: its identity was not singular in its source, but multiplicitous. It consisted of competing and contrasting pulls, in which the duality of Mexico's pre-Columbian and Hispanic experience formed the background.

Whatever the profound differences between Rivera and Orozco's visual historical methodology, both engaged with and reflected a deeply significant process of national self-definition in the evolution of Mexican cultural and social identity. Indeed, their murals were part of that defining process, and form an element in the great panoply of Mexican nationalist culture. The Kenyan writer Ngugi Wa-Thiongo has observed that the most important area of domination by colonialism was in 'the mental universe of the colonized, the control through culture of how a people perceived themselves and their relationship to the world. . . . To control a people's culture is to control their tools of self-definition in relationship to others.'[37]

The epic of Mexican history and American civilization, with which Orozco and Rivera engaged in the 1930s was not confined to that decade. From the 1940s onwards Orozco, Rivera and

Siqueiros created murals whose subjects centred on the theme of Mexican or American history. What began in the 1930s was an engagement with the process of Mexican self-definition, a re-envisioning of the nation and its people through the epic of their collective historical experience. The murals that Orozco created at Dartmouth and at Guadalajara, together with those that Rivera painted in Mexico City and Cuernavaca became not so much the tools of Mexico's redefining of itself, as the visual and narrative vocabulary of that redefinition.

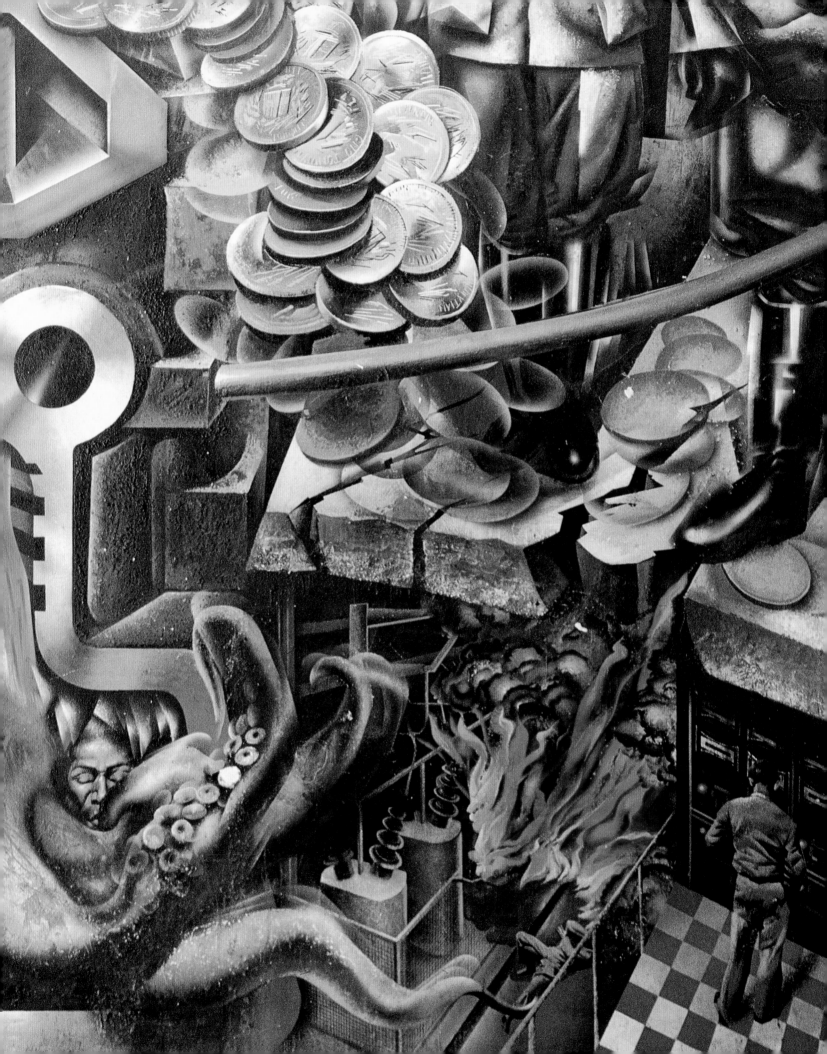

David Alfaro Siqueiros: *Portrait of the Bourgeoisie* (detail). Pyrozatine on cement, 1939–40. Mexican Electricians' Syndicate, Mexico City.

FIVE

THE TECHNOLOGY OF UTOPIA

VISIONS OF MODERNITY

The concluding sections of the great historical cycles that Orozco and Rivera painted during the 1930s preceded and anticipated a series of other cycles painted during the same decade, which further extended their involvement with the theme of modernity. For Rivera, this took place in a series of murals derived explicitly from his experience of the United States, in which the image of the modern industrial and political world of North America became the basis for much of his subject-matter. By contrast, Orozco's Mexican and North American murals of this period described the modern industrial world in a different way. As in the concluding panel at Dartmouth, the world of industrial and technological modernity was represented in a pictorial discourse with a moral and judgmental thrust, often harsh, deeply sombre and pessimistic. In some of Orozco's murals, the social background of Mexico provided the context in which Orozco engaged with the moral and political dilemmas posed by the modern world. In others, he created a more generalized image of a mechanical and industrial reality enmeshing, incarcerating and imprisoning humanity.

For Siqueiros, the modern world proved to be the catalyst for an engagement with new methods of production, like capitalist industry itself, as well as providing the thematic background for his continuous preoccupation with revolutionary struggle. His methodology for producing murals added a further dimension to the character of Mexico's public art.

Although the concept of modernity was not perceived by the three muralists as an exclusively American phenomenon, as the most advanced and technologically powerful society and one of which they had first-hand experience, the industrial and political culture of America contributed significantly to their thematic and visual vocabulary. Between the early 1920s and the late 1930s, North American industrial society was transformed. The collapse of the optimistic decade of the 1920s and the tragic years that followed the Depression affected the lives and thinking of everyone living through those times. Orozco, Rivera and Siqueiros spent significant periods of time in the United States during these years, and were profoundly influenced by the contrasting realities of the world's richest and most advanced industrial society.

American capitalist society had been characterized by enormous economic progress during the 1920s. By 1929, its industry had moved towards the mass production of consumer items. Its factories poured out enormous numbers of cars and electrical appliances of every variety, with industrial output doubling during the decade. The unparalleled wealth, economic growth and faith in American capitalism during the 1920s was shattered by the Depression. In March 1929 Herbert Hoover was elected President of the United States with the campaign promise of 'Two cars for every garage'; years later, Harry Truman remarked that Hoover really meant 'two families for every garage'. Eight months later, the great Wall Street crash occurred, provoking the collapse of the world's strongest economy. Although the

greatest single losses were experienced by those holding stock, all Americans were affected, with the industrial worker, the farmer and the small businessman suffering most. By 1933, unemployment had reached the staggering figure of 25 per cent. In the countryside, droughts throughout nearly all the major farming areas of the mid-United States led to the dust bowl. Already crippled by the economic depression, farmers could no longer earn a living from the land and were unable to service their debts which forced them to leave their farms. In both city and country, poverty, starvation and financial ruin were realities. Not surprisingly, American society as a whole lost faith in capitalism. No longer able to make even a basic livelihood within the capitalist economy, the American industrial worker turned increasingly to protest, strike and the politics of the radical left. American intellectuals turned increasingly towards Marxism and Communism as the crisis in American capitalism took its toll on society.

Optimism, growth, wealth and personal prosperity, followed by depression, unemployment, financial ruin and abject poverty for millions were the two alternative realities presented by modern North American industrial society. Although profoundly different in character from the United States, Mexico was also characterized by two contrasting realities during these years. Still largely an agrarian country, Mexico was influenced less by the total collapse of American industry than by the corruption of the revolutionary agendas that had stimulated the political and social dynamism of the early 1920s. By the early years of the 1930s, the spirit of the revolution had become a lifeless façade. Rhetoric and the pursuit of power had become concentrated within an increasingly centralized political authority marred by corruption. Up until 1934, Mexican politics were to all intents and purposes controlled by Plutarco Elías Calles, who was elected President in 1924. *Caudillismo* (rule by political bosses) once again took its place in the political culture, enforcing an authority sanctioned only by a belief in the myth of revolutionary legitimacy.

Although Calles completed his presidential term in 1928, by then he had amended the constitution drawn up during the revolution to allow his colleague and former president, Obregón, to succeed him for a second term. Both men believed in strong government, and had concluded that the best way of consolidating the gains of the revolution was to create an unofficial dynasty whereby Calles and Obregón would alternate in office at regular four-year intervals.[1] However, such plans came undone when Obregón was assassinated three weeks after his re-election. Although the Mexican constitution prevented Calles from being re-elected immediately to office, he nevertheless wielded enormous power and influence from behind the scenes. A succession of puppet governments ruled Mexico from 1928 to 1934. Although Emilio Portes Gil (1928–30) made some attempt to continue the spirit of revolutionary reform, subsequent presidents halted such activities. Pascual Ortíz Rubio, who was ruled by the influence of Calles, was unceremoniously driven from office in 1932 for considering policies independent from those envisaged by his mentor. The third president, General Abelardo Rodríguez, was part of a circle of people who had made their fortune out of the revolution, and flaunted his wealth with huge houses.

Calles himself, during this last phase of his influence, had become increasingly conservative in his political ideas. . . . (He) became disillusioned with the poor economic results of the agrarian programme, and virtually put a stop to the distribution of the land. The one-time socialist now saw the country in terms of industrial development, which in alliance with local and foreign capital he did his best to foster.[2]

By the mid-1930s, however, the wheel of politics had turned full circle. In place of the betrayal that scarred Mexican politics in the early 1930s, under the presidency of Lázaro Cárdenas (1934–40) the second half of the decade saw the restoration of at least some faith in the revolutionary process. By the end of the decade, however, the world had been plunged into conflict.

The visions of the modern world created by Rivera, Orozco and Siqueiros between 1930 and 1940 were located within these contrasting realities. For Siqueiros, they formed the basis for a deeply partisan reading of the modern world. In Orozco's case, the contrasts often formed the premise for a judgmental interrogation of the conflict between the ideal and reality. In Rivera's work, the dualities of the modern world were treated to a conflicting combination of positions, either in an uncritical mythologized vision of American modernity or through the rhetoric of his revolutionary socialism.

Rivera spent four years in the United States from late 1930 until 1934 and was the first of the three muralists to portray the modern industrial world of North America. He had been known to some Americans as early as 1915, when Maria de Zayas' small gallery on Fifth Avenue in New York had exhibited a number of his European *pointillist* landscape paintings. In 1924 his reputation in the United States took root as news of his mural work at the Ministry of Education in Mexico City began to spread northwards. The press began to write about Rivera and collectors began to buy his work. In 1929 the American Institute of Architects awarded him the Fine Arts' gold medal in recognition of his fresco work. By the end of 1930 his position as Mexico's leading painter had been assured as far as the Mexican establishment was concerned. This had been underlined by his appointment in 1929 as Director of the Academy of San Carlos with an offer from President Portes Gil to create a post for him in the cabinet.[3] Having been expelled from the Mexican Communist Party in 1929 for his refusal to join political demonstrations against the government and for accepting the directorship of the Academy, Rivera became the target of virulent criticism from former comrades and fellow artists for being, among other things, a 'false revolutionist' and a 'millionaire artist for the establishment'. Abroad, however, Rivera's reputation was decidedly different. In the United States his image was that of a radical Marxist painter, whose work was rooted in depictions of agrarian and proletarian revolution and national anti-imperialist history. When he arrived in the United States in late 1930, Rivera's reputation as the leading exponent of Mexican muralism was therefore well established.

The images that Rivera created while he was in the United States gave rise to highly contradictory visions of the character of modern industrial culture. In large measure much of the spirit of the murals contrasts strongly with the realities of the time, which so closely informed the rhetoric of his own publicly displayed political ideology. Yet in truth Rivera's own position was one of ideological and political contradiction, of strange contrasts. Indeed, there was some irony in that it was capitalist and corporate America that extended the hand of invitation to the erstwhile communist painter to travel north to paint murals, an irony reinforced by the glad acceptance of the invitation.[4]

However, if Rivera's position at this time was one of contrasts and contradictions, then it was no more so than the character of the capitalist modernity that he went north to paint. The country that Rivera portrayed when he was in California and Detroit in the early 1930s was one characterized primarily by the utopian mirage of the 'roaring twenties' and its claim to a society abundant with opportunities, prosperity and material well-being. For Rivera and, indeed, the Marxist socialists with whom he claimed allegiance, the idea of the proletariat ruling and controlling the development of modern technological means of production in order to create a society of abundance and freedom was also a utopian concept. Although they took radically different ideological positions concerning the nature of society, both the proponents of the American dream and those of revolutionary socialism nevertheless shared a belief in the attainability of their ideal. For the American dreamers, the 1920s signified the ideal in the process of becoming a reality. For the revolutionary socialists, the crisis and collapse of industrial capitalism in the 1930s confirmed their belief that the basis for the revolutionary transformation of society had arrived.

With his own penchant for utopian visions, Rivera was captivated simultaneously by the American dream of an abundant mass-producing capitalism in the making, and by socialism's claim to the attainability of a new revolutionary society. Indeed, he seemed to see the former as displaying what the latter would more fairly control and distribute in the future. He was thus able to identify with both ideological positions, as far as is implied through his use and choice of subject-matter.

The pictures that Rivera constructed were for the most part not the gritty realities of ash-can realism, but the romantic visions that had informed so much of his painting in the previous decade, whether it had been his poetic images of the Mexican revolution or the political mythology that he had woven in his visual tapestry of Mexico's national identity on the walls of the National Palace in Mexico City.

Rivera's first mural in the United States at the San Francisco Stock Exchange was typical of this position. Entitled *Allegory of California*, the mural was painted on the main wall of the stairwell leading to the Luncheon Club of the exchange. The origins of

132
Diego Rivera: *Allegory of California.*
Fresco, 1931. The Stock Exchange
Tower, San Francisco, California.

133
Diego Rivera: *The Making of a Fresco,
showing the Building of a City.* Fresco,
1931. San Francisco Art Institute,
San Francisco, California.

124

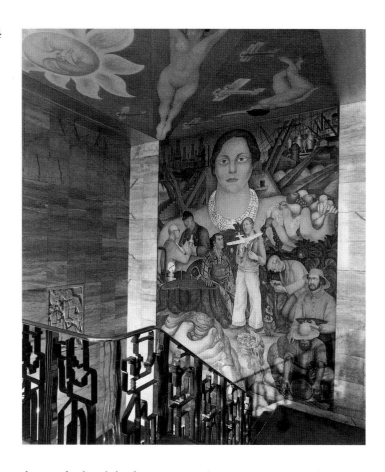

complete the large, 44-metre-square fresco by the middle of February 1931. The central feature of the mural is an enormous portrait of the tennis star, Helen Wills Moody. Young, energetic and attractive, Moody epitomized for Rivera the essence of California which he stated he wished to represent 'with the three bastions of her richness, gold, petroleum, and fruits. Transportation, rail and marine will be motifs stressed, and on the ceiling, energy and speed.'[5] In a reworking of the motif he had originally intended to use at the top of the central arch of his fresco in the National Palace in Mexico City but which he had abandoned in favour of a depiction of revolutionary leaders, Rivera portrayed Moody on the main wall of the stairwell site of the stock exchange. She appears as an earth-mother figure gathering around her the human and natural fruits of the land, seen in front of a landscape dominated by scenes of industry. Below are images of industrial workers and the technicians of modern industry in the state of California, while in the centre Rivera portrayed a young man 'as a symbol of the future . . . facing the sky with a model aeroplane in his hand'.[6]

Rivera's mural at the stock exchange reflects the very obvious excitement that he felt at being in a modern industrialized country. In the panel *Wall Street Banquet* that he had painted on the third floor of the Ministry of Education in 1927, Rivera had depicted the representatives of American capitalism in a highly satirical manner. In San Francisco, while the different aspects of Californian working class are centrally depicted, there is no hint of a critique of the system in which they work. Indeed, the opposite seems to occur, for there is a strong sense of celebration of the productive and creative abundance of the system in which the labourers are engaged. Readings of the mural at the time it was painted underline the utopian aspect of Rivera's image. Emily Joseph, who translated for Rivera, wrote that

the significance of the Californian mural is plain. The heroic figure of California, the mother, the giver is dominant. She gives gold and fruit and grain. California and her riches are here for all. Without the genius of her own sons, her riches would be a dead matter. Under the earth, over the earth, and above the earth, man's will and spirit transform gold, wood, metal into gods that are to liberate the life of man. The idea of liberation is involved in the entire fresco.[7]

the work dated back to 1926 when Ralph Stackpole, a San Francisco-based sculptor who had known Rivera in Paris, returned to San Francisco from Mexico. While in Mexico he acquired two of Rivera's paintings and had seen his work at the Ministry of Education in Mexico City. In 1929 Stackpole, who had been engaged as a sculptor on the decoration of the stock exchange building, persuaded Timothy Pflueger, the building's architect, to offer Rivera a wall for a mural project. Following an agreement on price and with assistance from William Gerstle, the President of the San Franciscan Art Commission, who had facilitated the arrangements for Rivera to travel to San Francisco, Rivera accepted the offer and arrived with his wife, the painter Frida Kahlo (1907–1954) in November the following year.

Rivera executed the Luncheon Club mural with a prodigious display of energy. Beginning in December 1930, he managed to

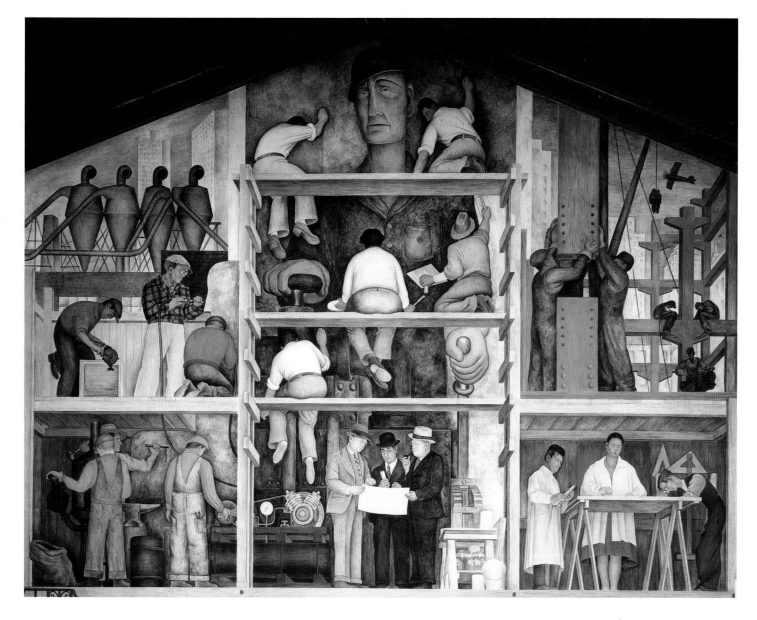

The spirit of the stock exchange mural was clearly emulated in Rivera's second San Francisco mural, painted at the California School of Fine Arts (now the San Francisco Art Institute). He completed this at the beginning of June 1931, after just five weeks of work.[8] The fresco is a pictorial trinity of construction, with a rear-view image of Rivera occupying the centre of the mural. Next to him are his assistants. They are pictured on scaffolding painting a huge mural picturing a construction worker who is surrounded by other images representing the construction of a modern industrial city.[9]

There is no hint of political critique in this mural either. It is worth noting that the Acquisitions Committee of the San Francisco Art Association wanted no part in a political mural. In a letter to William Gerstle, Spencer Macky, Director of the Association, wrote 'The character of the mural might have a very wide choice of subject matter – anything but of a political nature – of course suitable for an art institution.'[10] Although not a particularly significant mural by the standards of Rivera's previous achievements – its composition is stilted and awkward, the figures more mannequin than human – nevertheless it contributes to the overall picture of Rivera's artistic thesis of American industrial modernity. Although the rhetoric of celebration is more muted and distant than at the stock exchange, it clearly echoes the enthusiastic public statements Rivera had made about the industrial modernity of American society. In 1931, for example, he had written 'Become aware of the splendid beauty of your factories, admit the charm of your native houses, the luster of your metals, the clarity of your glass....'[11] Like the stock exchange fresco, the mural seems to affirm the optimistic industrial spirit of America, and excludes any wish to express the

uncomfortable realities of Californian society in the early 1930s. Like some latter-day re-creation of the spirit of the Italian renaissance, the work depicts a world awash with architectural, constructive and scientific enterprise. The dominating compositional device of the builders' scaffold spreads across the whole surface of the mural, conveniently framing every sub-plot of activity and lifting the eye up towards the triangular apex of the wall where the wood colouring of the scaffold poles seems to become part of the actual wooden timber rafts of the studio's roof. The spirit of the mural could not contrast more strongly with the monumental and tragic scene of *Exit From the Mine*, which Rivera had painted earlier in the Ministry of Education's Courtyard of Labour in Mexico City. There, the dark background, the strong artificial foreground light and the crucifixion stance of the miner spoke of the tragedy and bitter exploitation of man. In the Art Institute mural in San Francisco all appears as a collective and equal endeavour towards some magnificent constructive cause.

Both San Francisco murals clearly reflect Rivera's enthusiasm for a truly modernized industrial culture, in this case the United States. Significantly, there is an absence of concern for the origins and identity of his own country, despite the obvious connections that Mexico had with the south-west of the United States. Nor is there any trace of the anti-colonialist sentiments embedded so firmly in his two cycles on the history of Mexico, and which he might have expected to continue, even if only in a veiled way, in the United States.

Rivera's love affair with the dynamism of modern industrial culture found its most intense reflection in the enormous cycle of frescoes that he undertook in Detroit following those that he painted in San Francisco. The Detroit frescoes undoubtedly represent one of the great peaks of his creative powers. The roots of the commission stemmed directly from a meeting with Dr. William Valentiner, the Director of the Detroit Institute of Arts (DIA), at the behest of their mutual friend Helen Wills Moody, in San Francisco in 1931. Enthused by what he had seen of Rivera, Valentiner returned to Detroit and presented to the Institute's Art Commission, whose chairman was Edsel Ford, president of the Ford motor company, the plan for Rivera to come to Detroit and carry out a fresco commission in the Institute of Art. Valentiner wrote to Rivera saying that the Art Commission had decided to ask him

to help us beautify the museum and give fame to its hall through your great work. . . . The arts commission will be very glad to have your suggestions of the motifs, which could be selected after you are here. They would be pleased if you could possibly find something out of the history of Detroit, or some motif suggesting the development of the industry of the town; but at the end they decided to leave it entirely to you, what you think best to do.[12]

Rivera arrived in Detroit in April 1932 to undertake the commission, the theme of which was essentially to be of Rivera's choice. He began his frescoes on 25 July 1932, completing the work less than a year later. Although not without their fair share of controversy (*The Detroit News* of 18 March 1933 ran an editorial calling for the entire cycle to be whitewashed), the frescoes reinforced still further his public reputation.[13]

The city that Rivera portrayed in his fresco cycle was a great industrial complex, which by the late 1920s had become the largest and most technically advanced in the world. By 1927, Ford had introduced his revolutionary automated car-assembly line at the Rouge. This industrial city within Detroit contained all the manufacturing elements for the production of the motor car, including factories producing steel, cement, glass and electrical power. The company also developed ship, tractor and aeroplane manufacture, and owned all the rail and shipping. It was, in short, a vast integrated industrial production centre that had no equal anywhere else in the world. It was this that Rivera sought to depict. He spent nearly three months preparing drawings and sketches for the frescoes. He toured all the plants, making hundreds of drawings and studies for his various scenes. With these and the many photographs taken for him by the company's official photographer, W. J. Stettler, Rivera built up a series of stunning images that gradually dominated the baroque inner courtyard of the Detroit Institute of Arts.

The cycle in the museum's inner courtyard is dominated by two huge central panels on the south and north walls. These are the orchestrated climax to Rivera's vision of industrial production. The north wall depicts the construction of the interior of the automobile, with specific reference to Ford's famous 1932 V8

134 *top left*
South-east corner of the south wall
with scaffolding in place during the
painting of the Detroit fresco.

135 *bottom left*
Rivera posing in front of the north
wall at the Detroit Institute of Arts
during work on the fresco.

136 *top right*
Documentary photograph of a
pressing machine used during work
on the Detroit fresco.

137 *bottom right*
Rivera working on the south wall of
the Detroit fresco.

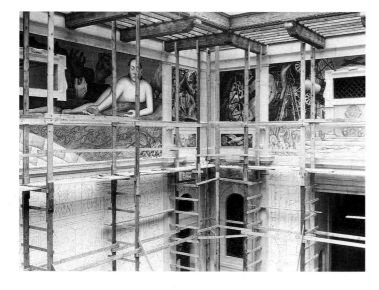

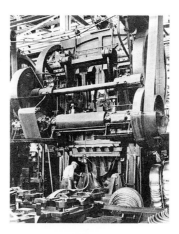

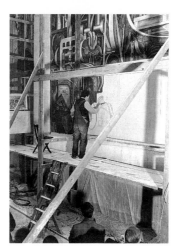

engine. Rivera wove all the various elements in this production
process into a tight rhythmic composition of human and
mechanical movement: blast furnaces making iron ore; foundries
in which moulds for the engine blocks were made; conveyor belts
carrying casting boxes; drilling operations and gear inspections.
Along the bottom of the panel, Rivera represented the different
stages of the worker's day in monochrome, in the manner of an
Italian fresco. In the large panel opposite on the south wall,

THE TECHNOLOGY OF UTOPIA

138
Diego Rivera: *Detroit Industry.*
Fresco, 1933. Detroit Institute of
Arts, north wall, Detroit, Michigan.

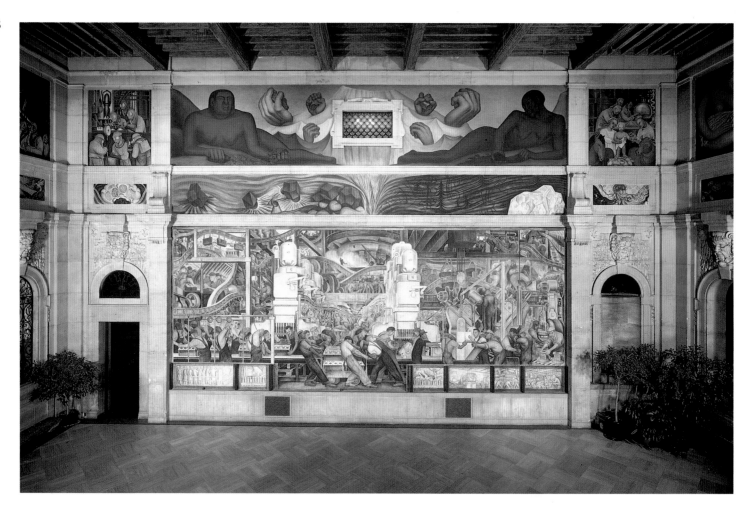

Rivera showed the manufacture of the exterior of the motor car. The great body-pressing machine is shown here among the gears and engines and seems to echo in its configuration the outline of Coatlicue, the Aztec goddess.

Following his customary approach to narrative, Rivera placed these main panels, which were the centre of this theme, among other images showing the human and physical origins from which they sprang. On the east wall, a foetus lying in the soil suggests the origins of life. On the large south and north walls, figures of different races inhabiting the American continent are seen with pictures of the substrata beneath the Detroit landscape. Early agriculture gives way to images of industries in

Detroit other than those of automobile construction, such as aircraft manufacture. Rivera contrasts their positive and negative aspects: on the left-hand side of the north wall, the chemical industry is shown producing gas for warfare; on the right-hand side, its positive and peaceful face is shown in the production and distribution of vaccines for medical purposes.

The cycle of frescoes were unveiled on 13 March 1933. Rivera managed to complete the monumental and complex work in the unbelievably short time of under eight months. His daily work schedule had been punishing; he had driven himself and his assistants to near exhaustion, often working up to fifteen hours a day.[14]

Diego Rivera: *Detroit Industry*.
Fresco, 1932–3. Detroit Institute of
Arts, south wall, Detroit, Michigan.

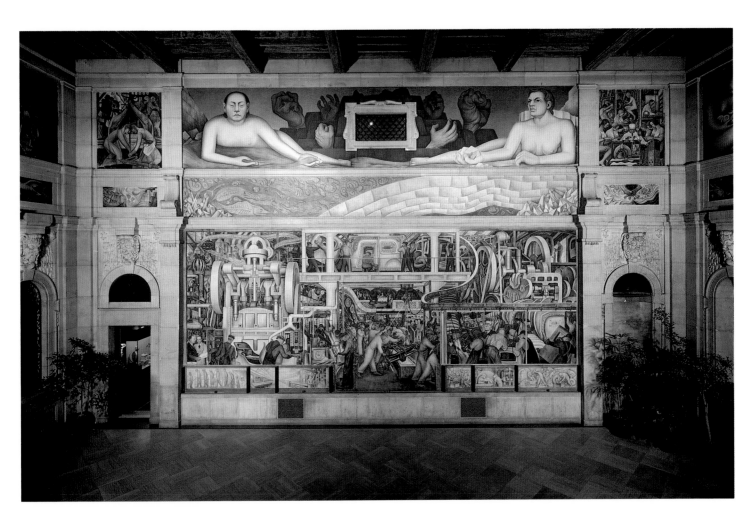

Despite Rivera's largely celebratory and uncritical vision of modern industrial production, the Detroit frescoes did not escape controversy. Criticism centred on religious grounds in the case of the panel depicting the vaccination of the child on the right-hand side of the north wall. The public outcry against this scene was orchestrated by the Reverend Ralph Higgins, a local church leader who objected to the panel on the grounds that it showed 'a fat ugly child, flanked by a nurse and a physician who are engaged in vaccinating the infant. The composition of the portrait', Higgins continued, 'together with animals in the foreground and the golden halo about the child's head combine to suggest strikingly the Holy family.'[15] Another critic, Eugene

Paulus of Loyola University in Los Angeles, considered the panel implied that science would triumph over religion, and accused Rivera of symbolizing religion as 'a great burden on the backs of the people.'[16]

The great paradox of the Detroit murals is embedded in what was an essential dimension of the discourse of Rivera's very public murals during this period of his life, that is, the fracture between the expressive ideal and an all-too-painful social reality. He was fascinated by the genius of organization and the immense productive power of capitalist industry and its modern technology. Clearly the manufacturing industries of Detroit and the new industrial workers employed by them represented for

Rivera, even more closely than the reality that he had confronted in California, the foundations of a great new industrial culture. He painted men and machines as a gigantic symphony, a harmonious synthesis of human and mechanical action, which together represented a potential creative power unparalleled in history. Indeed, in a comment which seemed to imply a belief in the vision of modern capitalist production as the realization of the means to a new society, he described Detroit's use and production of steel as 'the means of a true revolution in modern life all over the world'.[17]

But if this is how Rivera saw industrial Detroit, the day-to-day realities of the life of Detroit's working masses were frighteningly at odds with the utopian vision. E. P. Richardson, the Education Director at the DIA at this time, wrote that Detroit was 'a disaster such as none could have conceived. . . . it was a terrible human situation we were living in while the fresco was going forward – the whole world was collapsing around us'.[18] Detroit in 1932 was a city riddled with gangsters, racism and virulent anti-communism. There was widespread unemployment, and production at Ford was only a fifth of what it had been in 1929. Strikes, soup kitchens and bread lines were a daily reality, and the Ford company's antagonism to organized labour had been well summed up in Henry Ford's dictum 'people are never so likely to be wrong as when they are organized'.[19]

Only a few weeks before Rivera's arrival in Detroit, the city had witnessed a communist-organized hunger strike of 3,000 people at the Ford company's Rouge plant. The demonstration ended in a violent confrontation with the police, in which three people were killed and many more injured and hospitalized. There is no hint of this reality in Rivera's fresco cycle. Indeed, the only slogan in the whole work, 'we want', which is barely visible on the worker's hat in the centre left area of the large centre panel on the south wall, refers to the famous cry of the time, 'We want beer', which was aimed at the repeal of the prohibition laws.

Instead of portraying a fertile political terrain on which Rivera's publicly expressed Marxism might have been expected to bear fruit, he chose to depict a vision of an industrial Detroit unscarred by the onset of the great Depression. The frescoes powerfully reflect upon the synthetic mix of a once real and very dynamic reality and a utopian and mythogenic vision of limitless growth, production and prosperity.

In 1932, only a few months after he had started work on the Detroit frescoes, Rivera, along with Henri Matisse and Pablo Picasso, was approached by John R. Todd, the official architect of the new Rockefeller Centre, which was undergoing construction in Manhattan, New York, to consider undertaking mural commissions for the building. In October that year, Rockefeller was told that Matisse had declined the approach, suggesting that his work would not be seen to best advantage in the building, and that Picasso had also declined. The Rockefellers, however, had been patrons of Rivera for some time. As early as 1930, Mrs. John D. Rockefeller had joined forces with other eminent, wealthy Americans to form the Mexican Arts Association in order to 'promote friendship between the people of Mexico and the United States by encouraging cultural relations and the interchange of fine and applied art'. At the first meeting, Rivera was chosen as the most suitable artist for the association's widely publicized cultural promotion exercise. In 1931, Frances Flynn Paine, an art dealer and advisor to the Rockefellers and a member of the Mexican Arts Association, visited Rivera in Mexico while he was engaged in painting the National Palace fresco to suggest a retrospective of his work take place at the Museum of Modern Art in New York. The Rockefellers had also expressed an interest in Rivera coming to the United States to undertake a mural commission prior to the Rockefeller Centre project. Indeed, in 1931, Mrs. John Rockefeller had suggested that Rivera be invited to paint the mural at Dartmouth College that Orozco eventually executed.

Although keen to commission Rivera, the negotiations were fraught with difficulty. Rivera initially refused to participate in what he interpreted as a competition, and only accepted the commission after the personal intervention of Nelson Rockefeller, and then only after he had secured agreement that the mural be carried out in fresco and in colour, and not as the architects had originally stipulated, a painting in monochrome on canvas.[20] The theme set by Rockefeller was absolute and precise. Its title was *Man at the Crossroads Looking with Hope and High Vision to the Choosing of a New and Better Future*. For Rivera's rich American patron, the mural's content was first and foremost to be

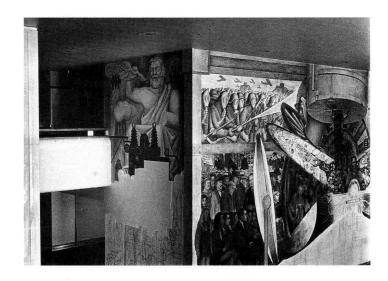

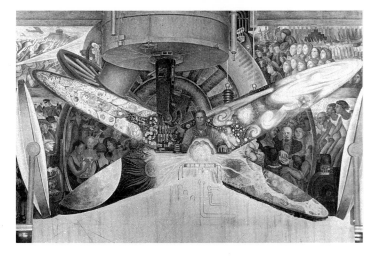

140 & 141
Diego Rivera: *Man at the Crossroads*.
Fresco, 1933. These two
photographs were taken at the time
when Rivera was dismissed from
the Rockefeller Center, and before
the mural was destroyed.
Rockefeller Center, New York.

possession over a map of the world. . . .'[22] In short, the mural was to be a eulogy to revolutionary socialism. What pushed Rivera towards a more overt display of his celebrated public Marxism, in contrast to its absence or at least the muting of it at Detroit and San Francisco, can be understood by reference to the position he found himself in during this time. Criticized by former comrades in the communist movement as an opportunist painter for millionaires, Rivera saw the Rockefeller mural as the perfect premise on which to salvage some political integrity and one which would allow him to create a public mural that would, as he put it, 'continue to have aesthetic and social value – when the building eventually passes from the hands of its temporary capitalist owners into those of the free commonwealth of all society'.[23]

Rivera planned his theme from left to right. The left-hand side of the mural was to depict

human intelligence in possession of the Forces of Nature, expressed by lightning striking off the hand of Jupiter and being transformed into useful electricity that helps to cure man's ills, unites men through radio and television, and furnishes them with light and motive power. Below, the Man of Science presents the scale of Natural Evolution, the understanding of which replaces the Superstitions of the past. This is the frontier of Ethical Evolution.[24]

The right-hand side of the mural was to

represent the development of the Technical Power of man, my panel will show the Workers arriving at a true understanding of their rights regarding the means of production, which has resulted in the planning of the liquidation of Tyranny personified by the crumbling statue of Caesar, whose head has fallen to the ground.[25]

The central area of the mural was to have an image of a telescope and microscope bringing

to the vision and understanding of man the most distant celestial bodies. The microscope makes visible and comprehensible to man infinitesimal living organisms, connecting atoms and cells with the astral system. Exactly in the median line, the cosmic energy received by two antennae is conducted to the machinery controlled by the Worker where it is transformed into productive energy.[26]

philosophical and spiritual, to persuade people to stop and think, above all to stimulate a spiritual awakening.[21]

The portentousness of Rockefeller's own vision of the mural did not seem at the outset to present Rivera with any particular problem. Rivera had written that his mural would show 'Workers arriving at a true understanding of their rights regarding the means of production, which has resulted in the planning of the liquidation of Tyranny. . . . It will also show the Workers of the cities and the country inheriting the Earth. This is expressed by the placing of the hands of the producers in the gesture of

132

The design underwent major changes once it was transferred to the wall. The centre of the mural was no longer as Rivera described it. Instead it had been replaced by the single image of a worker. His description of mothers and teachers occupying the left-hand sections between the ellipses was replaced with a scene of a nightclub, which Rivera described as showing the debauched rich. However, it was the area to the right of centre that was to cause the premature ending of the commission and the destruction of the nearly completed mural, for it was here that Rivera placed his now notorious portrait of Lenin. He had written in his notes that

> In the center, Man is expressed in his triple aspect – the Peasant who develops from the Earth the products which are the origin and base of all the riches of mankind, the Worker of the cities who transforms and distributes the raw materials given by the earth, and the Soldier who, under the Ethical Force that produces martyrs in religions and wars, represents Sacrifice.[27]

Neither in these accompanying notes to the final sketch design, nor in the sketch design itself did Rivera indicate that the central figure of this group, the worker leader, would be Lenin. Indeed, the original drawing contained the figure of a worker wearing a cap, his features representing no one in particular.

By mid-1933, when the mural was nearing completion, reports in the newspapers spoke of a red-coloured mural containing communist demonstrations being painted for John D. Rockefeller.[28] As a result of the publicity that the nearly completed mural was receiving, Rockefeller visited the mural site and wrote a letter to Rivera asking him to remove Lenin's portrait

> As much as I dislike to do so I am afraid we must ask you to substitute the face of some unknown man where Lenin's face now appears. . . . You know how enthusiastic I am about the work which you have been doing and that to date we have in no way restricted you in either subject or treatment. I am sure you will understand our feeling in this situation and we will greatly appreciate you making the suggested substitution.[29]

Rivera refused to comply with this polite but firm request, stating in reply that 'rather than mutilate the conception, I should prefer the physical destruction of the composition in its entirety, but preserving, at least, its integrity.'[30]

Rivera, however, underestimated Rockefeller's resolve. On 9 May Rivera was ordered to stop work on the fresco and told to leave the building immediately. The work was then covered over with canvas and on 9 February 1934 the nearly completed mural was chipped off the wall.[31]

Rockefeller paid Rivera's fee of $21,000 in full. With the money left over, Rivera vowed 'to paint in any suitable building that is offered, an exact reproduction of the buried mural. I will paint free of charge except for the actual cost of materials.'[32] With no suitable wall to paint, Rivera instead painted a series of twenty-one small fresco panels entitled *Portrait of America* in the New Workers' School on West 24th Street in New York.

The public rhetoric that Rivera engaged in following the débâcle of the Rockefeller Centre mural was a manifest change to his approach. The public Marxist Rivera came out fighting. In an article in the *Workers' Age*, written a month after his dismissal, he wrote 'those who gave me the work at Radio City knew perfectly well my artistic tendencies and my social and political opinions. . . . As much for my personal opinions as for historical truth, the outstanding leader of the proletariat is Lenin, I could not conceive or represent the figure of the worker leader as any other than that of Lenin.'[33]

The controversy that surrounded the creation of *Man at the Crossroads*, together with the pictorial evidence of the painting itself, obscured Rivera's dilemma as an artist attempting to express what he conceived as the political and social transformations of the modern industrial age. Despite the weight of their

143
Diego Rivera: *Man at the Crossroads*.
Fresco, 1934. Palace of Fine Arts,
Mexico City.

144 *overleaf*
Diego Rivera: *Man at the Crossroads*
(detail). Fresco, 1934. Palace of Fine
Arts, Mexico City.

133

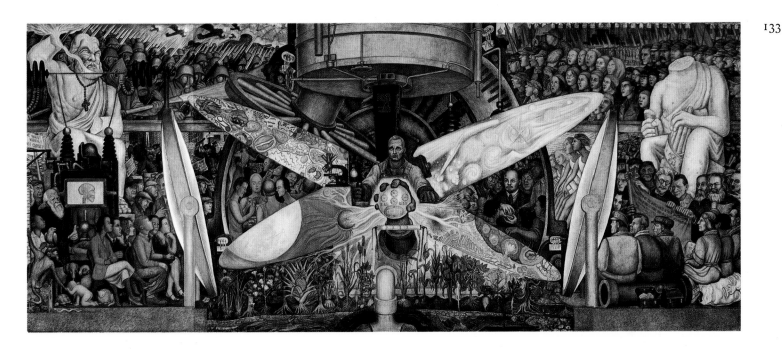

pictorial presence, both the unfinished work and the recreated version in the Palace of Fine Arts, which Rivera painted in 1934 on arriving back in Mexico, were merely rhetorical assertions of faith in the validity of certain assumptions of social change. Like his great work on the history of Mexico in the National Palace, which he still had not completed by the time he left the United States, the Rockefeller mural was the expression of a predetermined idea. Both works were constructed in order to arrive at a particular conclusion. In the former case, it was about the construction of a specific notion of Mexico's national identity, while the latter was about an equally constructed view of capitalism's eventual demise through the inevitable socialist transformation of society.

At Detroit Rivera had sought to express the idea of the seemingly unlimited productive potential of labour power and industrial technology inherent in modern capitalism. In the Rockefeller Centre, on the other hand, he had focused on what he saw as the political consequence of these relations of production. However, it was in this that Rivera confronted his greatest dilemma, for he found that he could say little more about twen-

tieth-century society that would not in the future be seen either as a retreat from his own publicly proclaimed political ideology or as a stale repetition of assertions stemming from that ideology. Now, in the light of recent political events, both the rhetoric and the assumptions seem to have been transformed into hollow myth, no longer even legitimized by widespread belief or faith in the veracity of its claims. Rivera would only succeed in the future by returning to themes that were historical or largely Mexican in orientation. By the end of 1935, having completed the final panel of the National Palace mural, Rivera found himself at a crossroads. His position as the foremost painter of the Mexican mural movement was rapidly being overtaken by José Clemente Orozco. Orozco's ferocious and powerful pessimism provided a dramatic contrast to the lyrical commentary of Rivera's idealistic and mythogenic assertions concerning modern industrial culture and its social reality. Less 'literal' and descriptive, Orozco's work of the 1930s, in which the artist sought to engage with and express the spirit of the modern industrial age, was much more realistically evocative of the painful cultural and social realities of the times, both in his own

THE TECHNOLOGY OF UTOPIA

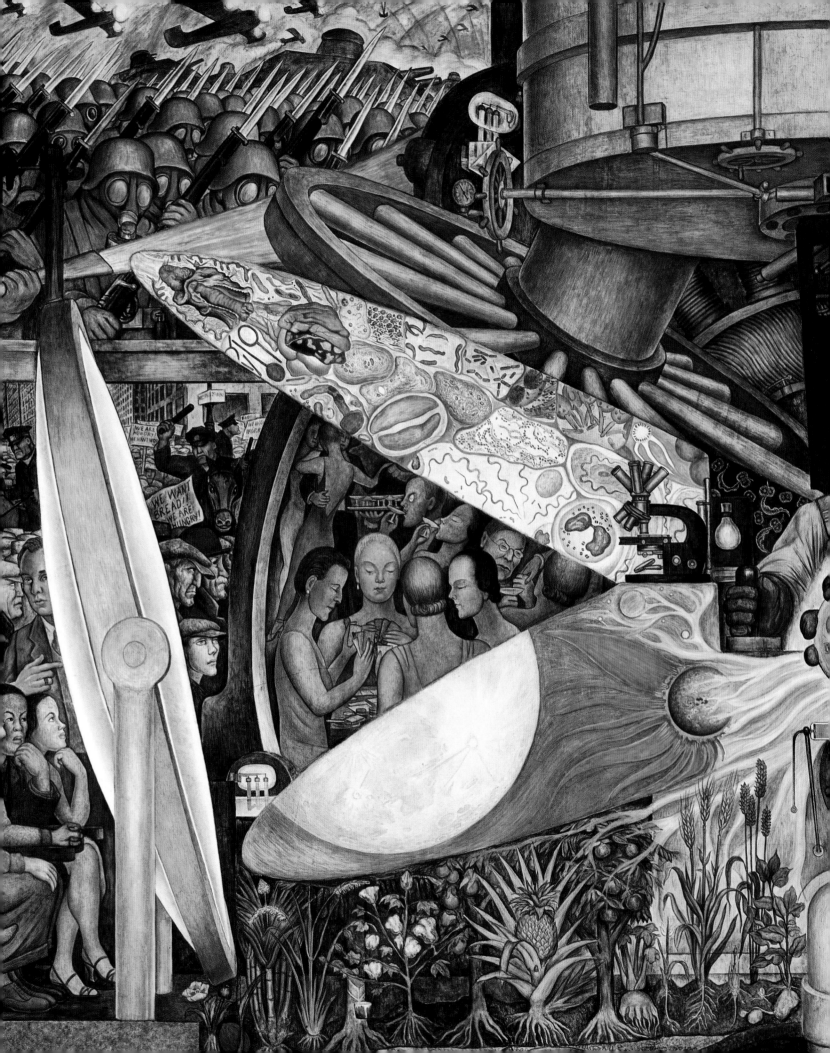

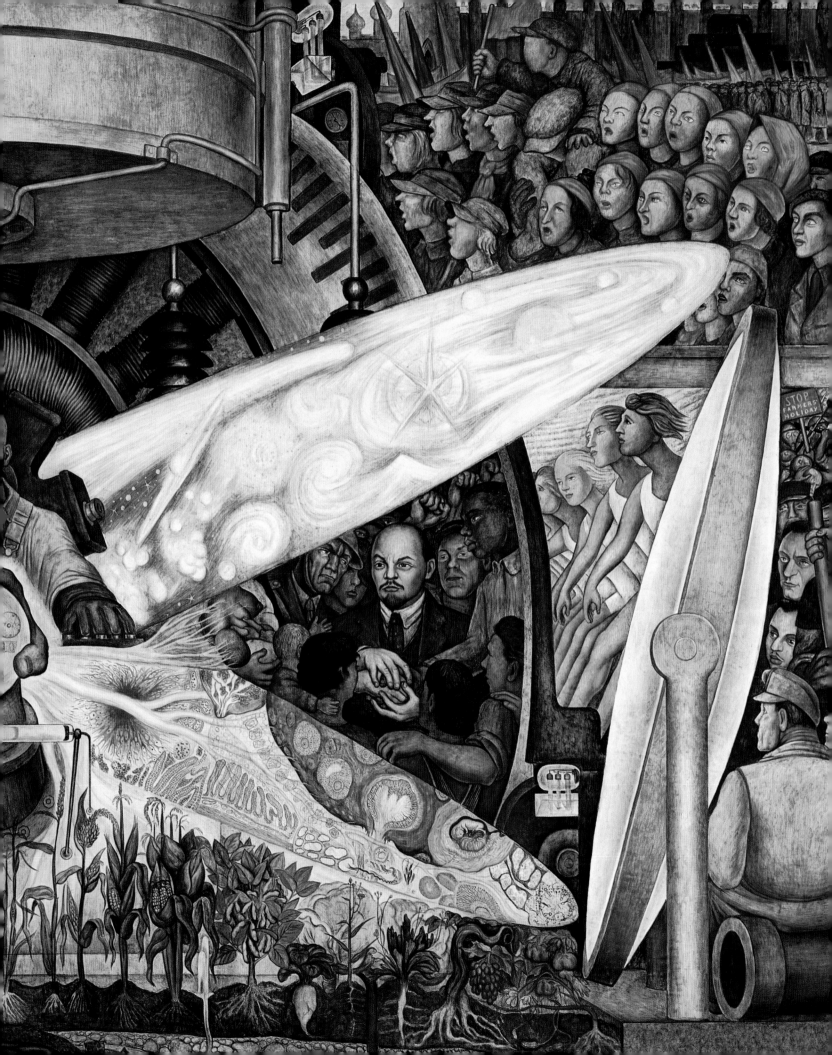

country and the world at large. Yet for all the grandiloquent weaknesses of the Rockefeller work and of Rivera's panels in *Portrait of America*, the Detroit frescoes had indeed been a triumph. Rivera's mentor from the time that he spent in Paris, Elie Faure, spoke of 'the poetry of the machine which was born in the frescoes in Mexico and San Francisco dominates those of Detroit: flames escaping from drills, dazzling crackling motors, silent and dancing rhythms of rods and pistons – all these beat the cadences of a new march, the rehearsals of a still hesitant humanity'.[34]

Whereas Rivera's engagement during the 1930s with the presence of modern industrial and political culture in his most successful mural work had often been a poetic, even romantic discourse, Orozco's vision was that of both the agnostic and the atheist. For Orozco, the paradigms of the contemporary world were an encyclopaedic display of entrapment, unfulfilled promise, menace and betrayal. Much less literal in his visual references than Rivera, Orozco nevertheless captured the essence of rupture of the hope that the political, industrial and cultural ideal of modernity offers up to humanity, which humanity destroys in violent conflict.

Unlike Rivera, whose visions of the modern industrial world of the 1930s were predominantly confined to the context of the United States, Orozco's murals during this period were situated in both America and Mexico. Orozco had gone to the United States in 1927. For more than three years, his work as a painter was confined to the easel, to drawing and the lithograph. His experience in the United States clearly influenced his thinking with regard to the concept of a modern culture. In an article published in 1929 he had written

The art of the New World cannot take root in the old traditions of the Old World, nor in the aboriginal traditions represented by the remains of ancient Indian peoples.... Already the architecture of Manhattan is a new value, something that has nothing to do with the Egyptian pyramids, with Paris Opera, with the Giralda of Seville or with Saint Sofía any more than it has to do with the Maya palaces or Chichén Itzá or with the 'pueblos' of Arizona.[35]

Although by no means his most important works – indeed by the standards of his other murals, they are awkward and rigidly conceived, both compositionally and thematically – the frescoes that Orozco completed in 1931 at the New School for Social Research in New York are perhaps the first example of Orozco engaging in an ideological dialogue with the cosmopolitan modern age using the mural form. The frescoes were painted shortly after he completed his mural at Pomona College in Claremont, California, where he had used the image of Prometheus, the symbol of knowledge bringing fire to mankind. Both the fire and the echoes of this Promethean theme figured prominently throughout the rest of the decade in his murals as telling and evocative images in his powerful vocabulary of commentary on the modern world.

The commission for Orozco to paint murals at the New School for Social Research was gained through his benefactor, Alma Reed, who used her connections with one of the school's instructors, Lewis Mumford, to contact its director, Alvin Johnson. Johnson, who already admired the work of Orozco, agreed to include Orozco in his plans for works of art in the school.[36] The parameters he laid down for the theme and subject-matter of Orozco's mural were to 'work within the framework of contemporary life'.[37] In his later descriptions of the murals, Johnson noted that Orozco 'chose to depict the revolutionary unrest that smolders in the non-industrial periphery, India, Mexico and Russia'.[38] Although the murals are clearly influenced by the thinking of Alma Reed and the Ashram community she had started and to which Orozco belonged, nevertheless they are significant for the way in which Orozco chose to portray the ideologies of modern political discourse. The cycle, painted in a small, low-ceilinged room that is now a classroom, contains panels depicting *The Homecoming of the Worker of the New Day, Tale of Brotherhood and Universality, Socialism* (Yucatán) and *Communism* (Russia) and *The Orient*; outside in the passageway is the *Allegory of Science and Labour*. None of these panels contains any indication of the characteristically tragic view that appeared in the murals Orozco painted later in the decade. Indeed, for the most part the frescoes are positive, unproblematic portrayals of the principal political and ideological figures of the contemporary world, or equally optimistic renderings of the worker in the modern age. Lenin figures prominently in one mural. In the panel of Mexican socialism, the portrait of Carrillo Puerto almost heroically

THE TECHNOLOGY OF UTOPIA

138

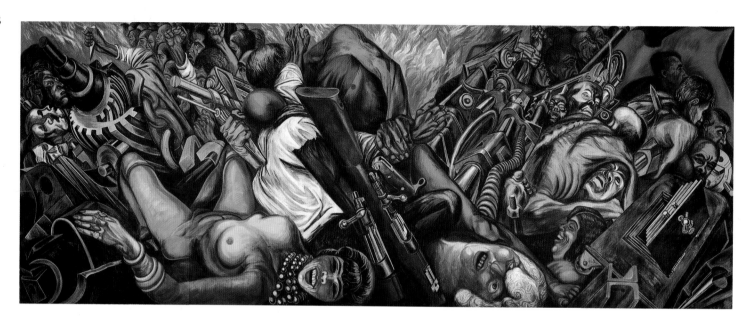

dominates a massed group of Mexican peasants, while Indian nationalism is depicted in *The Orient* panel by the figure of Mahatma Gandhi sitting serenely opposite figures representing British colonialism.

Conceived within the rigid framework of Dynamic Symmetry, a compositional theory developed by Jay Hambridge, Orozco's murals were anything but dynamic. In spirit, so unlike his work during the rest of the decade, the New School murals are important for providing an absolute contrast against which to read his later work.

Although Orozco's apocalyptic vision of the modern world with its themes of mechanization and spiritual entrapment, political and moral betrayal, false leadership and blind conflict are contained within his cycle on the history of North American civilization at Dartmouth, the first real hints of his expressive pessimism came not in a mural but in an easel painting of 1931 entitled *The Dead*. The painting's image of a crowded cascade of crumbling modern buildings forms a discursive and aesthetic link between his 1926 fresco panel, *Destruction of the Old Order* at the National Preparatory School in Mexico City, and his devastating 1934 mural *Catharsis*, painted at the Palace of Fine Arts in Mexico City following his return from the United States.

Although the 1926 panel had symbolized the revolutionary demise of the old regime in a compositional montage of collapsed and collapsing classical architecture, its spirit was nevertheless a blend of nostalgia and optimism. By contrast, the easel painting of *The Dead* is a cataclysmic picture of disjointed, fractured buildings crumbling into a dynamic maelstrom, where humanity is conspicuous by its absence.

In *Catharsis*, humanity is present, and its predicament is frighteningly expressed. Using the same axial compositional device as that of the 1931 canvas, and which Orozco evidently employed to express conflict and cataclysm, the fresco depicts a humanity locked into a violent and self-consuming conflict of spiritual entrapment and moral decay. Against a flaming background, at the right-hand side of the composition human beings are portrayed being sucked into a mechanical quicksand. An open safe seems to symbolize theft. A dagger thrust into the back of a man to the hilt speaks of horrifying violence. At the left is an evocative image of a human torso transformed into a monstrous cogwheel leading a heckling mass in an onslaught of murderous intent upon a group of individuals fast disappearing under the weight of this mechanical mass. The centre and foreground are dominated by images of rifles, further self-consuming violence,

and a hysterically laughing, whore-like figure, whose open thighs seem just to have given birth to the monstrous human cogwheel in the upper left portion of the fresco.

Painted as it was so shortly after Orozco's return from the United States, both the spirit and the imagery of this powerful fresco are clearly commentaries on modernity. In the United States, the idea of the modern age had conspicuously brought into the foreground the use and development of industrial production as the generator of prosperity and the fulfilment of human desire. Yet Orozco's fresco employs the vocabulary of an industrial age in the throes of a crisis. By the time he left the United States, he had witnessed a country that had descended from apparently abundant prosperity into economic and social catastrophe. His country had gone through its own crisis and betrayal in the early 1930s when the pursuit of power had usurped the notion of the political ideal. In *Catharsis* Orozco did not even allow himself the luxury of an ideal against which he could set his portrayal of the modern world, nor was he prepared to acknowledge the sense of national optimism that Mexican political society was again experiencing with its newly elected and radical president, Lazaro Cárdenas. Instead, in the starkest of terms, the mural is a foreboding of the fire that would consume the modern world five years later as it descended into the Second World War. Painted in the same building and at the same time as Rivera's *Man at the Crossroads*, which it faces, *Catharsis* offers an uncompromising reality and contrast to Rivera's grandiloquent rhetorical vision of the future.

Upon the completion of this mural, Orozco accepted what were to be the most significant commissions of his career, in Guadalajara in the state of Jalisco. The Guadalajara murals, which include those on the history of the Spanish conquest painted in the Hospicio Cabañas, are a return to a more Mexican context in terms of their subject matter. Yet despite this, they also function as an incisive commentary on the contemporary world. They represent a continuation of thematic motifs that had already appeared in Orozco's work, those of struggle, betrayal, self-consuming violence, and the disparity between the ideal and reality. Orozco's ideological position was profoundly at odds with that of Rivera and Siqueiros. For him, the ideal of freedom could not be gained by joining a political party of the left, as his

two compatriots had done. Indeed, throughout his life his position was that of committed non-alignment. But he was far from being an anarchist as suggested by some of his critics, and vehemently rejected such charges: 'Those who say I am an anarchist do not know me. I am a partisan with absolute freedom of thought, a real free thinker: neither a dogmatist nor an anarchist: neither an enemy of hierarchies nor a partisan of unyielding affirmations.'[39] In an examination of freedom as an ideal, Orozco expressed himself in his work in ways which many found contradictory. Wherever he saw the call for freedom being tarnished by an impostor, he brought a ruthless criticism to bear on its usurpers, however fine their rhetoric and however pure the colour of their banners. Yet his sharp criticism of the social world was only one aspect of the stand that he took, for he seemed to accept both good and bad. It is within these unities and polarities that Orozco's political, moral and philosophical discourse on the modern world is to be found in Guadalajara.

The first of the cycles was painted in the assembly hall of the University of Guadalajara and was begun in 1936. The cycle consists of two separate murals, one high up in the huge cupola of the building, entitled *Creative Man*, depicting a synthesis of the most noble qualities within humanity in the form of images of the worker, the philosopher-teacher, the scientist and the rebel. The four large figures are portrayed against a deep red background and occupy the whole of the cupola. The scientist, whose head faces in several directions simultaneously, represents the inquiring human mind seeking knowledge through discovery and invention. The figure of the worker – technical and constructive man – appears to emanate from a strange, hooked machine complex, while the hands clasp a lever. In the relationship of the other two figures, the philosopher-teacher and the rebel, Orozco postulates an ideal between thought and action.[40] The rebel, whose body projects strongly down towards the viewer, is shown constrained by a rope around his neck, the symbol of his oppression. In one of his hands he holds a swirling red flag which flows over to form the background to the didactic gesture of the philosopher-teacher. The clasped hands of the rebel and the philosopher, just visible at the edge of the cupola, cement this unity of thought and action, the physical and intellectual aspects of progress.

THE TECHNOLOGY OF UTOPIA

147
José Clemente Orozco: *The Rebellion of Man – The Leaders*. Fresco, 1936. University of Guadalajara, left-hand panel, Mexico

148
José Clemente Orozco: *The Rebellion of Man – the People and Their False Leaders*. Fresco, 1936. University of Guadalajara, centre panel, Mexico.

149
José Clemente Orozco: *The Rebellion of Man – The Victims*. Fresco, 1936. University of Guadalajara, right-hand panel, Mexico.

150 *opposite*
José Clemente Orozco: *Creative Man*. Fresco, 1936. University of Guadalajara, Mexico.

140

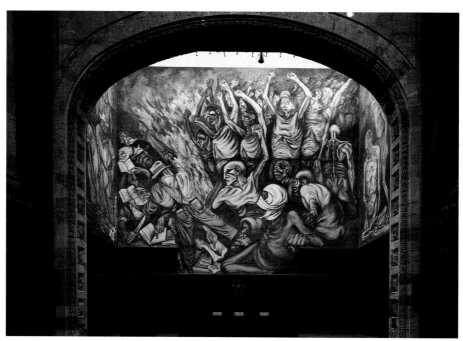

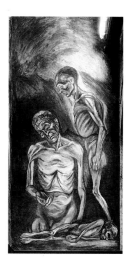

In the mural below, however, Orozco expresses the duality of thought and action in a different light. Here, his subject is not the realm of human ideal but that of a real, modern human experience. *The Rebellion of Man* represents the rebellion of the masses against their exploiters. However, the exploiters are not greedy, stereotypical capitalists, but prophets of a false ideology, whose henchmen's despotic presence seems to promise the continuation of misery, poverty and starvation. The presentation of this bitter and angry theme is subdivided into three constituent parts. Each part occupies a separate panel of the niche and conveys its own subject and character, which, in an almost Brecht-like way, Orozco plays off against the subject of the adjoining panels. The central panel, *The People and Their False Leaders*, forms the introduction to the theme. Orozco has placed a mass of wretched, emaciated people against a flaming background. In their anger and desperation, they gesticulate at a group of men to their left – the ideologues of modern social revolution. The bearded figure with dark glasses to the left,

wielding a knife and pointing to the pages of a book has a notable resemblance to Karl Marx, while the face of the figure in the upper background could easily be a caricature of Leon Trotsky. The figure in the foreground, holding a book in the left hand and a carpenter's saw in the right, could be that of Siqueiros.

In the two narrow adjoining panels showing corrupt leaders and the suffering masses, Orozco presents the reasons for his expressive anger. In the left-hand panel, *The Leaders*, three ape-like figures represent the presence of a new set of power-seeking *caudillos* (political bosses), who have arisen as a consequence of false leadership and now have a pretext for revolt. Their swaggering stance and menacing sledgehammers, together with the pile of books and rifles at their sides express the imposition by force of the ideologies contained in the books. The physical attributes of the figures in the foreground indicate that Orozco intended the panel to be a criticism, not of organized labour, but of some of its more notorious Mexican leaders.[41]

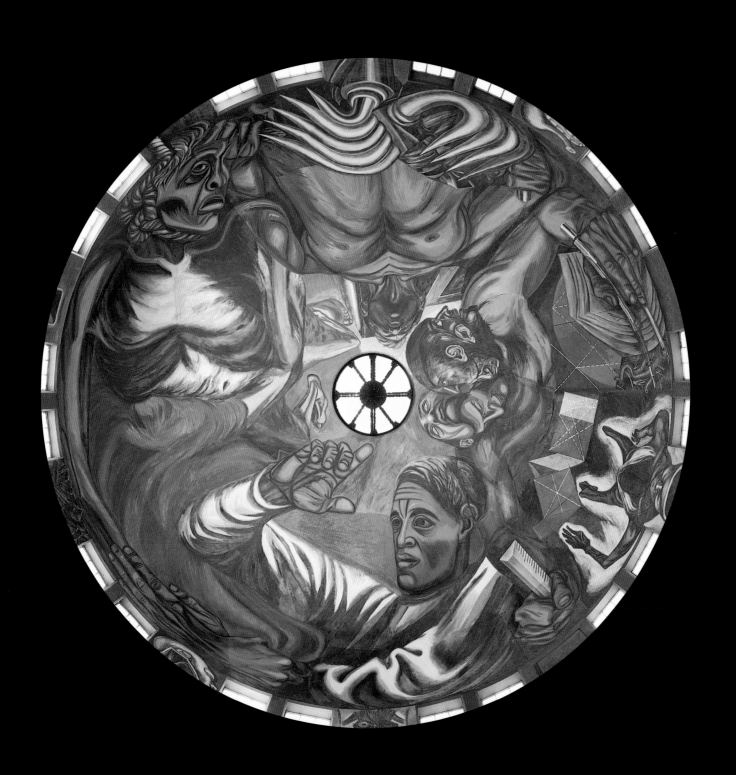

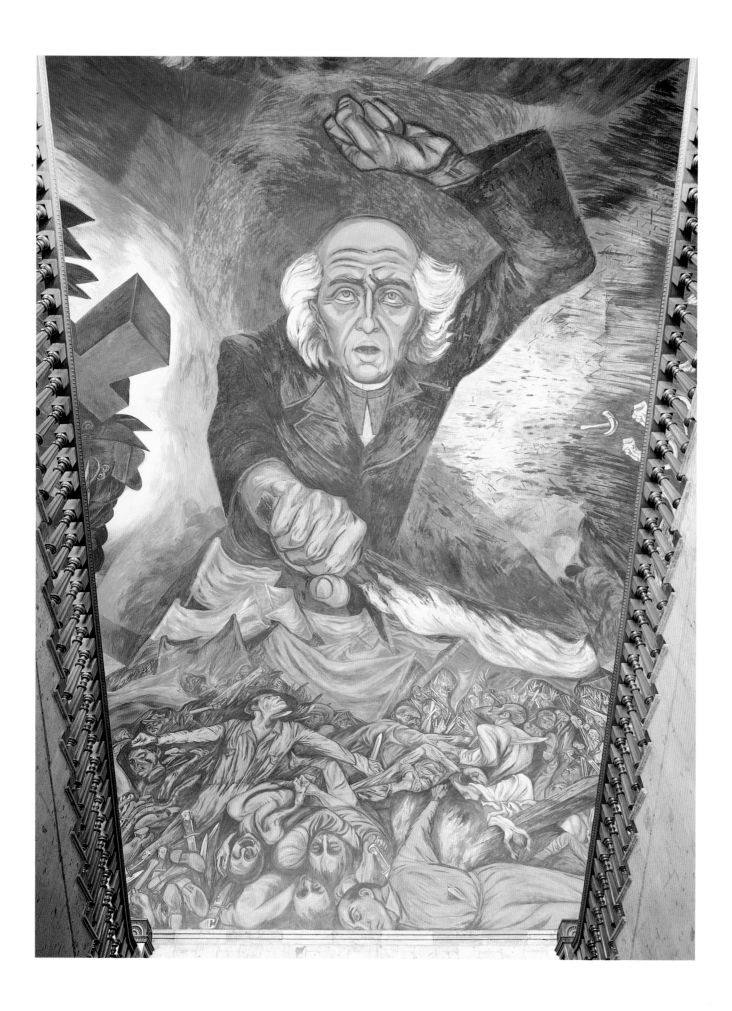

151
José Clemente Orozco: *Hidalgo*.
Fresco, 1937. Governor's Palace,
Guadalajara.

The right-hand panel, *The Victims*, is a display of emaciated and tragic figures. Taken together, the three panels can be interpreted as a commentary on what Orozco saw as the betrayal of the Mexican revolution during the early part of the decade. But painted as it was at the beginning of what was also one of the most radical and politically optimistic times of Mexico's post-revolutionary experience, the mural can simultaneously be interpreted as a thesis on what Orozco saw as the questionable assumptions of modern ideological political revolutions, in which the liberation of the masses seems to be sacrificed. Whatever its critical specificity, the theme of contemporary revolt was one that Orozco repeated in his second cycle, on the walls of the main staircase of the governor's palace in Guadalajara.

In this second cycle, a figure from Mexican history, Miguel Hidalgo – the priest and father of Mexican independence in the nineteenth century – is used to deliver a commentary on the contemporary world. As a champion of the Indian, the poor and the oppressed, the figure of Hidalgo is synonymous in the Mexican mind with the struggle for independence. However, although the principal figure is Mexican, the thrust of the work's commentary transcends strictly national boundaries. Apart from the figure of Hidalgo, the work contains no other specifically Mexican references.

The cycle was begun in 1937 and is painted around three large adjoining walls above a grand staircase. The walls converge at the top in a sweeping curve that then drops down towards a series of arched entrances leading on to an upper-floor corridor. The figure of Hidalgo occupies the whole of the upper part of the central wall, rising vertically from its base and arching over the staircase. The effect of this is to present Hidalgo as a giant, physically dominating the whole area beneath him. Below Hidalgo is an image of the now familiar cataclysmic revolt: a hoard of emaciated figures are seen bludgeoning and knifing each other to death among a sea of red flags and flames. The conflict is one of total confusion and despair.

On the walls to the right and left Orozco painted images that provide a context for this confusion. On the left, *The Phantasms of Religion in Alliance with the Military* expresses the dark, mystical and demonic forces of the clerical and military establishment. It

is a reference to the role played by these forces in Mexican history. On the right, in *The Carnival of the Ideologies* Orozco lambasts the contending ideologies of the political left and right of the twentieth century.

The figure of Hidalgo and the struggle depicted below him is a reworking of the idea expressed in the relationship between the philosopher-teacher figure and the rebel in the assembly hall of the university. Yet instead of calmness, here Hidalgo suggests a messianic urgency, his clenched fist echoing that of Christ in Michelangelo's *Last Judgment* (1508–12; Sistine Chapel, Rome). Orozco used these two side panels in a similar way to his book-wielding ideologues and brutish political leaders in the assembly hall. In each cycle, the figures symbolize the confounders and oppressors of the masses. As if to underline the nature of Orozco's criticism of modern political ideology, the image of the red flag covering the face of the military figure in *Phantasms* is unmistakable. It is a reworking of the idea that he had employed a decade earlier in the National Preparatory School in *Revolutionary Trinity*, where the red flag symbolized a loss of direction in the revolutionary struggle. At Guadalajara, the image has the more threatening connotations of modern ideological dogma leading to political despotism aggravated by its militaristic aspects.

For Orozco, the images of the left and right walls at the governor's palace symbolize both the historical and the contemporary political and ideological forces that have distorted the cause for which Hidalgo fought. Hidalgo depicted in Messianic purity is not the ideal but the instigator of an ideal, a catalyst in a rebellion and struggle that becomes lost in confusion and despair in the modern world.

At the university in Guadalajara as well as at the governor's palace, the physical separation of the ideal and reality in each cycle is a constant feature. The lower sections of both murals contain material that is severe, critical, pessimistic and often nihilistic, whereas the upper sections express affirmation and are inspirational and idealistic in tone. This is the domain of human ideals, intellect and hope. This polarity is reflected in the colour schemes Orozco employed in the upper and lower sections of each mural. The lower sections are generally austere in colour, bordering on the monochromatic. Acidic greys are highlighted

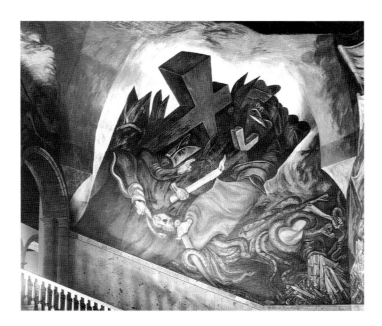

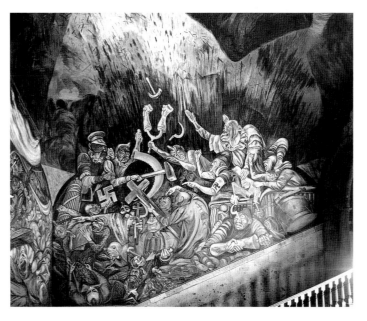

with flecks of white in the figures. The drawing is satirical, gestural and expressionistic, conveying anger and bitterness. Conversely, the drawing in the upper sections of the cycles is much clearer and more monumental, even classical; likewise, the colours are brighter and the tones more brilliant.

Orozco's dualistic approach is also reflected in his imagery. The red flag changes dramatically in meaning in different contexts. In the cupola of the university, it is an emblem of solidarity, while on the staircase of the governor's palace, it expresses the opposite – tyranny, exploitation and cruelty – and is literally portrayed as a blindfold. Perhaps the most impressive and telling of all the motifs employed by Orozco in Guadalajara is the image of fire. It features as a raging conflagrational background in the lower mural at the university, as a firebrand in the hands of the monumental image of Hidalgo on the stairs of the governor's palace and appears in the famous cupola image at the Hospicio Cabañas. It is an evocative visual symbol of conflict, pain and suffering, of purification and inspiration, its meaning, like that of the red flag, dependent on the context in which it was used by Orozco.

In 1940 Orozco was commissioned to paint a fresco panel for the Museum of Modern Art in New York, and he chose to return to the theme he had explored in *Catharsis*, the oppression of humanity by a mechanized modernity. Entitled *Dive Bomber*, the mural portrays human heads crushed beneath the heavy weight of a composition of gigantic mechanical parts, heavy chains and conveyor belts. As in the images of the murals at Dartmouth College and the Hospicio Cabañas, as well as in *Catharsis*, Orozco 'seems to be trying to say here that in modern society based on industry – or rather capitalism – the machine dominates human dynamism, iron dominates flesh, matter dominates the mind, and militarized mass dominates man'.[42]

Another dimension that was increasingly embedded in Orozco's mural work of this decade was the mindlessness of the masses, perhaps the most questionable of Orozco's discourses on the modern world. This theme would emerge more fully in the murals that he painted at the end of the 1930s in the Gabino Ortíz Library in Jiquilpan. In his expression of ideological betrayal and mechanized oppression, Orozco seems to see little hope for a humanity free from the most dire consequences of the

modern apocalypse. Their revolutionary ideals betrayed, their sense of direction lost, the revolutionary masses in the lower panels in the Hospicio Cabañas become nothing more than caricatures of a modern humanity, spiritually dislocated and distorted. They are no longer tragic, for they have been transported into a hideous farce.

The profoundly critical spirit that permeates so much of Orozco's work at Guadalajara is in striking contrast to the radical optimism that attended the Cárdenas administration (1934–40). It is worth recalling that Orozco painted these murals in a city at odds with the radical agendas of Cárdenas. It is perhaps also reasonable to suggest that Jalisco's conservative governor, Don Torpete, saw an important political and cultural opportunity in inviting Mexico's leading iconoclast back to the place of his birth to paint murals in the city's most prestigious public buildings. In so doing both he and Orozco were making a gesture against the hegemony of Mexico City, with its leftist, nationalist rhetoric and radical cultural and political agendas. That Orozco created such a powerful and critical discourse in Guadalajara emphasized the nature of the gesture, even if there was no overt collusion in its making.

During the decade of the 1930s, the work of Rivera and Orozco had provided contrasting expressions of the same reality. Their work diverged most in terms of the character of their commentary. Certainly their style of painting and their pictorial formulations also differed. However, as far as their murals were concerned, neither Rivera nor Orozco displayed a need to revolutionize the aesthetics of their work in relation to the means or the materials of execution. Although the age of technology and the social realities of the modern world were often the subject of their pictorial comment, neither factor directly influenced the physical characteristics of their creativity at this time. Indeed, both painted in the fresco medium, a time-honoured tradition for mural painters that extended back over many centuries. By contrast, the working practices of Siqueiros as a mural painter were profoundly influenced by the technical innovation of the modern industrial age. His drive to revolutionize the means of creating murals during the 1930s is thus as much a commentary on the age of modernity as is his powerful imagery.

Siqueiros began the decade of the 1930s in prison, following his participation in a May Day demonstration. Released in November 1930, he was sent into internal exile for a year in the silver-mining town of Taxco, where his movements were tightly controlled and he was forbidden to leave the town without the permission of the police. The year in Taxco was important to Siqueiros' development as an artist, for not only did he produce much studio work during this time but he also met with a number of important foreign writers, intellectuals and artists. Among these the most significant was the Russian film director Sergei Eisenstein, who was in Mexico at the time making his film ¡Que Viva México!.[43]

Siqueiros' friendship with Eisenstein during his time in Taxco was of fundamental importance for his approach to the analysis and use of pictorial form. It is quite clear that by the time Siqueiros left Mexico in May 1932, he believed that the technically innovative character of the modern industrial world would require a profound transformation in the methodologies and aesthetics of artistic practice.

Like his two compatriots, in the early 1930s Siqueiros found himself in the United States. In 1932 he went to Los Angeles, a move that was as much the result of the political pressure from the Mexican government as his wish to fulfil an invitation to hold an exhibition of his work in the city.[44] While in exile in Taxco, Siqueiros had come into contact with Mrs. Chouinard, the director of the Los Angeles-based Chouinard Art School. Chouinard was keen to transform her school into a progressive centre for modern art and had invited Siqueiros to give a course in fresco painting.[45] Accepting the offer, Siqueiros ended a six-year break from mural painting. It also provided him with the opportunity to immerse himself in what became a major pre-occupation: experimentation with new modern techniques and methods for creating murals.

Siqueiros created five murals during the 1930s: three in Los Angeles, an experimental work in Argentina, and his first great mural, Portrait of the Bourgeoisie, which he began at the Electricians' Union in Mexico City in 1939. The first of these, at the Chouinard Art School, arose out of the fresco course he had been invited to teach there. As originally envisaged, the course proved far too limiting in its scope for Siqueiros.[46]

I searched for an adequate wall, but there did not exist anything convenient inside the school. . . . In despair at not finding anything adequate I located an exterior wall. But this wall was on the front part of the school and this front had six windows and a door. The best thing for learning fresco painting, I told the proprietor, was just such a problem. And this was a very interesting problem.[47]

By using the exterior face of the school, Siqueiros confronted formidable difficulties that demanded a radically innovative approach to the use of materials and techniques to combat rain, sunshine and walls of rough concrete. In consultation with the architects of the building, Richard Nuetra and Sumner Spalding, Siqueiros devised a solution which involved painting on a mix of waterproof white cement and sand while the cement was still wet, thus ensuring the chemical bonding of the pigment to the cement base while the latter was drying. However, in devising this solution Siqueiros and his student group encountered the problem of the rapidity with which the cement dried in the hot Californian sun, allowing only small areas to be painted at a time. Siqueiros duly solved this by abandoning paint brushes, using instead a compressor and a spray gun. This allowed for the rapid painting of much larger areas at a time.

Other innovative procedures were employed in the Chouinard mural, some of which stem from Siqueiros' relationship with Eisenstein. Siqueiros wrote

After making our first sketch we used the camera and motion picture to aid us in the elaboration of our first drawing, particularly of the models. To draw our figures from posing models would be like reverting to the ox cart for transportation. . . . To replace the slow and costly method of pencil tracing and poince-pattern projection we used the photographic projector, a method of enlarging . . . and thereby project-ing our drawing directly onto the wall.[48]

Besides his use of innovative methods and materials, Siqueiros created a mural team out of his class and some graduate students which he called 'The Block of Mural Painters'.[49]

The Chouinard mural was inaugurated on 7 July 1932. Enti-tled *Street Meeting*, it met with a mixed public reaction. Some attacked it for its overtly political subject-matter. One magazine wrote that 'the art of fresco in this country will languish until it is able to free itself from the sorrows of Mexico and the dull red

glow of communism'.[50] Certainly the image depicting a workers' meeting implied an agitational and propagandist approach, par-ticularly since its setting was a very public and exterior one in a city whose authorities were stridently against labour unions. Arthur Miller described the central scene as 'a red shirted orator haranguing the hungry people. On either side of the soap box and listening very intently were a black man and a white woman each carrying a child.'[51]

The completion of this first Los Angeles mural represented a major step forward for Siqueiros. It allowed him to incorporate a whole range of innovative techniques, materials and methods into his working practices, some of which neither he nor other mural painters had used before. The mural made a substantial impact on the cultural community in Los Angeles. As a result, Siqueiros was asked by F. K. Krenz of the Plaza Art Center in Olvera Street to undertake another mural. This second public work in Los Angeles, entitled *Tropical America*, was much larger than the previous piece, stretching over eighty feet along the length of a hall housing the Plaza Art Center. More important than its dimensions was the fact that the centre was situated in the middle of the area of Los Angeles where most of the city's Mexican population lived.

Tropical America provided Siqueiros with the opportunity for more emphatic political content than his previous mural. For him, tropical America meant 'our land, our America, of under-nourished natives, of enslaved Indians and Negroes, that never-theless inhabit the most fertile land in which the richest and most ferocious people on earth lie. And as a symbol of the United States' imperialism, the principal capitalist oppressor, I used an Indian crucified on a double cross, on top of which stood the Yankee eagle of American finance.'[52] The obvious militant and agitational content of the Plaza Art Center mural was set against the context of a California in which thousands of Mex-ican migratory workers lived and suffered in the most wretched social conditions and whose efforts to improve their circum-stances were continually and ruthlessly crushed.[53] The mural provides a clear example of how profoundly different Siqueiros' work was from any of the works Rivera created in California. Rivera largely eschewed depictions of or comments on the pain-ful political realities existing in California at the time, with which

154 *top*
David Alfaro Siqueiros: *Tropical America*. Fresco, 1932. Exterior of the Plaza Art Center, Olvera Street, Los Angeles, California. The mural has been partially painted over and has suffered bad deterioration.

155 *bottom*
Study drawing for *Tropical America*.

he might have been expected to identify through his Marxist ideology. Unfortunately, due to the original whitewashing and the decay of the paint surface, both the Chouinard mural and *Tropical America* to all intents and purposes have ceased to exist.

In the execution of *Tropical America*, Siqueiros employed the same innovatory practices that he had used in the Chouinard mural, although here he allowed for the reintroduction of the brush in order to refine the somewhat insensitive forms rendered through the use of the airbrush. The introduction and use of the photograph and projector in both of Siqueiros' Los Angeles murals owes much to the influence of Eisenstein, but the proximity of Hollywood was also an important factor. Hollywood film directors were the first to use the technique of photo-murals as it proved more economical than using scene painters to paint backdrops.[54] Also, in May 1932, when Siqueiros arrived in Los Angeles, a large exhibition at the Museum of Modern Art in New York entitled 'Murals by American Painters and Photographers' was claimed by the author of the exhibition's catalogue, Julian Levey, to be the first public recognition of the photo-mural as a valid form, and in which recognized artists in the medium were invited to exhibit. Whether Siqueiros was

aware of this exhibition is uncertain, but the context of the times suggests that the use of photography and by extension the use of the projector was current practice in some quarters and may well have influenced Siqueiros to take up this approach.

Before leaving Los Angeles, Siqueiros painted a third mural in the home of the film director Dudley Murphy. Entitled *Portrait of Mexico Today*, it was painted along the wall of a covered patio. Its imagery contains the same receding stepped pyramids that Siqueiros had employed in *Tropical America*. Its composition is simple and stark. On the left is a seated figure brandishing a gun with bags of gold. The man's red mask has been allowed to drop, revealing the features of Mexico's 'strongman' at the time, President Elías Plutarco Calles. The image symbolizes betrayal. The victims of the betrayal are portrayed at the centre and far end of the work. Two peasant women and a small child sit in the middle of the receding steps, while on an adjoining wall on the right, two bodies are depicted: victims of Calles' revolutionary treachery.

Siqueiros left Los Angeles in October 1932 when the American authorities refused permission for him to stay any longer. His experience in the United States was evidently profound. Unlike Orozco and Rivera, Siqueiros developed an approach to his mural art which synthesized his overtly communist ideology with a belief that both this and the age of industrial and technical modernity required the application of equally radical and revolutionary materials and techniques. The age of the industrial worker was for Siqueiros the age of the masses. This called for an exterior mural art which could address those masses. Similarly, modern industry now produced materials and equipment that would completely revolutionize the working practices of the creative visual artist. It was a dynamic symmetry in a new ideological aesthetic that was created by Siqueiros.

The circumstances of the next stage of Siqueiros' development as a mural painter precluded any practical realization of his new commitment to exterior mural work. Nevertheless, the period that he spent in South America after leaving the United States in 1932 was no less significant in terms of the further practical and theoretical development of his art. Siqueiros first went to Montevideo in Uruguay, where he had been asked to deliver talks to various cultural groups within the city.[55] Hints of his principal

156
David Alfaro Siqueiros: *Plastic
Exercise*. Keimfarben silicate paint on
cement, 1933. Private residence,
Buenos Aires, Argentina. This
illustration is a reconstruction of
the mural and site.

148 ideas on mural painting at that time were contained in the text of
a speech he delivered to the city's Fine Arts Circle

> I realized that it was necessary to organize a totally new method of
> pictorial composition. The Mexican muralists found themselves obliged
> to disentangle themselves from Italian and Indian masters of the past
> and to establish the basis for a dynamic composition for murals in
> accordance with the movement of the spectator, in contrast to the
> antique and modern academic theories that are the product of the
> laborious study of easel painting methods.[56]

Siqueiros often repeated the claim that it was his dissatisfaction
with antiquated materials and techniques that led him to con-
sider dramatic innovations in the creation of murals. Although
true to some extent, many of his innovations were the result of
accident or of circumstances that made it impossible for him to
continue with old methods.[57]

An example of chance discovery from his time in Montevideo
underlines the genesis of much of Siqueiros' innovations. Run-
ning short of paint one day and in urgent need of further sup-
plies, Siqueiros toured various stores in Montevideo in search of
more oil paint. Finding none, he decided to buy some cans of
industrial pigment as a substitute. Siqueiros bought a paint
system based on a nitrocellulose medium and which was similar
to the paint used in the car industry. A later version refined by
Siqueiros' collaborator, the chemist José Gutierrez, known by
the more familiar name of pyroxaline, became the principal
material with which Siqueiros painted the majority of his murals
from 1939 onwards. Although he executed a number of
experimental easel works to try out this new paint in Monte-
video, he had to wait until 1936, when he opened up his
experimental workshop in New York, before he could really
subject the industrial paint to all the creative rigours that were
made possible by its special properties.

Siqueiros' claim that innovative procedures, techniques and
modern materials had a crucial generic effect on the creation of a
modern aesthetic was never more obvious than in the one mural
he painted in South America, commissioned by Notalio Botaño,
the editor of *Critica*, in 1933 for his private residence outside
Buenos Aires. There was a certain irony in Siqueiros' acceptance
of this commission, located in the bar area of the basement of

Botaño's home. It seemed to be the antithesis of Siqueiros' call
for a public art shortly after arriving in Argentina. In an article
written for *Critica*, entitled 'A Call to the Artists of Argentina',
Siqueiros had written that it was necessary for artists to 'create
work on the most visible sides of high modern buildings, in the
most artistically strategic places in working-class districts, in
Union halls, in public squares, in sports stadia, in open air
theaters.'[58] Nevertheless, the project represented an important
innovation leading towards what Siqueiros described as 'a
revolutionary improvement in plastic and graphic arts'.[59]

In carrying out the experimental mural project for Botaño,
Siqueiros adopted similar procedures to those which he had
employed in Los Angeles with his 'Block of Mural Painters'. He
collectivized the creative process by creating what he termed a
'polygraphic team' to execute the work. This team was made up
of the Argentine painters Antonio Berni, Juan Carlos
Castagnino, Lino Spilembergo, the Uruguay artist Enrique
Lázaro and the film maker Leon Klimovsky. Although the
character of this mural was quite different from those that had
been painted in Los Angeles, aspects of the work procedure were
similar. To make the initial sketches on to the wall surfaces, for
example, the spray gun was used instead of a brush. A camera
was used to collect material and to make readjustments, while a
projector was used to project images which the team then traced
on to the wall surfaces.[60]

The significance of *Plastic Exercise*, as a purely experimental
work, lies not so much in its expression of theme or imagery, in
this case mostly female nudes, as in its technical features. The
room in which the project was carried out was unusual in that it
was long and tunnel-shaped. The composition of the mural was
thus developed according to what Siqueiros described as the
'dynamic character' of the room's architecture. Particular atten-
tion was paid to analyzing the movement of potential spectators
within the room. This appears to have been the first case of
Siqueiros' practical use and development of what he would term
'polyangular perspective composition'. This involved walking
around the room to determine the points on the floor area from
which the mural would be viewed, resulting in the formulation
of a number of different vanishing points of perspective, which
would come into view as the spectator moved around the room

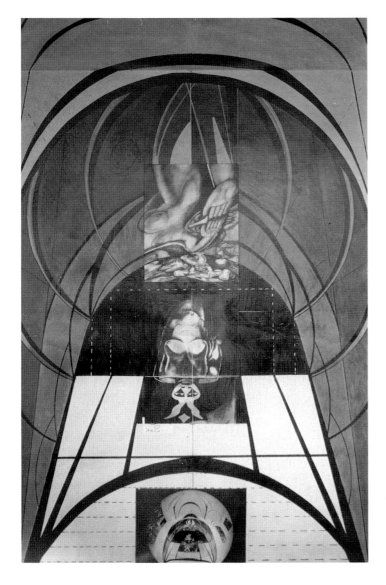

Instead of placing the camera symmetrically in front of the parts we wanted to photograph, we kept it moving, following the path logically taken by a spectator.... We used the camera as though it were the eye of a normal spectator.[61]

Siqueiros worked with his polygraphic team on *Plastic Exercise* for approximately three months, finally completing the work in December 1933. In conclusion, Siqueiros did indeed regard the work as an exercise. He wrote

Plastic Exercise is NOT an ideologically revolutionary work, by which I mean that it is not a work of direct, immediate use to the revolutionary proletariat.... In a solitary and distant private residence, and in the most private place of that residence, it could not be revolutionary.... As its name indicates, *Plastic Exercise* is only a project of abstract art, only a group art exercise, art practice, dynamic, technical, plastic GYMNASTICS.... indispensable in order to produce the totally revolutionary art which was our objective.[62]

Siqueiros was forced to leave Argentina as a result of having attended, against the restrictions placed on him by the Buenos Aires police, a meeting of the Argentine Furniture Workers Union. Following his expulsion, he returned to New York, where he held an exhibition of his work at the Delphic Studios. The period between his departure from Argentina and his decision in 1937 to go to Spain to join the Republicans in the country's civil war, was a period of further frenetic activity for Siqueiros.

While he was in New York in 1934, he engaged Diego Rivera in a very public and grotesquely theatrical polemic, which continued after both returned to Mexico the following year. Siqueiros' confrontation with Rivera, in terms of their respective positions in politics and artistic matters, had a history that extended back to the days of the Syndicate and *El Machete*. The gulf between the two artists could not have been wider. In terms of sheer quantity and quality, the work of Siqueiros was greatly overshadowed by Rivera's international reputation. In an article entitled 'Rivera's Counter-Revolutionary Road' in the communist journal *New Masses*, in May 1934, Siqueiros strongly criticized Rivera, linking his support of Trotsky both to his artistic weakness and driving personal ambition. This crude construction of Rivera's position did not entirely overshadow the importance of the critique that Siqueiros aimed at his compatriot's

to the optimum viewing positions on the floor area. By establishing the design of the composition in this way, Siqueiros exploited the transformation that occurs in the shapes and lengths of forms when viewed along specifically constructed lines of perspective from different distances and directions. The movement of the spectator results in a kaleidoscopic effect, enhancing the dynamic character of the composition.

In this particular instance, Siqueiros' preoccupation with compositional dynamism was greatly assisted by the cylindrical shape of the room, the curved surfaces of which greatly increased the distortions of form as seen by a moving spectator. It also influenced the way in which his team created their composition. 'There was no previous sketch', Siqueiros wrote,

we started directly on the walls, and were influenced by architectural space as we progressed. By living permanently with its geometry, we developed and readjusted our work.... We broke with the tradition of static photographic reproduction ...(with) the use of a cine camera.

work. Central to this was Siqueiros' contention that Rivera was technically backward. Siqueiros found that Rivera had not discovered

the technique and methodology appropriate to revolutionary art. The technique of Rivera, as that of the whole Mexican artistic movement, is mystical for the purposes of revolutionary art. Interior walls, that anachronistic fresco technique, the paint brush etc. He never had any inventive capacity in revolutionary techniques. His are useless media and materials not only for the purposes of the art of the propaganda, but also for the conditions of modern construction. . . .[63]

Siqueiros also criticized Rivera for being an 'aesthete of imperialism' and the creator of 'little paintings that could be snapped up . . . quickly to comply with the demand of foreign tourists'.[64] Other criticisms were that Rivera was pandering to the market, a remark that was clearly directed at his acceptance of commissions from some of the leading American industrialists. Unfortunately, Siqueiros' observations became so enmeshed in an onslaught of factionalist communist political criticisms that his artistic critique was almost totally obscured. The impact was further diminished by the fact that the murals he singled out for criticism, such as those in Detroit, were widely considered to be masterpieces of twentieth-century mural painting.

The polemic raised by the article in *New Masses* continued into the next year. It resurfaced at a conference of teachers at the Palace of Fine Arts in Mexico City, and later in the pages of the 1935 winter edition of the *Kansas University Review*, in an issue devoted to the theme of 'Art and Social Struggle'. In an essay entitled 'The Art Movement in Mexico', Siqueiros attacked Rivera for being a government painter and for painting murals with 'sickles and hammers in obscure places unfrequented by the masses. . . . served only by government workers, stenographers and bureaucrats and which were never seen by the Indians of Xochimilco'.[65]

Siqueiros returned to New York in 1936 as a delegate to the meeting of the American Artists' Congress. He remained there until his departure for Spain the following year, and the intervening period proved to be especially important, for it was then that he opened his 'Experimental Workshop', an enterprise that focused on innovation in the methods and materials used in the creative process. In New York, Siqueiros gathered around him a group of artists, many of whom were American. They included the sculptor Harold Lehman, Jackson Pollock and his brother Sande McCoy, with whom Siqueiros had worked in Los Angeles, Axel Horn, George Cox, Louis Ferstdt and Clara Mahl. The other artists in the group were Latin American, many of whom had also gone to New York to attend the congress. These included Roberto Berdecio, José Guttiérrez, Conrado Vásquez, Antonio Pujol, and Luís Arenal, with whom he had also worked in Los Angeles, and who was to shortly become his brother-in-law. In April 1936 Siqueiros and his group opened the Experimental Workshop at 5, West 24th Street in Manhattan, describing it in a press release as 'a laboratory of modern techniques'.[66]

Two main points were embodied in the workshop plan. The workshop was to be a laboratory for experimentation in modern techniques and was to create art for the people. Under the first heading came experiment with regard to tools, materials, aesthetic or artistic approaches and methods of working collectively. Under the second point came a utilization of media extending from the simple, direct statement of the poster, whose service is fleeting, to the complex statement of a relatively permanent mural.[67]

Although the group did not execute any murals, there is no doubt that the experience of Siqueiros' Experimental Workshop was fundamentally important to his development as a mural painter. The experimental easel paintings that were created, such as *Birth of Fascism*, *Collective Suicide* and *Stop the War*, all produced in 1936, the experimentation with and exploitation of the unplanned results of throwing, dripping or splattering the new pyroxaline paint system with nitrocellulose lacquers, and the employment of techniques and materials such as airbrushing, stencils, sand, wood and paper, all contributed to what Siqueiros described as his 'technical road as a revolutionary painter'.[68]

The political floats and posters that the group created were also significant. In many cases, these also involved the use of innovatory approaches and techniques. The polychromed, three-dimensional float constructed for the May Day rally in 1936 was particularly significant. Harold Lehman described it as crystallizing 'practically all the ideas about which the workshop had been

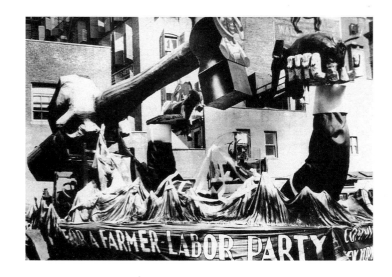

Horn's description indicates the importance of the industrial paint system that Siqueiros had discovered by chance in Montevideo. The pyroxaline's properties were to become important in his painting, for one of its most advantageous aspects was its rapid drying and adhesive qualities. This made it ideal for use in the spraygun or airbrush, devices that he would make constant use of in the years to come. Siqueiros wrote that for him the spray gun was 'an instrument for making marvellous atmospheric effects, for creating space, for making it concave and convex and giving unsuspected strength to its volume . . . the mechanical brushes an ally without equal in the formation of flat surfaces'.[71]

In broad terms, Siqueiros saw his Experimental Workshop as the beginning of a second stage in Mexican mural painting. It also constituted the final step on the road to the creation of his mural *Portrait of the Bourgeoisie* at the Electricians' Syndicate building in Mexico City. In it he synthesized seven years of material, methodological and technical development with the feelings of his political radicalism to produce his first mature work and one of the great moments in twentieth-century mural art.

Although Mexican muralism had never departed from the expression of ideological content, it had nevertheless remained largely within a traditional aesthetic framework. From a technical point of view, apart from Siqueiros' murals in Los Angeles in the early 1930s and his *Plastic Exercise* project in Buenos Aires in 1933, the mural movement had varied little in its use of the fresco technique. Although Siqueiros had undoubtedly made a significant contribution to a new approach to the mural form in the years leading up to the Electricians' Syndicate mural, his reputation as a muralist and his murals in general had nevertheless not entered the public domain to the extent of those of Diego Rivera or Orozco. In part, this was because Siqueiros had carried out fewer murals. Additionally, those that he painted in the 1930s were not the result of major institutional commissions; they were either private projects far away from the public gaze, or 'radical', open-air street mural projects, none of which had the public effect of either Rivera's commissions in Detroit and New York or Orozco's at Dartmouth College in New Hampshire, sanctioned by prestigious institutions or benefactors, giving

organized. It was art for the people, executed collectively; and into it went dynamic ideas, new painting media, mechanical construction and mechanical movement, polychrome sculpture and the use of new tools.'[69] In many ways, the creative approach of this float with its moving parts and polychromed, three-dimensional design foreshadowed Siqueiros' monumental work, *The March of Humanity in Latin America*, which he would create at the Polyforum in Mexico City in the late 1960s, where he brought together in one vast collective endeavour two- and three-dimensional elements, sound, light and movement.

The experimental easel work was conducted by Siqueiros with extraordinary gusto. Many of the painting techniques and methods involved precede the approach emulated some fifteen years later by Jackson Pollock, who worked on these paintings as part of the Workshop's group of artists. Axel Horn recalled the approach

Spurred on by Siqueiros, . . . everything became material for our investigations. For instance lacquer opened up enormous possibilities in the application of color. We sprayed through stencils and friskets, embedded wood, metal and sandpaper. We used it in thick glazes, or built it up in thick globs. We poured it, dripped it, splattered it, hurled it at the picture surface. It dried quickly, almost instantly and could be removed at will. . . . Siqueiros soon constructed a theory and system of 'controled accidents'.[70]

152 them a high public profile. Up until this time, Mexican mural painting was therefore primarily identified with Rivera and Orozco.

However, with the creation of *Portrait of the Bourgeoisie*, Siqueiros consolidated the development of his radical and innovative aesthetic for the mural medium. This reflected a decisive break with the traditions within which most Mexican mural work had been confined. He mixed radical social content with his innovative methods of working with the new materials and instruments of the modern industrial and technological age. It was a synthesis that would map out Siqueiros' identity as an artist and provided the artistic basis for his increasingly international reputation in the post-war years.

Siqueiros' work on the mural began in 1939, following his return from fighting with the Republican Army in the Spanish Civil War in 1938. Siqueiros' original intention in going to Spain had been to organize a Mexican and Spanish collective of artists to produce pictorial and graphic work for the Republican cause. However, finding that most of the Spanish artists were already mobilized in the war, Siqueiros himself became involved in the fighting. Although he was a foreign national, he was drafted into the ranks of the Spanish Republican Army in March 1937 and was paid a colonel's salary. He remained in Spain until the end of 1938, when he returned to Mexico via Paris and New York. His experience in Spain had an important bearing on the nature of the mural that he painted at the Electricians' Syndicate Building. As an active participant in the anti-fascist struggle, Siqueiros was left with an indelible impression of that time, which informed both the theme he developed and the imagery that he incorporated into it. The description of the battle of Madrid, in which Siqueiros had participated, by Carlos Contreras, Siqueiros' commander, is particularly telling. It 'was a struggle to the death that lasted more than a month. The dead and wounded numbered tens of thousands. I remember the terrible days of the battle of Pingarron with Siqueiros returning from that inferno in the last days of the fighting. He was not the man I had always known, fond of joking and carefree.'[72]

From the start, the commission from the Electricians' Syndicate presented Siqueiros with the opportunity of developing a mural work with a theme that would, he hoped, extend well beyond the largely utilitarian character of the public art that he had created in New York in his Experimental Workshop. It was perhaps his first real chance to execute a mural that would have, as he put it, maximum physical impact and at the same time transcendent and absolute value. By July 1939, with the agreement drawn up between himself and the directorate of the Syndicate, Siqueiros gathered together a team of artists with whom he would carry out the work collectively. It consisted of the Mexican artists Luís Arenal, Antonio Pujol and Roberto Berdecio, and three Spanish painters, Miguel Prieto, Antonio Rodríguez and José Renau. Siqueiros conceived the working of this mural team on a thoroughly egalitarian basis. Everyone was to be paid the same, and he also insisted, at least at the beginning, that discussion and initiative on all matters relating to the project, particularly those concerning the form and content of the mural, should be entirely free. However, as José Renau recalled, there was never any doubt as to who would lead the project and Siqueiros was acting more out of courtesy than from any conviction that others in the group could equally be leaders.

In receiving the commission, Siqueiros was fortunate to be offered by the union's directorate and the architect of the building a choice of what he considered to be the most appropriate site for the painting. This provided Siqueiros with the chance to conceive the project on the basis of every innovation he had developed during the preceding years in relation to the whole creative methodology of the mural. Siqueiros chose the main stairwell of the building leading up to the general offices on the second floor. His choice was made because of the large number of people that would pass through the stairwell and because of the functional and spatial challenge posed by the site. The initial stages of the project were taken up with discussions concerning the architectonic character of the chosen space, with its three vertical walls and a ceiling surrounding the staircase. The second and equally important matter that the team had to consider was the theme for the work and how it would be expressed in relation to the architecture of the site.

In considering the conceptual formal framework within which the theme could be expressed, Siqueiros and his colleagues decided 'to develop the overall theme as a single and dynamic continuous pictorial surface, thus creating a new space that

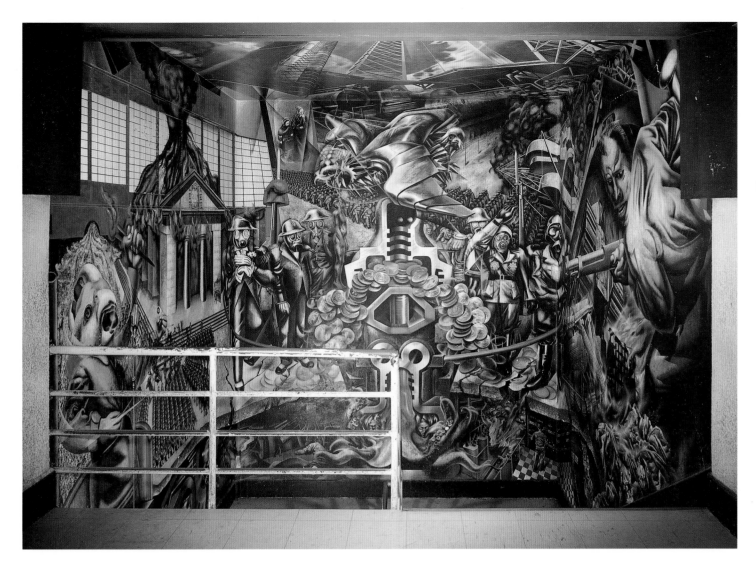

visually breaks the cubed architectural structure of the stair-well'.[73] The decision to opt for a continuous pictorial composition was due to the ascendant curving character of the site. Only certain areas of the site could be seen together by a spectator moving up or down the staircase at any particular moment, and even then not necessarily in any logical thematic sequence. Furthermore, the combination of the moving spectator and the rectangular construction of the site, with each wall surface at right-angles to the others, made it imperative that the team develop a composition that would visually destroy the rigidity of the cubed construction of the site. Only by doing this could they hope to create a smooth continuous flow of vision that would synchronize with the visual field of the ascending and descending spectators. The approach that Siqueiros and his team used in their work was therefore based on the adoption of his principle that 'all true architectonic space ... is a machine, and its parts, such as walls, floor,

arches, ceiling etc. are the wheels of this machine, which moves rhythmically . . .'[74]

It is perhaps ironic that the theme for the mural was finally developed only after initial site analyses and formal conceptualizations undertaken by Siqueiros and his colleagues had been completed. After all, Siqueiros was an insistently ideological artist, whose use of theme was very much part of the basis of his overall political aesthetic. In the normal tradition of such thinking, the theme would have influenced the generation of the work. However, Siqueiros himself interpreted an understanding and subsequent exploitation of the architectonic dynamics of any architectural and social context for a potential mural as having an important impact and influence on the psychology of looking at and 'receiving' a mural. Siqueiros needed to consider these aspects before developing any specific subject-matter.

The directorate of the Syndicate had originally indicated an overall theme based upon electrical industry for the mural.

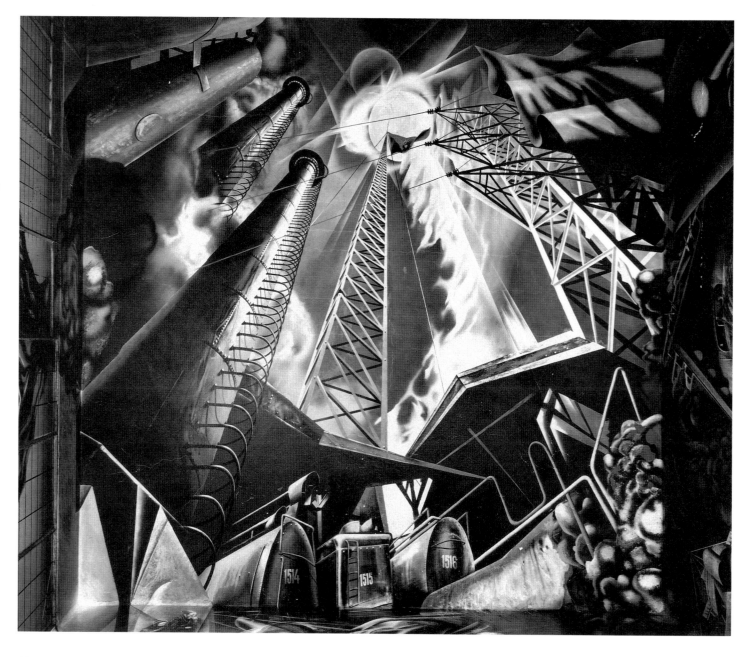

However, this general approach conflicted with what Siqueiros and his team considered to be appropriate both for the times in which they lived and for the chosen site of the mural. The experience of the Spanish Civil War, with the Cárdenas administration openly supporting the Republican anti-fascist cause, had had a considerable impact on Mexican society. Such a neutral theme seemed to Siqueiros and his colleagues to be inappropriate for a public art work housed in a trade-union building. In the end the potential conflict between the mural team and the Union's directorate was resolved through Siqueiros' team's direct contact with the workers who used the building, persuading them of the need for a more radical approach to the content.[75]

With a free hand in the choice of theme and with the contact that the team had made with the workers using the building, the immediate political context of the times inevitably proved to be the decisive aspect in the formulation of the project's subject matter. In its original conception, the mural was to be an image of fascism depicted as reaping its destructive consequences upon the world, opposed by the forces of revolution and progress. More specifically, the team chose to focus on fascism as a war machine, and modern weapons of destruction would form some of the central elements of the mural.

Apart from Siqueiros' own input, José Renau perhaps contributed most initially to the visual development of the mural. In order to shape the pictorial basis of the composition,

159
David Alfaro Siqueiros: *Portrait of the Bourgeoisie*. Pyroxaline on cement, 1939–40. Mexican Electricians' Syndicate, ceiling area, Mexico City.

160
David Alfaro Siqueiros: Spectator movement analysis of Electricians' Union mural site for *Portrait of the Bourgeoisie*.

161
David Alfaro Siqueiros: Viewing analysis of Electricians' Union mural site for *Portrait of the Bourgeoisie*.

155

Renau applied himself to solving the more complex architectonic problems posed by the site by photomontages of images superimposed on a scale model of the stairwell. He was also largely responsible for developing the ceiling area and those sections of the site beneath what the team had discovered to be the lowest viewing curve for a spectator ascending or descending the staircase. In these areas and on the ceiling Renau developed images of the electrical industry, deriving his visual material from photographic excursions to the Nonoalco hydroelectric plant at Necaxa. Renau concentrated his initial efforts on the corner areas of the site, where ceiling, central and right-hand walls converged. He experimented with images intended optically to 'deform' or destroy the angles within this area of the space. The visual analysis that Renau and Prieto had made of the site showed that this upper right-hand corner was particularly visible at the point from which a spectator would start to climb the stairs into the area occupied by the mural. This corner area therefore constituted an important element in the visual dynamic of the composition, and a solution had to be found so that the spectators' vision could be projected uninterrupted up into the ceiling, as well as simultaneously around to the right-hand wall. Renau solved this particular problem by creating an image of smoke and cloud spreading across all the corners and joins of the top right-hand section where central and right-hand walls converged with the ceiling. This had the effect of disguising the join of the walls, allowing him effectively to use images of electrical pylons, radio antennae and chimney stacks in the ceiling areas as formal extensions of the diagonal lines forming the main descriptive elements of the huge aircraft carrier and battle tank on the vertical central wall below. Configured in sharply receding perspective, the images of pylons and antennae on the ceiling created the illusion of deep vertical space, creating a particularly dramatic effect for the spectator ascending the staircase.

Although the main tenets of the theme had been chosen by Siqueiros and his colleagues, there was initially only the vaguest of ideas as to how these might be conceptualized. The clue to the specific images lay in the visual material that the team had at its disposal. Luís Arenal and Antonio Pujol, for example, had compiled an archive of cuttings from contemporary magazines. José

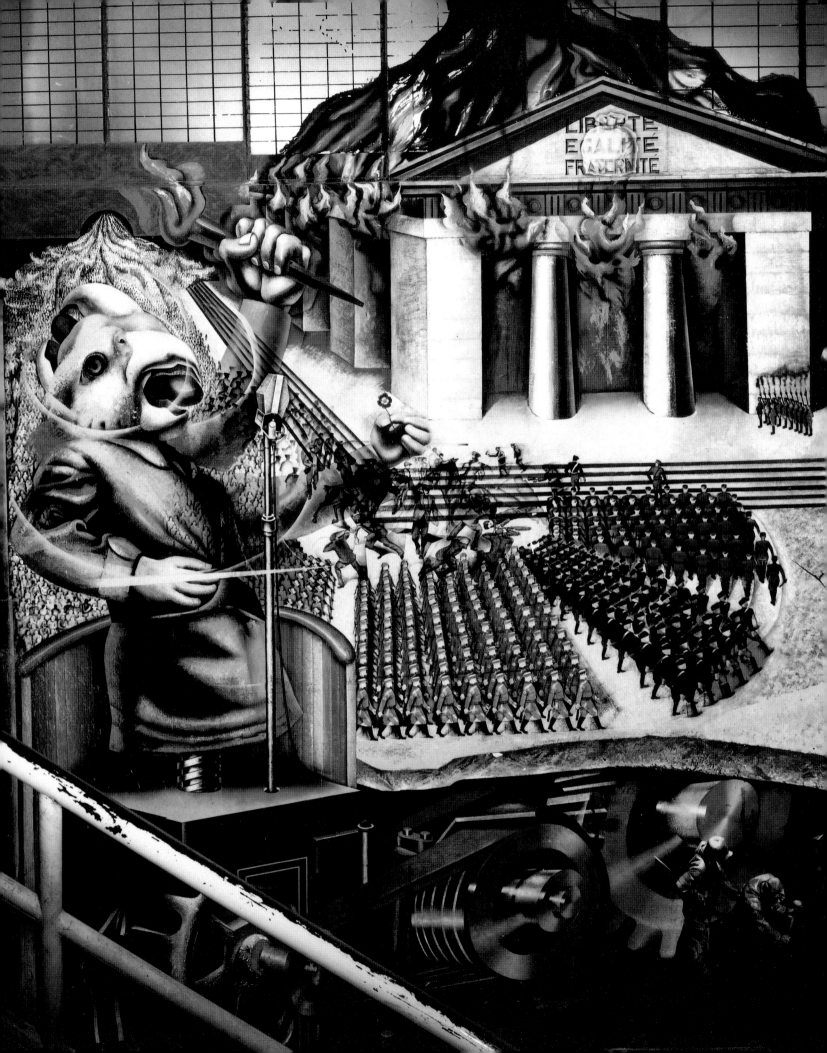

162 *opposite*
David Alfaro Siqueiros: *Portrait of the Bourgeoisie*. Pyroxaline on cement, 1939–40. Mexican Electricians' Syndicate, left wall, Mexico City.

163 *below*
David Alfaro Siqueiros: *Portrait of the Bourgeoisie*. Pyroxaline on cement, 1939–40. Mexican Electricians' Syndicate, right wall, Mexico City.

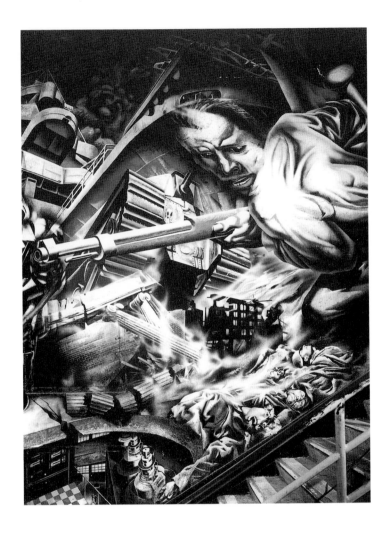

The actual painting of the mural presented considerable problems at first. The necessity of forging a stylistic or integral unity, as Siqueiros put it, meant that the two Spanish painters Prieto and Luno eventually left the team. The difficulty they encountered in working as part of a team was due, to a considerable extent, to the nature of their training. Luno's painting of the eagle on the central wall proved to be particularly problematic, for he was unable to achieve the required definition and compactness in comparison with the rest of the painting.[76] The mural was in the end painted largely by those remaining. Renau was responsible for painting most of the mechanical areas, particularly the ceiling area, the major part of which he designed himself.[77]

Siqueiros' contribution to the work was very much that of an active director. Of the more important areas for which he was responsible, the fascist 'parrot' figure on the left-hand wall, the fascist and capitalist figures on the central wall, and the image of the revolutionary worker brandishing a rifle on the right-hand wall illustrate his ability to realize dynamic mural images. Overall, the main figure work was painted by Siqueiros assisted by Pujol, while Arenal was often responsible for the background elements.[78] Ironically, the interior location of the mural conflicted with Siqueiros' own publicly expressed commitment to an accessible, exterior mural art. Nevertheless, the building of the Electricians' Syndicate was a very busy gathering place for the city's electrical workers, a fact that for Siqueiros qualified it as a public place. Siqueiros' potential and immediate audience for the mural was proletarian, a matter that was of great concern to him.

In many respects, *Portrait of the Bourgeoisie*, with its strongly anti-capitalist, anti-fascist theme reflecting the world conflict against German national socialism, painted at the outbreak of the Second World War, appears to be quintessentially a work of the 1930s. Politically, the 1930s were dominated both by a profound crisis within capitalist societies and the development and growth of fascism. Anti-capitalist sentiment, which tended to identify capitalism with fascism during this period, had coalesced around the banners of radical socialism. This was viewed by many as the only positive opposition to the growth of tyrannical right-wing politics. During the 1930s in particular, radical socialism often also became identified with communism and the communist parties, which in turn led to a strong identification

Renau had been able to salvage his own archive of 35mm negatives from the effects of war. Renau's desire to use his photomontage and photographic experience was particularly important in relation to Siqueiros' own well-established concern for the importance of the photograph as a valuable creative tool for the mural artist. The visual characteristics of the mural rely to a considerable extent on both men's concern for photography as an advanced source of pictorial inspiration in both technical and creative terms. In many respects, photographic influences give the work its contemporary, journalistic quality, creating a technically advanced yet popular art form.

164 & 165
Photographic source material used
for *Portrait of the Bourgeoisie*.

158

among large sections of the traditionally left-wing urban working class and some groups of radical middle-class intellectuals with the Soviet Union and Soviet Communism. Among these sections of society, the Soviet Union represented not only a reliable bulwark against fascism, but also a model for the new society that would supersede what they saw as the dying and increasingly dictatorial capitalist regimes.

Although the global struggle against fascism would extend well into the next decade, the time during which Siqueiros executed this mural marks the point of closure of much of what the pre-war epoch had stood for. In Mexico, the regime of the presidency of Lazaro Cárdenas was drawing to a close, and with it, perhaps the most radical period in Mexican national politics since the end of the revolution. In the United States, the crisis wrought by the great Depression was waning with the cumulative success of the massive public employment programmes introduced by the Roosevelt administration. The entry of the United States into the Second World War would also sweep the remaining unemployed into the war effort. American industry became geared towards production for the war and with it the basis for the rebirth of American capitalism in the post-war era was set. Although the struggle against German fascism in Europe and Japanese militarism in Far East Asia was to consume the world in violent conflict for more than half a decade, the start of the Second World War was in reality the beginning of the end of these regimes. Their eventual defeat by the Western democracies and the Soviet Union created a political and social environment in the world during the following decades that was constructed on very different terms from that which existed in the years before the war. The struggle against fascism was replaced by economic competition and political and military confrontation between the victors of that war: the advanced liberal capitalist democracies headed by the United States and the communist power of the Soviet Union. It would usher in the period of the Cold War.

Siqueiros' mural *Portrait of the Bourgeoisie* then stands at the intersection between two distinctly different periods. With its theme reflective of and rooted in the political culture of the 1930s, its aesthetic, by contrast, pointed decidedly in the direction of Siqueiros' well-established desire to create a new, more

technologically based unity between form and content. Such a view had been present in much of his thinking throughout the 1930s, during which time he had tirelessly attempted to overhaul the approach to muralism with his constant experiments in techniques and materials. However, the thinking that underpinned the notion of this aesthetic was in reality an almost utopian projection into the future, which, even if it was never to be expressed completely in Siqueiros' own work, would nevertheless find its rationale in the technological basis of post-war Western economic development.

There is a further important dimension to this mural. *Portrait of the Bourgeoisie* is also a powerful critique of the age of the modern machine. In his Detroit cycle, Diego Rivera had viewed man and machine as a spectacle of dynamic productive synthesis. In *Catharsis*, on the other hand, Orozco had conceived industrial modernity as a monstrous oppression. The oppression, however, was given no other imagery than a mad internecine struggle and faceless, dehumanized mechanical figures. In Dartmouth and at Guadalajara, when Orozco focused on the modern ideologies as falsifiers and betrayers, the modern machine was not placed in the foreground as an integral part of the process; it was merely implicated. Siqueiros, on the other hand, highlighted his passionate denunciation of fascism by clothing its image in the garb of mechanical and industrial modernity. It was a combination that makes the mural all the more startling, for it eloquently expresses the appalling consequences of the combination of political despotism and the modern machine. During the 1930s each of the three muralists had views of the modern world, the age of industrial modernity. Each view was different, influenced by different concerns and visions. Importantly, their expressions of the modern industrial world created a dimension to their murals of these years that was located, not within the boundaries of an exclusively Mexican cultural reality, but in a setting of universal relevance.

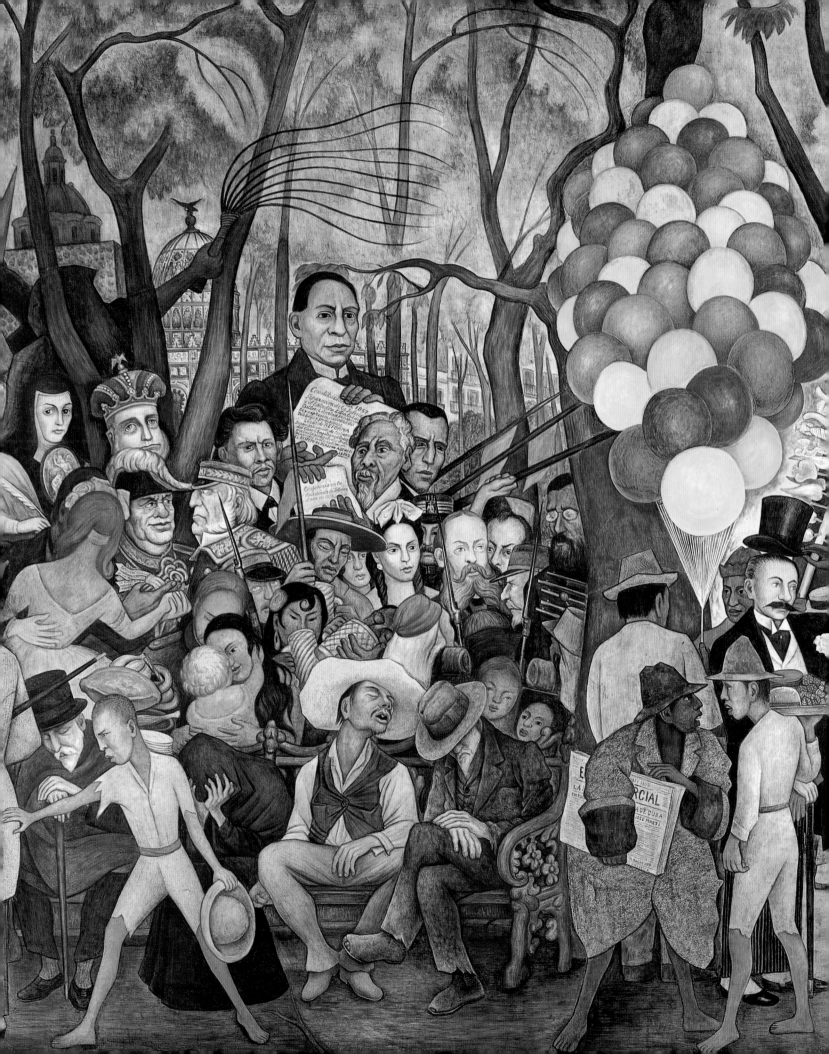

Diego Rivera: *A Dream of a Sunday Afternoon in Alameda Park*. Fresco, 1947–8. Detail of left-hand side. Mexico City.

SIX

OROZCO AND RIVERA

1940–1957

If the two pre-war decades of the Mexican mural movement's history had essentially been two separate and defining periods, then the years from 1940 formed another distinct episode for the work of Rivera, Orozco and Siqueiros. The instability created by the Second World War further enlisted the already strong tendency of the Mexican state to rule by exhortations to national unity. Forces within the state, weakened by the radical years of the Cárdenas presidency, reasserted themselves and as a consequence, the popular demands of the agrarian and labour movements went unanswered. After 1946, beginning with the Presidency of Miguel Alemán, Mexican politics consolidated this development. Foreign investment flourished in Mexico resulting in a major but very uneven economic expansion for the country. Such expansion was at a cost. Agrarian reform rapidly diminished, more equitable distribution of wealth and power was never realized, and the demands of labour organizations were as ruthlessly suppressed as they had been during the late 1920s and early 1930s. Throughout much of the post-war era, Mexico became increasingly enmeshed in the demands of the expanding foreign capital being used for national expansion. At the same time, the country's political autonomy was held within the overriding constraints of a post-war, east–west political conflict and the resulting regional demands placed on it by the all-powerful neighbouring United States.

The era of the Cold War created a cultural and economic environment which affected and influenced the work of all three painters in ways that were unpredictable and in many senses contradictory. The increasing influence of the United States on Mexican society in the years of McCarthyism had a particularly pressing impact on Mexican culture. The radical social rhetoric of the country's post-revolutionary art became increasingly less tolerated by the Mexican cultural establishment, a fact that helped to create the fertile ground on which the commercialized consumer culture of the United States could take root in Mexico. The enormous economic influence and power of the United States in the post-war period also provided the context for what has been called the third stage of the Mexican revolution, that of the 'consolidation' or 'modernization'.[1] During this period Mexican society was no longer exclusively defined by its traditional agrarian categories, but by others that were increasingly industrial, technologically advanced and modern.

The work of Mexico's three leading muralists must be seen against this post-war, Cold War context that was so profoundly different from the two pre-war decades. The relationship of the three artists was profoundly changed in the post-war period from what it had been at the outset of the movement. With the international recognition all three had gained from the murals that they had executed in the 1920s and 1930s in Mexico and the United States came a formalization of their relationship with the Mexican state. From radical young artists, barely tolerated by the government that had commissioned them in the early 1920s, all three artists in the post-war period came to be regarded by the

167
Lazaro Cardenas addressing a
political meeting in Michaocan,
Mexico, 1934.

168
José Clemente Orozco: *Allegory of
Mexico*. Fresco, 1940. Gabino Ortiz
Library, Jiquilpan, Michoacán.

162

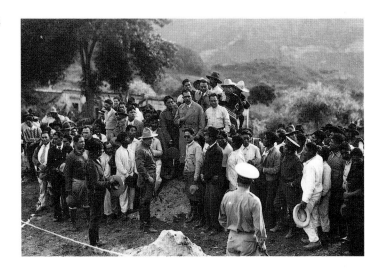

During the nine years from 1940 until his death in 1949, Orozco created four murals in which Mexico was the principal subject. These were the *Allegory of Mexico*, painted on the main end wall of the Gabino Ortiz library in Jiquilpan in 1940; *National Allegory*, painted in 1947 at the National Teachers' School in Mexico City; the 1948 fresco panel *Juárez, the Church and the Imperialists* painted at the National Museum of History in Chapultepec Castle in Mexico City; and the mural *Hidalgo: The Great Mexican Revolutionary Legislation and the Liberty of the Slaves*, which was painted in the Chamber of Deputies' Government Palace in Guadalajara, completed shortly before his death in 1949.[4]

The *Allegory of Mexico* and the later *National Allegory*, painted on an external wall, are profoundly different from each other, despite sharing an identical theme. The first, in the Jiquilpan library in the State of Michoacán, is part of the cycle containing the celebrated black-and-white fresco panels on the theme of the revolution. Revolutionary struggle is depicted in them in the starkest terms. In two of the panels, *The Burial* and *After the Battle*, the shooting of the constitutionalist General Alvírez, and the execution of Madero's followers, both of which took place in Michoacán during the revolution, provide the thematic reference. Other panels include Orozco's uncompromisingly nihilistic view of the masses.

Of the main panel, *Allegory of Mexico*, the Mexican critic and writer Justinio Fernández has written: 'Orozco has projected here his concept of the Mexican – the painful, slow advance, the violence, the drama and dignity, evil and greatness; this human comedy – pretension without substance, religiosity without religion – and undefiled the true national conscience.'[5] *Allegory of Mexico* is in two respects quite different from previous murals that Orozco had painted with a specifically Mexican national theme. In earlier murals, such as in his work at the Hospicio Cabañas, Orozco's subject of Mexico and its history had been assembled out of many different images. No single image had stood for the whole; instead, each had been a component part, albeit often with immensely powerful and telling visual metaphors. Also, Orozco seldom used imagery derived so completely from the visual vocabulary of Mexican folklore as that which he employed in *Allegory of Mexico*. Furthermore, he had never before created a public work that seemed to express the

Mexican state as valuable cultural figureheads. Although this did not preclude controversy around their work, and nor did it prevent the Mexican government from gaoling Siqueiros for his political activities in 1960, all three painters enjoyed employment on prestigious artistic projects and commissions from various branches and organs of the state. As the creators of work that was regarded as part of the treasured National Patrimony, Orozco, Rivera and Siqueiros gradually became institutionalized during the post-war period. This development profoundly affected the attitudes of younger radical artists, who were increasingly at odds with what they saw as the dogmas of cultural nationalism.[2] Driven by the desire to locate Mexican culture within a more open, cosmopolitan and international context, the younger generation of artists saw the work of the three muralists as representing these dogmas, a far cry from those who had earlier looked up to and been inspired by what they saw as an art movement of revolutionary cultural radicalism.[3]

Although during this third stage of the development of mural painting each of the artists created a variety of murals with different themes and concerns, nevertheless all three remained centrally concerned with the subject of Mexico. But whereas the national theme had principally been used before 1940 as a way of examining the nation's history in order to explore and to forge a vision of the country's identity, in the post-war era it formed the basis of quite different preoccupations.

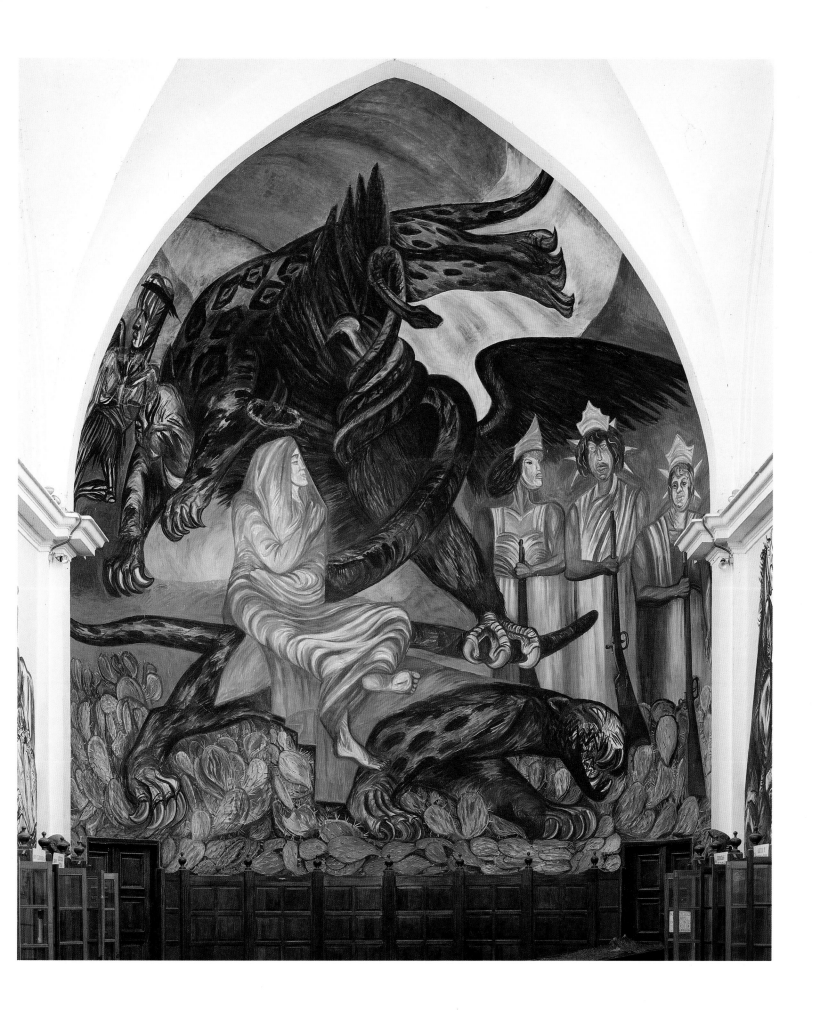

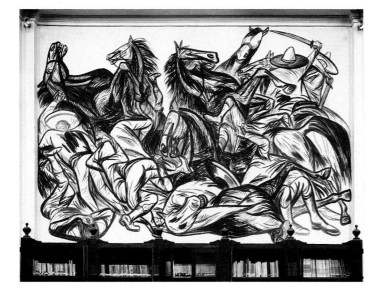

idea of a contemporary Mexico under what might easily be interpreted as an imperialist threat.

The central image of the mural depicts an eagle in the coils of a serpent. This ancient symbol of Mexico, representing the forces of night and day, life and death, battles with the symbolic power of the underworld. The deathly struggle is not resolved. Below, a female figure astride a jaguar rides her steed through an undergrowth of cacti. This triangular assemblage clearly symbolizes both a contemporary and ancient idea of Mexico, in which the dichotomy of proud and liberated independence against oppression is construed as the constant battle of forces for national definition. In the background, the huge red, white and green stripes of the national emblem further reinforce the intended symbol. The dichotomy is underlined by the menacing intervention, between the national emblem and this triangular assemblage, of an aggressive jaguar-like animal that arches round to attack the woman from behind. Bernard Myers describes this image as a 'voracious, hungry beast that symbolizes the menace of imperialism'.[6] On the right side of the mural, three female figures representing Law, Liberty and Justice stand as the guardians of an independent Mexico and its liberties. Painted during the first year of the Second World War, the mural seems to convey the idea of an independent Mexico constantly on guard against unspecified forces, that might threaten its integrity.

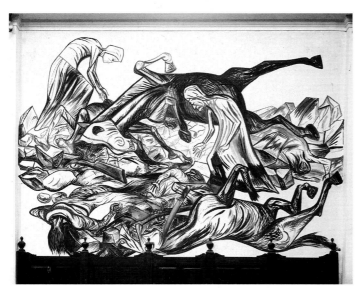

69
José Clemente Orozco: *Battle*. Fresco, 1940. Gabino Ortiz Library, Jiquilpan, Michoacán.

170
José Clemente Orozco: *After the Battle*. Fresco, 1930. Gabino Ortiz Library, Jiquilpan, Michoacán.

171
José Clemente Orozco: *The Masses*. Fresco, 1940. Gabino Ortiz Library, Jiquilpan, Michoacán.

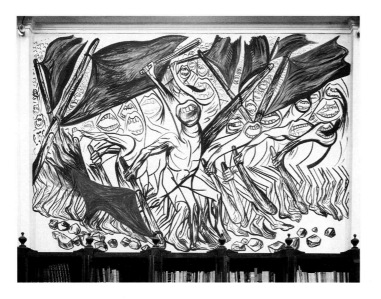

Although the work appears to mark an important stage in Orozco's development as a mature artist, compared to his previous achievements in Guadalajara, *Allegory of Mexico* is very uneven in quality. The compositional structure marvellously exploits the area bound by the arched panel, but the work as a whole is less synthesized than anything he painted in Guadalajara. The drawing of the figures, together with the expressive handling of the paint, often appears haphazard, thus losing its effective and expressive potential.

The second allegorical work on the subject of Mexico that Orozco painted in the 1940s was the external work at the National Teachers' School in Mexico City. Of all the murals that Orozco executed, *National Allegory* is unique. It is technically highly innovative in ways that Orozco had never attempted or envisaged in earlier work. Pictorially it is also a dramatic departure from his traditional figuration to a more formalized, almost abstract conception.

National Allegory was painted on a huge curved wall of the impressive open-air theatre of the National Teachers' School. Begun in November 1947 and completed in April 1948, the mural was the largest single image Orozco created, measuring 59 feet high and 72 feet across. Orozco described his ideas as

Theme: National Allegory, with large geometric forms, stone and metal. *In the centre*: the Eagle and the Serpent, a representation of life and death, a representation of the Mexican earth. *At the left*, a man with his head in the clouds moves up a gigantic staircase; *at the right*, a hand puts a block into place. . . . The forms of the composition are organized so as to acknowledge and preserve the parabolic form of the wall and to be seen at a distance.[7]

The move to a more formalized, abstract, less illustrative figuration allowed Orozco to develop the composition and colour of this mural in correlation with the architecture within which the mural wall was located. In particular, he echoed the lateral forms and colour of the surrounding architecture of the theatre. Similarly, the large, abstract, knife-like forms on the upper left of the composition help to extend the dynamic of a receding perspective created by the tiers, which in turn centres the eye on the stage area behind which the mural is located. The lines of colour that Orozco created, which traverse the composition

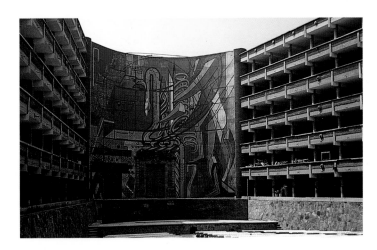

horizontally at various levels, also assist in creating a continuous and dynamic movement of form. The result is an extraordinary synthesis of pictorial and architectural form, in which both mural and architecture are combined and integrated into a whole. Although quite different in every other respect, Orozco's use of sight lines to enhance perspective and to direct the eye and unite one area with another, is very similar to the approach that Siqueiros adopted in *Portrait of the Bourgeoisie*.

It is perhaps ironic that it was Orozco who most completely and successfully realized, in this particular mural, Siqueiros' aim of plastic integration: the synthesis of architecture, painting and sculpture. Siqueiros had propagated this as one of his primary aims, particularly in the post-war period. Orozco, on the other hand, had never placed this among his main concerns. Yet at the National Teachers' School, in one dramatic example, he brought all three disciplines together into a balanced harmony to a degree that Siqueiros never achieved.[8]

Apart from the innovatory formal approach Orozco adopted to express his theme, the other striking aspect of *National Allegory* is his use of new materials. Until the creation of *National Allegory*, Orozco had not chosen to use any medium in his murals other than fresco. However, in this mural he employed ethyl silicate. In part, the external siting of the mural, open to the weather, meant that the use of fresco was questionably viable in the long term, imposing upon Orozco the need to consider other materials and approaches. Siqueiros had been preoccupied with the need to

173 *top*
José Clemente Orozco: *Hidalgo and
the Great Mexican Revolutionary
Legislation and the Liberty of the Slaves.*
Fresco, 1948–9. Chamber of
Deputies, Legislative Assembly of
Jalisco, Guadalajara.

174 *bottom*
José Clemente Orozco: *Juárez, the
Church and the Imperialists.* Fresco,
1948. National Museum of History,
Chapultepec Castle, Mexico City.

166 revolutionize the mural medium since the early 1930s, using a variety of approaches that ranged from painting on to cement to the use of nitrocellulose paint systems. By the time Orozco executed his commission at the National Teachers' School in the late 1940s, experimentation with different paint systems in Mexico had become well established. This research was being carried out principally at the Division of Research for Plastics in Mexico City's Polytechnic Institute, headed by Siqueiros' long-time technical collaborator, the chemist José Gutiérrez. Orozco was advised that ethyl silicate, with which Gutiérrez had been experimenting for ten years, was the appropriate medium for the commission.

National Allegory contained some of the same traditional and national folklore as *Allegory of Mexico*. The eagle and the serpent were present, with the latter again firmly held in the stylized talons of the eagle. The lower right area of the mural contains an assemblage of lines and forms representing the echoes of a pre-colonial past. Above, surrounding an image of a dark-skinned hand, is a further montage of structure lines describing the forms of modern construction and pre-Columbian pyramids. To the left of the central motif, huge, dagger-like images seem to press in and intimidate the two creatures symbolizing Mexico. Around the outer perimeter of the central doorway, the images of industrial drill bits are placed underneath the eagle's claws and adjacent to a highly formalized image of a wheat sheaf. Together with the huge figure of a man stepping out from what appear to be mechanical clasps, Orozco is once again exploring the conflicts and dilemmas of a symbolic image of Mexico, which seems to be threatened and transformed by the encroaching and oppressive realities of an aggressive technological world. In this respect, the visual metaphor is one that is familiar in the work of Orozco and that has its echoes in previous murals such as the panel in the Hospicio Cabañas depicting Cortez as a mechanical being standing above the prone figure of an Indian. However, in *Allegory of Mexico* and *National Allegory*, it is not an ancient Mexico threatened by an old colonialism, but a contemporary Mexico menaced by an as yet unspecified but very present modern threat that is depicted. The implicit threat in both of these allegorical works is left unstated; it might be a modern version of imperialism. It could equally be a foreboding of the dissolution of ancient

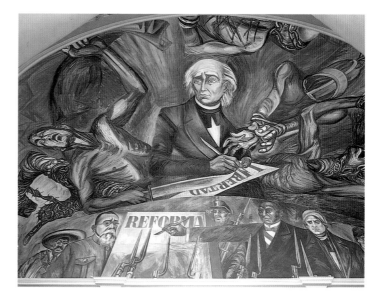

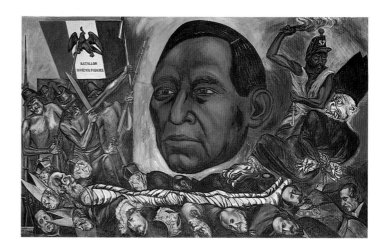

cultural roots at the hands of an inhuman industrial modernity. Whatever it is, Mexico is the target. After the completion of *National Allegory*, Orozco departed from the use of such strict allegory and returned to a more traditional, but highly expressive narrative to present his Mexican subject-matter.

In the final eighteen months of his life, Orozco created two murals centred not on the theme of a threatened Mexico but on Mexico and its liberators. These were his 1948 panel of *Juárez, the Church and the Imperialists*, painted in the Sala de la Reforma in the Museum of National History in Chapultepec Castle, Mexico City, and *Hidalgo and the Great Mexican Revolutionary Legislation and the Liberty of the Slaves*, painted in the Chamber of Deputies in Guadalajara.

In the first, Orozco constructed a gigantic portrait of Benito Juárez. Surrounding the face of Mexico's great nineteenth-century Indian President of the Reform is a curious scene depicting the clerical and military supporters of Napoleonic rule in Mexico in the nineteenth century.[9] These traitors carry the hideously elongated and mummified body of their puppet Emperor, Maximilian. Above them, to the left and right of Juárez' face, this pathetic assortment of conspiratorial instigators are attacked by the soldiers of the Mexican independence and rebellion.

In this late mural, the objects of Orozco's biting critique are presented in terms that recall the savage images he had created 25 years earlier in the National Preparatory School. Then, on the first floor of the building, his targets had been reactionary forces, false leaders, effete and pompous aristocrats, a catalogue of loathsome individuals. In the later mural, his targets are again quite specific, but this time they are traitors to Mexican liberty and independence. They are presented in the same cartoon-like drawings that Orozco had used before, recalling his work as a caricaturist.

Orozco had not dealt in previous murals with the subject or theme of nineteenth-century Mexican political history. To do so in the late 1940s would seem to imply a need to recognize the parallels of historical circumstance, yet on the surface, no such parallels existed. Mexico was independent, and not occupied by any foreign power, or ruled by foreign usurpers. Perhaps Orozco was articulating an underlying national unease as the nation rapidly found itself in the post-war era, in which the international political landscape placed questions over such great ideals as liberation, national integrity and independence. In such circumstances, the huge and benign figure of Juárez seems to stand not only as the antithesis of the Napoleonic adventurers of the nineteenth century and their Mexican supporters, who compromised the independence of a recently liberated Mexico, but also as a symbol of stability and integrity in an uncertain age.

In *Hidalgo and the Great Mexican Revolutionary Legislation and the Liberty of the Slaves*, Orozco, at the very end of his life, returned to the other great Mexican figure of the nineteenth century, Manuel Hidalgo. Ten years earlier, on the magnificent main staircase of the governor's palace in Guadalajara, Orozco had depicted Hidalgo as a messianic figure of liberation in what is perhaps the single greatest work of the Mexican mural movement. As the instigator of the long struggle for national independence, Hidalgo was also responsible for decreeing the abolition of slavery in Mexico, the first decree of its kind on the American continent. It is this that forms the central theme of the last mural of Orozco's life. The Hidalgo of this last work is a more gentle figure, the messianic quality of the earlier portrayal here transferred to the images of the slaves, who, bound in chains with hands tied, present some of the most agonized expressions of want and suffering that Orozco created. The mural was completed in August 1949. A few weeks later, on 7 September Orozco died of heart failure at his home in Guadalajara.

Throughout his final years, Orozco had revisited many of the themes and expressed many of the preoccupations present in his pre-war mural work. The familiar theme of justice, and the nightmare of a chaotic, exploitative and aggressive modernity had been powerfully expressed in his cycles at the Supreme Court in Mexico City in 1941, and at the old colonial Chapel of Jesús Nazareno in Mexico City in 1942.[10]

At the Supreme Court, Orozco was presented with a series of awkwardly placed panels surrounding the stairs of the building, in the so-called Hall of Lost Steps. He painted the struggles for justice and the corruption of justice in these panels in a series of powerful images entitled *Justice*, *False Justice*, *Proletarian Struggle*, and *National Riches*.[11] In *National Riches*, Orozco seemed to repeat part of the ideas embedded in *Allegory of Mexico* at the Gabino

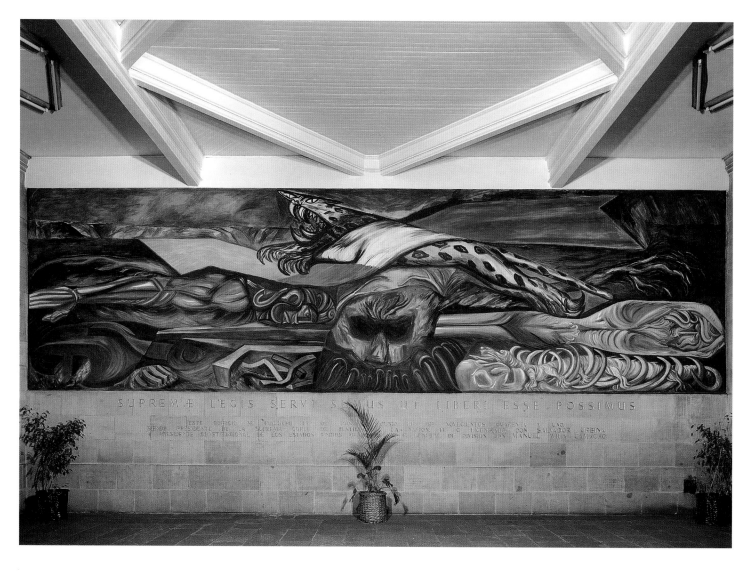

Ortíz Library. Once again, a Mexican jaguar-like animal wrapped in the national colours appears, here ferociously defending the symbols of Mexico's wealth. In *Justice* and *False Justice*, painted in panels flanking the stairs, Orozco depicted the first as an avenging angel striking down corruption, while opposite, its counterpart lies slumped and asleep in a chair oblivious to the corrupters below. In the panel facing the stairs, Orozco depicted *Proletarian Struggle* as yet another conflict to effect the liberty of the oppressed.[12]

The cycle of frescoes that Orozco painted in the Chapel of Jesús Nazareno, begun immediately after the completion of those in the Supreme Court, were never completed. He worked on the cycle until 1944, when funds for the work dried up. As a result, Orozco managed to paint only a few sections in the vault area around the choir. Created during the height of the Second World War, Orozco's *Allegory of the Apocalypse in Modern Times* expresses all of Orozco's sense of anguish, anxiety and dread of a modern world out of control, hurtling towards a cultural abyss. The spirit of the panels is summed up in the image of the Whore of the Apocalypse, a grotesque, laughing figure riding a jaguar – Orozco's repeated symbol of Mexico.

This last period of Orozco's life did not result in mural work as spectacular as that which he had produced in Guadalajara between 1936 and 1939. Nevertheless, it was a productive time during which he also created a number of important easel works, now in the Orozco family collection, such as *Mask with Butterfly* in 1947, and *Metaphysical Landscape* and *The Slave*, both in 1948. Throughout the murals of this final period, Orozco seems to have searched for a different voice with which to express the reality of a new age. Yet he still appeared acutely dissatisfied with the biting visual vocabulary that had become so familiar a part of the language of his public expression. In 1947 he wrote that

175
José Clemente Orozco: *National Riches*. Fresco, 1941. Supreme Court of Justice, Mexico City.

176
José Clemente Orozco: *Proletarian Struggle*. Fresco, 1941. Supreme Court of Justice, Mexico City.

there is the trend of revolutionary socialist propaganda, in which there continues to appear with surprising persistancy, Christian iconography ... superficially modernized; perhaps rifles and machine guns in place of bows and arrows; aeroplanes instead of angels; flying atomic bombs in place of divine damnation.... To all this outdated religious imagery very nineteenth-century liberal symbols are added.... Very ancient symbols of the 'Bourgeoisie, enemy of progress' type still play a prominent part in murals represented by pot-bellied toffs in top hats or by pigs, jackals, dragons or other monsters; so well known and so familiar that they are as inoffensive as the plumed serpent.[13]

In the last two works, and particularly in the murals he had painted in the Supreme Court and the Chapel of Jesús Nazareno, Orozco had certainly reverted to form. Yet the extraordinary departure from that norm in the conceptualization of his external mural, *National Allegory*, at the National Teachers' School, had been dramatic evidence of the potential that Orozco had for a new visual vocabulary to express his ideas.

By the time Orozco died in 1949, the relative positions of Rivera, Orozco and Siqueiros had changed dramatically from those they held in the first decade of the mural movement's history. Orozco, who had been forced to leave Mexico in 1926 in order to earn a living in America, had returned in 1934, a fully mature painter. In Guadalajara, during the latter half of the 1930s, his murals had brought him to the pinnacle of his career. The work that he did during the 1940s sustained his stature and his reputation as one of the most powerful painters the American continent had ever produced.

Conversely, Diego Rivera, after his return to Mexico in 1934, and in the wake of the controversy surrounding the débâcle of the Rockefeller mural, moved into a kind of exile from the movement in which he had played so central a part, and which in the 1920s had largely been defined by the work that he had produced. In part, Rivera's exile was made more intense by the extent to which former colleagues and comrades within the communist movement ostracized him. He had become the target of intense political criticism. Indeed, his position during the late 1930s placed him in further confrontation with those on the left who supported Stalin and the Soviet Union, when Rivera persuaded the then President of Mexico, Lazaro Cárdenas, to let Leon Trotsky seek exile in Mexico.[14]

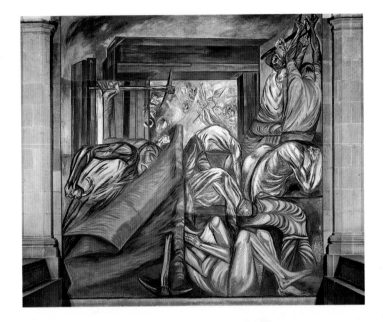

169

Following his return from the United States in 1934, and having recreated *Man at the Crossroads* at the newly completed Palace of Fine Arts in Mexico City and completed the left-hand wall of his *History of Mexico* at the National Palace, Rivera confined himself largely to easel painting.[15] It was only in 1940, when he returned to the United States to undertake the commission for the *Pan-American Unity* mural for the San Francisco Golden Gate Exhibition that he began to work again as a mural painter.[16]

Pan-American Unity forms an interesting comparison with the work of Orozco at Dartmouth College. Like Orozco, Rivera expressed his theme as the development of the American continent. His interpretation included not only the contribution of the Indian and *mestizo* peoples to that culture, but that of the European as well. Rivera expressed the cultural dualities of this American identity in the mural's dominant central image – here depicted as a giant figure constructed from the different forms of Coatlicue, the Aztec goddess of earth and death, and a huge modern industrial pressing machine. On either side of this symbolic motif, Rivera drew a series of images representing the evolution of the continent from its Indian roots to the age of modern industry. But unlike Orozco, who painted a devastating

OROZCO AND RIVERA

177
Diego Rivera: *Totonac Civilization*.
Fresco, 1950. National Palace,
Mexico City.

170

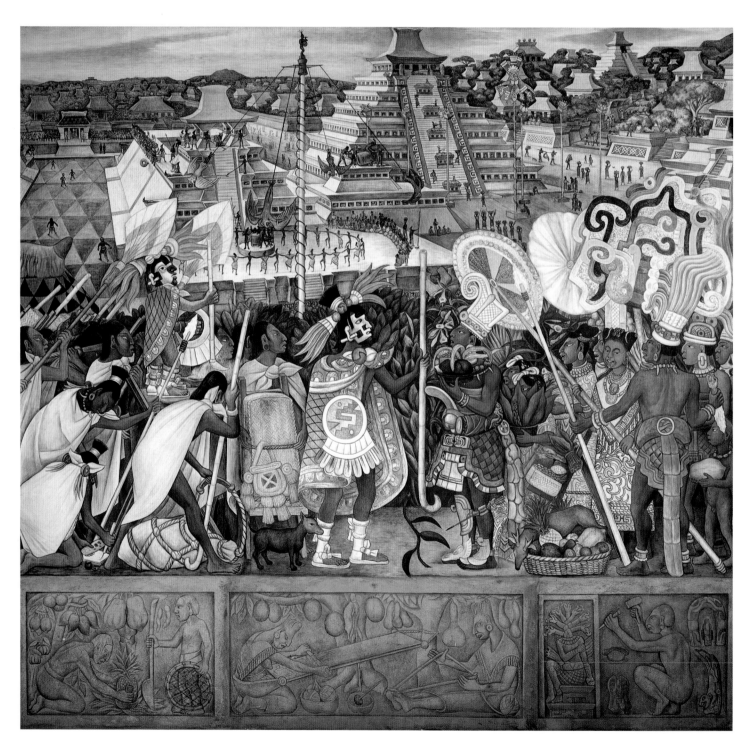

178
Diego Rivera: *Huastec Civilization*.
Fresco, 1950. National Palace,
Mexico City.

179
Diego Rivera: *The Papermakers*.
Fresco, 1950. National Palace,
Mexico City.

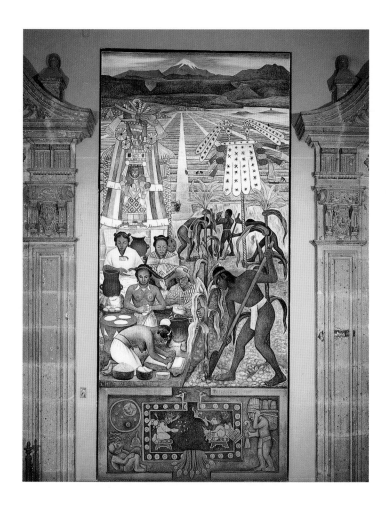

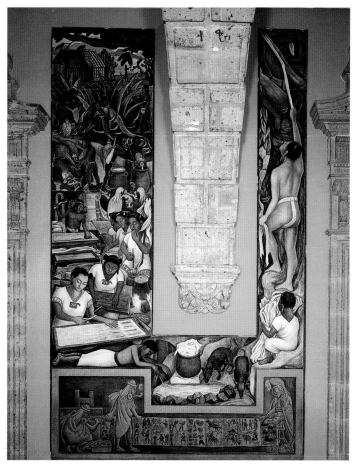

conclusion to his *History of the American Continent*, with the famous image of an angry Christ returned to hack down his cross, Rivera's portrayal is, like many of his other American murals, optimistic and celebratory. His only allusion to the world conflict of the time is the small lampoon of fascism at the bottom of the mural, which he painted in grisaille.

However, the main characteristics of Rivera's late murals are to be found at the National Palace, to which he returned in 1942. In the context of the rapidly modernizing and changing Mexican society, Rivera's work during the 1940s and 1950s witnessed an intense involvement with the theme of Mexico. However, it was an involvement that increasingly looked inwards and backwards; it was often nostalgic and highly idealistic. Indeed, the paradox

of Rivera's later murals is that while his work of the 1920s and 1930s closely reflected the impact of contemporary events and thinking, the murals that he created during the 1940s and 1950s increasingly distanced themselves in content as well as style from such realities.[17]

The murals that Rivera painted from 1942 to 1951 along the open corridors of the first floor of the National Palace were originally intended to link the indigenous origins of the country with what Rivera described as its Socialist aspirations. As it was, the cycle was never finished for Rivera only completed eleven of the panels, two of which are introductory panels in grisaille. The common characteristic of this cycle at the National Palace is the concentration on the subject and theme of pre-Columbian life

180 *below*
Diego Rivera: *The Great City of Tenochtitlan*. Fresco, 1945. National Palace, Mexico City.

181 *below right*
Diego Rivera: *The Disembarkation at Veracruz*. Fresco, 1951. National Palace, Mexico City.

182 *opposite*
Diego Rivera: *A Dream of a Sunday Afternoon in Alameda Park*. Fresco, 1947–8. Mexico City.

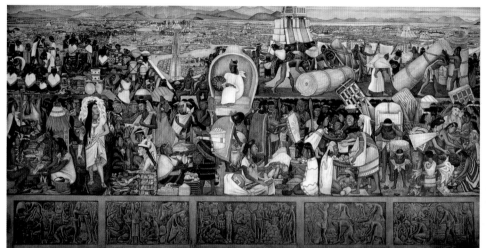

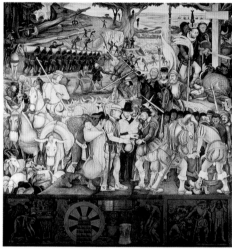

and civilizations. This dimension of the cycle is particularly significant, for Rivera was becoming increasingly absorbed by the need to picture these themes, not so much as political evolution, but as the fundamental core of a Mexican identity. In this sense, Rivera was giving expression to a conservative, almost nostalgic vision that he could never have experienced, but with which he nevertheless increasingly identified.

In the panel *The Great City of Tenochtitlan*, as in the others of the cycle, Rivera depicted the scene in great detail. The images appear as if they were faithful historical documents, thoroughly researched and correct in every detail. As Rivera later wrote, 'I took grave care to authenticate every detail by exact research, because I wanted to leave no opening for anyone to discredit the murals as a whole by the charge that any detail was a fabrication.'[18] His commitment to an authentic view of pre-Columbian life was closely associated with his sense of *indigenismo*. This had always been reflected in his need to present the pre-Hispanic world as idyllic. But now Rivera portrayed it as a society of great abundance, without hunger or poverty, an approach that Bertram Wolfe described as 'the return of the feathered serpent as a symbol of recurrence of tribal communism on a higher plane'.[19] Viewed in this context, Rivera's images stand as visual, political and economic apologia for a cultural return to the fundamental, and, for Rivera, socially radical roots of a Mexican identity.

Nowhere is this allusion to Mexico's indigenous past more clearly synthesized than in the relationship between the panels of *The Great City of Tenochtitlan* of 1945 and that of *The Disembarkation at Veracruz*, painted in 1951. Both panels show political and cultural epochs that are as much identified with colonial subjugation and oppression as they are with civilization and culture. Yet in the panel of Tenochtitlan there is 'no hint of Aztec imperialism, which the market symbolizes. Tribute and sacrificial victims were brought to Tenochtitlan from the subject peoples.'[20] By contrast, in the disembarkation panel, Cortez is depicted as a hideous, syphilitic being, and the world that he brings as one of murder, torture and slavery. Unlike the cycle painted by Orozco in the Hospicio Cabañas in Guadalajara, here Rivera magnified the oppressive, exploitative character of the Spanish conquest by choosing not to reflect the equally exploitative and cruel character of Mexico's indigenous past.

If Rivera projected a view of Mexico's past as an idyll in this later cycle of frescoes, then the next work he created for a public site in 1947 transposes that idyll into a kind of personal nostalgia. In this huge work, Rivera portrays a landscape with himself as a child standing against a backdrop of Mexican history. This history is drawn from his childhood memories alongside the prominent personalities of nineteenth- and twentieth-century Mexican history.

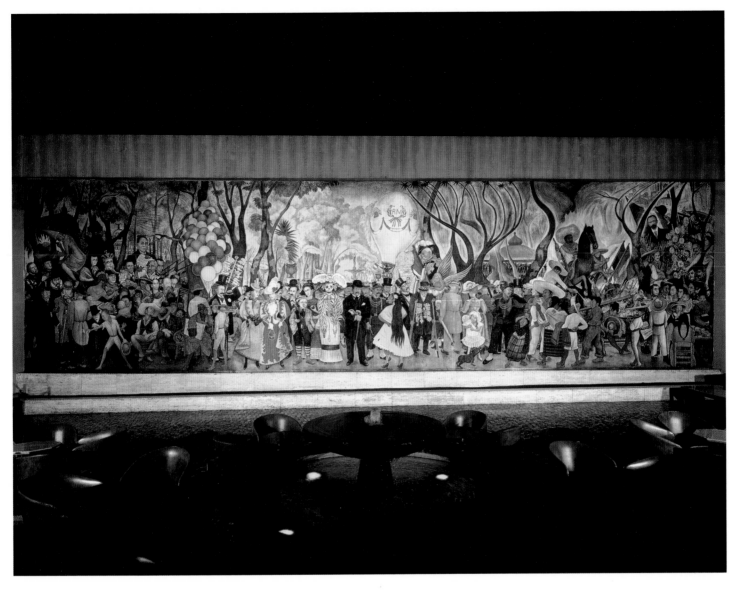

Entitled *A Dream of a Sunday Afternoon in Alameda Park*, the mural was commissioned for the main lobby of the Alameda Hotel which stands directly opposite the Alameda Park in the heart of Mexico City.[21] When it was completed, it proved to be one of the great masterpieces of Rivera's later years. In the densely packed composition, at the centre of the mural, Diego Rivera painted himself as a young boy. He is portrayed holding hands with a *calavera* or skeleton, who in turn is holding the hand of Rivera's childhood mentor, the Mexican engraver José Guadalupe Posada. Directly behind, but still part of this group, is the figure of Rivera's wife, the painter Frida Kahlo. In the foreground, surrounding these figures, are scenes representing the poor and the destitute of the dictatorship of Porfirio Díaz. Rivera took these scenes from his experiences as a child, showing pickpockets, street urchins, newspaper vendors and Indian peasants plying their trades and being ejected from the park by the

dictator's police. This is society's underclass, on whose behalf the revolution was made. Rivera contrasts them with the well-dressed figures representing Mexico's ruling class, which he placed in the mural composition's middle ground.

Sweeping up towards the left, Rivera created an assemblage of colonial and nineteenth-century figures, placing a scene of the Spanish Inquisition on the left-hand side of them.[22] Rivera also pictured the major figures of this period of Mexico's history in this area, including Cortez, Maximilian and Carlotta, together with the figure of General Scott, the American whose forces invaded Mexico in the 1840s, and whose troops camped in the Alameda in 1847.[23]

In contrast, on the right-hand side of the mural Rivera constructed a crowd of people that represents the world of Mexico's revolt against the oppression of colonialism and dictatorship. Among the most significant are Zapata, mounted on his horse,

183 & 184 *top & bottom*
Diego Rivera: *A Dream of a Sunday
Afternoon in Alameda Park*. Fresco,
1947–8. Detail of right-hand side.
Alameda Hotel, Mexico City.

185 *below*
Diego Rivera at work on the mural
*A Dream of a Sunday Afternoon in
Alameda Park*.

186 *opposite*
Diego Rivera: *A Dream of a Sunday
Afternoon in Alameda Park*. Fresco,
1947–8. Detail of centre. Alameda
Hotel, Mexico City.

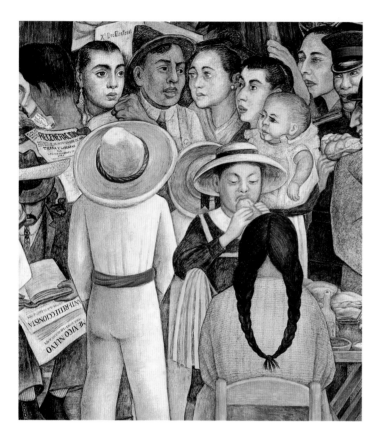

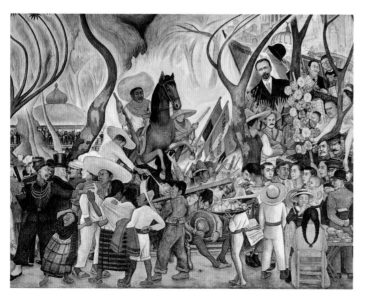

and the revolution's instigator, Francisco Madero, together with portraits of Rivera's family by his first wife, Lupe Marín. Rivera's decision to include his family in this area of the composition, in addition to Kahlo and Posada in the centre, emphasizes his extraordinary joining of fantasy and fact in his reminiscences and his thematic narrative. The resulting atmosphere of intense nostalgia is underpinned by the golden colouring. The trees that Rivera painted appear almost like a theatrical curtain and the extraordinary array of historical figures, family and friends like actors taking their final curtain call at the end of a great performance.

Of the many murals that Rivera painted, the Alameda work is unique in the extent to which it interlaces autobiography and fantasy. Although ten more years of his life remained, this mural appears almost like a valedictory statement. After nearly a quarter of a century as a mural painter, Rivera had presented his

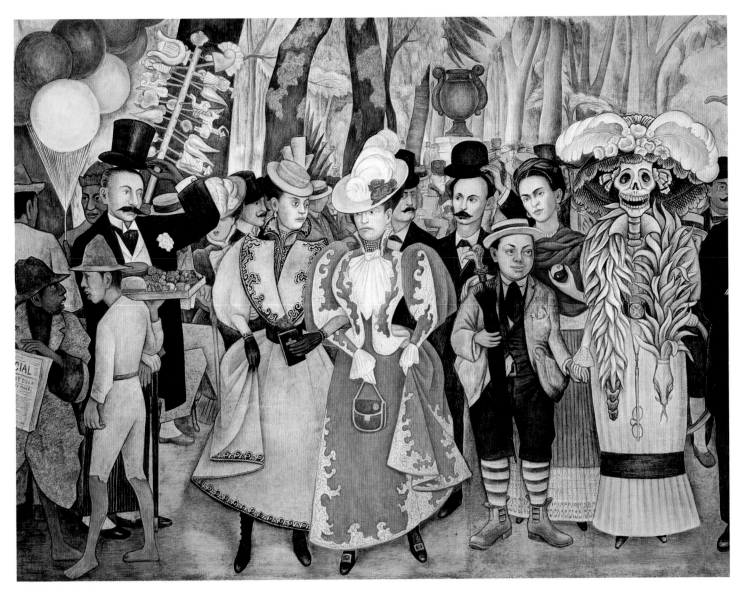

public with a panorama of everything that had formed his character. Strikingly, however, he included almost nothing that was not Mexican, and apart from his family with Lupe Marín, and his portrait of Frida, he incorporated only three personalities that extended beyond his early life. These included Luís Martínez Rodríguez (at the top on the far right of the picture), the then archbishop of Mexico City; José Vasconcelos (in the centre of this right-hand group) and Manuel Martínez, his assistant (next to Vasconcelos). As with his allusions to Mexican national identity at the National Palace, which he was still painting at the time of this mural, Rivera located and defined himself before the intervention of the world of modern and contemporary experience.

Although *A Dream of a Sunday Afternoon in Alameda Park* contains none of the fierce rhetoric of many of Rivera's earlier works, its completion nevertheless met with a storm of protest because of the words that he had shown on a placard held by the figure of the nineteenth-century Mexican philosopher, Ignacio Ramírez. The offending words, 'God does not exist', had been uttered by Ramírez during a lecture delivered to the Letrán Academy in 1836. On seeing them, the archbishop, Luís Martínez Rodríguez, refused to bless the newly-built hotel in which the fresco had been painted. Outraged Catholic students attacked the mural, damaging the figure in the centre representing the young Rivera. The students also scratched out the offending words painted on the placard.[24]

Rivera's intense involvement with the past continued in other murals of this period, such as his two fresco panels on the history of cardiology, painted in 1944 in the Centro Médico, his large 1953 mural in the Hospital de la Raza, and the mosaic work *A Popular History of Mexico*, executed the same year for the façade of the Teatro de los Insurgentes, all in Mexico City.

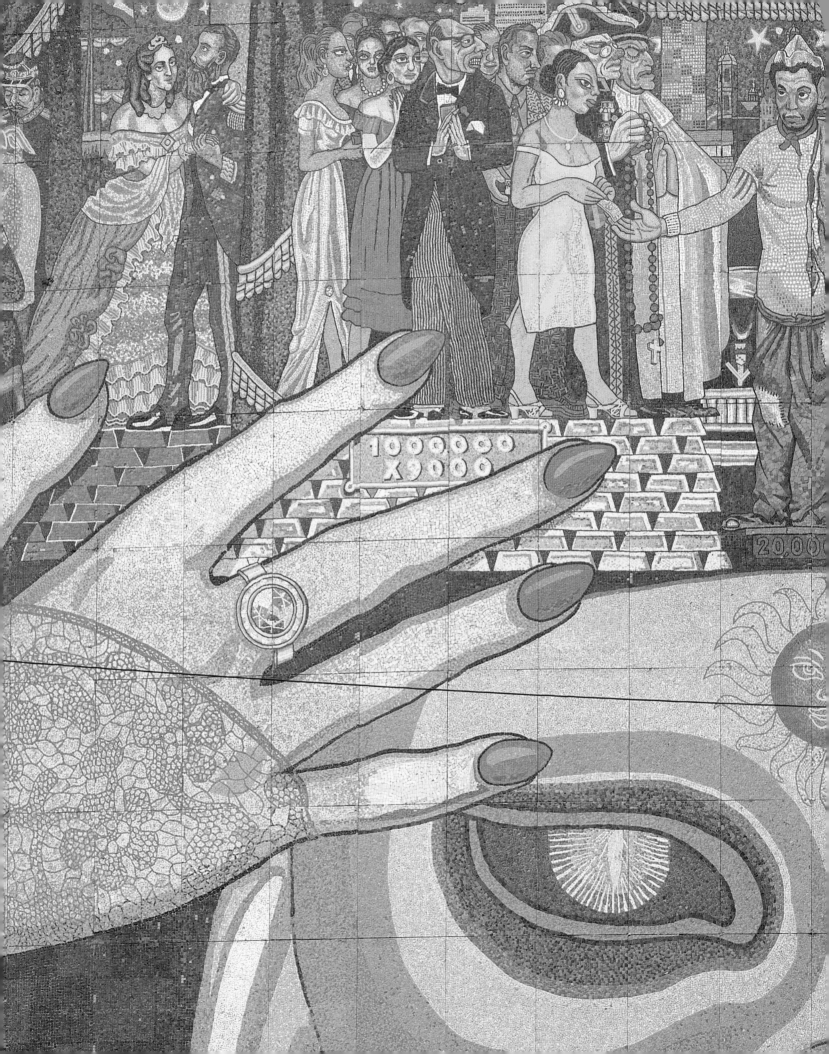

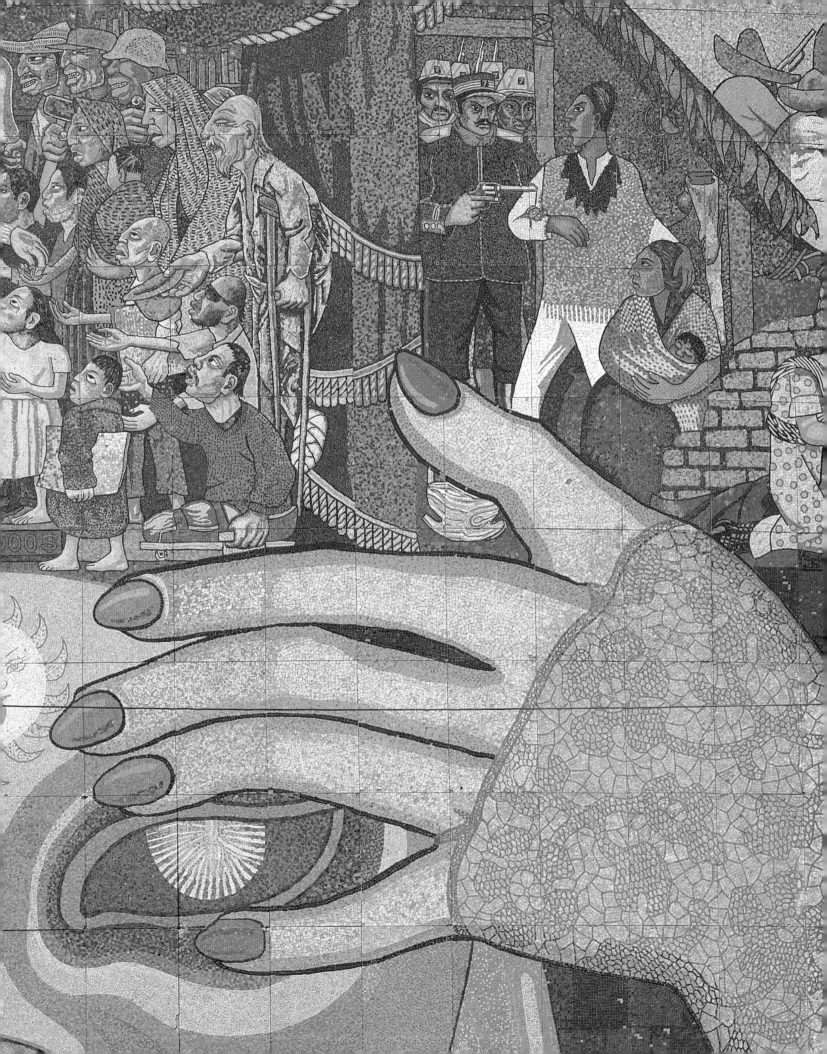

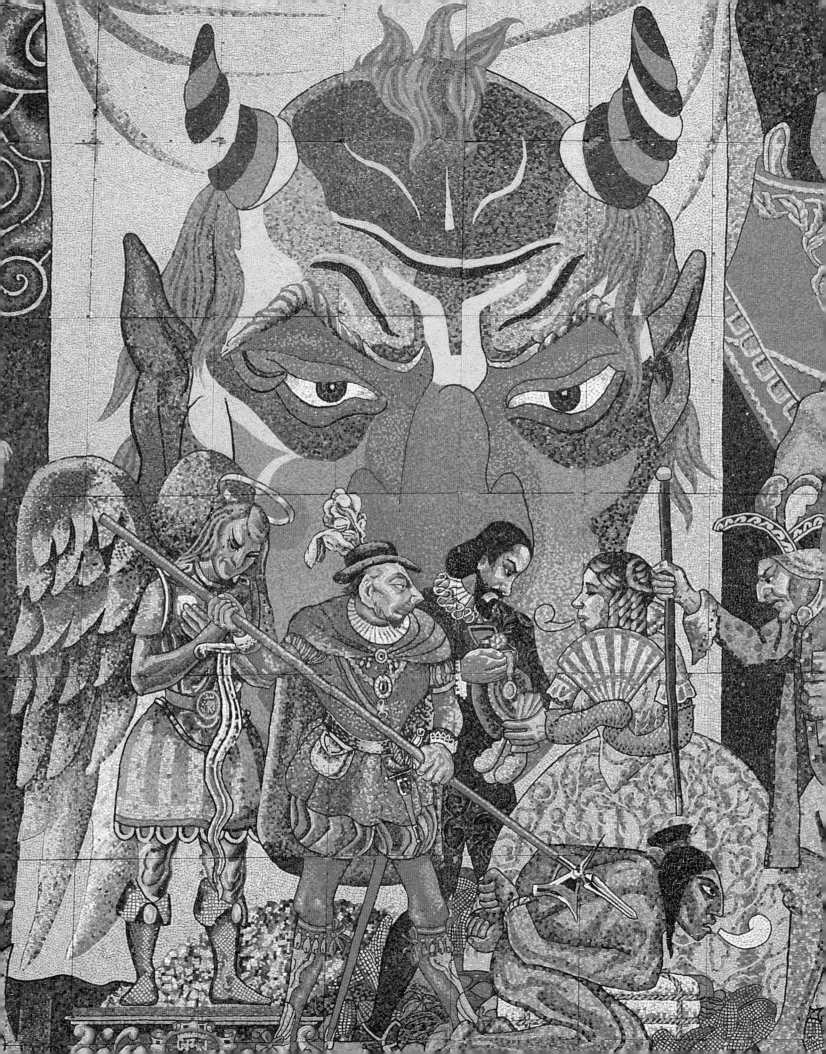

187 *previous pages*
Diego Rivera: *A Popular History of*
Mexico (detail). Mosaic, 1953. Teatro
de los Insurgentes, Mexico City.

189 *below*
Diego Rivera: *A Popular History of*
Mexico. Mosaic, 1953. Teatro de los
Insurgentes, Mexico City.

188 *opposite*
Diego Rivera: *A Popular History of*
Mexico (detail). Mosaic, 1953. Teatro
de los Insurgentes, Mexico City.

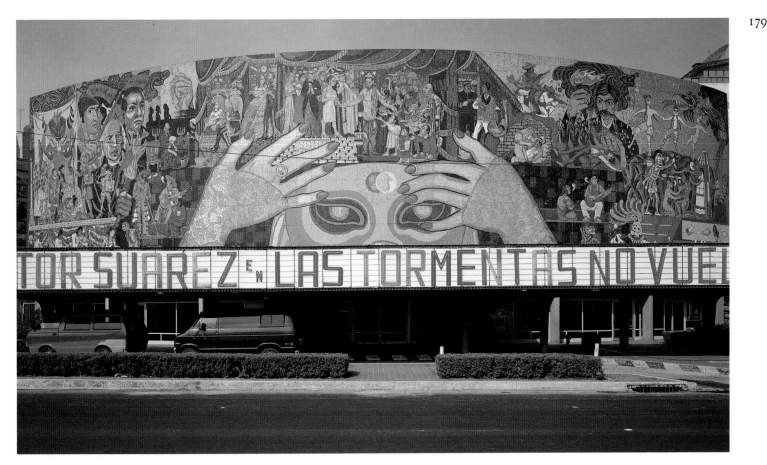

Rivera presented his theme on the façade of the Teatro de Los Insurgentes in a raucous, almost music-hall vein. Using the famous and much-loved Mexican comic actor, Cantinflas, as a central component, Rivera created a scene of satire and amusement. He portrayed Cantinflas taking money from the rich and giving it to the poor against a background of Mexican history, which included the great Mexican figures of liberty and independence, Hidalgo and Juárez. With its highly public setting, on one of the busiest avenues in Mexico City, and with its garish colouring, the giant mosaic mural evokes the populist spirit of the comic papers which Rivera so loved.

Although, like the Alameda mural, *A Popular History of Mexico* did not appear controversial or offensive, it nevertheless upset many people. In this case, the criticism concerned the image of

Cantinflas, which Rivera had placed directly in front of the towers and stars of the sacred symbol of Mexico, the Virgin of Guadalupe. In the drawings that he had prepared for the mural, he also depicted Cantinflas wearing the emblem of the Virgin. Devout Catholics interpreted Rivera's concept as a blasphemous portrayal of Juan Diego, the Indian in front of whom the Virgin is believed to have appeared on three occasions.[25]

A Popular History of Mexico was an attempt by Rivera at populist historical narrative. By comparison, his treatment of history in his two medical murals is more significant and thematically complex. The differences between the two works also highlight the extent to which Rivera called upon the racial and social roots of his country to present a radical version of contemporary Mexican politics.

180

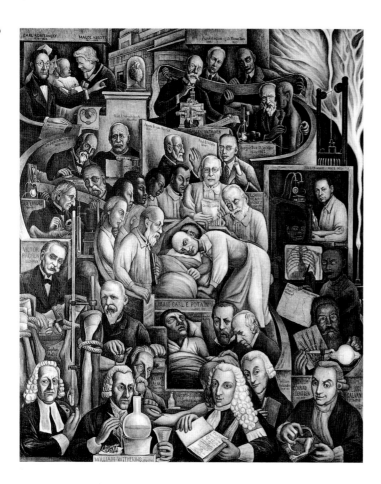

191
Diego Rivera: *A History of Cardiology
– Ancient Cardiology*. Fresco, 1943–4.
Institute of Cardiology, Mexico
City.

The frescoes of *A History of Cardiology* were Rivera's first public commissions since undertaking the four fresco panels for the Pani family in 1936. He painted a double panel based on a thoroughly researched history of the heart and the circulation of the blood. The first panel represents cardiac medicine in ancient times; the companion panel shows its modern development. Both are semi-spiral compositions containing a mass of life-sized figures representing the great names of cardiac medicine. In a manner that parallels the faithful documentation of historical fact displayed by Rivera in his frescoes along the patio corridors of the National Palace, *A History of Cardiology* gives the impression of an illustrated medical thesis. Yet Rivera still managed to achieve passages of great depth and expressive power in these two mural panels. The image in the first, left-hand panel, depicting the execution of the sixteenth-century anatomist, Michel Servet, who was burned at the stake for his theories on the circulation of the blood, is particularly strong.

Ten years later, in the Hospital de la Raza, Rivera again demonstrated his knowledge of the history of medicine.[26] Here, however, he contextualized his theme by providing a background in which he juxtaposed images of modern scientific medicine with those of pre-Columbian cures and practices. The central image of the mural features the figure of Tlazoltéotl, the Aztec goddess who was believed to absorb dirt and remove debris through physical attachment.[27] To her right, Rivera painted a minutely detailed display of the practices and rituals of ancient Indian medicine. Dominated by the figure of Izcuitl, the goddess of medicine, it is imbued with the same nostalgia with which he depicted pre-Columbian civilization at the National Palace.[28]

On the left-hand side of the mural, Rivera portrayed contrasting images of twentieth-century medical practice and science. He divided his sub-theme at the top of this area by juxtaposing scenes of medicine for profit, which only the wealthy are able to afford, and scenes of a socialized, freely available medicine for all. The contrast between the images of abundance and the egalitarian spirit in the scenes portraying the medicine of the ancient Indians, and those of white-skinned plutocrats staring grim-faced at the free distribution of modern medical services to the dark-skinned poor, is particularly telling. Through the use of

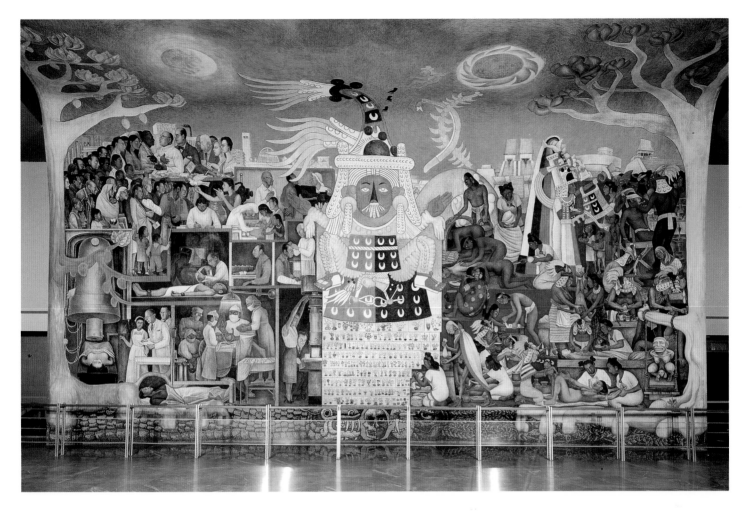

visual juxtaposition, Rivera once again skilfully synthesized his notion of an ideal ancient Indian egalitarianism with a modern vision of radical socialist practice. The result is resonant with ideological and nationalistic overtones.

Ever since Rivera had painted the Detroit cycle of frescoes, he had demonstrated his particular ability to absorb information about science and technology and to weave into it connections with the past and the origins of life. The evolution of the natural world meant as much to him as its counterpart in the human and social world, and the relationship between the two is the basis of much of his most evocative imagery. At the Agricultural School at Chapingo, nearly three decades before, Rivera had painted a hymn to the earth. In 1951, at the Rio Lerma water-works in Mexico City, he turned his attention to the theme of water, its life-creating properties and its relationship to mankind.

Painted inside the Rio Lerma water distribution plant, Rivera's mural cycle covered the walls, floor and tunnel of the cistern basin. In this unique cycle, Rivera divided his thematic conception into stages. The first was the evolution from mineral elements and the first cells to the beginning of life. This is followed by a vision in which water workers offer the vital fluid to the different social classes of Mexican society, and succeeded by scenes of the directors and technicians who participated in the construction of the plant. At the very heart of the composition, located above the tunnel entrance, Rivera placed a giant pair of worker's hands, offering water, the symbolic gift of Tlaloc, the rain god, to the city. Outside, he created a giant mosaic earth sculpture of the rain god to symbolize the link between the creation and distribution of water and Mexico's pre-Columbian past.

When Rivera began this mural he considered it a unique opportunity, particularly since the building was envisaged as a cultural and educational entity as well as a water distribution plant. He intended to create a unity in the work which would link the exterior to the interior, organically combining modernity with the country's pre-Columbian past, and linking the origins of life with the water of the earth. However, the mural also carried a deliberately political message, so characteristic of Rivera's public works. During the building of the water distribution plant, thirty-five workmen had been killed and the completed mural is as much a monument to these workers as it is an evocation of the origins of life.

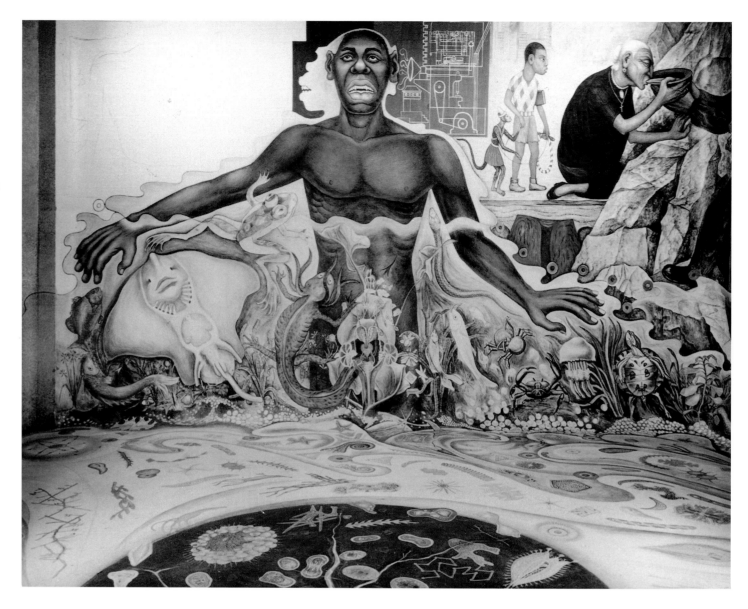

Although the work is badly deteriorated, after the Alameda mural, it is perhaps the most significant achievement of Rivera in the post-war period.[29] Like Siqueiros at this time, Rivera conceived of the mural as more than mere painting on a flat surface. He envisaged it as a total environment in which paint would cover every surface, and the design would be visually and thematically linked to the architecture of the site and to the sculptural concept created outside. Together with the polychrome reliefs that he made for the exterior of the Olympic Stadium in Mexico City in 1952, the Río Lerma mural constituted a radical departure from his previous work, for throughout his life he had been associated with the use of traditional materials and techniques. However, Rivera's failing health prevented any further incursions into innovatory design concepts or new materials or methods.

When Rivera began painting murals in the 1920s, Mexico had just emerged from a largely agrarian revolution. In those early years, his public mural works had closely mirrored the political and intellectual atmosphere of Mexican society at the time. Revolutionary imagery and the reassertion of traditions and cultural roots were closely reflected in the style, themes and subjects of his murals. However, in the post-war period, Mexico's revolutionary culture became transformed and to a certain extent absorbed by the demands of a modern political, industrial and commercial culture.[30] The old indigenous and revolutionary values of the 1920s and 1930s appeared to be increasingly at odds with the progress of this 'new' Mexican reality, which was far more urban and metropolitan in its characteristics and concerns. In the United States in the 1930s, Rivera had been transfixed by the image of the modern industrial age. For him it was not only

193 *opposite*
Diego Rivera: *Rio Lerma*. Fresco,
1951. Rio Lerma Waterworks,
Mexico City.

194
Diego Rivera posing with the Rio
Lerma Waterworks mural.

195
Diego Rivera: *Rio Lerma*. Fresco,
1951. Rio Lerma Waterworks,
Mexico City.

183

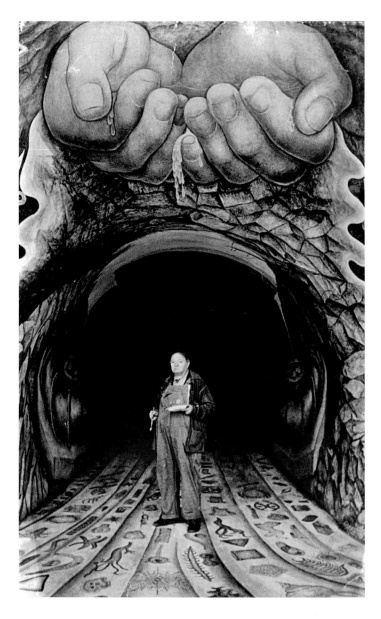

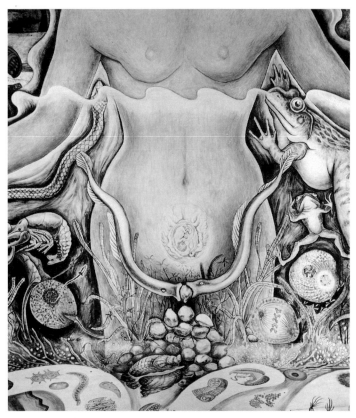

the evidence of the modern world, but also the key to a new society. Yet the paradox inherent in the murals that Rivera created from 1940 until his death in 1957 is an apparent rejection of this thesis. Indeed, many of his later murals seem to be firmly anchored in the past as a reminder of the intellectual and cultural roots from which the Mexican people have sprung, but from which their new Mexican society seemed increasingly to distance itself.

OROZCO AND RIVERA

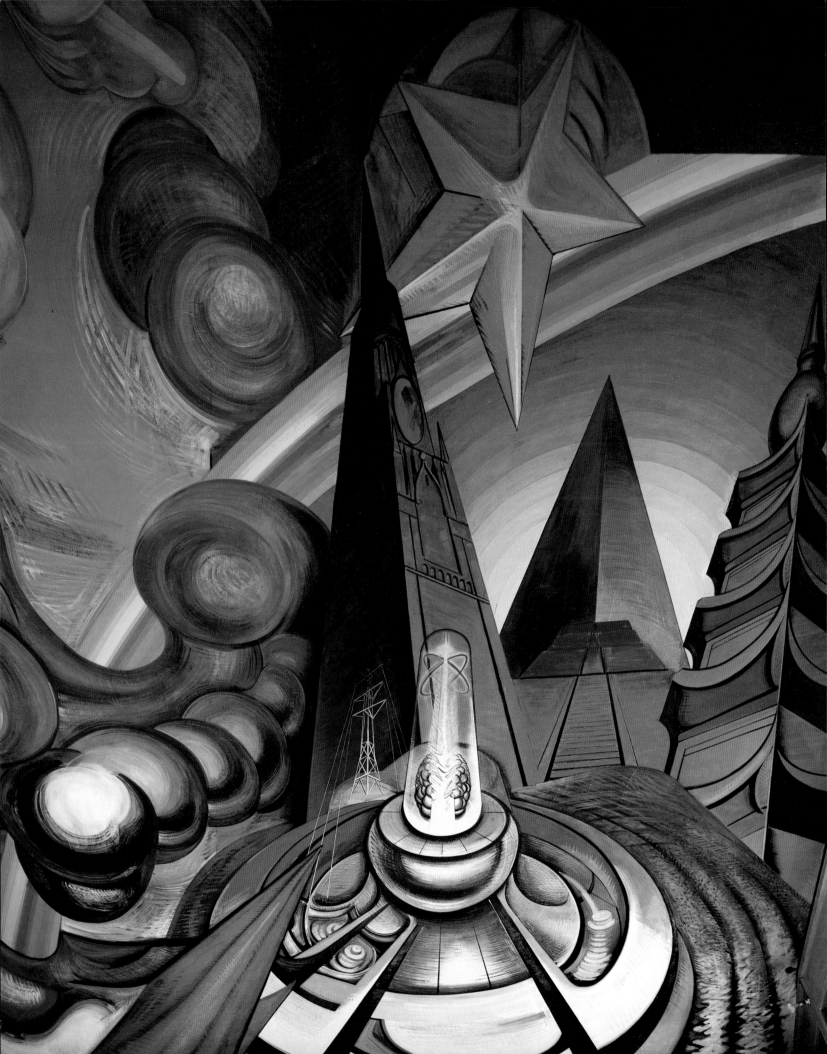

196
David Alfaro Siqueiros: *For the Complete Safety of all Mexicans at Work*. Vinylite and pyroxaline on plywood and fibreglass, 1952–4. La Raza Hospital, detail of ceiling from centre point of the room, Mexico City.

SEVEN

SIQUEIROS, 1940-1971

THE IDEOLOGY OF INVENTION

The ideology that fired Siqueiros' political and artistic imagination during the 1920s and 1930s remained with him throughout the post-war period. It was an imagination that continued to claim a unity between revolutionary socialism and technological modernity. Though such unity now seems to be no more than a myth, the contradiction, far from undermining Siqueiros as an artist, helps provide the key to understanding the post-war years of his maturity. For instead of playing out the myth through delusory acts of thematic repetition, Siqueiros transposed the contradiction by redrawing it within the boundaries of Mexican reality. He highlighted the tensions and paradoxes of a country in which the drive towards industrial and economic modernity took place in a society whose ruling political class developed its interests behind a cloak of anti-colonialist rhetoric, always recasting the nation's identity in the radical glow of its revolutionary history.

Portrait of the Bourgeoisie brought together the ideas and methods Siqueiros had learned and developed during his decade of experimentation and innovation in the 1930s. The mural work that Siqueiros created in the 1940s and 1950s finally synthesized his preoccupation for pictorial innovation through a more sustained involvement with theme and subject-matter. In part, the practical opportunities for Siqueiros to develop as a thematically sophisticated artist, equal to Rivera and Orozco, came as the result of a growing recognition during the War and in the post-war period that Siqueiros was indeed a painter of consider-

able stature, worthy of official commission by the Mexican state. It could be argued that Siqueiros' public commissions of the 1940s and 1950s were driven in part by the need of the Mexican cultural and political élite to mask the true nature of their ideological interests behind a veneer of cultural radicalism. By fêting Siqueiros' notorious reputation as a political revolutionary, these élite sectors could legitimize their ambitions in a cloud of anti-colonialist cultural posturing. They could continue to direct Mexico down the road mapped out by the demands of international capital, while at the same time appearing to preserve and develop the country's valued radical cultural credentials. The extent to which this is true is debatable, but it is an aspect that should be considered in any critical analysis of Siqueiros as a major cultural figurehead in Mexico during the post-war period.

The exploitation of Siqueiros' reputation can be seen, to a certain extent, in the circumstances that led up to the creation of his first mural of the 1940s, *Death to the Invader*, painted in Chillán in Chile in 1941. Exiled by the Mexican government following his release from prison for his involvement in the attack on Trotsky of May 1940, the same government presented him with the Chillán commission. The commission arose out of the circumstances surrounding the 1938 earthquake that had so devastated the area. Relief donated to Chile by the Mexican government included the building of a new school in the town. Through the persuasive influence of Pablo Neruda, the Chilean Ambassador to Mexico at the time, the Mexican government

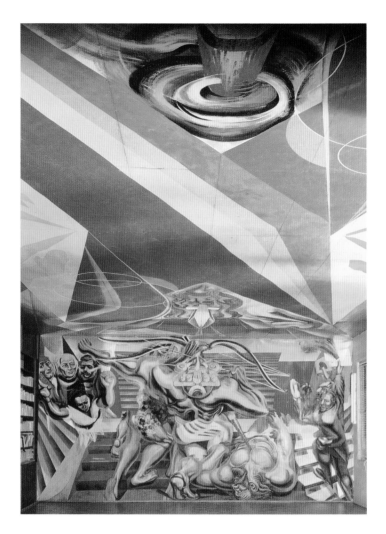

197
David Alfaro Siqueiros: *Death to the Invader*. Pyroxaline on masonite and plywood, 1941–2. Escuela Mexico, view of south wall, Chillán, Chile.

186 agreed to terms of exile for Siqueiros that included a commission to decorate the new school's library room with a mural.

Death to the Invader was in many respects a reaffirmation of the idea of Latin-American struggle that had inspired the creation of Siqueiros' earlier Los Angeles mural, *Tropical America*. In Chillán, this theme was transformed into a dramatic baroque historical epic which paved the way for a series of other historically oriented murals during the 1940s and 1950s.

The circumstances surrounding the origin of the commission are closely linked to the nature of the theme Siqueiros chose. Mexico and Chile's collaboration over restoration and aid following the disastrous earthquake, had suggested to Siqueiros a Mexican–Chilean theme. In this case, he chose to allude to the struggle both countries had engaged in to gain their independence from colonialism. Siqueiros described his intentions:

My thematic proposition was . . . To make a plastic hymn to the most prominent figures in the popular struggles of Mexico and Chile. . . . I wanted to paint the . . . fundamental basis behind the history of both people's struggles, for both are peoples of Latin America. Their uprising against Spanish colonialism started at exactly the same time, and finished at exactly the same moment. Their later struggles, which we called 'The Reform', had exactly the same characteristics . . . our Juárez is their Galvarino, and for us, Galvarino is Juárez.[1]

The idea of a common thread running through both countries' historical experience is the central tenet of the mural's theme. The pictorial organization, however, was heavily influenced by the physical disposition of the wall surfaces on which it was painted. The site was a long room with a relatively low ceiling, at either end of which were the two walls where the mural was to be painted. The thematic concept and the characteristics of the site combined to present Siqueiros with a perfect basis on which he could begin to synthesize his concept of dynamic architectonic compositional form with an equally dynamic theme.

At one end of the room, Siqueiros depicted his vision of the history of the Mexican people. At the other, in a more densely crowded composition, he represented his vision of Chilean history. On the Mexican wall, Siqueiros' central figure is that of the great Aztec leader, Cuauhtemoc, who symbolizes the heroic

struggle against Cortez and his conquistadors. At the other end of the room, Cuauhtemoc's Chilean counterpart is the legendary Aurancanian Indian, Galvarino.[2] Together, their common historical role as defenders of their nation's integrity against Spanish subjugation is symbolized by the prone and dying figures that lie at their feet. These include an invading conquistador, his head pierced with an arrow, fired from Cuauhtemoc's still quivering bow. Below the figure of Galvarino lie a pair of heavily armed Spanish knights, their torsos threatened by an array of huge spears held by a myriad hands to the left of Galvarino.

Surrounding these two great national heroes, Siqueiros presented figures associated with the revolutionary struggles for independence in the nineteenth century and for land and progress in the twentieth. On the Mexican wall, Hidalgo, Morelos and Zapata are pictured to Cuauhtemoc's left, while to the right are the figures of nineteenth- and twentieth-century political reformers in Mexico, Benito Juárez and Lázaro Cárdenas. Siqueiros depicted Chile's heroic equivalents on the Chilean wall. The bearded figure to the left, almost merging into

Galvarino, is Bilbao, while to his left is the figure of Caupolican. Still further to the left are portrayals of Lautero and Recabarren. To the right of Galvarino, Siqueiros showed Bernard O'Higgins, the founder of Chilean independence, and on the concave segment at the outer edge of the mural is Balmaceda. Siqueiros wrote of the significance of his choice of figures and who they represented

Lautero ... is an expression of the theory of struggle of the Aurancanian peoples against the Spanish conquistadors, and (Recabarren) ... the most important theorist of the Chilean workers and trade union movement. ... if Lautero was the ideologue, the political apostle of the Aurancanian peoples, then Caupolican was the giant, who hit the Spanish with the bodies of their own dead. ... Galvarino, the hero without equal, who with his arms mutilated, crossed the Andean mountains to the sea mobilizing his people in the holy war against the invaders.[3]

In many senses, *Death to the Invader* is a connection between Siqueiros' achievement in the Electricians' Syndicate and the murals that he painted throughout the post-war period. Much of *Portrait of the Bourgeoisie* pointed towards further development of innovative and formally radical approaches to mural construction. Thematically, *Portrait of the Bourgeoisie* reflected the political culture of the 1930s with its strident, but nevertheless compelling and powerful anti-fascist rhetoric and foreboding of war. By contrast, although Siqueiros thought otherwise, *Death to the Invader* was a thematic step forward, for it marked his engagement with a theme with which he was involved throughout much of the 1940s and 1950s, namely the allusion to history as a means of reflecting on the political present.[4] The mural was also a considerable formal advance, for it demonstrated still further the possibilities that lay in Siqueiros' aptitude for novel solutions to the pictorial construction of the mural.

The conceptual approach to the visualization of *Death to the Invader* was extremely daring. Aided by his small team of assistants, Siqueiros saw his primary challenge as the uniting, both visually and thematically, of the two walls at each end of the room.[5] He felt that a sense of unity existed because of the two centuries of common Latin-American historical experiences. Typically, he arrived at a formal solution. The curved surfaces

that he and his team had constructed on the two end walls produced a continuous and uninterrupted surface between vertical walls and horizontal ceiling. Siqueiros wrote

I had to compose (each) ... side ... as though it were coming over from the opposite side of the room. ... The solution was to 'optically' raise the ceiling on one side and then on the other, making the horizontal ceiling appear vertical from whichever side of the room it was being viewed. On the Chilean side the figurative element used to create this effect was a shaft, a volcano, for as Neruda has said, Chile is an essentially volcanic country. In the case of the Mexican end it was a shaft of fire, a generic and symbolic element.[6]

The resulting verticality 'visually' raised the height of the ceiling quite dramatically, particularly when viewed from the opposite end of the room. Additionally, Siqueiros managed to create the extraordinary sensation of forms, in this case often linear and abstract, moving up from one wall and reaching out over the ceiling to merge with the forms of the wall opposite. It is an illusory device, activated by the movement of an observer walking from one end of the room to the other. To do it is an experience that certainly underlines the narrative intent to present the idea of the common historical heritage of the two countries.

Although Siqueiros used many of the techniques and materials of his previous murals, his approach here involved some modifications. He still used the spray gun and airbrush, but the use of the traditional hand brush was certainly more in evidence. The result greatly increased the 'texture' of the mural, for Siqueiros was developing a painterly style that involved a larger gesturing in his handling of brushwork and the extensive use of impasto, giving the work a greater sense of expressive power.[7] With regard to optical achievement, Siqueiros wrote of his Chillán mural that 'This was conceived as the painting of a total architectural surface, and not as the organization of various isolated panels. This is a different way from that which ... my mural colleagues in Mexico used. It is in this respect an evident advance on my previous murals ... and on the fundamental doctrine of the painting of buildings'.[8]

Despite the relative isolation of the town of Chillán, the mural received extensive critical attention. Among the most significant

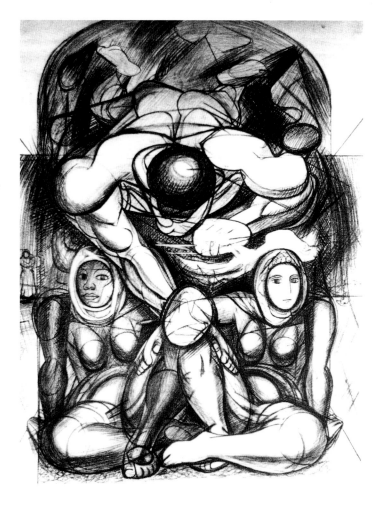

198
David Alfaro Siqueiros: *Allegory of Racial Equality*. Drawing for a project in Havana, Cuba, 1943.

American State Department that he was prohibited from entering the United States.[12] The circumstances surrounding Siqueiros' ban on entering the United States at this time were shrouded in intrigue. On being told of the denial of an entry visa, Siqueiros was nevertheless informed by the Embassy that he was to be offered, by way of compensation, a commission to carry out the very mural that he had proposed to paint in New York. More mysterious still was the fact that the mural was to be financed by the Rockefeller Foundation.[13] Siqueiros did not ever execute the work, accepting instead a commission for an interior mural in the private residence of the sugar planter María Luís Gómez Mena, entitled *Allegory of Racial Equality*.

Of the work that Siqueiros carried out while he was in Cuba, only *Allegory of Racial Equality* was technically a mural.[14] Its theme recalls the spirit of the Los Angeles mural *Tropical America*. The impact of the radical subject matter and its treatment in this mural was largely neutralized by the very private and internal siting of the painting. The real significance of the work thus lay in innovative forms and techniques, which Siqueiros based largely on the further use and exploitation of curved surfaces. Siqueiros' preoccupation with painting on curved surfaces was primarily influenced by his belief that painting had, until then, only achieved what he termed as the 'fixed graphic moment'. He considered it was necessary to develop a concept that produced the actual movement of visual phenomena. In Argentina and Chile, Siqueiros realized that straight lines only remain straight from one particular viewpoint. To achieve this effect a spectator had to move to the particular point in question. Curved surfaces that contained various straight lines and planes at different angles required constant movement to 'straighten' them. However, an observer moving to a particular point in order to 'straighten' a particular line of plane, would see that other lines and planes distributed at different angles had now become distorted away from their straight or flat positions. To rectify these distortions the spectator needed to continue moving, thus creating a process of dynamic movement in all the forms distributed throughout the entire curved surface of the picture. When he had completed *Allegory of Racial Equality*, Siqueiros wrote that for him the fundamental aspect of the mural was 'not the forms, nor even the colour, nor the relation between the geometric forms

comments were those of Lincoln Kirsten, then director of the Latin American section of the Museum of Modern Art in New York. Kirsten wrote that 'In Chillán one meets the most important new synthesis of plastic elements since the cubist revolution of 1911. And when one thinks of Guernica (that astounding and decorative failure) one is certain of Siqueiros' triumph.... We are very far from the romantic days of the syndicate. Instead we have a new classicism of an emotional and poetic realism, non decorative, non exotic, non romantic.'[9]

The completion of the Chillán mural indicated most of the main thematic preoccupations that would come to dominate Siqueiros' work during the next ten years and, in particular, his concern with depicting national history. Released from the contractual and legal obligations of his political exile in Chile, Siqueiros embarked on a tour of other Latin American countries with the intention of gathering the support of artists in the allied struggle against fascism.[10] As a finale to his campaign, Siqueiros intended to go to New York, where he wanted artists from both North and Latin America to collaborate in the production of a huge anti-fascist public mural.[11] Unfortunately this plan was curtailed when on arrival in Cuba he was informed by the

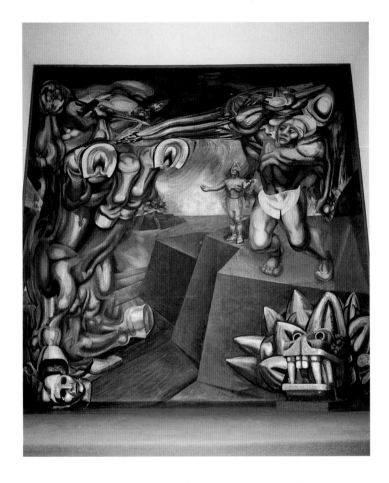

199
David Alfaro Siqueiros: *Cuauhtemoc
Against the Myth*. Pyroxaline on
celotex and plywood, 1944. This is
the reconstructed version of the
original, which was moved to the
Tecpan Building in Tlatelco, Mexico
City in 1964.

200
Documentary photograph used for
the centaur in *Cuauhtemoc Against
the Myth*.

and the colour; the fundamental thing was the movement, the
activity of the forms'.[15]

Siqueiros returned to Mexico at the beginning of 1944.
Although his term of exile had been completed, the political
cloud that still hung over him as a result of his involvement in
the attack on Trotsky four years earlier meant that for several
months he lived in a state of near hiding in the home of his
mother-in-law.[16] Despite the difficult circumstances in which he
found himself on his return, the period between then and the
awarding of his first government commission in twenty years
was to prove particularly significant. During this interlude
Siqueiros created one of his most notable murals, *Cuauhtemoc
Against the Myth*. He also established the *Centro de Arte Realístico*
(the Centre for Realist Art).

The establishment of the centre signalled a public declaration
by Siqueiros of the political aesthetic principles on which his
mural work of the post-war period was to be based.[17] Much of
what the Centre was to stand for was contained in Siqueiros'
manifesto, entitled 'Essential Propositions of the Centre for
Modern Realist Art', the ideas for which Siqueiros had developed
in several public talks that he had given during the time he spent
in Cuba. The most significant of these was his contention that
modern art in Mexico had lost its way, and strayed from the
revolutionary principles that had originally guided it at the
beginning of the movement. He wanted to promote what he
termed a second stage of Mexican mural painting, 'a stage of
experimental technique and the consolidation of the doctrine of
neo-realism, integral realism, in short a modern realism.'[18]
Although Siqueiros' claims for the influence of the Centre on the
national artistic life of the country at this time were often exag-
gerated, nevertheless the connection between the organization's
ideas and the creation of his murals was important.

Cuauhtemoc Against the Myth was painted inside the building
designated as the headquarters of the Centre for Realist Art, and
Siqueiros used the occasion of the mural's inauguration to
launch the Centre's manifesto.[19] The mural is a clear example of
Siqueiros' preoccupation with experimental, innovative mural
painting, depicting national historical, anti-colonialist, anti-
imperialist themes. As he later admitted, it was 'the technical
experimental continuation of my murals in Chile and Cuba

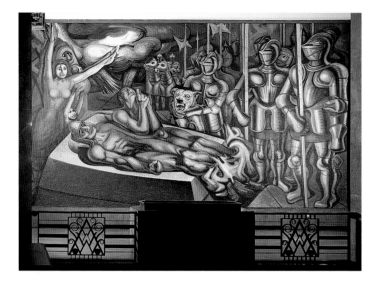

201
David Alfaro Siqueiros: *The Torment of Cuauhtemoc*. Pyroxaline on masonite, 1950. Palace of Fine Arts, Mexico City.

190

produced not on a flat or rectangular surface, but composed in absolute unity on diverse surfaces made up of various walls and ceilings'.[20] The mural was painted on a wall that extended up and around two floors of a staircase. Two side walls were adjacent to this main wall. In addition, the outer wall of the staircase created a second surface, in front of the main wall, which gave the whole site and the completed mural an architectonic quality. As in Chillán, Siqueiros constructed concave links between the main and lateral walls, creating a continuous surface. In addition, the staircase running down and across the main wall of the work ruptured the flatness of the main wall by descending a few feet and then tucking in underneath itself, creating a well of architectural space below the stairs. Siqueiros also made use of this as part of the composition of the mural.[21]

The narrative of the Cuauhtemoc mural focuses on the story of the Aztec prince's disbelief in the myth that Hernan Cortez represented the reincarnation of the legendary god Quetzalcoatl, perpetrated by Aztec priests at the time of the conquest. The priests strongly cautioned against opposing Cortez. The advice persuaded the Aztec king, Moctezuma, to receive the Spaniard in an act of naive appeasement, which rapidly led to the fall of his authority. Although Moctezuma's loss of will signified an ignominious defeat for the Aztecs, their resistance was reborn in the heroic struggle of the king's nephew, Cuauhtemoc. Antonio Rodríguez wrote that

discounting tradition and the augers of advice, Cuauhtemoc threw himself into the fray. . . . He challenged the gods, who were advising surrender through the priests, and prepared to fight. The fight was unequal. The Spaniards had brought gunpowder, horses, the dagger and the cross. Cuauhtemoc had only his unshakable will and a divided people. Still he resolved to fight, be it with his bare hands, as he said to his followers. He resisted his invader, and above all the myth, with his obsidian-tipped spears.[22]

Siqueiros constructed his mural from three component images. On the left, he depicted a gigantic writhing centaurian figure. Opposite, on the right side, standing on a pyramidal plinth is the figure of Cuauhtemoc. Between them, considerably reduced in scale, with his arms outstretched in a gesture of compliance, is Moctezuma. Siqueiros later reflected on his use of the centaurian figure: 'the figure is more than a centaurian. It is a "horseman", because the Indians thought that the Spanish knight and the horse, on which it was mounted, was one individual. For the Indian the Spaniard was a horse that emitted fire and had two heads, and so I painted that.'[23] Siqueiros underlined the Hispanic symbolism of the writhing centaurian figure by picturing it clutching a dagger, the upper half of which is a crucifix. The image parallels a similar use of symbolism by Orozco at the Hospicio Cabañas in Guadalajara, in which the duality of Spanish colonialism is evoked through the image of a spiritual transformation attended by violent armed aggression. Here, the clenched fist and extended complex of Cuauhtemoc's arm and obsidian dagger, pointing directly at the heart of the centaur, expresses the idea of indigenous revolt against the violence of colonial intrusion. However, the image of the mural as a whole is not narrative. Siqueiros' depiction of a fearful and unequal combat between a mythical beast, aided by an appeasing king, and the lone individual, is a visual metaphor. The pictorialization of conflict between foreign intrusion and the indigenous non-believer is just one small part of the narrative. But the readings of this part cannot escape the larger narratives of Mexican history. The struggles for national independence of the nineteenth century and the revolutionary political culture of the early twentieth century in Mexico transform the simple pictorial historical narrative in *Cuauhtemoc Against the Myth* into a metaphor for the rejection of the idea of external invincibility, in this case, of a foreign power. It is a powerful, anti-imperialist statement.

Although they were painted a few years later, Siqueiros' two other large works on the theme of Cuauhtemoc, painted in 1950 at the Palace of Fine Arts in Mexico City, are particularly relevant. They highlight the powerful hold that the symbol of Cuauhtemoc has on the Mexican radical nationalist political psyche. The theme of the first of the Cuauhtemoc mural

202 *below*
Documentary photograph of *The Torment of Cuauhtemoc* in progress.

205 *right*
Documentary photograph of *The Torment of Cuauhtemoc* in progress.

panels, *The Torment of Cuauhtemoc*, centres on the capture of Cuauhtemoc by Cortez's forces and the torture he underwent to reveal the whereabouts of the Aztec gold. The second panel, *The Resurrection of Cuauhtemoc*, is a more ambivalent image, depicting Cuauhtemoc reborn in the armour of a Spanish conquistador.

203 & 204
Photographs of model posing for *The Torment of Cuauhtemoc*.

These two mural panels continue the theme of national heroism which was the narrative base for *Cuauhtemoc Against the Myth*. In *The Torment of Cuauhtemoc*, the array of static, apparently impenetrable, faceless armoured knights and snarling dogs expresses the Aztec's sense of utter isolation and pain as the flames of his torture consume his lower limbs. Siqueiros' aim was to transform the historical narrative of this episode by relocating its significance within the social and political readings of the present. This approach is only fully revealed in the context of the second panel, *The Resurrection of Cuauhtemoc*. Here, the narrative of Cuauhtemoc has passed beyond the story of his heroic confrontation with the myth that inhibited the Aztecs from properly defending their kingdom. Embedded in the panel's imagery is the idea that the superiority of the Spanish conquistador derived not from divine ordination, but from the technical sophistication of his armour and weaponry. Siqueiros wrote that

The value of the Mexican hero is rooted in history as a symbol of the struggles of all the oppressed peoples of the world. For this I saw the opportunity, in the first panel, to refer to the torment that the colonial and semi-colonial countries suffer, and I emphasized the tremendous

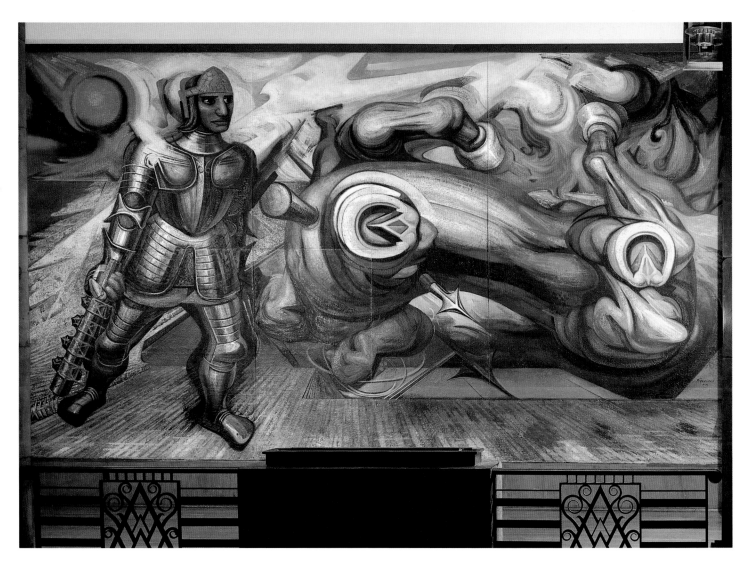

difference of arms between the conqueror and the conquered. In the second theme I presented Cuauhtemoc in armour to signify that Mexico, and in general weak peoples, should take up arms in order to bring down their enslavers and executioners. I employed the centaur . . . to symbolize the conquistador as the conqueror and destroyer of cultures. The centaur raises in his hand the symbol of the atomic bomb to represent the form of massacre employed today.[24]

Siqueiros' employment of imagery, particularly in the second panel, was especially inventive. In re-constituting Cuauhtemoc in the metallic armour of his conquerors, he expresses a disbelief in the victory of the oppressed based solely on the morality of their cause. Siqueiros' reconfiguration of the Aztec prince turns the technological inequality of oppressor and oppressed on its head in order to suggest that only through the attainment of technological equality can the moral certitude of the oppressed have any guarantee of success. Such a reading is derived from the transformations in the first and second panels of the respective positions of Cuauhtemoc and the Spanish. Siqueiros' attempt to engage in the imagery of pictorial metaphor did not meet with universal approval and comprehension in this case. Joel Marrakin accused Siqueiros of having created a 'tinned national hero'.[25]

Although Siqueiros had continued with the theme of Cuauhtemoc in the panels of the early 1950s, there is a substantial difference between these and the earlier mural of 1944, *Cuauhtemoc Against the Myth*. The difference lies in the visual stylistic conception. In the earlier murals of the 1940s, including his Chillán work *Death to the Invader*, Siqueiros expressed his themes and ideas as much through the mechanics of the dynamic visual form he employed as through the literalness of his subject matter and imagery. In the two later Cuauhtemoc panels in the Palace of Fine Arts, there is a greater emphasis on the nature and interplay of pictorial symbolic imagery. A variety of approaches were employed in the three murals that he created between 1944 and 1951, when he finished the second of his Cuauhtemoc panels in the Palace of Fine Arts.

206
David Alfaro Siqueiros: *The Resurrection of Cuauhtemoc*. Pyroxaline on masonite, 1950. Palace of Fine Arts, Mexico City.

207 *top*
David Alfaro Siqueiros: drawing study for *The New Democracy*. 1944. Palace of Fine Arts, Mexico City.

210 *overleaf*
David Alfaro Siqueiros: *The New Democracy*. Pyroxaline on canvas, 1944–5. Palace of Fine Arts, Mexico City.

In the large panel *The New Democracy*, painted in 1944, Siqueiros created what he termed a 'cuadro grande', or literally 'large work'.[26] Despite its length of 40 feet, which is considerably larger than many of the murals painted in Mexico, Siqueiros did not consider *The New Democracy* to be a mural in the strict terms that he understood. It was not conceived, for example, as an architectonic work relating to the immediate architecture of the site in particular, or to the building in general. It is, however, a monumental work of great physical presence. It depicts a giant female revolutionary figure bursting out of a volcano, thrusting aside the chains of her oppression and subjugation.[27] The overwhelming physical presence of *The New Democracy* was derived not simply from its size and dynamic compositional form, but from the painterly means which Siqueiros increasingly employed in many of his post-war murals and which included highly textured and impastoed painted surfaces that highlighted the very expressive and gestural application of paint.[28]

The stylistic changes that Siqueiros' mural work had undergone since the completion of *Portrait of the Bourgeoisie*, nearly five years earlier, should be recalled. In that mural, the use of the airbrush produced a very tight, carefully worked and more naturalistic rendering of forms. In *The New Democracy*, the fine airbrush technique had been abandoned in favour of the larger industrial spray gun, which Siqueiros then overlaid with the use of traditional hand brush filled with pigment. The pictorial conception of *The New Democracy* contrasted strongly with the massive architectonic works that Siqueiros regarded as true murals. The essential characteristic of the 'large paintings', as he called them, was their reliance on the centrality of a singular monumental figure to convey narrative. In this sense, *The New Democracy* has much in common with some of the large easel works Siqueiros created during the 1940s and 1950s.[29] In the great architectonic murals, however, the multi-planal architecture on which the murals were painted was often the vehicle through which the complex, multi-layered meaning of the work could be read. Siqueiros used such surfaces to sub-divide his themes into divisions of time, place, ideology, etcetera. By exploiting the architecture to create such divisions or contrasts, Siqueiros could explore the dialectic of thesis and anti-thesis established by the use of plot and sub-plot, text and sub-text. In cases where there was a ceiling,

208 & 209 *left & above*
Photographic studies of Siqueiros' wife, Angelica Arenal de Siqueiros, modelling for the main figure for *The New Democracy*. 1944.

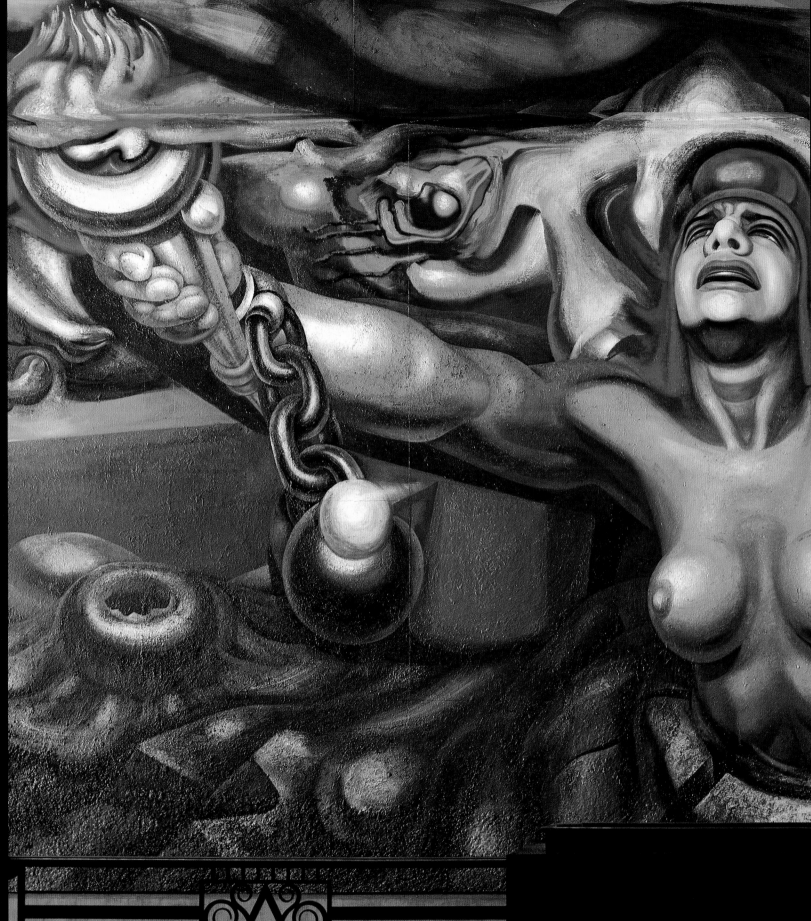

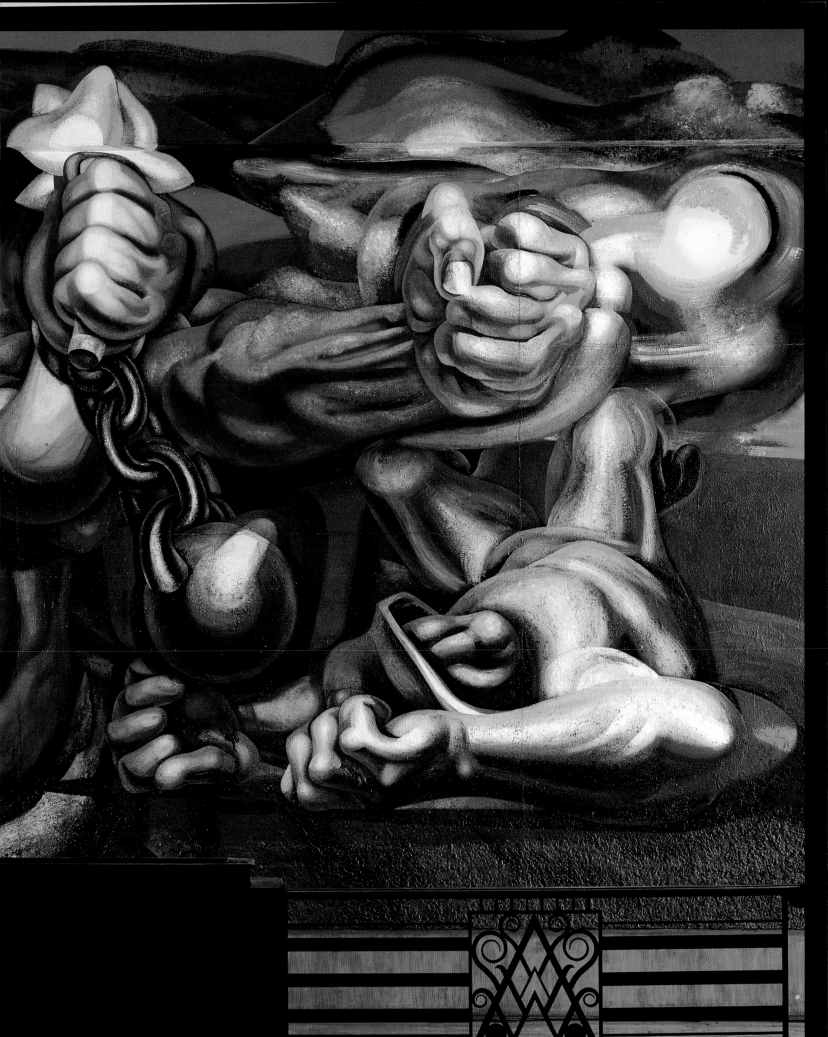

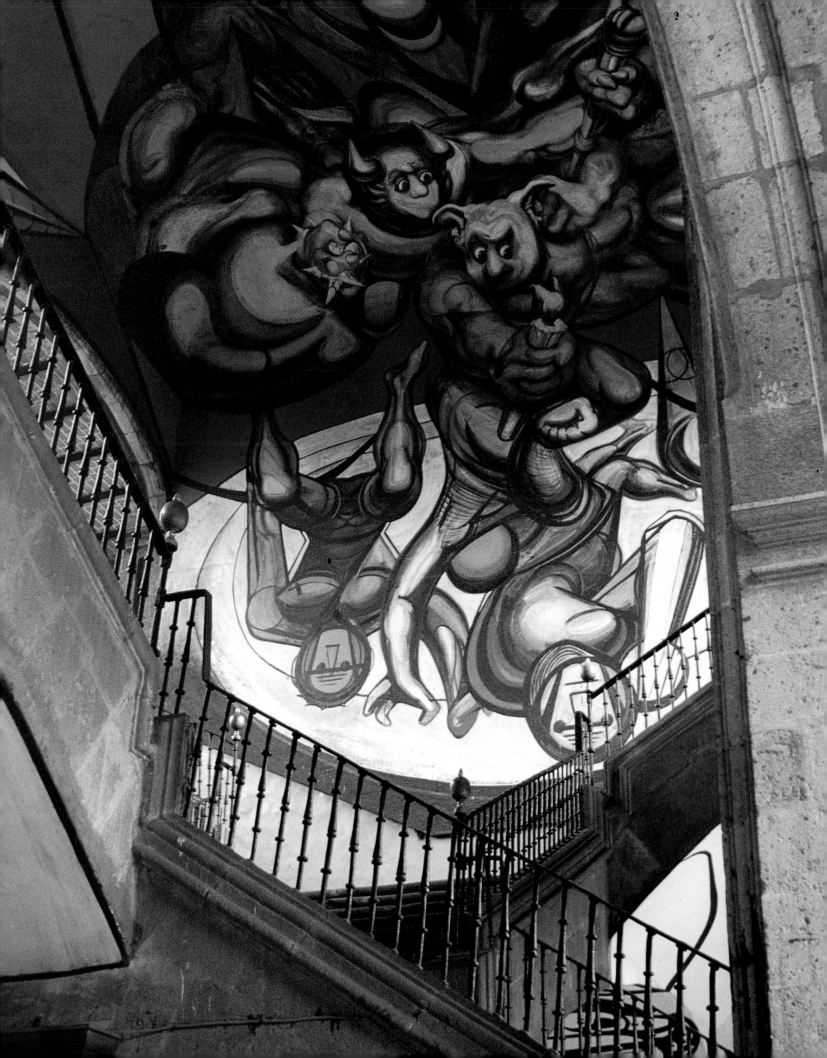

211 *opposite*
David Alfaro Siqueiros: *Patriots and Parricides*. Pyroxaline and acrylic celotex on masonite, 1945. The work remains uncompleted. Ex Aduana de Santo Domingo, west wall, Mexico City.

212 *below*
David Alfaro Siqueiros: *Patriots and Parricides*. Pyroxaline and acrylic celotex on masonite, 1945. The work remains uncompleted. Ex Aduana de Santo Domingo, decorated underside of staircase, Mexico City.

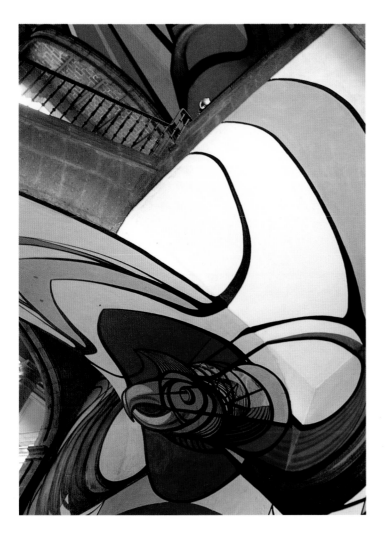

Siqueiros would create formal connections between opposite walls in order to unify thematically the sub-plots within the general theme of the mural, as in the Chillán work. In *The New Democracy*, however, the use of dynamic and expressive form on the flat surface of the large panel created enormous power and a sense of presence, but did not add any narrative meaning to the work. Siqueiros thus created two streams of realist practice in the production of his 'large paintings' and large architectonic murals. One was a monumental symbolic realism, as in *The New Democracy*; the other was architectonic realism, as in the murals *Portrait of the Bourgeoisie* and *Death to the Invader*.

The architectonic approach was at the heart of the mural Siqueiros painted following his completion of *The New Democracy*. *Patriots and Parricides*, painted in the Ex-Aduana de Santo Domingo (the old customs house) in Mexico City, was perhaps his most ambitious undertaking to date. Consisting of two huge main walls and the ceiling of the building's central staircase, the site provided Siqueiros with a magnificent opportunity to exploit the relationship of the painting to the architecture. Although Siqueiros never finished this project, the half-completed mural nevertheless remains the most instructive work he ever created.[30]

Siqueiros' methods and approach can clearly be seen in the unfinished areas of the mural. The design of the old customs house building, a classic example of early colonial architecture, was particularly challenging. Siqueiros saw this as a potential problem, recognizing that it would be difficult to synthesize his modern mural aesthetic with the building's colonial architecture. Nevertheless, before finally signing the contract, in preliminary correspondence with the Director of National Monuments, he wrote that 'In accepting such a commitment to paint a mural in an important colonial building in the City, I considered that a structure of such a style could be complemented, should be complemented, with a mural of technically modern character. . . .'[31] Siqueiros began his work on the mural by reforming the curvature of the large vaulted ceiling of the staircase by applying a separate celotex surface, which he placed on a specially constructed and enormously complicated wooden frame. This was then attached to the upper walls and ceiling covering the original stone wall surface.[32] With his team of assistants, Siqueiros undertook the design for the mural in three separate stages. It is clear from photographic sources that the first stage was to apply large areas of colour, onto which he then applied the simplified version of the design in a basic outline of the shapes and major forms. This simplified second stage incorporated the application of further flatly painted colour to the forms. In the unfinished areas of the mural the effect of this approach is to produce a schematic, almost cartoon-like image, which nevertheless clearly indicates how the forms and eventual colour will function in the overall design.

The third stage of the painting, only achieved fully on part of the ceiling area and on one of the two staircase walls, was the

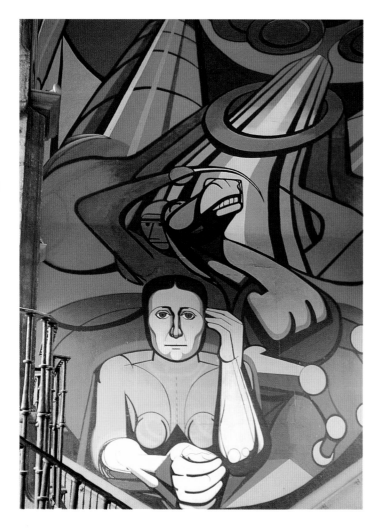

213
David Alfaro Siqueiros: *Patriots and Parricides*. Pyroxaline and acrylic celotex on masonite, 1945. The work remains uncompleted. Ex Aduana de Santo Domingo, east wall, Mexico City.

application of volume to the forms and limbs of the figures. In these areas, the original flatness of the basic design has been transformed through glazed colour to produce a dynamic fluidity characteristic of the original drawing.

As in his previous murals, Siqueiros employed a number of techniques and materials with which he was very familiar. Nearly all the underlying forms in this mural, for example, display modelling through the use of the spray gun. He also employed the spray gun at the beginning to lay in the areas of flat colour rapidly. Surface modelling of the forms, however, was achieved through the use of the traditional hand brush, giving an expressive effect to the more finished areas of the mural.

The theme for this mural was a familiar one for Siqueiros, and followed on from the spirit of the work at Chillán. It was the struggle for national liberty and independence.[33] *Patriots and Parricides* or, as Siqueiros named it, the *Apotheosis of the Liberty of Expression*, was to depict on one side of the staircase the rise of the great Mexican patriots and defenders of national integrity and liberty, such as Morelos, Juárez and Zapata, while on the opposite wall the traitors and enemies of the Mexican people,

such as Santa Anna Iturbide and Victoriano Huerta were to be shown descending 'into hell'.[34] Although much of the mural remains in a very preliminary and schematic stage, it is evident that Siqueiros' intention was to keep recognizable narrative to a minimum. Together with the use of dynamic architectonic form, he relied on the use of a few simple, monumental images which would become familiar.[35] The rearing horse and its rider is the most obvious. Here, its presence does not signify the conquest, as in *Cuauhtemcoc Against the Myth*, but the Mexican revolution. The familiar picture of the revolution as a struggle waged by men on horseback is an enduring one; indeed, particularly in the countryside, the revolution was often fought by armies of mounted men, and Zapata and his white horse have become part of the visual iconography of the Mexican revolution.

Siqueiros' exploitation of the architecture of the site and his use of dynamic form within the composition remains the most significant aspect of this unfinished work. It shows the extent to which Siqueiros intended to use architecture and form to reinforce the narrative and meaning of his more literal images. The specially constructed surface which he added to the walls, making the ceiling curved, is also intriguing, for his decision to do this cannot be interpreted solely as a technical necessity. Above all, his intention was to reform the architecture in order to suit an idea. Siqueiros wrote that 'the only adequate way to paint this cube is to consider the two side walls and roof as one single unit. To paint these as single panels would be a grave technical error. . . . Mural painting is the painting of architectural space.'[36] In the mural's uncompleted state, it is possible to see the basis of Siqueiros' argument. By simply juxtaposing the contrasting elements of his exteremely simplistic narrative on opposite walls, the main thematic intention would have been lost. However, with the curving space between the two opposite walls, through the use of thrusting abstract forms Siqueiros was able to create a sense of continuous dynamic movement that extended up the wall depicting the symbols of liberty, through the ceiling and down the wall on which the enemies of the people are portrayed. This downward flow of forms on the area of the wall portraying the Parricides is unmistakable and clearly results from Siqueiros' particular exploitation and synthesis of pictorial form and physical architecture.

Patriots and Parricides was the most protracted and frustrating work of Siqueiros' career. It was plagued by endless problems, such as water seepage in the walls; a drastic increase in the price of materials, requiring several rewritings of the contract and delays in payment. Additionally, Siqueiros' wish to extend the original concept of the mural meant that the work became extended over a twenty-year period.[37] In part, the slowness of the work resulted from the endless criticisms of the pictorial concept Siqueiros had envisaged for the mural. Although Siqueiros had intended that the work be technically modern, in reality it was a spectacularly inappropriate concept, both in terms of colour and in the approach to overall design, for the magnificent old colonial building. Siqueiros had championed and would continue to do so in the decades that lay before him, the concept of Plastic Integration, that is the synthesis of art, architecture and sculpture. The inappropriateness of his idea of integration in this particular project lay specifically in his concept of reconstruction of the magnificent multi-planal surfaces of the site in order to produce a dynamic architectonic mural. The result was to overpower and destroy the integrity of the original architecture. This undermined a proper integration of architecture and painting.[38] Rivera was particularly damning and sarcastic about Siqueiros' efforts. He wrote

According to (Siqueiros) we want to paint on walls, by which he means we do not respect architecture but destroy it. This objection of Siqueiros' is directed against himself and his work. He sticks cardboard over the cornices and roof of a stone building . . . which hides architectural details and provides excellent cover for rats although the building was not constructed for breeding such animals. In these conditions, Siqueiros' painting is nothing but a stage decoration, a sort of allegorical chariot or triumphal arch built in the street for a patriotic pageant.[39]

Patriots and Parricides was never completed and today stands as testimony to a failed concept. Yet in its failure it reveals more about the nature of what Siqueiros was seeking in his overall concept of mural painting than any other of his equally ambitious and more successful murals.

Throughout the 1940s, Siqueiros had been largely concerned with expressing themes and depicting subjects that were rooted in national history. Indeed, the historical dimension of the themes of his work of this period is one of its most significant characteristics. It signifies the consolidation of a distinctly nationalistic and Latin American thinking that influenced Siqueiros' political thinking and activities as much as it did his art. From the end of 1950, following his work on the two Cuauhtemoc panels in the Palace of Fine Arts, Siqueiros' murals changed direction with regard to theme. With the exception of his great masterpiece *From the Dictatorship of Porfirio Díaz to the Revolution*, completed in 1965 in Chapultepec Castle, Siqueiros never again centrally concerned himself with depicting a national historical theme. Instead, his mural work took a more contemporary and often technical direction. This latter characteristic was enhanced by a more complete realization of his innovations connected to the architectonic and environmental qualities inherent in his work. This change in emphasis was foreshadowed in statements from the 1944 manifesto that he wrote for the Centre for Realist Art. In it, he had stressed the need for a really 'modern' dimension to Mexican mural painting that would move into a second stage of experimental technique and the consolidation of what he termed as neo-realism or integral realism.

The first indication of this change in direction came in the mural Siqueiros painted in 1951 for the Polytechnic Institute in Mexico City. Entitled *Man the Master, not the Slave, of Technology*, the mural was painted on to a long, curved freestanding wall specially constructed of wood over which aluminium had been stretched.[40] It was, as Antonio Rodríguez wrote, 'the first step of Mexican muralism towards the second phase of its existence.'[41] Siqueiros explained his own concept of the theme: '. . . The mural depicts . . . man, hitherto victim of his own great scientific discoveries, taking command of atomic energy, the greatest physical force of the present, and utilizing it only for constructive purposes in a world of progress and peace. The instrument of industrial production will no longer be the machine that oppresses man, but the machine in the service of man.'[42]

Notwithstanding the short time-frame within which Siqueiros painted the mural, the completed work is hardly his most engaging post-war project. Its simplistic concept depicts a worker standing on a circular plinth with outstretched arms in the centre of the composition. His left hand holds the symbol of

214
David Alfaro Siqueiros: *Man the
Master, not the Slave, of Technology.*
Pyroxaline on aluminium, National
Polytechnic Institute, Mexico City.

215
David Alfaro Siqueiros: *Man the
Master, not the Slave, of Technology*
(detail). Pyroxaline on aluminium,
1952. National Polytechnic Institute,
Mexico City.

200 atomic energy, while with his right arm he points to the horizon where Siqueiros painted a rising sun, symbolizing the dawning of the future. In the background a shaft of gold and steel echoes the futuristic symbolism. On the left-hand side of the central figure a gigantic foot, arm and leg enmeshed in a complex of mechanical forms represents the domination of mankind by technology, with the moon above hinting at the darkness of such reality.

The mural nevertheless provides an interesting parallel and comparison with Diego Rivera's work. Rivera's own pre-war

Institute, which had been established during the presidency of Lázaro Cárdenas, was one of Mexico's main centres of higher education. Originally its 18,000 students were drawn largely from peasant and working-class backgrounds. The social character of Siqueiros' audience, the technical nature of the Institute itself, and its associations with the most radical of Mexico's presidents since the end of the revolution, provided Siqueiros with the arena in which to engage with his penchant for futurist visual rhetoric.

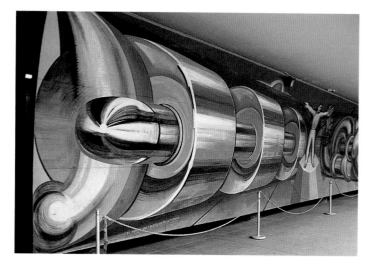

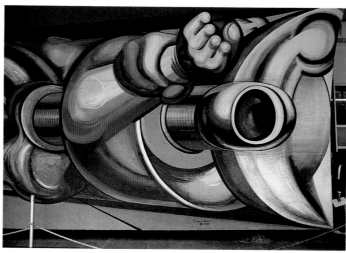

visions of modern technology painted in the United States had been highly utopian, even eulogistic. In the post-war period, Siqueiros was engaging the same subject with a remarkably similar, if more simplistic sense of the utopian. Any criticism of the capitalist society that his communist politics sought to overthrow was likewise muted into vague generalization. The most striking comparison between the two muralists is perhaps their shared sense of the utopian. During the post-war period, Rivera's work was often marked by visions that were deeply nostalgic, a yearning for a past that could only be expressed in utopian terms. In some of his key post-war works, Siqueiros was equally utopian, but his visions were essentially directed towards the future rather than the past. In this sense, the thrust of the Polytechnic theme cannot be disconnected from the institution in which Siqueiros painted the mural. The National Polytechnic

The Polytechnic mural is nevertheless significant in that it foreshadows a series of murals that Siqueiros created during the rest of the 1950s and which display strongly futuristic, technological traits, such as his 1958 mural in Mexico City's Centro Médico, entitled *Apologia for the Future Victory of Medicine over Cancer.* However, of these futuristic murals, the enormous work that he produced at the Hospital de la Raza from 1952 to 1954 is by far the most important. Until this point in his career, Siqueiros had not been presented with the opportunity simultaneously to test all the ideas that he had been developing during the previous two decades concerning the mural form, perspective and architectonic composition. He had created some important murals but they had either been physically too restricted, or, as in the case of the work at the old customs house of Santo Domingo, remained uncompleted.

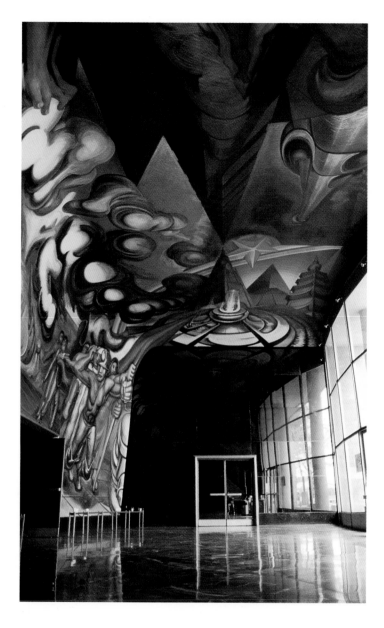

216 *left*
David Alfaro Siqueiros: *For the Complete Safety of all Mexicans at Work*. Vinylite and pyroxaline on plywood and fibreglass, 1952–4. Hospital de la Raza, Mexico City.

217 & 218 *below*
David Alfaro Siqueiros: *For the Complete Safety of all Mexicans at Work* (details). Vinylite and pyroxaline on plywood and fibreglass, 1952. Hospital de la Raza, Mexico City.

towards a utopian collective and integrated future. With its somewhat unwieldy title, *For the Complete Safety of all Mexicans at Work*, Siqueiros devised his theme in three parts. He described the left-hand section as 'a worker injured in a work accident. . . . He lies there in a world in which machines are the instrument of his oppression and imprisonment.' To the right of this introductory scene are a group of female figures, which Siqueiros indicated represented 'the ideal Mexican race, as a product of the new world, based on better food, and a better mixture of the races; women with flowers, fruit and healthy children, all of the euphoric in their pose reflecting the happiness of life'. Siqueiros saw the concluding group within the dynamic composition as marching towards the integrated society of the future headed by 'the industrial workers (the working class)'.[45] Described literally, the theme of the mural is simplistic and schematic, with the individual sequences conforming to a rather predictable ideological framework. However, the power, complexity and depth of the work is not, as in so many of Siqueiros' murals, articulated and expressed through complex thematic imagery. Rather, it is conveyed through the use of dramatic and dynamic architectonic form. As a consequence, simple statements, which might otherwise seem nothing more than crude agit-prop, are given tremendous power and gravity.

201

The Hospital de la Raza presented Siqueiros with the largest and most suitable space to date in which to realize the full scope of his ideas. The site of the mural in the new hospital was the huge entranceway to the auditorium or lecture theatre.[43] The project and commission itself was an almost perfect scenario for Siqueiros, in that from the very beginning he was able to collaborate with the building's architect, Enrique Yánez. Originally rectangular, the room contained a huge glass window occupying the whole of one wall. Working with Siqueiros, Yánez reconstructed the room so that the wall and ceiling to be painted were transformed into a giant concave, semi-hemispherical surface in which all corners were eliminated.[44]

Thematically, Siqueiros' concept for the mural at the Hospital de la Raza was a vision of the contemporary world's dynamic march away from the conveyor-belt slavery of modern capitalism

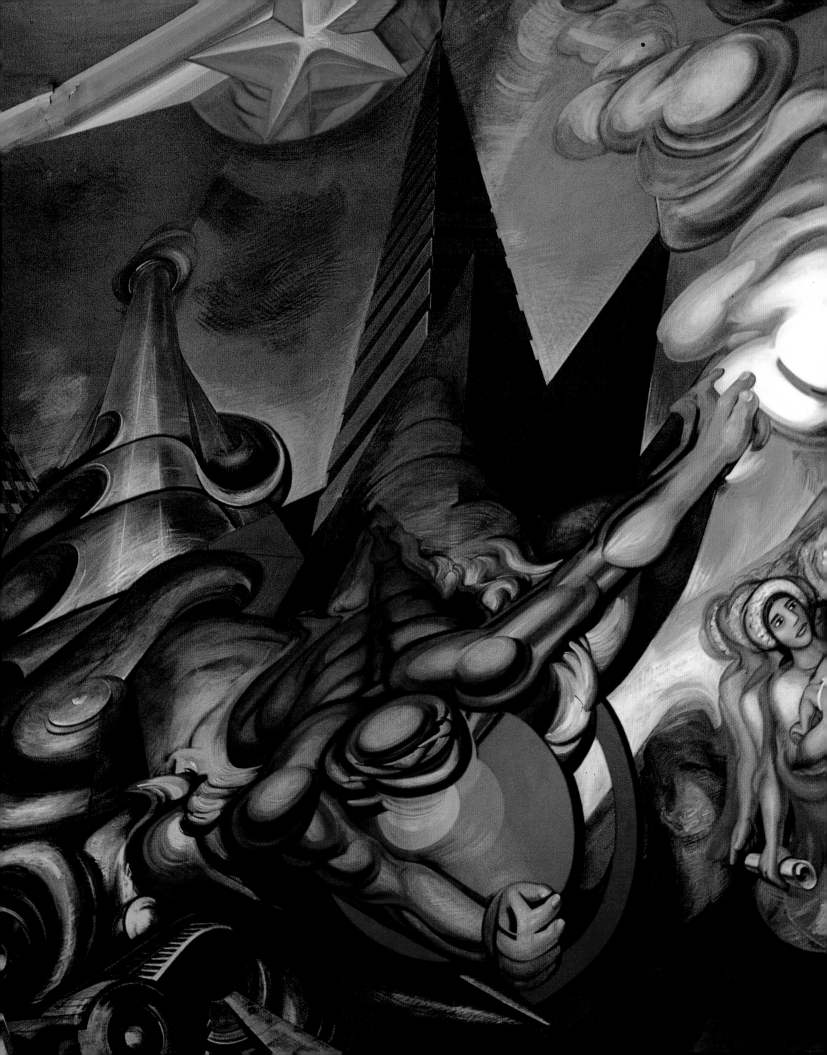

219 *opposite*
David Alfaro Siqueiros: *For the Complete Safety of all Mexicans at Work* (detail). Vinylite and pyroxaline on plywood and fibreglass, 1952–4. Hospital de la Raza, Mexico City.

220
David Alfaro Siqueiros: *For the Complete Safety of all Mexicans at Work* (detail). Vinylite and pyroxaline on plywood and fibreglass, 1952–4. Hospital de la Raza, Mexico City.

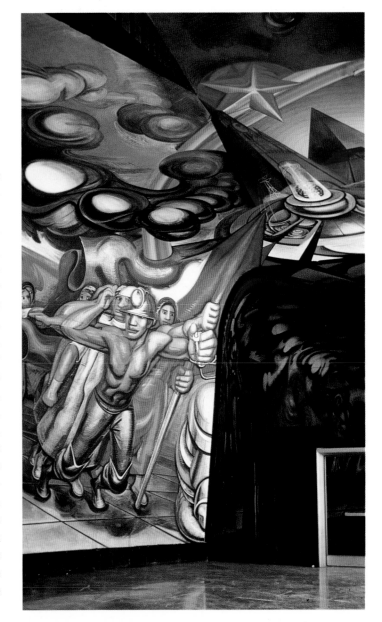

The mural's most outstanding feature is its dynamic sense of movement, principally generated by the gentle concave curving surface. Siqueiros' exploitation of the surface involved two lines of movement. The first, around the figures, extends around the room from one end of the mural to the other. Here, the ground plane on which the figures stand has been constructed so as to create different vanishing points depending on where the viewer is situated. Likewise, the figures have been constructed to exploit the different angles from which they are likely to be viewed. In his book *Como se Pinta un Mural* (How to Paint a Mural), based on his experimental mural at San Miguel de Allende in 1949,[46] Siqueiros had written extensively on the need to consider the distortions that figures and objects were subject to when seen from very acute angles. In his book he proposed that from a full frontal position, human beings could be represented within a circular or elliptical form, so that when seen from an acute angle the lateral 'shrinkage' of the form would then make the figure or object appear 'normal'. This method of counteracting distortion might also involve the amplification of certain areas of the figure or the use of form 'echoes'. Nowhere is this compositional thesis better demonstrated in the La Raza work than in the middle group of female figures, where it is possible, merely by walking from one end of the room to the other, to witness the dramatic inflation and deflation of the figures.

221 *far left*
Photographic study of model posing for the central group of figures in *For the Complete Safety of all Mexicans at Work*.

222 *left*
Photographic study of model posing for the figure of the injured worker in *For the Complete Safety of all Mexicans at Work*.

223

David Alfaro Siqueiros: *For the Complete Safety of all Mexicans at Work* (detail). Vinylite and pyroxaline on plywood and fibreglass, 1952–4. La Raza Hospital, Mexico City.

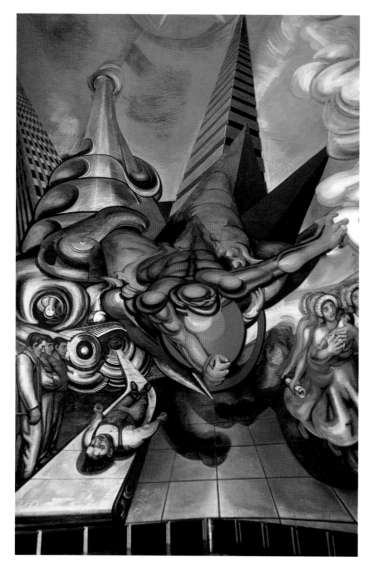

The second line of movement travels through the elongated architectural images situated at either end of the mural and up and across the ceiling, to meet in the centre of the ceiling. As in Chillán, here at La Raza Siqueiros made the horizontal surface of the ceiling appear vertical. Movement in the ceiling area of the mural is again 'switched on' by the movement of an observer. The result is astonishing, with the architecture of the buildings that have been drawn on to the ceiling moving rapidly to and fro

as the spectator walks from one end of the room to the other and back again.

These dynamic movements contribute as much to the meaning of the mural as the images themselves. Indeed, in large part the visual movement of the forms most effectively expresses Siqueiros' intention of depicting a social movement of the people towards a future society. This is particularly noticeable in the ceiling area. At the beginning of the mural, the skyscrapers of contemporary society project across the ceiling in an aggressive and dominating fashion, appearing to push the architecture that symbolizes the future integrated society at the other end of the composition downwards and backwards. Seen from the other end of the room, however, the opposite occurs. The once-dominating forms of the contemporary world rapidly recede under the weight of the architecture of the social future of mankind.

This optical creation is perhaps the best realization of Siqueiros' idea, first expressed in the 1930s, that revolutionary art did not depend for its content on images of revolution alone, but as much on the creation of formal and aesthetic equivalents of revolution. This perhaps explains why Siqueiros' art did not degenerate into crude rhetorical depictions of a future socialist society. The images that he created at La Raza, symbolizing his vision of future society, did not depend on a simplistic cartoon version of the world of socialism. Rather, he used a montage of architecture to represent what he saw as the great cultural achievements of mankind's past and present, the Egyptian pyramid, the Chinese pagoda, the Aztec pyramid, the turbine of modern electrical power, and the Kremlin tower.

Siqueiros and his assistants finished their work at La Raza in 1954.[47] It was undoubtedly Siqueiros' most significant achievement in architectonic realism. Elvira Vargas described what Siqueiros and his team had created as 'opening up a new and definitive stage in the history of pictorial art'.[48] However, despite its dynamic characteristics and the successful integration of the form of the mural with the specially reconstructed interior architecture of the room, the La Raza mural was only a partial realization of Siqueiros' concept of Plastic Integration. Although he had included it in his 1944 mural, *Cuauhtemoc Against the Myth*, sculpture had not really been an integral element in Siqueiros'

224 *below*
Relief model for *The People for the University. The University for the People.*

225 *right*
Work in progress on *The People for the University. The University for the People.*

205

work. It was certainly absent at La Raza. However, in 1955 on the site of Mexico City's new university campus, Siqueiros attempted to integrate painting, architecture and sculpture. To a large extent the restrictions on finance precluded the full and satisfactory realization of this concept. Nevertheless, while the visual result did not achieve the dynamic synthesis of the La Raza project, Siqueiros' creation at the UNAM, as the campus is called, forms an important dimension of his mural work.

Siqueiros' concern at this time with the creation of exterior murals and the achievement of the integration of painting, sculpture and architecture was not new to his thinking. It had first surfaced as far back as the early 1930s in Los Angeles, when he had created his two exterior works *Tropical America* and *A Workers' Meeting*. In 1948 he had published his first concise treatise on the subject in *Hacia una Nueva Plástica* (Towards a New Integral Art). In it, he had written that, in his view, there was not the slightest doubt that the architecture of the future would be

on an urban scale (the architecturally autonomous building will cease to exist). . . . And these buildings will be built not only in the big towns but all over every country and they will be integrally artistic, as in the best periods of the past. . . . A pictorial and sculptural technique . . . will be added to architectural surfaces . . . and broken up into *pictorial and sculptural areas* which will be part of the preconceived architectural plan.[49]

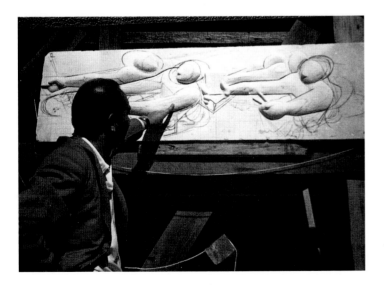

Siqueiros saw the planning and construction of the enormous new National University campus as a crucial opportunity for Mexican art to move forward towards what he envisaged as this more integrated artistic concept. In 1950, before his contractual involvement in the decoration of the campus, he had written that he could not imagine the construction of the University without a concept of plastic integration.[50] In early 1951, believing such an opportunity was slipping away, Siqueiros wrote to the chief architect in charge of designing the UNAM, Carlos Lazo, saying that the construction of the university city or campus would provide the opportunity for Mexican painting and sculpture to attain its second stage. Siqueiros recommended that

A commission of the most experienced Mexican muralists, and of younger painters with mural experience, together with a few sculptors should immediately be co-opted on to the panel of architects and engineers in charge of the project. . . . This commission . . . should resolve . . .

a) The exterior and interior polychroming of the University City.

b) The decision as to where mural paintings and sculptures are to be placed, both inside and outside of buildings.

c) Which subjects correspond to the University City as a whole, and to each of the separate buildings or sections. Architects, painters and sculptors . . . should immediately proceed to revise all the work in progress . . . from the point of view of plastic integration.[51]

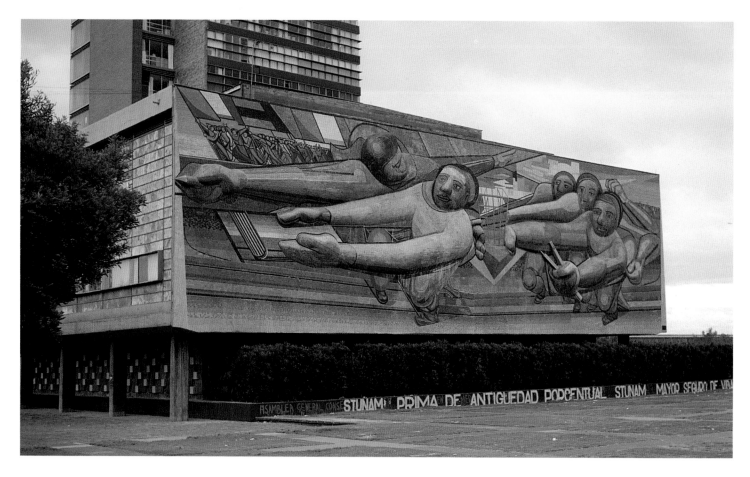

In the end, Siqueiros' vision of an integrated concept for the new campus was not realized. Although many painters were commissioned to carry out mural decoration on the campus, all were commissioned individually and not integrated into the scheme as Siqueiros had wanted.[52] Siqueiros' contribution to the decoration of the campus comprises his polychromed *bas-relief* mural decorations, executed between 1952 and 1954 on the exterior of the university's rectory. Originally conceived as four separate panels, only three were created. Of these, the largest and most significant is the panel *The People for the University. The University for the People: For a Neo-Humanist National Culture*.[53]

Although from a technical point of view the exterior mural was a *bas-relief*, Siqueiros adamantly preferred to describe it as a sculptured painting. He defined this term as the use of diverse protruding planes of more than thirty centimetres in height, which had an exclusively optical or textural intention. In an article written in 1956, entitled 'My Experience in Painting Murals on Exteriors', Siqueiros discussed the question of his use of sculptural painting and its relevance to external mural work. He wrote that 'The surface of the external mural cannot properly be left completely smooth. Sculptured reliefs are necessary. When viewed outside, objectively flat forms lose their strength when they are forced to compete with the three-dimensional

forms of trees, houses etc. around them. . . . Any shortcomings are due to the complete technical novelty of this technique.'[54] These comments point to what Siqueiros saw as the problem of creating a realist expression for external sites at the same time as having to use certain types of materials and techniques. In his work at the university, for example, he had been forced to use methods that inhibited the increasingly gestural and expressive quality that was developing in his mural painting. In Siqueiros' view, this severely hindered his capacity to express the realism of his subject-matter. He had written of the use of mosaics that 'I would not advise anyone to use mosaic in external murals, not even in the way that I have done in the rectory mural, because it is an archaic material. It is in fact a graphic process in which the colour merely "illuminates".'[55]

Siqueiros' concept of realism was not just a matter of image or subject-matter, but of rendering, of giving expression to what he defined as an aesthetic equivalent of the realist intent. For him, the intention often stood or fell on the materials used in the creative process. At the university, Siqueiros had sought to recreate the gestural and expressive quality of his mural painting by creating huge schematic mosaic relief forms for distant viewing. In the end, the piece lacked the increasingly expressive nature of his interior mural work. Designed as an addition,

226
David Alfaro Siqueiros: *The People for the University. The University for the People*. Relief mosaic, 1952–6. National Autonomous University of Mexico, Mexico City.

227
David Alfaro Siqueiros: *Theatrical Art in the Life of Mexico*. Acrylic on plywood, 1959. Although it has been inaugurated, the mural remains technically unfinished. Jorge Negrete Theatre, Mexico City.

rather than as an integral element of the university's rectory building, the mural portrays five giant figures representing Science, Technology, Industry, Agriculture and Culture. As a site-specific work of art in an external architectural setting, the mural neither complements nor is complemented by the architecture. It is an unashamedly proclamatory image, more bombastic than expressive, and its significance lies more in its exploration of form and technique in relation to concepts of exterior mural decoration, than in its expressive or realist accomplishment.

In the post-war murals created prior to 1957, Siqueiros tried, as at the university, to create works of maximum visual impact. In the cases where he succeeded, such as at La Raza, he had done so through magnificent displays of inventive use of architectonic concepts of form and composition. At the same time, however, such visual impact was often accompanied by uncomfortable expressions of exhortational rhetoric, denying the intensely expressive realism that Siqueiros wanted to achieve. In the late 1950s, however, Siqueiros was able to move towards this goal. His success was based on a more concentrated concern for the social significance of his chosen subject-matter and the use of more traditional expressive qualities. Two murals in particular exemplify this new character. The first, entitled *From the Dictatorship of Porfirio Díaz to the Revolution*, painted in the Room of the Revolution in Chapultepec Castle, Mexico City between 1957 and 1965, is arguably his greatest achievement as a mural painter. The other, entitled *Theatrical Art in the Life of Mexico*, created for the entrance foyer of the Jorge Negrete Theatre in Mexico City from 1959 to 1969, was never completed. Nevertheless, some passages of this incomplete work exhibit the most powerfully emotive and expressive imagery Siqueiros ever created in a mural.

In the murals Siqueiros had created previously in the post-war period, the human figure had for the most part been used sparingly. In the Polytechnic Institute he had employed only one human figure; at La Raza, Siqueiros included less than ten major figures in an area of over 3,000 square feet; his university sculpture-painting mural consisted of just five monumental figures. However, in the murals of the late 1950s, including a second hospital mural, *Apologia for the Future Victory of Medicine over Cancer*,

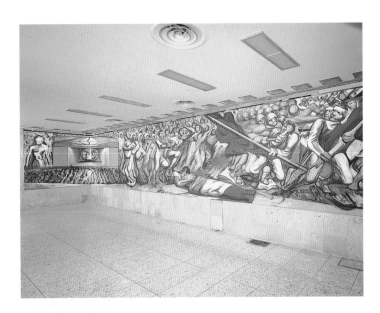

207

228
Photographic study used for the image of the murdered railroad worker in *Theatrical Art in the Life of Mexico*.

Siqueiros dramatically increased the numbers of figures in his compositions, creating a dynamic sense of moving humanity. The rationale for this conceptual change lay in the need to express the movement and conflict of irreconcilable social forces. This need arose because, for the first time since the 1930s, Siqueiros was engaged with subject-matter that was specifically located within the political and social dynamic of contemporary Mexican society.

In the huge interior mural at Chapultepec, *From the Dictatorship of Porfirio Díaz to the Revolution*, Siqueiros confronted a subject that, paradoxically, he had never tackled before, namely the Mexican revolution.[56] His aim was not to create a mural 'about' past history, as Rivera had so often done in the post-war period. It was to create a mural painting of history in the present. The

229
David Alfaro Siqueiros: *From the Dictatorship of Porfirio Díaz to the Revolution – The Martyrs* and *Mounted Revolutionary.* Acrylic on plywood, 1957–65. Hall of the Revolution, detail of left-hand section, National History Museum, Chapultepec Castle, Mexico City.

230
David Alfaro Siqueiros: *From the Dictatorship of Porfirio Díaz to the Revolution – The People in Arms.* Acrylic on plywood, 1957–65. Left-hand section, showing the martyrs, the revolutionaries, the ideologues and the leaders of the revolution. Hall of the Revolution, National History Museum, Chapultepec Castle, Mexico City.

231 *opposite*
David Alfaro Siqueiros: *From the Dictatorship of Porfirio Díaz to the Revolution – Porfirio Díaz, Ministers and Courtesans* (detail). Acrylic on plywood, 1957–65. Hall of the Revolution, National History Museum, Chapultepec Castle, Mexico City.

208

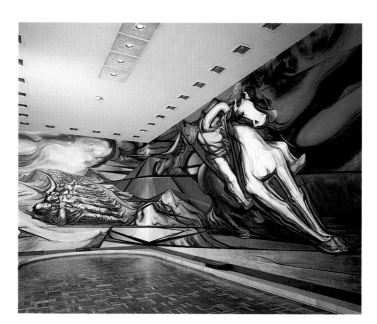

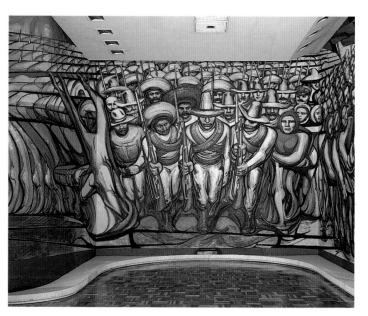

work that he created is as much a comment on contemporary politics as it was a representation of past and increasingly distant events.[57]

Siqueiros began work on the mural during the latter months of office of President Cortines.[58] However, much of the development of the mural took place during a period in which Cortines' successor, López Mateos, attempted briefly to revitalize the spirit of the revolution with policies that reflected the heady radical days of the Cárdenas administration two decades earlier. Set against the context of the post-war, the Cold War and late 1940s and 1950s, Mateos' radical initiatives failed to address the grievances set in motion by the increasing inequalities of the country. As a result, labour unrest, strikes and political agitation grew, causing deep concern in Washington, resulting in a dramatic slowdown and withdrawal of American investment in Mexico. Mateos reacted to these developments by abandoning his radical policies, becoming instead extremely authoritarian and repressive with the political opposition.[59] The radical left interpreted these moves as evidence that Mexico's political and economic life had fallen hostage to the influence of external forces and considerations.

Although, as the title suggests, the mural depicts the confrontation of the forces of the 1910 Mexican revolution with those of the Díaz dictatorship, there is an implicit thematic and visual allusion to the state of Mexico's independence some five decades later. Painted around a multi-faceted framework, the huge mural presents its subject as a construction of thematic opposites. On the left-hand side of the room are figures associated with the forces of the revolution, its martyrs, armed peasants and ideological and political leaders.[60] On the right-hand side of the room, the society of Porfirio Díaz is depicted in the form of the dictator surrounded by adoring courtesans and political stooges.[61]

Siqueiros' central theme is brought into a climactic visual confrontation on the long wall connecting the right- and left-hand sides of the room. This shows two men at the head of their respective massed forces struggling for the national flag of Mexico. The two protagonists represent William C. Green of the Green Consolidated Copper Company of America, and Fernando Palomares, a leading member of the Liberal Party. Siqueiros used these two figures and the forces arranged on either side of them to depict the industrial strike and unrest of

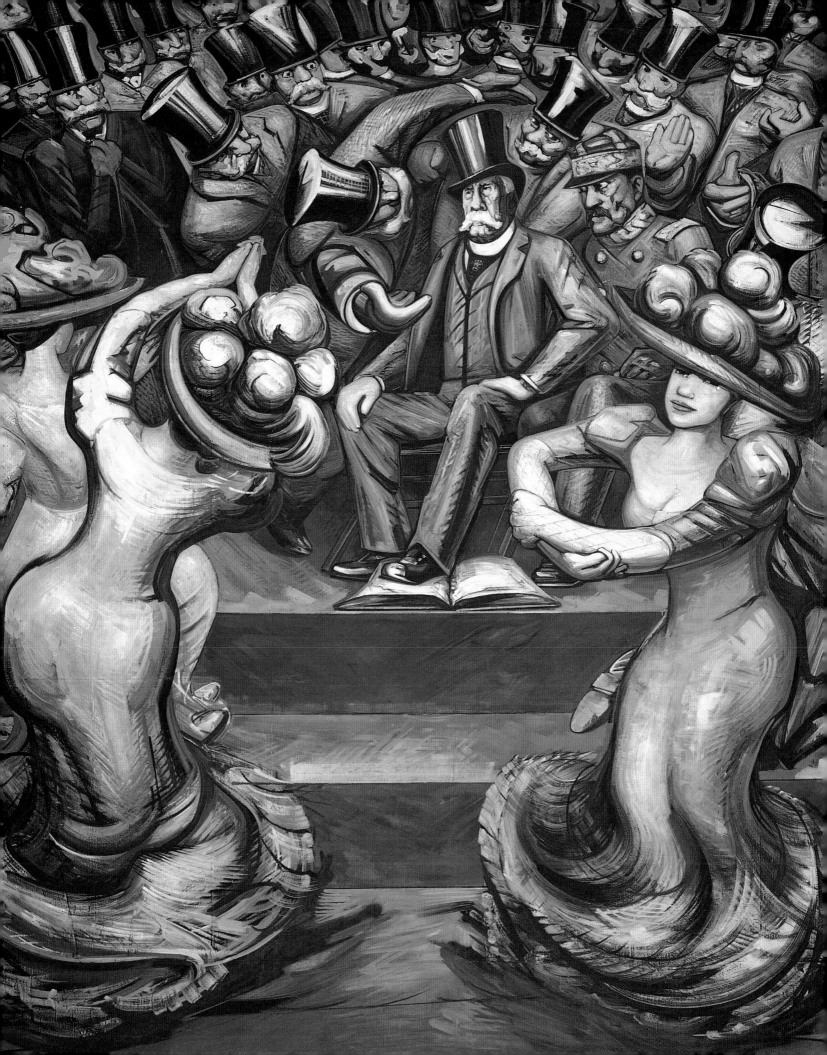

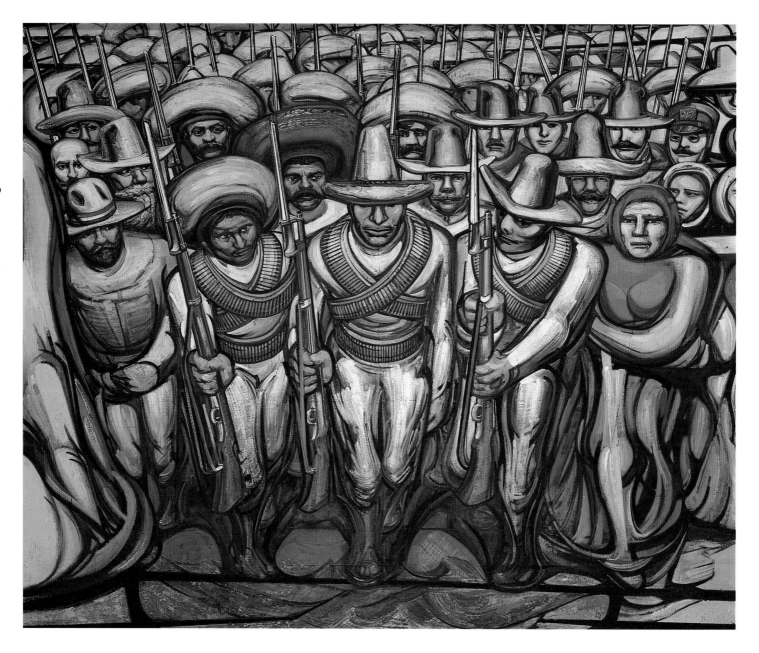

233 & 234
Photographic studies for the mural. Siqueiros is on the left in the right-hand picture.

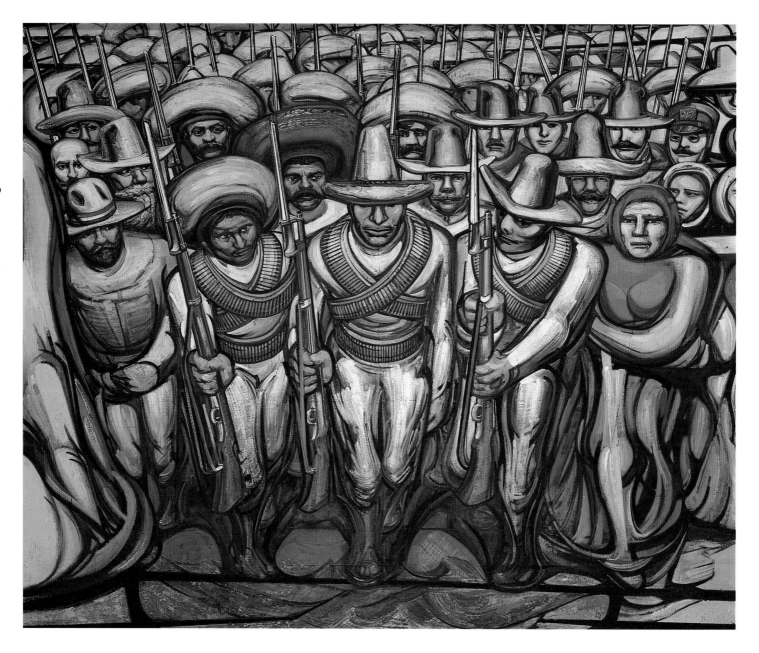

Mexican workers against their employers, the Green Consolidated Copper Company of America. This famous labour dispute took place in 1906 and was a significant event in the political developments leading up to the Mexican revolution of 1910.[62] For Siqueiros, the dispute and the ensuing strike epitomized the spirit of Mexico's endlessly complex revolution. The strike by Mexican workers against their foreign employers, who in response brought in forces of their own national army to suppress the unrest, encapsulated the extent of Mexico's economic and political domination and oppression. But the nationalist dimension of Siqueiros' presentation of this theme is not anchored in images of racial and cultural ancestry or origin. Instead it is expressed in the depiction of the two main protagon-

232 opposite
David Alfaro Siqueiros: *From the
Dictatorship of Porfirio Díaz to the
Revolution – The Revolutionaries*.
Acrylic on plywood, 1957–65. Hall
of the Revolution, National History
Museum, Chapultepec Castle,
Mexico City.

235 & 236 *below, left and right*
David Alfaro Siqueiros: *From the
Dictatorship of Porfirio Díaz to the
Revolution*. Acrylic on plywood,
1957–65. Right-hand section
showing the Cananean miners'
strike of 1906, with William C.
Green of the Green Consolidated
Mining Company of America, and
Fernando Palomares, leader of the
Mexican Liberal Party, struggling

for possession of the flag of Mexico.
On the right-hand wall Porfirio
Díaz is depicted, surrounded by
courtesans and advisors. Hall of the
Revolution, National History
Museum, Chapultepec Castle,
Mexico City.

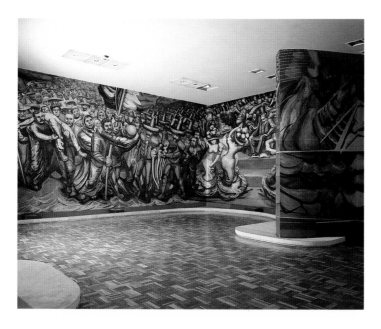

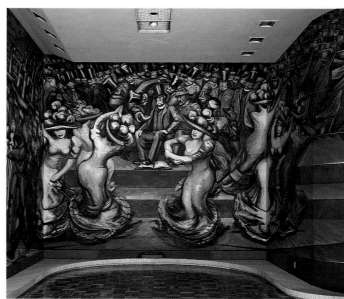

ists of this passage struggling for possession of the national flag of Mexico. Here Siqueiros created an image that can be interpreted not merely as a historical reference, but as a metaphor for the incomplete nature of the Mexican revolution and the continuing domination of the country by the economic interests of foreign powers, particularly the United States. Why else would Siqueiros represent the national emblem as still being in the possession of William Green, the foreigner? That this theme was uppermost in his mind is evidenced by many of his political speeches and writings during the period in which he created this mural. The struggle against American imperialism in Latin America and his constant accusations that the Mexican government was allowing the country to become dominated by this influence can be seen to have been distilled by Siqueiros into an allusion that both reflects the aims of Mexico's 1910–1917 revolution, and implicitly comments on the state of the contemporary struggles some four-and-a-half decades later.

Although Siqueiros used many recognizable figures in the mural, there is an extraordinary sense of momentum and revolutionary confrontation in this work. Siqueiros' use of vast numbers of packed figures assembled into an independent

architecture of form and composition gives the mural this powerful revolutionary dynamic, best seen in the long central wall where, on either side of the figures of Green and Manuel Diguez, one of the strike leaders, the compacted rows of figures are assembled on a tilted plane of curvilinear perspective. The downward curving horizon implied in the form composed of rows of massed figures creates a dramatic sense of opposing forces moving towards each other in an unstoppable momentum.

Although not fully completed or entirely visually resolved, the mural *Theatrical Art in the Life of Mexico*, which Siqueiros painted in the Jorge Negrete Theatre in Mexico City, shares the use of a historical narrative as an allusion to contemporary politics. In this case, Siqueiros used his primary theme of the history of drama in Mexico to present the concept of tragedy, which in the context of the mural was translated into a passionate protest against the repressive policies of the López Mateos government and the Mexican state, in opposition to which he was actively involved.[63]

Siqueiros' interpretation of the theme that he had been contracted to depict provoked enormous reaction and opposition from those who had commissioned the work.[64] He had

deliberately blurred the boundaries between art and politics. As the mural developed, the directorate of the actors' union that had commissioned him sought legal injunction against him for what was seen to be a gross departure from the agreed theme. In a lecture delivered in Caracas in 1960, following the placing of the legal injunction, Siqueiros explained his motives in his approach to the mural

> This was a time when the Mexican government had just staged the worst aggression ever perpetrated by a 'revolutionary' government against the organized workers of the country. More than five thousand had been imprisoned. . . . Many railroad workers had been tortured and killed. What could I do under these circumstances? I painted this situation as a concrete example of tragedy. I painted the aggression of the police and the military against the workers, and their leaders, who in essence were blindly obeying the orders of the American State Department.[65]

Although the mural is indeed far from resolved, particularly on the right side of the work, it nevertheless presents some of the most expressive and powerful passages of painting in any of Siqueiros' mural works. Like the work at Chapultepec and his other mural of this period at the Centro Medico, Siqueiros employed a mass of compacted figures to evoke intense feelings of struggle as both a compositional and narrative technique. Within the composition he also added violently contorted figures to heighten the degree of expressiveness. The focal point of the composition is a weeping mother, mourning a dead son, a communist, killed in a street fight. Siqueiros pictured this martyred figure wrapped in a shroud of the national colours. To the right, a menacing group of soldiers stamp their feet on the 1917 constitution, an image that further underlines the rationale for depicting the dead worker as both a revolutionary and a nationalist. Both images signify the essence of a tragedy in which the nation's democratic rights and its identity have been martyred.

There is another characteristic to this mural, perhaps more prominently displayed than in any other of Siqueiros' mural works, which is his extremely gestural and expressionistic handling of paint. It is a quality that lends an emotive resonance to those areas of the mural that are resolved, not encountered in his other, earlier works. Indeed, the passage of figures to the left of the central group is reminiscent of Goya's so-called 'Black Paintings'.

In the third mural of the late 1950s, painted in 1958 in the entranceway of the Department of Cancer in the capital's Centro Médico, Siqueiros returned to his now familiar display of futurist and technological rhetoric. However, as in both the mural at Chapultepec and at the Jorge Negrete Theatre, he drew out an analogy with contemporary politics, a point highlighted by the work's subtitle, *The Historical Parallel between the Scientific Revolution and the Social Revolution*. Siqueiros painted the mural around the two main adjacent walls in the entrance to the centre's Department of Cancer. In simple terms, it consists of a narrative in which humanity's past meets its future in an extraordinary image of a female patient lying within a vast cobalt ray-gun, surrounded by the white-coated figures of doctors and medical personnel. On either side of this central image, Siqueiros introduced lines of compacted human figures. To the right, the figures represent the social development of humanity from the era of the cave dweller to modern technological science. To the left of the central image, Siqueiros created one of his most inventive passages of imagery. It depicts the cancer virus being transformed into the means of its own destruction. This passage contains two monstrous figures. The first is hideously contorted, the second an equally demonic image that seems to be drilling into the entrails of the human figure. The two images are a powerful invention of visual dialectic, from which Siqueiros draws out forms that move across the wall to the centre of the composition. There they become transformed into the cobalt ray-gun, the image of their own destruction. Siqueiros draws a parallel here between scientific advance in medicine and what he saw as the advance of a new revolutionary society. The analogy is clear: from the past comes the present and the future. From the presence of disease comes the knowledge of its destruction.

As a site-specific public mural painting, the composition was related to the low-ceilinged architecture of its location. In the process Siqueiros also created an intriguing manipulation of the pictorial space through the exploitation of optical illusion, engaging the spectator and promoting the need to move to different viewing positions in order to absorb the full impact of

237 *top*
David Alfaro Siqueiros: *Apologia for
the Future Victory of Medicine over
Cancer*. Acrylic on plywood, 1958.
National Medical Centre, detail,
Mexico City. The mural had to be
taken down following irreparable
damage to the building in the
Mexican earthquake of 1985.

238 *bottom*
David Alfaro Siqueiros: *Apologia for
the Future Victory of Medicine over
Cancer*. Acrylic on plywood, 1958.
National Medical Centre, detail of
centre wall, Mexico City.

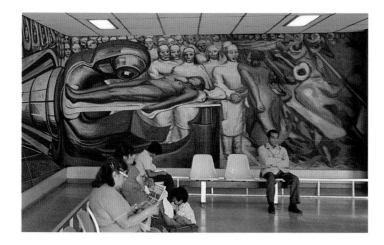

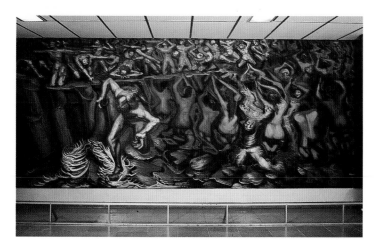

limited. In his view, its aesthetic sweep and social possibilities as an art form for a future revolutionary society extended far beyond what he saw as the narrower concerns and horizons of the studio easel painter. Ultimately it was not mural painting as such that captured Siqueiros' creative and social imagination, so much as the concept of a total aesthetic, the social integration of all the plastic arts of painting, sculpture and architecture. Siqueiros devoted his efforts during his last active years to this idea in the creation of his final work, the massive *March of Humanity in Latin America Towards the Cosmos* at the Polyforum Siqueiros in Mexico City.

Begun in 1967 and finally completed in 1971, three years before his death, the monumental *March of Humanity*, with its astronomic costs and the huge numbers of people involved in its creation deserves a long, in-depth study to itself. Leonard Folgarait's book *So Far From Heaven. David Alfaro Siqueiros' The March of Humanity and Mexican Revolutionary Politics*[67] provides an excellent picture of the social and political context out of which this final work emerged. As a work of art, and one with profound implications concerning social meaning and the role of a radical artist in the late twentieth century, *March of Humanity* was both the most ambitious undertaking of Siqueiros' career and the most questionable.

From ideas first generated during the time he spent in prison from 1960 to 1964 for the crime of social dissolution, Siqueiros saw the concept as one involving every possible element of the plastic arts.[68] It was the ultimate realization of his long-established ideal of plastic integration. On his release from prison in July 1964, he was given the chance to put his ideas into practice when he was approached by the cement manufacturer and real-estate millionaire, Manuel Suárez. Suárez originally commissioned Siqueiros to produce eighteen panels, each of twelve square metres, for the main hall of the conference centre Suárez was constructing at the Hotel de Silva complex in Cuernavaca.

The commission underwent rapid alteration, however, when Suárez was given permission by the government to develop a huge site in the Parque de la Lama in Mexico City as part of the government's tourist and conference centre development plans. Suárez conceived the idea of an enormous cultural complex or

the work. However, for his audience, who were relatives of cancer patients, or those themselves awaiting diagnosis or treatment, the rhetoric of the mural was deeply inappropriate.[66]

Of the three murals of the late 1950s, that in the National Museum of History at Chapultepec Castle marks the culmination of Siqueiros' work as a mural painter. From a strictly formal point of view, the optical concepts he engaged with, and his synthesis of architectonic form and social content reflect an idea of mural painting that extends well beyond the scope envisaged by Orozco or Rivera. But despite the great achievement of the Chapultepec mural, the idea of mural painting as a self-contained form was for Siqueiros aesthetically and politically

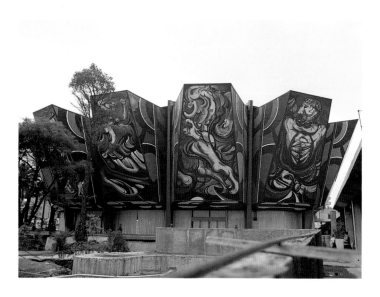

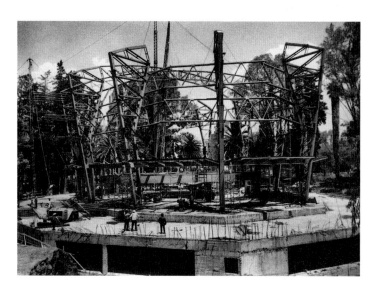

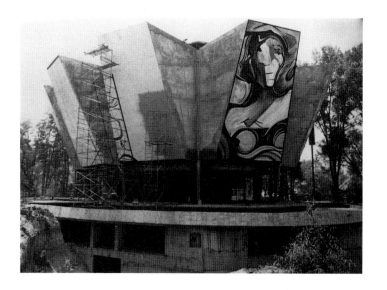

239 *top*
David Alfaro Siqueiros: Cultural
Polyforum, exterior. Asbestos
panels, cement, metal, acrylic and
pyroxaline, 1971. Parque de Lama,
Mexico City.

240 & 241 *centre & bottom*
Archive photographs showing the
construction of the Polyforum,
Parque de Lama, Mexico City.

242 *opposite*
David Alfaro Siqueiros: Cultural
Polyforum, exterior. Asbestos
panels, cement, metal, acrylic and
pyroxaline, 1971. Parque de Lama,
Mexico City.

Polyforum for this site. It was to be a building that would provide all the cultural amenities of the site, with an exhibition hall, a theatre and, as its major attraction, a vast mural by Siqueiros. By 1965 the original commission at Cuernavaca was transformed, and in its place the idea of the *March of Humanity* was born.

In collaboration with the architects of the site, Guillermo Rossell and Ramon Miquelajuarequi, Siqueiros conceived a twelve-sided building intended to have a total integral scheme of decoration both inside and out. Each of the twelve exterior faces carries one of Siqueiros's sculptured mural paintings depicting different themes and subjects. They are

Destiny: The World Marches Forward;
Ecology: The Leafless Tree and The Tree Reborn;
Acrobats: The Transition from Spectacle to Culture;
Masses: Man and Woman in their Struggle for Peace;
Decalogue: Moses Breaks the Tablets of Law;
Christ: Christian Why Persecutest Thou Me?;
Indigenous Peoples: The Sacrifice of the Aborigine Before the
 Civilized Man's Divinity;
Dance: Modern Movement Towards Love and Victory;
Mythology: The Development of Abstract Thought;
Mingling of The Races: The Drama of War and Love During the
 Conquest;
Music: Art Without Discrimination; and
Atom: The Triumph of Peace Over Destruction.

Inside Siqueiros created the *March of Humanity*. Covering an area of several thousand square feet, the sculptured painting was created over a huge elipse formed by the dome-like vault of the ceiling area of the upper floor of the building. Accompanied by light and sound, the viewing area for the work rotates so that the viewer becomes a participant in the action being represented.

When it was completed, Siqueiros had created a unique work of art, but one with some disturbing aspects. For the work of a self-proclaimed, revolutionary socialist artist, the enormous costs incurred, the imposition of an entrance fee, the siting of the building beyond the reach of the general public, and the abstracted rendering of the theme all have considerable implications for the project's achievement as a significant work of popular public, social and political realism.[69] Indeed, the work is to some extent tainted by the rationale of Manuel Suárez, whose justification

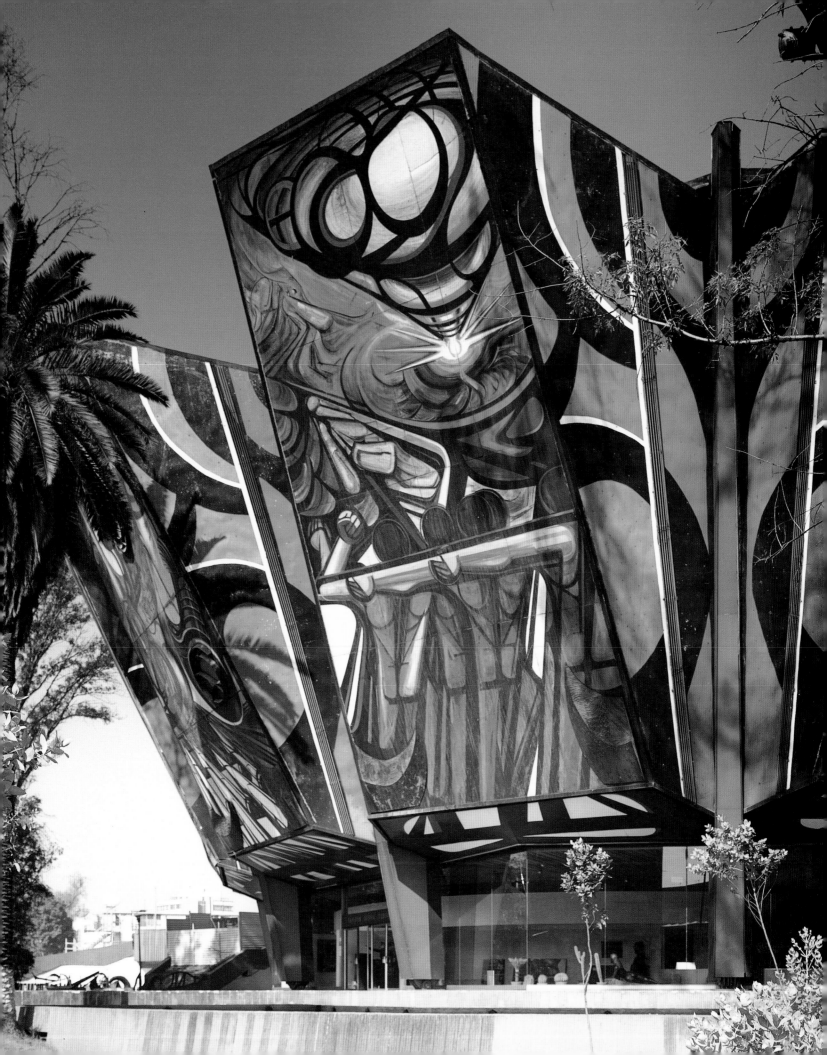

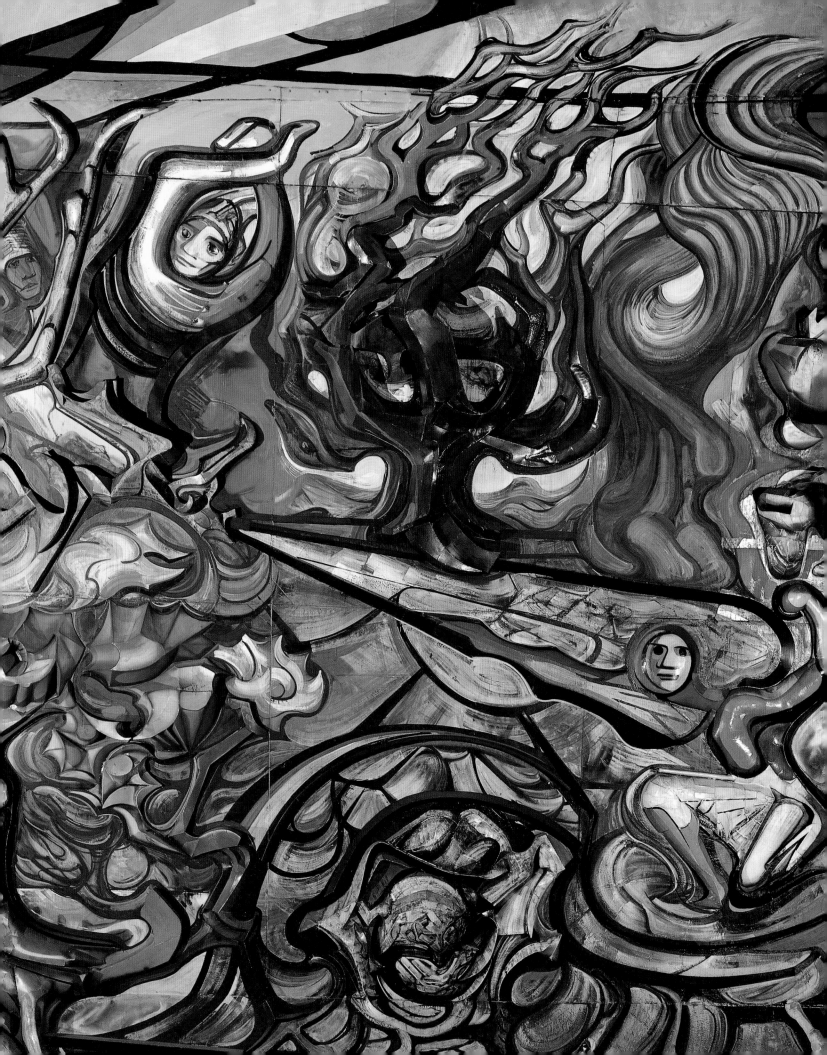

243 *opposite*
David Alfaro Siqueiros: *The March of Humanity*. Asbestos panels, cement, metal, acrylic and pyroxaline, 1971. Cultural Polyforum, Parque de Lama, Mexico City.

244
David Alfaro Siqueiros: *The March of Humanity*. Asbestos panels, cement, metal acrylic and pyroxaline, 1971. Cultural Polyforum, Parque de Lama, Mexico City.

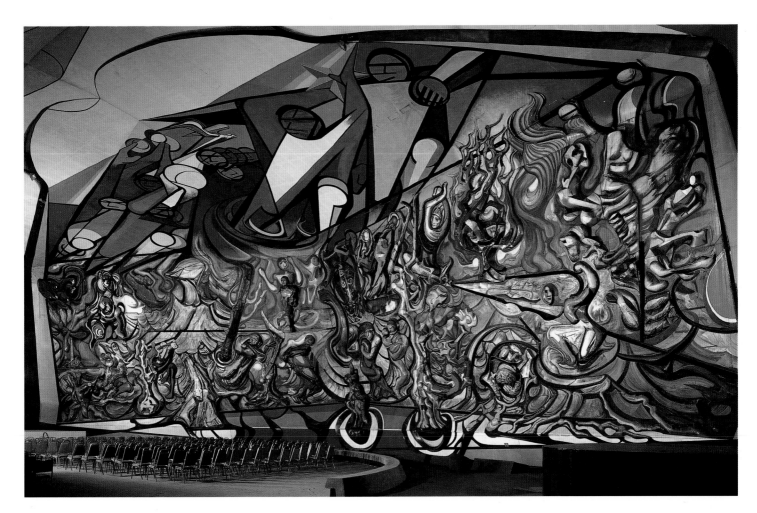

for the project was acutely expressed when he said 'Let us make tourism an even more important form of expression; let us make it grow by means of art. . . .'[70]

From an aesthetic viewpoint, *March of Humanity* is overblown, unremittingly oppressive in its use of violent red and ochre colours and its endlessly gyrating figural composition. Furthermore, the conceptual unity of the work is not successful, a problem largely resulting from the highly ambitious but almost impossible task of integrating the work of the different teams of artists who assisted Siqueiros in its creation.

Yet in the final analysis, Siqueiros' work in the Polyforum is an immense achievement. Its value lies in the physical evidence of its aims and intentions, and in the material, technical and aesthetic implications of its creation for the future of public mural art. In conceptual and technical terms, Siqueiros achieved something no other artist of this century had even attempted. In organizing one great creative team, Siqueiros and his many assistants broke new ground and presented a basis on which the possibility of a collective plastic creativity could be realized. As Antonio Rodríguez has written, 'Many will disagree with (Siqueiros') theories and his form of painting, but nobody can deny the originality of his art, an art which enabled him to make a major artistic contribution while always following the aim which he had served himself – that of serving his people.'[71]

Postscript

When Siqueiros died in 1973 at the age of 77, the story of Mexican mural painting did not end. A second generation of active and prolific muralist painters existed, such as Rufino Tomayo, Carlos Cháves Morado, Juan O'Gorman, Enrico Eppens, Jorge Gonzáles Camarena and, later still, such painters as Arnold Belkin and many others. Today, painters in Mexico continue to work on public commissions such as major projects in some of the subway stations of Mexico City.

Much has changed, of course, in the character of Mexican mural art since the early days of the mural movement. But the work of Orozco, Rivera and Siqueiros constituted a defining of the original aspirations and intentions of the Mexican movement. How are we to view this movement and, in particular, the work of these three painters as we approach the end of the century? Where can we place them in the stories of twentieth-century art?

In one sense, the task of locating the murals of Orozco, Rivera and Siqueiros within the diversity of the historical narratives that make up the history of twentieth-century art is much easier now than at any period since the end of the Second World War. The centrality and authority of the modernist ethos that permeated so much of the practice and theory of artists and writers in the twentieth century, particularly in the post-war period, has broken down and given way to an inclusion of diversity and difference, to an acceptance of 'the other'.

But perhaps as important as the breaking down of the centrality and authority of the modernist ethos is the dramatic reconfiguration of the global political landscape that up until very recently was defined by the contending claims and assumptions of the two conflicting ideologies of liberal capitalism and Soviet socialism. The cultural, ideological and political world of the post-war era was not, of course, constructed entirely or exclusively within the absolutist terms represented by these dominating oppositions. Nevertheless, the opposing aspirations of these two dramatically different views of society created an ideological environment in which artists like Siqueiros and Rivera, in particular, could be marginalized or excluded from the main narrative of modern Western art by the liberal capitalist societies of the West. The hidden and unhidden Western assumptions were that the association of artistic practice and political and social expression was a barren marriage, in which the domain of the creative imagination was inappropriately controlled and influenced by unrelated factors.

The apparently total collapse of Soviet communism and the demise of the Soviet Union have not necessarily altered such liberal beliefs, but the political and ideological 'disappearance' of the Soviet Union has weakened them. In the absence of the ideological imperatives that powered the East–West conflicts of the past, North American and Western European culture can no longer justify the exclusion or marginalization of those artists perceived as too heavily influenced by or engaged with matters unrelated to the exclusive demands of artistic practice.

But if it is true that we can now deal with the art of Orozco, Rivera and Siqueiros as part of the diversity of narratives that make up the history of twentieth-century art, then it is important that the cultural dynamic that makes this possible is understood. The dramatic changes that have taken place in the East–West political and ideological landscape are part of this dynamic, forces that inevitably recontextualize the readings that have so often been made of Mexican muralism and, in particular, of the work of its three leading painters.

The terms which have often been used in the past to describe the mural movement and the work of Orozco, Rivera and Siqueiros, such as socialist, revolutionary and political, are still valid to a certain extent. But they are also simplistic and, worse, often very misleading. In the changing cultural dynamic of the 1990s these terms divert attention away from what today is a profoundly different and more radical interpretation of their potential significance.

Such interpretations must begin by recognizing the specifically North American and Mexican context within which the mural movement was created. Here, in the wake of Mexico's colonial past and its turbulent revolution, the movement became essentially a process of cultural re-empowerment. This process of cultural redefinition took place not only in relation to Mexico as a nation and as a people, but also in relation to its colonized past and to the contemporary world.

Today, in the context of the North American continent, of which Mexico is fundamentally a part, we must recognize that the classic colonialisms of the past, which plundered, destroyed or transformed the once indigenous North American landmass, have been superseded by another, very different type of colonialism. It is one that has taken control of culture even more thoroughly, and increasingly attempts to strip away the collective tools by which peoples define and empower themselves.

To travel from one country to another in the late twentieth century is increasingly to recognize the extent to which the new colonialism wrought by the economic culture of the free market is inexorably transforming diversity into 'oneness' and difference into 'sameness'. Nowhere is the process stronger than in the North American continent. Yet it is in the face of this homogenizing process that a paradox is confronted. The essential characteristics of North America are diversity and difference, yet in the context of the free market culture, these diversities, far from diminishing, are becoming increasingly entrenched both culturally and politically. The reasons for this are varied. In part, it is because the historical consequences visited upon this once indigenous landmass by the colonialisms of Spain, France, Britain and, more recently, the United States, together with all the ensuing patterns of immigration and settlement by both exploiters and the exploited, have helped to generate a culture of diversity and difference. But more significantly we must recognize that today the increasing fragmentation into difference and diversity in North American culture is also being powered by a radical resistance. It is a resistance that seeks to counter the free market's cultural obliteration of the mechanisms by which peoples define their sense of identity. Such resistance seeks to emphasize roots, origins, ethnicity, and the examination and re-envisioning of history, diversity and difference, in order to recon-nect a sense of the collective self in relation to those diverse and different pasts and origins.

It is within these diversities and differences that I sense the emergence of a dynamic which could be described as the beginnings of a pan-North American cultural radicalism. It is a cultural dynamic whose essential characteristics are those of resistance, empowerment and a process of definition. This cultural dynamic is one that necessarily resides in the realm of the public, as opposed to the private, domain. In observing the formation of these characteristics, we also return to the great paradox. The process which they resist and against which they compete, is the same process that propels them into the cultural and political foreground, namely the forces of the free market.

The homogenizing influence of the free market, with its numbing ahistorical certainties, so typically reflected in consumerism, presents us in the late twentieth century with a process that is helping to redefine the contours of our cultural, political and social landscape. The full consequences of this cannot yet be known. However, it is certain that whatever those consequences will be, they will profoundly alter the terms of reference by which nation states, peoples, their origins and identities are defined.

It is in this light that the Mexican mural movement and the work of its three leading painters takes on a new significance. In residing so insistently in the realm of the public domain, the movement addressed those matters that are, I believe, central to the issues that surround the contemporary North American cultural phenomenon of diversity and difference. The murals represent a people's roots, their ethnicity, their shared sense of origin, in which the examination and re-appropriation of history can focus on the struggle for freedom, liberty, justice and, above all, identity.

NOTES

INTRODUCTION

1. Herbert Read, London, Faber and Faber, 1951: p. 43
2. *El Machete*, No. 7, 1924, Mexico. The manifesto was first proclaimed on 9 Dec. 1923, in response to the political events in Mexico.
3. Leonard Folgarait, *So Far From Heaven. David Alfaro Siqueiros' The March of Humanity and Mexican Revolutionary Politics*, Cambridge Iberian and Latin American Studies, Cambridge University Press, 1987: p. 1.
4. Clement Greenberg, *Art and Literature*, No. 4 (Spring 1965): pp. 193–201.
5. Bertolt Brecht, 'Popularity and Realism', published in *Schriften zur Literatur und Kunst*, Frankfurt, 1967.
6. Clement Greenberg, ibid.
7. Luis Cardoza y Aragon, *Mexican Art Today*, Mexico City, Fondo Cultura Economica, 1966: pp. 21–22.
8. George Biddle, *An American Artist's Story* (from a letter written by George Biddle to President Roosevelt, 9 May 1933), Boston, Little Brown, 1939: p. 268.
9. Francis V. O'Connor, *Art for the Millions*, Greenwich, CT, New York Graphic Society, 1973: p. 69.
10. José Clemente Orozco, 'New World, New Races, New Art', *Creative Art Magazine of Fine and Applied Art*, New York, Volume 4, no. 1, 1929.
11. Quoted in Raquel Tibol, *Arte y Politica, Diego Rivera*, Editorial Grijalbo, Mexico, 1979, p. 27.
12. Herbert Read, *A Concise History of Modern Painting*, New York, F.A. Praeger, 1968, p. 8.
13. *A Declaration of Social, Political and Aesthetic Principles.* Drawn up by Siqueiros in 1922 and signed by all the members of the Syndicate of Technical Workers, Painters and Sculptors, among whom were Diego Rivera, José Clemente Orozco, Jean Charlot, Ignacio Asunsolo, Xavier Guerrero, Fermín Revueltas, Roberto Montenegro and Carlos Mérida. An English translation is published in *Art and Revolution*, Lawrence and Wishart, London, 1975: pp. 24–25.

CHAPTER ONE

1. A feature of debt peonage was that landless peasants who worked on haciendas were forced to live in accommodation owned by the landlords, and to buy clothing, food and medicine from their stores. The peasants' wages never covered these basic provisions. By insisting on credit being given at the hacienda stores, the landlords created ever-increasing levels of exploitation for their workers. They deducted these debts from their wages, with the result that the peasant and his family received nothing for the work that he did.
2. Jean Franco, *The Modern Culture of Latin America*, Pelican Books, Harmondsworth, 1971: p. 66.
3. Jean Franco, ibid.: p. 66.
4. This famous labour dispute was a significant event in the political developments leading up to the Mexican revolution of 1910. 2,000 Mexican workers struck in protest at the low level of their wages in comparison to those paid to American employees of the company working in the same mines. Led by Manuel Diguez, Calderón and Plácido Rios, the Mexican workers marched to the mine headquarters in Cananea to demand higher wages. They were met by a hail of bullets from US company security guards. In the conflict that followed Galbraith, the Consul General of the United States, ordered American Rangers into Mexico to suppress the strike, resulting in 23 deaths, 22 injuries and more than 50 people being imprisoned.
5. James Creelman, "President Diaz, Hero of the Americas", *Pearson's Magazine*, Vol. XIX, No. 3, March 1908.
6. *Mexico and Its Heritage*, New York, Century Company, 1927: p. 635.
7. Antonio Rodríguez, *A History of Mexican Mural Painting*, London, Thames and Hudson 1969: p. 385.
8. David Brading, *The Origins of Mexican Nationalism*, University of Cambridge, Centre for Latin American Studies, 1985: p. 99.
9. Ibid.: p. 101.
10. Ibid.: p. 1.
11. Justinio Fernández, *A Guide to Mexican Art*, University of Chicago Press, Chicago, 1969: p. 151.
12. Ibid.: p. 140.
13. Nicola Coleby, unpublished MA thesis 'La Construcción de una Estetica: El Ateneo de La Juventud, Vasconcelos, y la Primera Etapa de la Pintura Mural Posrevolucionaria, 1921–1924', Universidad Nacional Autónoma de México, Facultad de Filosofía y Letras, 1986: p. 68.
14. Ibid.: p. 68.
15. Ibid.: p. 68.
16. José Clemente Orozco, *An Autobiography*, University of Texas Press, Austin, Texas, 1962: p. 20.
17. Ibid.: p. 20.
18. *El Imparcial*, Mexico City, 13 Nov. 1910.
19. Quoted in Jean Charlot, *The Mexican Mural Renaissance*, New York, Hacker Books, 1979: p. 49.
20. Ibid.: p. 49.
21. Ibid.: p. 70.

22. Ibid.: p. 70.
23. *Art and Revolution*, ibid.: p. 69.
24. Charlot, ibid.: p. 89.
25. Quoted by Renato Molina Enriquez, 'La Decoración de Diego Rivera en La Preparatoria', *El Universal Illustrado*, Mexico City, 22 Mar. 1923.
26. Quoted in Charlot, ibid.: p. 90.
27. Ibid.: p. 93.
28. Vera De Córdova, for example, wrote in a caustic article in the magazine *Revista de Revistas*, of 25 Feb. 1923, that 'bluff is the word written on the studio door of each one of those fashionable artists who climb the steps of a certain infatuated Secretary.... The official backing that artists of the calibre of Roberto Montenegro and Adolfo Best receive can foster only ridicule.'
29. Charlot, ibid.: p. 141.
30. Quote from an interview with Octavio Paz, published in *Arts Canada*, Jan. 1980.

CHAPTER TWO

1. Florence Arquin, *Diego Rivera: The Shaping of an Artist, 1889–1921*, University of Oklahoma Press, Norman, 1971: p. 86.
2. Jean Charlot, *The Mexican Mural Renaissance*, Hacker Books, New York, 1979: p. 209.
3. José Clemente Orozco, *An Autobiography*, University of Texas Press, Austin, Texas, 1962: pp. 39–40.
4. Ibid.: p. 8.
5. Charlot, ibid.: p. 215.
6. Orozco, ibid: p. 54.
7. Charlot, ibid.: p. 217.
8. 'La Exposición de la Escuela Nacional de Belles Artes', *Revista de Revistas*, 7 May 1916.
9. Charlot, ibid.: p. 220.
10. When Orozco entered the United States, the American customs service confiscated and destroyed much of the work he was carrying, claiming it to be indecent.
11. 'Mexican Painting Today', *International Studio*, Jan. 1923.
12. Besides being a well-known poet, Tablada was also a newspaper columnist. This took him frequently to the United States, from where he sent home a weekly column entitled 'New York by day and by night'.
13. Siqueiros was taught by Germán Gedovious for oil painting, by Emiliano Valdés for the nude figure, by Saturnino Herrán for drawing of the clothed figure, by Francisco de la Torre Herrán for landscape and by Carlos Lazo for the history of art. It should be noted that although teaching at the Academy was controlled by the 'Pillet' system, the growing cultural nationalism and concern for Mexican subject-matter did not leave Siqueiros' instructors unaffected.
14. Charlot, ibid.: p. 191.
15. *Art and Revolution*, Lawrence and Wishart, London, 1975: p. 69.
16. *Me Llamaban El Coronelazo. Memorias de David Alfaro Siqueiros*, Biographás Grandesa, Mexico City, 1977: p. 86.
17. From a manuscript in the Siqueiros archives, Mexico City, entitled 'Autobiographical notes'.
18. 'Un Nuevo Artista', *El Universal Illustrado*, 15 Nov. 1918, quoted by Charlot, ibid.: p. 196.
19. Ibid.
20. 'Mi Repuesta', Centro de Arte Público, Mexico City: pp. 16–17.
21. 'Mi Repuesta', ibid.: p. 18.
22. See Peter de Francia, *Léger*, Yale University Press, New Haven and London, 1983: p. 3, and Siqueiros, *Memorias*, ibid.: p. 130.
23. From the manifesto 'Three calls to American Painters: Detrimental Influences and Tendencies', *Vida Americana*, Barcelona, 1921. Translation published in *Art and Revolution*. Ibid. Chapter 3.
24. 'Three Calls to American Painters', ibid.: pp. 21–2.
25. See F. T. Marinetti, 'The Foundation and Manifesto of Futurism', 1908, published in H. B. Chipp, ed., *Theories of Modern Art*, University of California Press, Berkeley, Los Angeles and London, 1968: p. 284.
26. John White, *The Birth and Rebirth of Pictorial Space*, Faber, London, 1972: p. 140.
27. *Memorias*, ibid.: p. 163. The Barcelona manifesto was produced in collaboration with Salvat Papaseit and, according to Siqueiros, with the help of Salvador Dalí. Unfortunately Siqueiros does not expand on this interesting connection in his memoirs.
28. 'Three Calls to American Painters', ibid.: p. 21.
29. Ibid.: pp. 22–3 (Siqueiros' italics).
30. Charlot, ibid.: p. 169. Borjórquez wrote the letter because Siqueiros considered that it might speed up the bureaucratic delay in advancing the money that he had requested from Vasconcelos for a prolongation of his stay in Europe.
31. Charlot, ibid.: p. 200.

CHAPTER THREE

1. Nicola Coleby, unpublished MA thesis 'La Construcción de una Estetica: El Ateneo de La Juventud, Vasconcelos, y la Primera Etapa de la Pintura Mural Posrevolucionaria, 1921–1924', Universidad Nacional Autónoma de México, Facultad de Filosofía y Letras, 1986: chapters 1 and 3.
2. *Diego Rivera: A Retrospective*, exh. cat., Founders Society, Detroit Institute of Arts and W.W. Norton & Company, New York and London, 1986: p. 237.
3. Antonio Rodríguez, *A History of Mexican Mural Painting*, Thames and Hudson, London, 1969: p. 186.
4. Jean Charlot, *The Mexican Mural Renaissance*, Hacker Books, New York, 1979: p. 209.
5. Charlot, ibid.: p. 145.
6. Charlot, ibid.: p. 143.
7. Charlot, ibid.: p. 149.
8. David Alfaro Siqueiros, 'Diego Rivera Discute', *El Democrata*, 2 Mar. 1924.
9. Charlot, ibid.: p. 203.
10. David Alfaro Siqueiros, 'Lectures to Artists', *New University Thought*, Winter 1962.
11. *El Universal Illustrado*, 19 June 1923. Guerrero's technical development incorporated the use of juices from fermenting leaves of the nopal cactus as a paint binder and for helping to spread the paint. Aside from its appalling stench, the technique proved to be faulty, and was eventually abandoned in favor of the traditional *buon fresco* recipe. The use of nopal cactus leaves in part explains the reason for the less than perfect condition of the early mural panels in the Ministry of Education.
12. José Clemente Orozco, *An Autobiography*, University of Texas Press, Austin Texas, 1962: p. 85.
13. Quoted in Charlot, ibid.: p. 227.
14. Charlot, ibid.: pp. 228–9.
15. Laurence Hurlbert, *The Mexican Muralists in the United States*, University of New Mexico Press, Albuquerque, 1989: p. 19. In 1921 Vasconcelos commissioned Dr. Atl to paint mural decorations in the former convent of San Pedro y San Pablo in Mexico City; he painted panels entitled 'The Sun', 'The Moon', 'The Wind', 'The Rain', 'The Titan', 'The Vampire', 'Night', 'The Wave' and 'The Man who came out of the Sea'. They were subsequently all destroyed. Hurlbert refers here to one of these panels.
16. Rodríguez, ibid.: p. 198.
17. Vasconcelos was singularly unimpressed with the union and refused to recognize it. In his memoirs he wrote 'I was amused when they organized themselves into a union. Siqueiros communicated the formation to me.... I will not deal with your union, nor with (Siqueiros). Personally I prefer to accept from all of you your resignations. The money which has been going into your murals we will employ on primary school teachers.'
18. The first issue of *El Machete* was published at the beginning of March 1924. Intended as a two-weekly publication it was officially registered as required by law on 6 Mar. 1924. Printed in large format, it had two colours, usually black and red. Its size allowed it, as Siqueiros put it 'to be stuck to street walls as a poster, and as a wall newspaper in the centers of local union and agrarian buildings'. A subscription for *El Machete* was 50 centavos for three months. The first issue contained such articles as 'Towards a Worker Peasant Government. What is Revolution?', written by Alfonso Goldsmidt,

and 'Assassins', written by Rivera. Siqueiros contributed an article entitled 'Marginal notes to the Syndicate of Painters and Sculptors' Manifesto'. In it, Siqueiros wrote of how artists of the Syndicate had 'united themselves in a Communist movement for creative art and for carrying out work of social importance'.

19. The text of the manifesto is published in English in David A. Siqueiros, *Art and Revolution*, Lawrence and Wishart, London, 1975: pp. 24–5.

20. Rodríguez, ibid.: p. 199.

21. José Clemente Orozco, '*New World, New Races and New Art*', *Creative Art Magazine of Fine and Applied Art*, January, 1929 supplement: pp. 44–6.

22. Charlot, ibid.: pp. 295–6..

23. Rodríguez, ibid.: p. 189.

24. Charlot, ibid.: p. 285.

25. Ibid.: p. 235.

26. D. H. Lawrence, *The Plumed Serpent*, Penguin Books, Harmondsworth, 1977: p. 59.

27. Bernard Meyers, *Mexican Painting in Our Time*, Oxford University Press, New York, 1956: p. 89. The mural was commissioned by Francisco Sergio Iturbe. The building, a classical colonial structure, now houses the Sanborn's department store and restaurant.

28. Malinche spoke both Mayan and Aztec languages. Cortéz was also able to communicate through the Spaniard, Jerónimo de Aguilár, who had a knowledge of Mayan language (he had lived in Mexico for eight years prior to the arrival of Cortéz).

29. Las Casas was one of the most remarkable men of the sixteenth century. The first secular priest to be ordained in the new world, Las Casas became a lifelong defender of the Indians. David Brading has written that 'his conversion seems to have consisted of the simple, but passionate realization that natives of the new world were as much men as the Spaniards, and hence to much the same rights and treatment as Spaniards. Conversely he experienced a passionate revulsion against those Spaniards, who were guilty of crimes against the Indians.' (From *Prophesy and Myth in Mexican History*, Centre of Latin America Studies, University of Cambridge, Cambridge: p. 16.)

30. Orozco's views on this question are amusingly summed up in *An Autobiography*, ibid.: pp. 99, 103.

31. Siqueiros was in part responsible for other murals on the site at this time. However, they are so badly deteriorated that they can no longer effectively be deciphered. In the case of *The Myths*, much of what is still visible appears to have been the work of other artists such as Xavier Guerrero, with Siqueiros contributing little to the overall image.

32. In his memoirs, Siqueiros cites the influence of the Communist Lorenzo Gómez as having had a particular bearing on his move to include more political content in his murals. *Memorias de David Alfaro Siqueiros*, Mexico Biografias Grandesa, 1977: p. 215.

33. Siqueiros dedicated the mural to the great Indian socialist governor of the Yucatán by writing his name on a piece of paper in a bottle and plastering the bottle into the surface of the wall.

34. Rodríguez, ibid.: p. 187.

35. *Memorias*, ibid.: p. 222.

36. Siqueiros' contract was finally terminated by Cassauranc in August 1924. Orozco's contract was terminated at the same time.

37. Quoted in Charlot, ibid.: p. 311.

38. Guillermo Garcá Oropesa, *Murales de Jalisco*, Guadalajara, Gobierno del Estado, 1974: p. 74.

39. Quoted in Charlot, ibid.: p. 310. Oropesa, wrote that Siqueiros' panels were 'circular, triangular, prismatic, rectilinear' and that in Guadalajara, Siqueiros '. . . tried the possibilities of geometry'. This indicates that Siqueiros was probably responsible for the panels *The Machine* and *Unity of the Peasant and the Worker*, whereas de la Cueva was responsible for such panels as *Allegory of Zapata* (photographic evidence in Charlot, Plate 50b, seems to confirm this).

40. Following de la Cueva's tragic death, Siqueiros' involvement in trade union activity in the state of Jalisco centred around the National Peasant Congress, and the League of Agrarian Communities, together with the directorship of a workers' newspaper, *El Martillo*. This was followed by editorship of the newspaper *El 130*, and the direction of the Congress of Workers' Unification of Hostotipaquilla. In 1928 Siqueiros went to the Soviet Union as the delegate of the Jalisco Miners' Union to the 4th Congress of the Red International Syndicate. In January 1929 he was named Secretary General of the Unitary Syndicate of Mexico by the National Assembly of Peasant Worker Unification, and went to Montevideo as a delegate of the Congress of Latin American Unions. In May 1930 Siqueiros was arrested for his involvement in a banned May-day demonstration in Mexico City. He was charged with disturbing public order, instigation and incitement to rebellion. He was sentenced to jail in the Mexico City penitentiary, and was eventually released in November 1930, whereupon he was sentenced to a further year of internal exile in the silver-mining town of Taxco.

41. Rodriguez, ibid.: p. 197.

42. *My Life, My Art*, an autobiography written in conjunction with Gladys March, Citadel Press, New York, 1960: p. 134.

43. Rivera's assistants on these frescoes were de la Cueva, Guerrero and Charlot. They moved into the building in February 1923 to begin preparing the wall surfaces prior to painting. Rivera began the following month.

44. *Indigenismo* was reflected in the great interest in anthropology during the decade of the 1920s. Indicative of this concern was the employment of the painter Best Maugard in 1911 by the American Franz Boas to make drawings of thousands of pots from the valley of Mexico. From this, Boas developed an alphabet for teaching children. In 1922 Dr. Atl published his work *Artes Populares de Mexico*, and the great Mexican anthropologist Manuel Gamio, assisted by the painter Francisco Goitia, made his pioneering study of the archaeological site of Teotihuacan.

45. This panel caused enormous controversy when it was completed because Rivera had inscribed on one of the wooden pit-planks a poem by Gutiérrez Cruz, which ran: 'Comrade miner bending beneath the weight of the earth, your hand errs when it digs metals for money. Make knives with all the metals, and thus you will see how all the metals will be for you.' When this poem was discovered, Pani, the Secretary to the Treasury, forced Rivera to remove the words. He succeeded only after Rivera had agreed with his colleagues in the Syndicate that the political content of the mural would not be undermined by the removal of the poem.

46. *My Life, My Art*, ibid.: p. 136.

47. See Charlot, ibid.: pp. 278–9 for a description of the events leading up to Rivera's action.

48. Although not discovered until 1949, the Mayan murals of Bonampak in Yucatán, dating from AD 692, provide an excellent example of this particular idiom. See Rodríguez, ibid.: plate 29.

49. Rivera continued with this focus on the Indian later in 1928 when he painted the portraits of the great Indian revolutionary leaders along the second floor of the Courtyard of Labour in the guise of secular saints: Felipe Carrillo Puerto, Emiliano Zapata and Otilio Montaño.

50. *My Life, My Art*, ibid.: p. 136.

51. The work also makes an interesting comparison with Siqueiros' *Burial of the Sacrificed Worker*, in that Rivera's highly accomplished rendition of this theme shows the degree of his maturity as a painter at this time in comparison with Siqueiros.

52. Rivera only loosely followed the stanzas of the *corridos*, being more concerned to create the feel of these popular songs than strictly to adhere to the original texts. For a reading of the proletarian *corridos*, see Bertram Wolfe, *The Fabulous Life of Diego Rivera*, Stein and Day, New York, 1969: pp. 209–10.

53. Diego Rivera's trip to the Soviet Union was arranged by Edo Fimmen, President of the International Transport Workers' Federation. Fimmen obtained a special Soviet government invitation for Rivera to attend the tenth anniversary of the Soviet Revolution. While he was in Moscow Rivera signed a contract on 24 November with Lunacharsky, the Soviet Minister of Education, to paint a fresco in the Red Army Club (see letter to Rivera from Lunacharsky in Wolfe, ibid.: p. 217). Rivera did not in the end carry out this commission for health reasons and for what were termed 'unspecified' political reasons. The latter almost certainly referred to Rivera's growing sympathy with the political position of Leon Trotsky.

54. Wolfe, ibid.: p. 211.

55. The panel of *The Trench* makes an interesting comparison with the panel of the same title and subject painted by Orozco in 1926 in the National Preparatory School. In Rivera's work the atmosphere is poetic and lyrical, revealing nothing of the pain and tragedy that is monumentally expressed in Orozco's work.

There are some notable portraits in the fresco *Distribution of Arms*. These include that of Frida Kahlo, seen in the very centre of the mural distributing rifles. On the right side of the panel are the photographer Tina Modotti and Julio Mella. Mella was the founder of the Cuban Communist Party, and was walking with Modotti when he was assassinated in 1929. Siqueiros is also included in the fresco on the left side of the panel, wearing army uniform.

56. De Negri was also head of the National Agrarian Commission and was responsible for directing the partitioning of the old hacienda land of Chapingo and for its distribution to its peasant workers.

57. In a personal interview conducted in 1978 in Mexico City, O'Higgins spoke of how he and the others who assisted Rivera on the project would travel by train every morning from Mexico City to Chapingo to work on the mural.

58. These three figures echo the motifs depicted in Rivera's *Burning of the Judases* panel in the Courtyard of the Fiestas in the Ministry of Education.

59. The model for this figure was the photographer Tina Modotti. Modotti posed for other panels within the cycle, specifically for the *Germination* panel.

60. Louis Gillet quoted in Wolfe, ibid.: p. 234.

CHAPTER FOUR

1. José Vasconcelos, *La Raza Cósmica*, published in *Obras Completas*, 4 vols., Libreros Mexicanos Unidos, Mexico, 1957–61. Vasconcelos' ideas on the *mestizo* stemmed partly from the celebrated book published in 1909 by Andrés Molína Enríquez, *Los Grandes Problemas Nacionales* (Ediciones Era, Mexico, 1978). The author argued that the essence of Mexican nationality could never be identified with the Creoles, because European ancestry would by sentiment, culture and custom bind them primarily to their European origins. As for the Indians, Enríquez considered that due to the multiplicity of their languages and tribes it would be impossible for them to identify with anything beyond their village or *pueblo*. He thus proposed *mestizaje* as the basis on which the struggle for a Mexican national and cultural consciousness would develop. See Nicola Coleby, unpublished MA thesis, 'La Construcción de una Estetica: El Ateneo de la Juventud y la primera Etapa de la Pintura Mural Posrevolucionaria, 1921–1924', Universidad Nacional Autónoma de México, Facultad de Filosofía y Letras, 1986: pp. 49–52.

 Further writings by Vasconcelos on the matter of Mexican nationality and the question of the mestizo can be found in his work *Indología*, published in 1927 and included in *Obras Completas*.

2. The *Partido Revolucionario Institucional* or 'PRI', as it has become known, was formed in 1929. The party claims to represent all elements in Mexican society – peasants, workers and the middle class who support the aims and objectives of the Mexican revolution. As a social organization, it is immensely powerful and influential, having the vast apparatus of the state behind it together with huge financial resources. It is organized in three sections: an agrarian section of the C.N.C. (Confederation of Peasants), the C.T.M. (the powerful Confederation of Workers), and a so-called 'Popular Section'. This third section represents diverse groups from the professional sections of society. It is important to emphasize that the PRI is also supported by significant sections of the business community, many members of which have profited very greatly from its continual rule.

3. Rivera began work on the National Palace mural in July 1929. By the middle of August he was already well engaged with the right-hand panel representing pre-Columbian Mexico. By December 1929 he was working simultaneously on this mural and the cycle in the Cortéz Palace in Cuernavaca.

4. The mural covers 275 square metres.

5. In the Aztec world, Quetzalcoatl was the legendary god of civilization and learning. However, the myth of Quetzalcoatl extends back thousands of years. His first appearance was as a wind and sea god on the eastern coast of Mexico. The myth of Quetzalcoatl then became located at Teotihuacan, a city in the central valley of Mexico dedicated to his name. Following the fall of the city of Teotihuacan, in 600 AD, the deity moved to the Toltec city of Tula in the tenth century. The Toltecs used the name

by which Quetzalcoatl is now known, a combination of the words *Quetzal*, a green feathered bird from Chiapas, and *Coatl*, which is the Nahuatl word for snake. The combination of these two words makes up the image of the plumed-serpent god symbolizing the duality of the opposites of air and earth.

6. In his book *The Aztecs of Mexico* (Penguin Books, Harmondsworth, 1951, p. 174), George Vaillant wrote of the superstition surrounding Quetzalcoatl and how the Spanish exploited the myth both to justify and to smooth the path of spiritual conquest. He wrote: '. . . the annals and myths tell of Quetzalcoatl, the great king, who civilized the Toltecs and left for the east to return again. The friars seized upon this myth as evidence that St Thomas the apostle had visited Mexico and converted its inhabitants, who slid back into pagan ways. Therefore the friars, to justify the conquest, made much of a blond god who, after taking leave of his people promised to return from the east by sea.'

7. Stanton L. Catlin refers to the image in the top portion of the mural of an upside-down, half-sun face descending into a volcano as a symbol of the destruction and demise of the Aztec world. Rivera's compositional placement of the image of Pre-Hispanic dissent and inter-tribal conflict on the descending and lower portion of this wall might also suggest that such demise was in part a self-inflicted precursor to the eventual conquest of the society by the Spanish conquistadors. See *Diego Rivera. A Retrospective*, exh. cat., Founder's Society, Detroit Institute of Arts, 1986: p. 262.

8. As George Vaillant has written, the defeat of the Aztecs cannot be explained purely in terms of European history. Moctezuma, the Aztec king, has often been singled out by European authors as weak and vacillating. He was in fact no more than a tribal leader ruling over, not a vast empire, but a group of Indian communities intimidated to pay tribute. The celebrated Aztec warrior was by no means the equivalent of the Spanish soldier, and the defence of Tenochtitlán was not a military defence so much as a defence of the city by heroic and courageous individuals fighting for their lives. See Vaillant, *The Aztecs of Mexico*, ibid.: pp. 253–4.

9. The history of the conquest tells of Moctezuma the Aztec king being succeeded by his brother Cuitlahuac, who was quickly succeeded in turn by the heroic Cuauhtemoc. It was Cuauhtemoc who conducted the defence of the Aztec capital Tenochtitlán against Cortez's forces. The Aztec forces eventually disintegrated following a siege of the capital. Cuauhtemoc escaped by canoe. Eventually captured by Cortez, Cuauhtemoc was imprisoned. Cuauhtemoc is always credited with refusing to divulge to Cortez the whereabouts of the Aztec gold. He was hanged by Cortez four years later during the latter's march to the Honduras.

10. Vaillant, ibid., noting the myths surrounding Quetzalcoatl, suggests that the exploitation of this myth by the Spanish, with the supposition that Cortez may have been the incarnation of the returning Quetzalcoatl, may initially have been the reason why Moctezuma at first welcomed Cortez to Tenochtitlán. Certainly, Aztec prophecy of the timing of Quetzalcoatl's return seems to have coincided with Cortez's arrival on the beaches of eastern Mexico, further confusing the Aztec kingdom with its resolve to resist Spanish intrusion.

11. The beginning of the struggle for Mexico's independence is intimately associated with Manuel Hidalgo, whose famous *Grito de Dolores* (cry of Dolores) spoken on 16 Sept. 1810 from the pulpit of his church in Dolores, Guanajuato, called on his parishioners to fight the Spanish and throw them out of Mexico. Hidalgo left his parish with 600 followers, but within months this figure had risen to 100,000. Although he was defeated a year later at the battle of Aculco and subsequently at the battle of Puente de Calderon, which resulted in his execution, the fight for independence was carried on by others, most notably Morelos, Ignacio Allende, Matamoros and Iturbide. Mexico finally gained its independence from Spain with the Treaty of Cordoba, signed on 24 Aug. 1821. The Treaty ratified the three guarantees of the *Plan de Iguala*, which called for Roman Catholicism to be the only recognized religion for the country, equality for all Mexicans and an independent Mexico.

12. Mexico lost over half its national territory to the United States in 1848 at the end of the Mexican-American war. Following the arrival of French troops in Veracruz in 1861–2, Napoleon III installed the puppet Austrian emperor Maximilian and his wife Carlotta as the King and Queen of Mexico in 1864. In 1867, following the withdrawal of French support by Napoleon because of impending war with Prussia, Maximilian's

224 troops were defeated by Mexico's liberal armies. Maximilian was executed on Cerro de los Campos on 19 June 1867.

13. Rodríguez, ibid.: p. 246.

14. Only a few months prior to accepting this commission, Rivera, as a member of the Anti-Imperialist League of the Americas, had publicly denounced the influence of Wall Street on Latin America. As a member of the Workers' and Peasants' Block, he had headed a commission that called for the freeing of communists who had been detained for insulting Dwight Morrow during radical street demonstrations.

15. Also part of this gesture was the offer to assist with the finance to restore the local church and the Cortéz Palace, which had fallen into a state of disrepair. Rivera was predictably and bitterly criticized by his former comrades in the Communist Party, from which he was expelled in 1929.

16. The pictorial elements in this part of the fresco owe much to Paolo Uccello; in particular, the arrangement of the two main Aztec and Spanish warriors together with that of the knives, spears, swords and shields at their feet bear a striking resemblance to Uccello's painting, The Battle of San Romano (c.1455; National Gallery, London).

17. The Sahagún Codex is regarded as the most important existing manuscript illustrating the conquest.

18. It is clear that initially officials at Dartmouth College, together with the Rockefeller family, wanted to pursue the idea of Rivera coming to the college. In a letter dated 8 Aug. 1931, Artemas Packard, Chair of the Department of Art at Dartmouth, wrote to Abbey Rockefeller acknowledging 'your valuable suggestion of Rivera for our mural project. . . . I am more than a little excited by your suggestion of Rivera, who without doubt is a greater all rounder than Orozco'. (Dartmouth College Archives, Dartmouth College, Hanover, New Hampshire.) By the following year, opinion had clearly changed in Orozco's favour. In a letter of 31 May 1932, President Hopkins wrote 'my original interest in Orozco arose from a suggestion of one of our wealthy patrons of the college that in our teaching of the various eras of art it seemed that the college ought to give something in the way of instruction about Mexican art and about mural painting, both of which could be combined in the person of Orozco'. (Presidential Archives, Hopkins file, Dartmouth College, Hanover, New Hampshire.) The enthusiasm of the Department of Art for Orozco was well illustrated by Hopkins in the same letter, when he wrote 'I thereupon asked for a definite assurance in regard to the appropriateness, if any, of the theme suggested, and the Art department became somewhat irritated, saying as far as they went anything that Orozco did would be desirable for the college.'

19. José Clemente Orozco, An Autobiography, University of Texas Press, Austin, 1962: p. 123.

20. The Mexico in Revolution series was exhibited in Sept. 1928 at the Ashram. He exhibited the same drawings in the 57th Street Gallery, New York, owned by Marie Steiner. Orozco also exhibited his work during this time at the Delphic Studios in New York, organized by Alma Reed.

 Orozco's activity during this period, in which he was engaged on easel paintings, centred on both Mexican and North American themes. Of the former he produced such works as Winter, 1932 (Museo de Arte Carillo Gill, Mexico City), while his paintings of Queenboro' Bridge (1932) and The El (1930, both in the Museo de Arte Carillo Gill, Mexico City) are particularly important for their North American subject-matter.

21. Quoted by Churchill Lathrop in 'How the Murals were Commissioned' (symposium paper presented in autumn 1980 at the meeting of the New England Council of Latin American Studies, Dartmouth College, New Hampshire). Orozco had made a preliminary visit to Dartmouth in order to reconnoitre sites for a small fresco he intended painting as part of a course on the instruction of the fresco technique for students at the college. This preliminary panel was eventually carried out on a wall above the doorway from the Carpenter Hall leading to the lower level of the Baker Library. The small fresco which he eventually painted here was entitled Release, for which he was paid with funds provided by the Rockefeller family. The press-release for this small panel stated that the theme of the mural was Man released from the mechanistic, a statement adapted from Orozco's own description of the theme, which stated: 'In the recovery of the creative use of our hands (Orozco) says he wished to symbolise the recovery of the integrity of the human soul which is in danger of being lost in the confused welter of modern mechanised existence.' (From Dartmouth College press-release, Dartmouth College Archives, Hanover, New Hampshire.)

22. Laurence Hurlbert, The Mexican Muralists in the United States, University of New Mexico Press, Albuquerque, 1989: p. 59.

23. Quote taken from a letter to Matt Jones from Hopkins, dated 31 May 1932, p. 2, Dartmouth College, Presidential archives, Hopkins file, Hanover, New Hampshire.

24. Published in Dartmouth Alumni Magazine, Nov. 1933.

25. Hurlbert, ibid.: p. 61.

26. Quote from Orozco in a Dartmouth College press-release dated 25 May 1932.

27. Anthropology still contends that the Indians of America arrived through ancient migration over the Bering Straits, travelling down through what is now Canada and the United States and settling throughout North, Central and South America.

28. In Alfonso Caso's book, People of the Sun (Fondo Cultural Económica, Mexico, 1978), Caso writes: 'The Aztecs, the people of Huitzilopochtli, were the chosen people of the sun. They were charged with the duty of supplying him with food. For that reason war was a form of worship and a necessary activity that led them to establish Xochiyaoyotl, or "flowery war". Its purpose, unlike that of wars of conquest, was not to gain new territories, not to exact tribute from a conquered peoples, but rather to take prisoners for sacrifice to the sun. The Aztec was a man of the people chosen by the sun. He was a servant of the sun and consequently must be, above everything else, a warrior. . . . Since man was created by the sacrifice of the gods, he must reciprocate by offering them his own blood. . . .' (p. 24)

29. It seems that in the mural, the images referring to the age of Quetzalcoatl only very loosely adhere to chronological accuracy. The final image in the series, featuring the departure of Quetzalcoatl in a cataclysmic storm, appears to refer to the fourth or fifth stage described in pre-Columbian sources. See Vaillant, ibid.: p. 169.

30. Alma Reed, Orozco, Oxford University Press, Oxford, New York, 1956: p. 245.

31. As Laurence Hurlbert has pointed out, some of the academic figures in this passage of the mural are caricatures of President Edmunds of Pomona College and the Dean of Students, Jaqua. See Hurlbert, ibid.: note 167, p. 270.

32. The panels Orozco painted opposite the long, central north wall of this site, on the theme of Modern Industrial Man, seem out of place with the searing indictment of the historical conclusions painted in the main body of the work. Their rather light, even optimistic tone contrasts strongly with the deeply sombre and pessimistic positions taken up at Dartmouth in his mural Catharsis of 1934, and in his later murals of the 1930s in Guadalajara.

33. The Hospicio Cabanas was designed at the end of the eighteenth century by the colonial architect Manuel Tolsa. The foundations were begun in 1801. By 1810 the building, which was conceived as an orphanage, was almost complete and housed 66 of the city's orphans. At various times during the Mexican struggle for independence the orphans were forced to leave the building in order for it to become a barracks for one side and then the other, thus delaying its completion until the middle of the century. Its founder, Bishop Ruíz de Cabañas, died before the building's completion in 1845. Prior to Orozco's murals, the building contained, according to Salvador Echevarría, various wall paintings in the squinches depicting the saints' lives. One portrayed St. Julian miraculously saving a child who had fallen into a well. The other depicted St. Vincent de Paul carrying a child in his arms. Commissioned by Don Everardo Torpete, the governor of the state of Jalisco, of which Guadalajara is the capital city, Orozco was paid a sum of 70,000 pesos to paint the Cabañas cycle. It covered an area of approximately 1,250 metres. Guadalajara held special significance for Orozco as it was his birthplace.

34. The origin of the idea of the twin-headed horse goes back to the moment of conquest. The horse was imported by the Spanish into the Americas, where previously it had not existed. Contemporary accounts suggest that the Indians saw the animal and its armed Spanish mount as a twin-headed beast.

35. Salvador Echavarria, Jalisco en El Arte, Mexico City, 1973: p. 28.

36. Porfirio Ledo, Mexico Today, Institute for the Study of Human Issues, Philadelphia, 1982: p. 53.

37. Decolonising the Mind, Zimbabwe Publishing House, 1981: p. 18.

1. See Robert Marett, *New Nations and Peoples: Mexico*, Thames and Hudson, London, 1971: p. 109.

2. Marett, ibid.: p. 110. The radical left was harassed during this period. In August 1929 the Mexican government banned communists from entering Mexico, and throughout much of the latter half of the year the labour movement and the Mexican Communist Party was attacked and suppressed.

3. Rivera's position as Director of the Academy was subject to enormous criticism and he was relieved of the position after only eight months. The criticism levelled at Rivera, particularly by conservative academicians, centred on his radical ideas for a new curriculum, calling for a combination of eight years of daytime factory work with art courses at night, to be followed by another five years of daytime study.

4. Although invited to the United States, it is important to stress that neither Rivera's official entry to the country nor the reaction to his presence was without criticism. In the first instance, his entry was refused by the State department on the grounds of his left-wing politics, and it took the intervention of his San Francisco patrons to have the decision reversed. Similarly, public reaction to Rivera's presence in San Francisco was often hostile, and press headlines stressed his communist past.

5. Quoted from the *San Francisco Chronicle*, 11 November 1930.

6. The portrait of the boy holding the aeroplane is of Ralph Stackpole's son Peter. The symbol of the aeroplane is a reference to the aircraft industry that was developed in Burbank, California.

7. 'Rivera Murals in San Francisco', *Creative Art*, May 1931.

8. Rivera was under very considerable pressure at this time from the Mexican government to return home to complete his fresco on the history of Mexico which he was painting on the stairs of the National Palace in Mexico City. Indeed, the commission for the Art Institute was in doubt owing to the numerous telegrams that had been sent to Rivera from the President. Rivera had exhausted himself with the enormous amount of energy he had put into the stock exchange mural and had left San Francisco on completing the work to stay for six weeks at the home of Mrs. Stern in Atherton. There, instead of resting, he painted a mural in her house of an agrarian idyll showing children carrying fruit.

9. From the sketches that Rivera made during the preparation for this mural it is clear that originally he intended to continue with the earth-mother concept of both the stock exchange mural and the initial ideas for the upper centre area of his work in the National Palace in Mexico City. In the second sketch he prepared, the central figure is that of a woman holding fruit. The image strikingly resembles the outline profile of Helen Wills Moody, indicating a wish to repeat the theme of abundance and riches expressed in his use of the image in the stock exchange mural.

 The assistants for this mural included Matthew Barnes, Clifford Wright, John (later Lord) Hastings and Marion Simson.

10. Letter to William Gerstle dated 23 May 1929.

11. Diego Rivera, *Hesperian*, San Francisco, Spring 1931.

12. Letter to Rivera from Valentiner dated 27 April 1931, D.I.A. Archives. The commission ran into some problems at the beginning in that Valentiner had been authorized to release a sum of only $10,000 for the work. Rivera, however, charged $100 a square foot and the total area of the proposed site was 165 square yards. Initially Rivera agreed to paint only a portion of each wall. However Rivera was sufficiently enthused by the project to request to Ford to paint the whole site, which resulted in Ford agreeing to increase the price to $20,899. On 10 June 1932 Rivera signed a contract to paint all 27 panels of the museum's central inner courtyard walls.

13. From 23 December 1931 to 27 January 1932, Rivera was given a retrospective exhibition of his work at the Museum of Modern Art in New York. The exhibition was only the second one-man show held at the museum (the first was given to Matisse) and broke all attendance records with nearly 57,000 visitors.

14. In order to catch as many daylight hours as possible, Rivera usually started work around midnight, laying in the drawing and the grey tonal washes while it was still dark. By the time dawn came, he was ready to apply the pure colour using natural daylight. An indication of the speed with which Rivera worked is to be found in the dating of some of the panels. On the south wall both the upper panels as well as the large central panel bear the date 20 Sept. 1932, indicating that a mere two months had elapsed since he had first started to paint the cycle. Similarly, on the north wall the vaccination panel is dated 9 Nov. 1932.

Rivera had several assistants working with him at Detroit. Besides Clifford Wright, the British sculptor, who was his chief plasterer, there was Andrés Flores Sánchez, his chemist. His job was to test, grind and mix the pigments and generally prepare the paint for each day's painting. In addition there was Ernst Halberdstadt, who came to the project only after Rivera had already completed the first panels on the east wall. Other assistants included A. S. Neindorf, Lucienne Bloch, Stephen Dimitroff and Jack Hastings. Many of these assistants had worked for Rivera before, and would do so again in the future.

15. *Detroit Free Press*, 11 June 1933.

16. *Detroit Free Press*, 16 March 1933.
The general reception and reaction afforded to the Detroit fresco cycle on its completion was, to say the least, mixed. Besides the attack on the vaccination panel, the frescoes were also vigorously defended. The murals attracted thousands of visitors within days of being opened to the public. As many as 16,000 were reported to have visited them on the opening weekend alone (*Detroit Times*, 27 Mar. 1933, '16,000 enlist in murals war'). Much of the criticism was orchestrated by the most conservative element of Detroit society. *The Detroit News* of 18 Mar. 1933 ran an editorial saying that the best thing to do would be to 'return the court(yard) to its original beauty'. The editorial continued by suggesting that the murals were essentially 'un-American, incongruous, and unsympathetic', and that Rivera's depiction of the factory worker was not 'a fair picture of the man who works in the factory, where there is plenty of space and movement. . . . where there is good ventilation and light and every facility to encourage efficient labor'. Another fierce critic was Dr. John Derry, President of the Marygrove College for Girls, who accused Valentiner of having sold the best walls of the Institute to 'an outside half-breed Mexican Bolshevist'. Derry also considered that the clenched hands in the upper panels of the north and south walls represented 'The communist symbol of the clenched fist and the black hand . . . which means revolution by force and violence' (*Detroit News Magazine*, 13 Apr. 1975).

In private and formal correspondence with the D.I.A. directors, now in the D.I.A. archives, Mr. M. Knapp of the Detroit Citizens' Committee, in a letter dated 31 Mar. 1933 wrote that 'the murals are supposed to portray the spirit of this city and her people. But the interpretation is grossly one sided and hence unfair. Detroit is something more than the Ford Motor Company shops, chemical factories and power plants. This city has an amount of musical, educational, literary, artistic and religious life of which we have a right to be proud. . . . Even if the murals be accepted as a purely realistic interpretation of Detroit factory life, they are unfair both to the industrialists and workers; for the paintings are relieved in their suggestion of bondage to the tyranny of a heartless industrialism.'

There were of course many defenders of the murals. George Pierrot, a volunteer public-relations director to the Institute, organized a People's Museum Association and collected over 4,000 signatures, mostly from factory workers and students in defence of the murals. E. P. Richardson, the Institute's Education Director, prepared a printed broadsheet explaining the murals to the public. But none were politically more effective in the defence of the murals than Edsel Ford himself, who had at the outset promised Rivera full freedom of interpretation, had kept to that promise and had publicly applauded his achievement. Eventually the criticism abated and by the beginning of May, 1935, Valentiner was able to write to Rivera that 'your murals are the greatest attraction at Detroit' (letter dated 1 May 1935, Detroit archives).

17. Rivera *My Life My Art*, ed. Gladys March, Citadel Press, New York, 1960: p. 183.

18. From Linda Downs' interview with E. P. Richardson (6 Feb. 1978), p. 29 (in the files of the Archives of American Art).

19. Nevins and Hill, *Ford Expansion and Challenge, 1915-1933*, New York, Scribners 1957: p. 540.

20. The fee for this commission was $21,000. Rivera began his preliminary sketch for the mural during the autumn of 1932, while working on the frescoes in Detroit. By 1 Nov. he had completed the sketch designs for which he received the unqualified approval of

Nelson Rockefeller himself. In a telegram dated November 7 1932 Raymond Hood wrote Rivera '. . . Sketch approved. Can go right ahead with larger scale.' In March the following year, shortly after completing the Detroit frescoes, Rivera started work on the 1,000 square foot Rockefeller centre site.

21. Bertram D. Wolfe, *The Fabulous Life of Diego Rivera*, Stein and Day, New York, 1963: p. 320.

22. Wolfe, ibid.

23. Diego Rivera, *Portrait of America*, Convici Freide, New York, 1934: p. 21. As Wolfe has pointed out, in 1930 the American Communist Party journals *The New Masses* and *The Daily Worker* began to accuse Rivera of being a bourgeois painter and of never having been a Leninist. See Bertram Wolfe, *Diego Rivera*, Robert Hale, London, 1939: p. 253.

24. Wolfe, *The Fabulous Life of Diego Rivera*, 1963: p. 320.

25. Wolfe, ibid.: p. 321.

26. Wolfe, ibid.: p. 321.

27. Wolfe, ibid.: p. 322.

28. 'Rivera Paints Scenes of Communist Activity and John D. Jnr. Foots Bill', *World-Telegram*, 24 Apr. 1933.

29. Letter dated 4 May 1933. See Wolfe, 1963: p. 325.

30. Wolfe, ibid.: p. 326. Letter dated 6 May 1933.

31. See reports in *New York Herald Tribune* 10 May 1933 and 14 Feb. 1934.

32. Wolfe, ibid.: p. 334.

33. *Worker's Age*, Rivera supplement, 15 June 1933.

34. Elie Faure, 'La Peinture Murale Mexicaine', *Art et Médecin*, April 1934.

35. José Clemente Orozco, 'New World, New Races and New Art,' *Creative Art Magazine*, vol. 4, no. 1, Jan. 1929 pp. 44–6.

36. The most notable other artist to paint at the School was the American painter Thomas Hart Benson. Benson's mural cycle *America Today*, which he painted at the School, became one of the most celebrated murals of twentieth-century American art.

37. Alvin Johnson, *Notes on the New School murals*, dated 20 Aug. 1943, pp. 2–3.

38. Johnson, ibid.: pp. 2–3.

39. Published in *El Tiempo*, Mexico City, no. 13, Sept. 1946.

40. The face of the philosopher-teacher is reputed to be modelled on that of Vincente Lombardo Toledano. Toledano had commissioned Orozco's first murals while he was Director of the National Preparatory School in Mexico City in 1923. During the period of the Cardenas administration, (1934–40) Toledano became a widely respected Labour leader.

41. Orozco may have had in mind the Mexican trade union leader Luís Morones, whom he had previously satirized in a biting caricature. During the early 1930s, Morones was head of the *Confederación Regional Obrera Mexicana*, an important national workers' union, from which he was dismissed for corruption.

42. Antonio Rodríguez, *A History of Mexican Mural Painting*, Thames and Hudson, London, 1969: p. 350.

43. Siqueiros also met the writer William Spratling, and Anita Brenner, Hart Crane and Eyler Simpson. During the year that he spent in Taxco, Siqueiros produced over seventy paintings, drawings and prints. Some of these were portraits of the leading members of the large American community living there. He often executed these portraits in order to relieve financial hardship.

44. The exhibition was at the Stendhal Ambassador Gallery. From 12 to 31 May, 1932 he exhibited over fifty paintings. Siqueiros also exhibited the lithographs that he had done in Taxco at the Jeke Zeitlan Bookshop.

45. In a letter that Orozco wrote to his friend Crespo de La Serna in 1931 the terms fresco painting and fresco painter had '. . . taken on a meaning of almost mystical proportion' (see Luís Cardoza y Aragón *Orozco*, UNAM, 1959: p. 286). The demand that fresco painting be taught at the school was therefore seen as a particularly progressive step.

46. The original assignment was to teach ten students a course in fresco painting using small blocks on which they could experiment with the laying on of colour.

47. David Alfaro Siqueiros, *Me llamaban el Coronelazo: Memorìas de David Alfaro Siqueiros*, Editorial Grijalbo, Mexico City, 1977: p. 305.

48. Quoted from *Script Magazine*, 2 July 1932.

49. The team included Milliard Sheets, Merrel Gage, Paul Sample, Phil Paradise, Donald Graham, Katherine McEwen, Berse Millier, Henri de Kinf, Lee Balv, Tome Beggs and Dean Corwell.

50. *California Arts and Architecture Magazine*, July, 1932: p. 2.

51. Shifra Goldman, 'Siqueiros and three early murals', *Art Journal*, Summer 1974: pp. 321–7.

52. David Alfaro Siqueiros, *Mi Respuesta*, Ediciones de Arte Público, Mexico, 1960: pp. 31–32.

53. For a reading of the conditions of this period see Walker Beau, *California: An Interpretive History*, New York, 1968.

54. See Greta Barman, *From the Lost Years: Mural Painting in New York City under the W.P.A. Federal Arts Project 1935–1943*, Garland Publishing, New York and London, 1978.

55. Siqueiros gave four talks while in Montevideo. Two were to the Fine Arts Circle, another was in the studio of the painters Bellini and Aguerre, and the fourth was delivered at the Actors' Salon of Montevideo.

56. Raquel Tibol, *Un Mexicano y su Obra*, Expresas Editoriales SA, Mexico, 1969: p. 47.

57. Siqueiros eventually admitted the accidental nature of many of his innovations in a lecture entitled 'The Historical process of Mexican mural painting' which he delivered on 10 Dec. 1947 in the Palace of Fine Arts in Mexico City. An edited version is published in *Art and Revolution*, Lawrence and Wishart, London, 1971.

58. David Alfaro Siqueiros, 'A call to the Artists of Argentina', *Critica*, Buenos Aires, 2 June 1933. Siqueiros was placed under severe restriction by the Argentine authorities for the controversies provoked by his public speeches and meetings. Botaño, sympathizing with Siqueiros' position, provided him with the commission so that the artist could at least continue working.

59. David Alfaro Siqueiros, 'What "Plastic Exercise" is and how it was done', *Critica*, Buenos Aires, 22 Nov. 1933. An English translation of the article is published in *Art and Revolution*, ibid.: pp. 38–44.

60. The paint system that Siqueiros employed in this work was one that he had not used before and did not use again. He used Keim silicate paint, developed by the German chemist Adolf Keim in 1877 in Bavaria. As a paint system, it is similar to fresco in that water-based pigments are initially glazed onto a dry concrete or cement surface of a wall. The pigments, however, are then 'fixed' through the use of a silicate spray, resulting in a chemical bonding process of the paint pigment to the silicate of the wall surface. Used correctly, the system has a lifespan of many years.

61. *Art and Revolution*, ibid.: pp. 38–41.

62. *Art and Revolution*, ibid.: pp. 42–3.

63. David Alfaro Siqueiros, 'Rivera's Counter-Revolutionary Road', *New Masses*, New York, 29 May 1934.

64. Siqueiros, 'Rivera's Counter-Revolutionary Road', ibid.

65. David Alfaro Siqueiros, 'The Art Movement in Mexico', *Kansas University Review*, Winter 1935.

66. From a typewritten manuscript in the Siqueiros Archives in Trés Picos, Mexico City. This document is almost certainly the original wording of the press release the group sent out.

67. Harold Lehman, 'For an Artists' Union Workshop', *Art Front Journal*, New York, Winter 1937.

68. The *Birth of Fascism* was the first painting in which Siqueiros used the accidental effect of pouring and superimposing lacquers and pigments. In *Collective Suicide*, Siqueiros used nitrocellulose paint and the spray gun extensively. He also incorporated dripping and pouring techniques in order to build up an extensively impastoed surface.

69. Harold Lehman, 'For an Artists Union Workshop', ibid.

70. Axel Horn (known in the 1930s as Axel Horr), 'Jackson Pollock: The Hollow and the Bump', *Carlton Miscelleny*, Summer 1966: pp. 85–6.

71. Siqueiros. Letter dated 4.6.36. to Maria Asunsola.

72. Angelica Arenal de Siqueiros, *Vida y Obra de David Alfaro Siqueiros*, Fondo de Cultura Económica, Archivo del Fondo 44–45, Mexico City, 1975: quoted pp. 47–9. Contreras was the pseudonym of the Italian Communist Victorio Vidali, leader of the Communist Party's Fifth Regiment, in which Siqueiros enlisted.

73. José Renau, 'Mi Experiencia con Siqueiros', *Revista de Bella Artes*, Mexico City, Jan. 1976.

74. *Art and Revolution*, ibid. Chapter 18 is an extract from Siqueiros' book *Como se Pinta un Mural*. This book was based on Siqueiros' experimental mural conducted in San Miguel de Allende at the end of the 1940s, where he had been invited by the Director of the School of Fine Arts to teach a course in mural painting. The book is Siqueiros' most complete treatise on the mechanics, aesthetics and methodologies of mural painting.

75. See José Renau, ibid.

76. Siqueiros' complaint of the lack of integral unity is referred to in an unpublished manuscript from the Siqueiros Archives entitled 'Auto-Critical Thesis on the Work Executed by the International Team of Plastic Arts in the Social Building of the Syndicate of Electrical Workers', Tres Picos, Mexico City.

77. It was while painting the complex right-hand corner that Renau had his first argument with Siqueiros, when Siqueiros altered without discussion the clouds and smoke in order to give them greater form. Renau recalled that he considered the changes crude and also considered resigning from the project.

78. Although Siqueiros was undoubtedly the overall director of this project, and although he was responsible for the conceptual basis of the mural and the painting of many of the most significant passages, he was absent on numerous occasions during the work's process. His absence largely resulted from his involvement in the planning and execution of the attack on Trotsky's headquarters in Mexico City in May 1940. The group that carried out the attack included Siqueiros and two of the other painters involved in the mural: Antonio Pujol and his brother-in-law, Luś Arenal. In the attack, led by Siqueiros on 24 May 1940, machine guns were fired into Trotsky's bedroom, narrowly missing both Trotsky and his wife. In their escape from the house, Siqueiros and his team took with them a young American, Sheldon Harte, one of Trotsky's assistants and bodyguards. Harte was subsequently found murdered, his body buried in a lime pit in the grounds of a house in Santa Rosa, some 25 kilometres outside Mexico City, which had been rented by Siqueiros' wife as part of the plot to attack Trotsky. The identity of his murderer has never been discovered. Following the attack Siqueiros went into hiding from the police. The nearly finished mural was finally completed by José Renau. Siqueiros was eventually apprehended by the Mexican police, and as a result of his involvement in the Trotsky affair he was sent into exile in Chile.

CHAPTER SIX

1. Daniel Cosío Villegas, *A Compact History of Mexico*, El Colegio de Mexico, 1975: ch. 6.

2. A good example of what were seen as such dogmas were the many publications by Siqueiros during the 1940s and 1950s. In his public lecture of 1954 at the Palace of Fine Arts, for example, Siqueiros spoke forcefully of how a popular regime in Mexico would 'foster the development of a Mexican Art for Mexico'. In his earlier publication, *No Hay Más Ruta Que La Nuestra* (*Ours is the only way*), published in 1945, Siqueiros had written about Mexican muralism in such a way as to deny the validity of other possibilities and practices. These attitudes were seen by people such as José Luis Cuevas (b. 1934) as inhibiting the further development of contemporary Mexican culture.

3. Perhaps the leading opponent of the muralists was the artist José Luis Cuevas, who in 1959 wrote an article entitled 'The Cactus and the Curtain: An Open Letter on Conformity in Mexican Art' (*EverGreen Review*, no. 7, 1959). The article argued strongly for the need to move away from introspective nationalist dogmas and to open up Mexican art to a much greater and wider set of international influences.

4. The Gabino Ortíz Library was a former chapel converted into a library. The outgoing President Lázaro Cárdenas created this library with a personal gift as a way of commemorating his birthplace.

5. Justinio Fernández, 'Orozco: El Pintor de Nuestro Tiempo', *Anales del Instituto de Investigáciones Estéticas (Mexico)*, Universidad Nacional Autónoma de México, 1948: p. 38.

6. Bernard Myers, *Mexican Painting in Our Time*, Oxford University Press, 1956: p. 165.

7. José Clemente Orozco, *Sexta Exposición de Obras Recientes: Estudios y Bocetas de los Murales*, exh. cat., El Colegio Nacional de México, 1947–8.

8. From photographs it is difficult to detect the three-dimensional elements within this work. The first and most obvious is the magnificent, ornately decorated colonial doorway situated at the centre of the mural. Orozco successfully combined this with an intricate spiralling complex of forms running up and along the left side and top of the doorway. He employed other three-dimensional elements in this work in the form of metal pieces, indentations on the surface and the use of rough textures. Although Orozco had not employed this approach before, he had nevertheless produced marvellous integrations of pictorial composition in relation to architecture in previous works. A particularly good example of this is the enormous *Hidalgo* mural on the main staircase of the Governor's Palace in Guadalajara, where, by slightly twisting and spiralling the body of Hidalgo within the arched and curving ceiling, he created a pictorial dynamic that contributes much to the force and power of the image. Again, this aspect of the mural is not visible in photographs.

9. Benito Juárez was a pure Zapotec Indian, the first Indian president of Mexico. As Minister of Justice in the liberal governments of Juan Alvárez and then Ignacio Comonfort, he legislated the abolition of clerical and military privileges. In 1861, he became President of Mexico. In 1864, the military action of the French led to his regime's overthrow and the establishment of a Mexican monarchy with the rule of the Austrian Maximilian. In 1867, Juárez and his republican forces successfully overthrew the regime of Maximilian. Juárez again took power and ruled Mexico as a constitutional democratic and liberal president until 1872, achieving what others had not, namely breaking the economic and political power of the Catholic church in Mexico. His successful overthrow of the French-backed regime of Maximilian established him as a symbol, not only of reform but also of Mexican national independence. The Liberal Constitution of 1857, which he helped to define, established basic rights for the first time in Mexico, such as the right to vote, equality under the law, and the state's responsibility for public education.

10. The chapel was the former church of the colonial hospital of Jesús Nazareno, founded by Cortéz in the sixteenth century.

11. Orozco was originally commissioned to undertake these murals by Lázaro Cárdenas shortly before his term of office ended in 1940. However, in the intervening period he had gone to New York where he had been invited to paint a special work for the Museum of Modern Art. The fresco he did for the museum was the six-panel work of *Dive Bomber and Tank*. The creation of this mural had been planned to coincide with the museum's huge *Twenty Centuries of Mexican Art* exhibition. Orozco painted the frescoes in the museum in full view of the public while the exhibition was on.

12. ¡Orozco!, exh. cat., ed. David Elliott, Museum of Modern Art, Oxford, UK, 1980: p. 99.

13. Quoted in ¡Orozco!, ibid.: p. 100.

14. During the autumn of 1938, Trotsky and his wife were living in the house of Diego Rivera. It was at this time that the journal *Partisan Review* published the manifesto entitled 'Manifesto: For a Free Revolutionary Art'. It was signed by André Breton and Diego Rivera, but its text was Trotsky's. Although Rivera was publicly connected to Trotsky at this time, differences between the two had begun to emerge and eventually their personal and political relationship soured. In April 1939 Trotsky and his wife moved out of the house and in 1940, shortly before he was assassinated Trotsky became so disillusioned with Rivera that he refused to see him again. Rivera finally turned his back on Trotskyite politics, and in 1954 rejoined the Mexican Communist Party. In 1953 Rivera wrote an article in the review *Indice* entitled 'The Question of Art in Mexico', in which he directly linked his support of Trotsky's politics to a degeneration in the standard of his art.

15. Although not technically murals in the sense of works painted directly on to wall surfaces, one can include among his mural work the four fresco panels that he undertook for the Pani family in 1936.

16. The mural is now located in the San Francisco City College. The commission arose from the efforts of Timothy Pflueger, who had been responsible for arranging Rivera's earlier commission at the Luncheon Club of the city's stock exchange. Pflueger invited Rivera to paint moveable frescoes in the open on the theme of 'Art in Action' during the Golden Gate Exhibition.

17. While this tendency was generally the rule, there were some significant exceptions. Among these were the two mural-sized canvases, *Nightmare of War and the Dream of*

Peace and *Glorious Victory*. The first was commissioned by the Instituto Nacional de Bellas Artes for the large travelling exhibition *Mexican Art from pre-Columbian times to the present* in February 1952, and was painted during the Korean war as a fierce denunciation of Western powers. When it was completed, Carlos Chávez, Director of the Instituto Nacional de Bellas Artes, refused to have it exhibited because of what he regarded as the serious criticisms it contained of governments with which Mexico had friendly relations. With the assistance of the French Communist Party, the painting was publicly exhibited in Paris. In the autumn of 1953 Rivera sent the painting to China. It is no longer known if the painting still exists. The second major political public work of the period is the painting *Glorious Victory*. Rivera painted this in 1954, shortly after his re-admission to the Mexican Communist Party. The work directly denounced the overthrow of the leftist government of Arbenz Gúzman in Guatemala in 1953. The painting was last known to be in Poland, but its existence, too, is no longer verifiable.

18. Betty Ann Brown, *The Past Idealized. Rivera; A Retrospective*, Founders Society, Detroit & Norton and Norton, 1986: p. 154, note 28.
19. Wolfe, *The Fabulous Life of Diego Rivera*, ibid.: p. 264.
20. Shifra Goldman, 'Mexican muralism: Its Social Educative Roles in Latin American and the United States', *Aztlan*, 13, 1–2, 1982: pp. 111–33.
21. On 19 Sept. 1985, Mexico City was struck by one of the most powerful earthquakes of the century. The Hotel del Prado was severely damaged but fortunately, Rivera's mural was relatively unscathed. Fifteen months later, on 14 Dec. 1986, the mural was removed from the hotel and taken to the other side of the park, where a new building had been specially designed and constructed to house it.
22. The Alameda Park was often the site of executions by the Spanish Inquisition. For a while the headquarters of the Inquisition were housed nearby in the Ex-Aduano de Santo Domingo in the Avenida Brazil, which is now part of the Ministry of Public Education.
23. General Scott's invading army entered Mexico City on 14 Sept. 1847 as part of the War of the 1840s, when Mexico fought America over the absorption of the state of Texas into the union. Following this war, Mexico lost huge tracts of its territory to the United States. On 2 Feb. 1848, Mexico signed the infamous Treaty of Guadalupe, under which it surrendered the states of Texas, New Mexico and California, more than half of its national territory, to the USA in return for a mere 15 million dollars.
24. Following the controversy, Torrez Rivas, owner of the Hotel del Prado, had the mural covered with a moveable screen. Only after eight years had elapsed was the mural uncovered and displayed again in the hotel's lobby.
25. According to Rivera, Cantinflas always wore the emblem of the Virgin in real life.
26. The Hospital de la Raza is one of the leading hospitals in Mexico City. It was completed in 1953; its aim was to provide the best and most up-to-date free medical treatment.
27. Tlazoltéotl was also the mistress of lust and debauchery, and her image was taken directly from the Codex Borbónicus. Rivera represented the goddess on the lower right-hand side of the mural. Known also as the goddess of childbirth, the squatting sculpture seen with a child emerging from between her legs represents the moment of birth.
28. For a detailed description of the symbolism of each scene, see Betty Ann Brown, 'The Past Idealized: Diego Rivera's Use of Pre-Columbian Imagery', *Diego Rivera: A Retrospective*, exh. cat., Founders Society Detroit Institute of Arts and Norton and Norton, 1986: pp. 139–55.
29. Contrary to the advice given to Rivera by the Taller de Ensayo of the Mexico City Polytechnic Institute, Rivera painted the walls and floor area of the basin in polystyrene paint. When the water works were put into operation, the paint below and just above the waterline rapidly deteriorated, to the extent that today it is no longer visible. However, plans are in progress to restore the work.
30. A leading exponent of this thesis is the writer and critic Carlos Monsiváis. In his article 'Notas sobre la cultura popular en México', *Latin American Perspectives*, no. 16, Winter, 1978, he showed how popular culture in Mexico had been absorbed and manipulated by modern commercial culture. He once said that Robin and Batman have replaced Hidalgo and Morelos.

CHAPTER SEVEN

1. David Alfaro Siqueiros, *Me llamaban el Coronelazo: Memorias de David Alfaro Siqueiros*, Editorial Grijalbo, Mexico, 1977: p. 405.
2. Galvarino is pictured by Siqueiros with amputated arms. This mutilation was carried out on the orders of the infamous Doña Inés de Suárez, who was responsible for the massacre of thousands of Chilean Indians during the colonialization of Chile by the Spanish.
3. Siqueiros, *Me llamaban el Coronelazo*, ibid.: p. 339.
4. Paradoxically, Siqueiros saw this mural in opposite terms. He wrote that it 'belongs more to my penultimate period and does not provide a logical continuation of the political painting being done in Mexico today, such as our mural in the Electricians Syndicate. However, it is perhaps more important in some ways, its style is more homogenous, and the movement has been resolved more satisfactorily, because the room is larger, and I have been able to understand its geometry more satisfactorily.' (letter to José Renau published in David A. Siqueiros, *Art and Revolution*, Lawrence and Wishart, London, 1975: p. 195).
5. After a somewhat abortive start, Siqueiros was eventually sent two young Chilean painters as assistants, Erwin Werner and Alipio Jaramillo. These two became his chief helpers, although others worked on the mural. These included Luís Vargas Rosas, Laureano Guevara, Camilo Mori, Gregoria de la Fuente and the photographer, Antonio Quintana. Siqueiros regarded Werner, who was also a mathematician, as particularly helpful. According to Siqueiros, Werner provided the precise mathematical formulations to measure the extent to which shapes would change when seen from different directions and different distances.
6. Siqueiros, *Me llamaban el Coronelazo*, ibid.: p. 399.
7. Impasto is a technique in which the artist loads the brush with large quantities of pigment. If such pigment is then layered onto a previously applied, but not quite dry paint surface, a very expressive textured surface can be created in which elements of the colour on the surfaces below can still be seen through the top surface.
8. Raquel Tibol, *David Alfaro Siqueiros en la Integración Plástica*, Cuadernos 20, Instituto Nacional de Bellas Artes, Mexico, 1950: p. 12.
9. Lincoln Kirsten, *El Mercurio*, Santiago de Chile, 4 Feb. 1942.
10. In 1943 Siqueiros produced a manifesto entitled 'War Time, War Art' (published in *Forma*, Chile, Jan.–Feb. 1943). In it he called on artists in the Americas to join the war effort, writing 'the war needs your creativity, and the incomparable eloquence of which you are capable'.
11. Evidently encouraged by Kirsten's glowing praise of his Chillán mural, Siqueiros entered into correspondence with him concerning this mural proposal. He proposed that the mural 'would be executed with the collaboration of radical North American and Latin American artists in New York, which would give a feeling of indisputable intellectual continental unity. We could be almost sure to obtain the representation of painters from all the Latin American countries.' (Letter to Lincoln Kirsten, 4 Dec. 1942, Siqueiros archives).
12. According to FBI document no. 64-30854-7, Siqueiros had originally been granted a visa to enter the USA while he was still in Chile. However, the State Department later instructed the American Embassy in Havana to rescind this permission based on the law promulgated in 1941 preventing entry into the USA by members of the Communist Party. According to two other FBI files, nos. 100-1403-76 and 100-1403-721, Siqueiros attempted to enter the USA twice at this time using a false passport under the name of Miguel S. Garido González.
13. FBI files on Siqueiros state very clearly that through the auspices of the State Department, the Rockefeller coordinating committee obtained a grant of $2500 for Siqueiros to paint not an anti-fascist mural but a picture of José Martín and Abraham Lincoln. The file (no. 64-03854-1) also states that Siqueiros received $1750 as an advance and on completion of the work in November 1943 received the balance.

It would seem that Siqueiros' proposal to carry out a mural project in New York had been accepted in principle by the Museum of Modern Art, for it is unlikely otherwise the Rockefeller Foundation would have made the offer they did. Although no mural like the one Siqueiros had proposed to Kirsten was ever executed, Siqueiros' claim that

he refused anything to do with the offer is contradicted by the clear statements in the FBI documents.

14. The other two works that Siqueiros appears to have painted while in Cuba are *Dos Montaños de América*, and *El Nuevo Día de Las Democracias*. The first contained the portraits of José Martín and Lincoln, and seems to be the work referred to in the files of the FBI as having been financed by the Rockefeller Foundation (see preceding note 13).

15. Siqueiros, *Me llamaban el Coronelazo*, ibid.: p. 423.

16. Siqueiros' return to Mexico in 1944 was largely arranged by his brother Jesús, who obtained an undertaking from the Mexican government that Siqueiros would not be re-arrested should he return.

17. Siqueiros established the headquarters of his Centre for Realist Art at the large residence of his mother-in-law at Señora no. 9, Mexico City.

18. Throughout his life, Siqueiros formed many groups or organizations as vehicles through which he could channel his ideas. How effective such organizations were is debatable, but Siqueiros saw them as integral to the development of his political aesthetic. In an article written in 1944, entitled 'The Balance of the Plastic Arts in 1944', Siqueiros considered that the perceived success of his campaign to recuperate the lost values of Mexican art arose almost entirely out of the creation of the Centre ('Balance de las Artes Plásticas durante 1944', text from an article in the Siqueiros archives, file no. 00787–00789).

19. The mural was inaugurated on 7 June 1944 by Lombardo Toledano, then Director of the Confederation of Latin American Workers.

20. From a letter to Señora Gorostiza, dated 16 June 1963. This letter was written while Siqueiros was in prison serving his sentence for the Mexican crime of social dissolution. The bulk of the letter concerns his plea to the Director General of the National Institute of Fine Arts that the mural be saved and relocated somewhere else. The new owner of the house in which the mural was originally painted wanted it destroyed (letter from the Siqueiros archives).

21. Sadly the mural is no longer the intriguingly architectonic work that it once was. In 1963, while Siqueiros was in prison, the new owner of Señora no. 9 in which the mural had been painted threatened to destroy the work, as part of the refurbishment of the house. Following a campaign by Siqueiros and fellow supporters, the mural was taken down, and reconstructed in a special site in the Tecpan building in Tlatteloco in Mexico City. Although the reconstruction still retains some of the original work's concavity, the staircase of the original site could not be reconstructed. This area of the mural was thus redesigned to accommodate the flat surface. Siqueiros repainted this section of the work on his release from prison in 1963.

22. Antonio Rodríguez, *A History of Mexican Mural Painting*, London, Thames and Hudson, 1969: p. 282.

23. From a paper entitled 'Textos para la película sobre David Alfaro Siqueiros', 25 Oct. 1967, copy from the Siqueiros archives, Tres Picos, Mexico City.

24. Interview with Siqueiros published in *El Tiempo*, Mexico City, 31 Aug. 1951.

25. 'Alfaro Siqueiros y El Apoteosis de Cuauhtemoc', *El Popular*, Mexico City, 28 May 1951.

26. The origins of the commission for this mural have a considerable bearing on the theme that Siqueiros employed. Jaime Torres Bodet, Secretary of State for Public Education, approached Siqueiros with the idea that he paint a major mural to celebrate the struggle against Nazism, since the war was beginning to draw to a close. In commissioning the work, Bodet intended the mural to be part of the massive exhibition being put on in the Palace of Fine Arts on the theme of 'The Drama of the War in Mexican Painting', an exhibition which Siqueiros himself helped to organize. Besides the *New Democracy* panel, Siqueiros also included two smaller panels on either side, entitled *Victims of War* and *Victims of Fascism*.

The contract for this commission was dated 20 Aug. 1944 and was signed by Jaime Torres Bodet, Fernando Castillo for the Department of Law, Manuel Gill, Director General of Administration, Alvaro Olmeda, Head of the Department of Building Conservation, and Siqueiros.

The original contract for the mural stipulated that the work was to be 4 metres high and 12 metres long. It was to be painted with pyroxaline on masonite panels and the work had to be completed by 20 Nov. 1944.

A document in the Siqueiros archives entitled 'Memorandum relativo al mural de Siqueiros', details how the fee for the commission of 21,300 pesos was to be divided up: 3,000 pesos was for paint materials; 1,500 pesos for the preparation of the panel; 10,500 pesos for Siqueiros' personal fee; 5,250 pesos for his chief assistant; and 1,050 pesos for an extra assistant.

Siqueiros actually completed the work before the due date, signing the official handing-over document on 17 Nov. 1944. The document was signed by Siqueiros, Roberto Montenegro, and Christobel Zamorra for the Minister of Education and Secretary of Aesthetic Education.

27. Like many of Siqueiros' mural images, this was developed from photographic sources. In this case the source was a series of photographs taken of his wife, Angelica, posing as the model for the figure.

28. The impastoed surface of this work is in some areas between two and three centimetres thick. Siqueiros used the pyroxaline paint system in this work, mixed with nitro-cellulose, colour and cement, which, as the writer Hercules Quinones wrote, gave the mural 'the consistency of stone applied with a spatula' (from an article entitled 'Vida y Muerta' [Life and Death], published in *Hoy*, undated copy from the Siqueiros archives, Tres Picos, Mexico City).

29. A particularly striking example is *Our Present Image* (1947; pyroxaline on masonite, 87 by 68″, Museum of Modern Art, Mexico City).

30. Siqueiros signed the contract for this mural on 23 Nov. 1944. In it he agreed to complete the work in eight months (copy of contract details from the Siqueiros archives, Tres Picos, Mexico City).

31. Letter from Siqueiros to Jorge Encisco, Director of National Monuments, dated 11 Sept. 1944, Siqueiros archives, Tres Picos, Mexico City.

32. Siqueiros also covered the under-surfaces of the stairwell with celotex, as he incorporated these areas into his overall design. In a letter, dated 11 Dec. 1944, Encisco wrote to Siqueiros saying that since the ceiling area of the site was technically not an adequate surface on which to paint, his committee had unanimously agreed to Siqueiros' request in a letter dated 20 Sept., three months earlier, that a separate covering be applied, on condition that the new covering conformed to the style of the original architecture.

33. The original contract (copy from Siqueiros archives) stated that the theme for the mural was to be the Mexican revolution, and that the work should express the historic struggle of the Mexican people for the liberty of expression. The contract stated that the rationale for this theme was that the old customs house was to be designated as the site of a new museum of the revolution and therefore required a mural of appropriate theme. The contract also states that since the building was also once the headquarters of the Spanish Inquisition in Mexico, Siqueiros should undertake a theme concerning the liberty of expression.

34. Rodríguez, ibid.: p. 384.

35. One of the most striking of these images is that of the female figure, for which his wife Angelica was the model. Angelica's portrait was used by Siqueiros in his Chillán mural and, most powerfully of all, in *New Democracy*. Siqueiros seems to have used her face to symbolize the idea of heroic revolutionary militancy in a spirit that recalls Delacroix's painting *Liberty Guiding the People* (1831; Musée du Louvre, Paris).

36. Letter from Siqueiros to Jorge Encisco dated 20 Sept. 1944, copy in the Siqueiros archives, Tres Picos, Mexico City.

37. In a letter of 20 Mar. 1949 (copy in the Siqueiros archives), Siqueiros wrote to Carlos Chávez, Director General of the National Institute of Fine Arts, concerning the problems that had stopped work on the project. Among these he cited the 40% devaluation of the Mexican peso since the signing of the contract; as a consequence, many of the materials he needed for the project, which could only be bought from the USA, had drastically increased in price. On 19 May 1949 Chávez wrote to Siqueiros approving an increase of 30% in the finance for the project, and requesting that Siqueiros resume work on the project (copy letter in the Siqueiros archives). Siqueiros' extension of his original concept involved painting the surfaces of the walls underneath the main stairwell. A re-negotiated contract to allow for the extension was signed on 5 Apr. 1948 (contract copy in the Siqueiros archives). As late as Nov. 1970,

the Mexican newspaper *Novedades* ran a story entitled 'Siqueiros will conclude his mural "Patriots and Parricides" in the S.E.P.' (11 Nov. 1970) – some twenty-one years after Siqueiros originally agreed in a letter to Jorge Encisco (letter dated 11 Sept. 1949) that the work would be completed eight months after the signing of the contract.

38. In 1955 more than 300 of those who worked in the building's offices presented an official protest to the Treasury department of the Federal District, complaining about what they saw as the waste of money on the mural, particularly when the building itself was in urgent need of repair. In an interview conducted in Oct. 1978 with Arnold Belkin, who was one of the assistants on the project, Belkin confirmed the mass of complaints from those working in the building about having to climb through endless scaffolding and of having to step around all the equipment and paint that Siqueiros purchased for the project.

39. Quote from an article entitled 'Bureaucrats attack Alfaro Siqueiros', *Ultimas Noticias*, Mexico City, 19 Feb. 1955.

40. In a document dated 2 May 1951 entitled 'Puntos Para la Ejecución de una Pintura Mural en El Edificio al Interno del Instituto Politécnico Nacional' (Points for the execution of a mural in the interior of the Polytechnic Institute Building), Siqueiros pointed out that the mural was not to be painted directly on to one of the wall surfaces of the building because the building was to undergo substantial modifications (document from the Siqueiros archives). The contract for the mural was for 90,000 pesos, out of which Siqueiros was expected to pay for himself, his five assistants and all the materials required. The contract also contained terms that stipulated that the mural be painted during the month of May and the first 15 days of June, by which time it was to have been completed.

41. Antonio Rodríguez, 'New Mural by Siqueiros in the Polytechnic Institute', *El Nacional*, 20 Feb. 1952.

42. Quote from A. G. Magil, 'Man the Master, not the Slave of Technology', *Telepress*, 7 Feb. 1972. According to the contract, the theme of the work was 'Allegory of Industrialization in Mexico – Song to Technology – Homage to the Forceful Impulse of President Alemán'. The dimensions of the mural are 15.4 metres long by 3.5 metres high. The mural was inaugurated by President Alemán on 5 Feb. 1952.

43. When Siqueiros signed the contract for this project the hospital was still in the process of construction. It formed part of a massive building programme of new Social Security hospitals and clinics undertaken at the time by the Mexican government.

44. The reconstructed surface was made out of special wooden frames over which an impermeable material was stretched. These frames were attached to the walls and ceilings by means of brackets. The surface of the plastic material was then coated wth gypsum before being painted with the pyroxaline paint system Siqueiros used for the project (from a document in the Siqueiros archives detailing technical and material matters concerning the project).

45. 'Canto a la Vida a la Salud' (document dated 1955 in the Siqueiros archive, Tres Picos, Mexico City).

46. Published by Ediciones Taller Siqueiros, Cuernavaca, 1951. In 1948 Siqueiros was invited to go to San Miguel de Allende to teach a course in mural painting at the town's School of Fine Arts. The school had been designated by the American State Department as a suitable place for American GIs to receive art training. The school was consequently filled largely by American students, whose fees were guaranteed by the American State Department. The experimental mural that Siqueiros executed while he was there was based on the theme of the Ignacio Allende, one of the heroes of Mexico's independence wars, and was never completed. However, the work forms the basis of Siqueiros' seminal treatise on mural painting, *Como se Pinta un Mural*. The premature ending of the mural project in June 1949 was in part due to the pressure exerted by the American State Department on the director of the school. Siqueiros was known to the Americans as an active communist, and was being closely monitored by American intelligence agencies at the time. FBI files on Siqueiros indicate that some of the students, in particular Philip Stein, who went on to assist Siqueiros in several of his later murals, were questioned about their time at the school and in particular what they knew of Siqueiros.

47. The mural was inaugurated on 18 Mar. 1955. Altogether the work had cost 175,000 pesos, of which 55,000 pesos had been material expenses (copy of contract and the project's financial records in Siqueiros archives). To complete the work, Siqueiros had used 300 kilos of pigment and 60 gallons of pyroxaline primer. Siqueiros' team of assistants on this project included Félipe Estono, Armando Cormona, Guillermo Rodríguez, Fanciso Luno and Epitacio Mendiza.

48. Elvira Vargas, 'La Pictórica Integral de Siqueiros', *Novedades: Mexico En La Cultura*, 16 May 1954.

49. David Alfaro Siqueiros, *Hacia Una Nueva Plástica*, Espacios no. 1, Mexico City, Sept. 1948.

50. See *Projecto de Coordinación de la Pintura y la Escultura con la Arquitectura en la Construcción de la Cuidad Universitario de Mexico*, Cuadernos de Arquitectura no. 20, Mexico City, Sept. 1948: p. 15.

51. David Alfaro Siqueiros, letter to Carlos Lazo of 20 Feb. 1951 (copy in the Siqueiros archives, Tres Picos, Mexico City).

52. The most notable of the external murals created on the campus are those by Carlos Chávez Morado, Juan O'Gorman, who was responsible for the magnificent mosaic on the University library, and Enrique Eppens.

53. Siqueiros devised this commission by creating three teams of artists. The teams were led by Frederico Canesi, Luís Arenal, and Germán Cueto. Siqueiros was in overall charge. The budgeted cost of the U.N.A.M. project was 600,000 pesos, of which half were assigned for the payment of wages and the rest for materials. 101,890 pesos was spent on the mosaic tiles. (Receipts dated 27 Apr. 1954, copies in the Siqueiros archives, Tres Picos, Mexico City.)

54. David Alfaro Siqueiros, 'Mi Experiencia en el Muralismo Exterior', *Excelsior*, supplement *Diorama de la Cultura*, Mexico City, 25 Mar. 1956.

55. Siqueiros, 'Mi Experiencia . . .', ibid.

56. The contract for the mural was signed in August 1957. Its projected cost was 2,000 pesos per square metre (the mural measured 420 square metres). The mural was jointly commissioned by Dr. Eusebio Dávalas Huertado, the Director of the National Institute of Anthropology and History, and Antonio Arriaga, Director of the National Museum of History in Chapultepec Castle.

57. Siqueiros had a specialist historical advisor to this project, the distinguished Mexican historian Nicolás T. Bernal.

58. Siqueiros was assisted by a large team of assistants which included Philip Stein, Epitacio Mendoza, Mario Orozco Rivera, Sixto Santillan, Roberto Díaz de Acosta, E. Batista, Guillermo Cinceros and Electa Arenal (Siqueiros' niece).

59. Lopez Mateos had once been a 'barefoot' socialist, and his record of settling disputes as Minister of Labour under the previous administration had initially given workers reason to trust him when he was made President. The residue of this trust was such that in the aftermath of Mateos' election to the presidency, many of the country's labour unions agreed to call off further demonstrations in the belief that he would accede to their demands. As events subsequently proved, the trust was misplaced.

60. The photograph from which this image was developed was of dead revolutionaries taken in Nochistlan, Zacatecas, in 1913. It was significant for Siqueiros, because the front figure is that of Leopoldo Arenal Banuet, his father-in-law. Among the many figures of the Mexican revolution that Siqueiros portrayed in this passage of the mural, which extends from the left-hand inner panel and onto the main wall of the mural, are those of Madero, Serdan, Coss, Carranza, Montaño, Zapata, Obregón, Calles, Villa, Blanco and Alveredo. The two women featured are Marguerita and Rosaura Ortega, leading members of the Mexican Liberal Party. The ideological precursors of the revolution are portrayed on the left-hand section of the long central wall and feature the figures of Marx, Bakunin and Proudhon, whom Siqueiros included as the ideological predecessors of the Mexican revolution. Further along he portrayed the figures of Flores Magón, the founder of the Mexican Liberal Party, and the journalists and artists who supported the revolution such as Posada, Filomeno Mata, Carreon, and Santiago Rojo de la Vega.

61. Díaz is pictured with his foot on the 1857 Liberal Constitution, symbolizing the betrayal of this great step forward in nineteenth-century Mexican politics. At Díaz' side are Victoriano Huerta and Yves Limantour, the leader of the notorious *Científicos*.

62. See chapter 1.

63. Siqueiros became deeply involved at this time in the support of railroad workers

arrested during their nationwide strikes. He joined the National Action Committee for the Liberty of Political Prisoners and Defence of Constitutional Liberties. Together with the radical journalist Filomena Mata, he edited the committee's bi-monthly journal *Liberación*. His identification with the railroad workers' struggles in large part forms the basis of his expressive imagery in the mural.

64. The mural was commissioned by the National Actors' Association in October 1958. The theme was stipulated as *The History of Theatre up to Contemporary Cinema*. The contractual arrangements were that Siqueiros should start work no later than 1 January 1959. The work was to be completed in four months, by 30 April. The value of the contract was 80,000 pesos. (Copy of contract in the Siqueiros archives, Tres Picos, Mexico City.)

65. David Alfaro Siqueiros, *History of a Plot. Who are the Traitors?* A tract privately published by Siqueiros in 1960, p. 39 (copy in the Siqueiros archives). Siqueiros was legally prevented from further work on the mural. As a consequence no more work was done for nearly ten years. The legal action was eventually shelved when new leaders took over the actors' union directorate. In 1967 a new contract was drawn up and signed by Siqueiros and Fernández Reyes, in order to allow for the completion of the work. Although far from complete, and with large areas of the mural not fully resolved, the mural was nevertheless inaugurated in December 1969 by the Under Secretary for Culture at the Ministry of Education, Mauricio Magdaleno. In 1968 the mural was attacked with acid and badly damaged by a group of right-wing students, and in 1969 Siqueiros halted work on his last major project, at the Polyforum, in order to restore the damage, free of charge. During the serious earthquake in Mexico in 1985, the Jorge Negrete Theatre sustained major structural damage. In order to repair the building the mural was dismantled.

66. In 1985 the whole Centro Médico complex was rendered unusable as a result of the massive earthquake that hit Mexico City. The cancer department was particularly badly hit, and the site in which this mural was located sustained severe and irreparable damage. The mural, which was fortunately applied to a separate wall surface, was detached from the walls and awaits reconstruction in another suitable location.

67. Leonard Folgarait, *So Far From Heaven. David Alfaro Siqueros', 'The March of Humanity' and Mexican Revolutionary Politics*, Cambridge University Press, 1987.

68. The law against the crime of social dissolution was enacted in 1941, originally as a means of countering Nazi and Fascist subversion during the war. Although the law had been on the statute books for twenty years, no government had ever tried to use it until Siqueiros and others were arrested. Its provisions were all-encompassing. Any person could be charged for committing any activity which could be construed as havng tended to '. . . produce rebellion, sedition, riot and insurrection . . . hinder the functioning of the Republic's institutions, or promote disrespect on the part of Mexican citizens for their civil duties, subvert the institutional life of the country, or realize acts of provocation with the aim of disturbing the public order or peace'. The charge carried a maximum sentence of 12 years, and bail could not be granted. Siqueiros was arrested on 9 Aug. 1960, following days of radical street demonstrations by students and teachers in Mexico City. Gaoled in Lecumberri, Siqueiros was not brought before a court until March 1962, some eighteen months after his original arrest. At the trial, he and his colleague, the journalist Filomena Mata, were sentenced to eight years in prison. The sentence was largely due to Siqueiros' and Mata's activities in support of jailed and arrested railroad workers during the 1959 railroad strikes that overwhelmed the country, and for their very public work on the defence committees for the protection of the human rights of political prisoners. Siqueiros was finally released in 1964 by Presidential order. He was then 68 years old.

69. In the Mexican newspaper *Heraldo* of 12 Sept. 1969, Suárez reported that the cost of the project was some 32 million pesos, and that to complete the work would require another 3 million.

70. Quote taken from *Polyforum Cultural Siqueiros*, a publicity booklet from the Polyforum.

71. Rodríguez, ibid.: p. 410.

BIBLIOGRAPHY

General Sources

Brenner, Anita, *Idols Behind Altars*, New York: Payson and Clarke, 1929
Cardoza y Aragón, Luis, *Mexico, Active Painting*, Mexico: Ediciones Era, 1961
Charlot, Jean, *The Mexican Mural Renaissance*, New York: Hacker Books, 1962
Fernández, Justino, *A Guide to Mexican Art*, Chicago: University of Chicago Press, 1966
Helm, McKinley, *Modern Mexican Painters*, New York: Dover Publications, 1974
Hurlbert, Laurence, *The Mexican Muralists in the United States*, Albuquerque: University of New Mexico Press, 1989
Myers, Bernard, *Mexican Painting in our Time*, New York: Oxford University Press, 1956
Reed, Alma, *The Mexican Muralists*, New York: Crown Publishers, 1960
Rodríguez, Antonio, *A History of Mexican Mural Painting*, London: Thames & Hudson, 1969
Smeckebier, Lawrence, *Modern Mexican Art*, Minneapolis: University of Minneapolis, 1939
La Pintura Mural de la Revolucion Mexicana, Mexico: Fondo Editorial de la Plastica Mexicana, 1975

Diego Rivera

BOOKS

Abbott, Jere, *The Frescoes of Diego Rivera*, New York: Plandome, 1933
Arquin, Florence, *Diego Rivera: The Shaping of an Artist, 1889-1921*, Norman: University of Oklahoma Press, 1971
Edwards, Emily, *The Frescoes of Diego Rivera in Cuernavaca*, Mexico City: Editorial Cultura, 1932
Evans, Ernestine, *The Frescoes of Diego Rivera*, New York: Harcourt Brace, 1929
Fernández, Justino, *Diego Rivera: Artist of the New World*, Mexico City: Editorial Fischgrund, undated?
Gual, Enrique F., *Fifty Years of the Work of Diego Rivera: Oils and Watercolours, 1900-1950*, Mexico City: Editorial Fischgrund, 1950
March, Gladys, *Diego Rivera: My Life, My Art*, New York: The Citadel Press, 1960
Page, Addison Franklin, *The Detroit Frescoes by Diego Rivera*, Detroit: The Detroit Institute of Arts, 1956
Peña, Alfredo Cardona, *Conversaciones con Diego Rivera*, Mexico, Editorial Diana S.A., 1986
Pierrot, George F. and Edgar P. Richardson, *An Illustrated Guide to the Diego Rivera Frescoes*, Detroit: The Detroit Institute of Arts, 1934. Previously published as *The Diego Rivera Frescoes: A Guide to the Murals of the Garden Court*, Detroit: Peoples Museum Association, 1933

Puccinelli, Dorothy, *Diego Rivera: The Story of His Mural at the 1940 Golden Gate Exposition*, San Francisco, 1940
Ramos, Samuel, *Diego Rivera Watercolours (1935-1945)*, New York and London: The Studio Publications, 1949
Rangel, Raphael Lopez, *Diego Rivera y La Arquitectura Mexicana*, Secretaría de Educación, Mexico, 1986
Rayero, Manuel (ed.) *Diego Rivera*, Mexico City: Fundación Cultura Televisa A.C., 1983
Rochfort, Desmond, *The Murals of Diego Rivera*, London: Journeyman Press, 1987
Silva, E., and R. S., *Mexican History: Diego Rivera's Frescoes in the National Palace and Elsewhere in Mexico City*, Mexico City: Secretaría de Educación Pública, 1963
Wolfe, Bertram D., *Diego Rivera: His Life, His Times*, New York and London: Alfred A. Knopf, 1939
Diego Rivera, Washington D.C.: Pan-American Union, 1947
The Fabulous Life of Diego Rivera, New York: Stein & Day, 1963

CATALOGUES

Arte y Política Diego Rivera, Mexico, Editorial Grijalbo, 1978
Diego Rivera, Exposicion Nacional de Hommanaje a Diego Rivera, Mexico: I.N.B.A., 1978
Diego Rivera Hoy. Simposio Sobre el Artista en el Centenario de su Natalicio, Mexico: I.N.B.A., September 1986
Diego Rivera: A Retrospective, Founders Society, Detroit Institute of Arts. New York and London: W. W. Norton & Co., 1986
The Rouge. Images of Industry in the Art of Charles Sheeler and Diego Rivera, Detroit Institute of Arts, 1978

THESES AND DISSERTATIONS

Favela, Ramón, '*Rivera Cubista: A Critical Study of the Early Career of Diego Rivera, 1898-1921*', unpublished dissertation, University of Texas at Austin, 1984
Fuentas Rojas de Cadena, Elisabeth, '*The San Francisco Murals of Diego Rivera: A Documentary and Artistic History*', unpublished master's thesis, University of California at Davis, 1980

José Clemente Orozco

BOOKS

Cardoza y Aragón, Luis, *José Clemente Orozco*, Buenos Aires: Losado, 1944

Orozco, second edition, Mexico City: Universidad Nacional Autónoma de México, Dirección General de Publicaciones, 1974

Colegio Nacional, Mexico City, *Hommenaje de El Colegio Nacional al Pintor José Clemente Orozco*, Mexico City: Editiones de El Colegio Nacional, 1949

Dickerson, Albert I. (ed.), *The Orozco Frescoes at Dartmouth*, Hanover N.H.: Dartmouth College, 1962 (re-issue of 1934 edition)

Echavarría, Salvador, *Orozco: Hospicio Cabañas*, Guadalajara: Planeación y Promoción, 1959

Fernández, Justino, *José Clemente Orozco: The Painter of our Time*, Mexico City: Editorial Fischgrund, Modern Art Editions, 1944

 José Clemente Orozco: forma e idea, second edition. Mexico City: Porrúa, 1956 (revised edition with additional illustrations of post-1942 works and extended bibliography).

 Orozco: Universidad de Guadalajara, Guadalajara: Planeación y Promoción, 1960

Helm, MacKinley, *Man of Fire: J. C. Orozco, An Interpretive Memoir*, Boston: The Institute of Contemporary Art; New York: Harcourt Brace, 1953

Marrozzini, Luigi, (ed.), *Catalogo Completo de la obra Gráfica de Orozco*, San Juan, Puerto Rico: Instituto de Cultura Puertoriquena, Universidad de Puerto Rico, 1970

Mérida, Carlos, *Frescoes in Palacio de Justicia [Mexico City] and Jiquilpan [Michoacán] by J. C. Orozco: An Interpretive Guide with 19 Reproductions*, (Mexican Art Series, 11), Mexico City: Frances Toor Studios, 1943

Orozco, José Clemente, *Apuntes Autobiográficos*, Mexico City: Secretaría de Educación Pública, Subsecretaría de Asuntos Culturales, 1966

 The Artist in New York; Letters to Jean Charlot and Unpublished Writings, 1925-1929, translated by Ruth L. C. Simms, Austin: University of Texas Press, 1974

 Autobiografía, Mexico City: Ediciones Occidente, 1945

 An Autobiography, translated by Robert C. Stephenson, Austin: University of Texas Press, 1962

 Orozco 'Explains', New York: Museum of Modern Art, 1940. Also published in *The Bulletin of the Museum of Modern Art*, 7(4): August 1940

 Textos de Orozco: Con un Estudio y un Apendice por Justino Fernández, Mexico City: Imprenta Universitaria, 1955

 Orozco Pintura Mural, Mexico, Fondo Editorial de la Plastica Mexicana, 1989

Ramos García, Luis, *José Clemente Orozco en Guadalajara*, Guadalajara: Jalisco, undated

Reed, Alma. *Orozco*, New York: Oxford University Press, 1956

 Orozco, Mexico City: Fondo de Cultura Económica, 1958

Zuno, José Guadalupe, *José Clemente Orozco: El Pintor Ironista*, Guadalajara: Universidad de Guadalajara, 1962

 Orozco: y la Ironía Plástica, Mexico City: Editiones Cuadernos Americanos, 1953

ARTICLES

Benson, E. M. 'Orozco in New England: Dartmouth College Murals', *Magazine of Art*, 26(10) October 1933

Brenner, Antia, 'A Mexican Rebel', *The Arts*, 12, October 1927

 'Orozco, Murals with Meaning', *Creative Art*, 12(2), February 1933

Brenson, M., 'Orozco: Mexican Conscience', *Art in America*, 67, September 1979

Cardoza y Aragon, Luis, 'José Clemente Orozco, pintor Mexicano', *Revista Nacional de Cultura*, (Venezuela), 2(22), September 1940; 2(23), October 1940.

 'Contradicciones de Orozco', *Cuadernos Americanos*, 17, 1958

 'José Clemente Orozco: iniciación de su vida artística', *Cultura Universitaria* (Venezuela) 64, 1958

Charlot, Jean, 'Jose Clemente Orozco, su obra monumental', *Forma* (Mexico), 2(6), June 1928

 'José Clemente Orozco', *Magazine of Art*, 40, November 1947

 'Orozco in New York', *College Art Journal*, 19(1), Fall 1959

Cosgrove, Stanley and Ayre, Robert, 'Conversation about Orozco', *Canadian Art* 7(2), 1949-50

Echavarría, S., 'José Clemente Orozco en Guadalajara', *Artes de México*, (94–95), 1967

Eisenstein, Sergei, 'El Prometeo de la pintua Mexicana', *America Latina* (USSR), part 2, 1978

Fernández, Justino, 'De una charla con José Clemente Orozco', *Annales del*

instituto de Investigaciones Estétias (Mexico), National University of Mexico, 2(5), 1940

'Obras recientes de Orozco', *Hoy*, 349, October 1943

'Obras recientes de Orozco', *Méxicano en el Arte*, (6), December 1948

'Orozco: el pintor de nuestro tiempo', *Anales del Instituto de Investigaciones Estétcas* (México), National University of Mexico, 16, 1948

'Orozco: Genius of America', *College Art Journal*, 9(2), Winter 1949–50

Goodrich, Lloyd, 'The Murals of the New School', *The Arts*, 17(6), March 1931

Mumford, Lewis, 'Orozco in New England', *New Republic*, 80(1036), 10 October 1934

Myers, Bernard, 'Murales de Orozco, 1923-32', *Artes de México*, 5(25), 1959. (text in Spanish and English).

 'José Clemente Orozco: segunda parte, 1934-1940', *Artes de Mexico*, 5(30), February 1960. (text in Spanish and English).

Neumeyer, Alfred, 'Orozco's Mission', *College Art Journal*, 10(2), 1951

Orozco, José Clemente, 'Orozco explains Mural, Dive Bomber and Tank', *Art Digest*, 14, September 1940

Schmeckebier, Lawrence, 'The Frescoes of Orozco in the New School of Social Research', *Trend*, 1(2), June 1932

 'The Frescoes of Orozco', *Mexican Life* (Mexico), 9(3), 1933

Scott, David W., 'Orozco's Prometheus', *College Art Journal*, 17(1), Fall 1957

Soto Segarra, Luis de, 'El Museo Taller José Clemente Orozco', *Arquitectura* (La Habana) 20, 1952

Spratling, William P., 'Orozco', *Mexican Life* (Mexico), 5(10), October 1929

Tablada, José Juan, 'José Clemente Orozco, the Mexican Goya', *International Studio*, 78(322), March 1924

CATALOGUES

Exposición José Clemente Orozco, Casa Francisco Navarro, Mexico City, 1916

Ink and pencil drawings from a series 'Mexico in Revolution' by José Clemente Orozco, Galleries of Marie Sterner, New York, 1928

Work by José Clemente Orozco, Delphic Studios, New York, 1930

Works of José Clemente Orozco, Downtown Gallery, New York, 1931

José Clemente Orozco, Delphic Studios, New York, introduced by Alma Reed, 1932

Two papers presented at the American Artists' Congress, February 15, 1936, for the Mexican delegates by Orozco and Siqueiros, and the catalogue of the exhibition at the A.C.A. Gallery, New York City, ACA Gallery, New York, 1936

Catálogo de la primera exposición de Orozco en El Colegio Nacional, Colegio Nacional, Mexico City, 1943

Exposición nacional de José Clemente Orozco, Instituto Nacional de Bellas Artes, Mexico City, 1947

Exposición nacional de hommenaje a José Clemente Orozco con motivo de XXX aniversario de su fallecimiento, Palacio de Bellas Artes, Mexico City, 1979

Orozco, Museum of Modern Art, Oxford, 1980

David Alfaro Siqueiros

BOOKS

Cardoza y Aragon, Luis, *La Pintura Mexicana Contemporánea*, Mexico: Imprenta Universitaria, 1953

 with Inés Amor, Carmen Barreda, Justino Fernández, and Salvador Novo, *Colección de Pintura Mexicana de Licio Lagos*, Mexico, 1968

 México: Pintura de Hoy, Mexico: Fondo de Cultura Economica, 1964

Carrillo, Rafael A., *Siqueiros*, Mexico: Secretaria de Educacíon Pública, 1974

 Pintura Mural de México: La Epoch Prehispánica, el Virreinato y Los Grandes Artistas de Nuestro Siglo, Mexico: Editorial Panoramas, 1981

Consejo Nacional de Cultura, *Siqueiros*, La Habana: Delagación Provincial de Cultura, 1964

Crespo de la Serna, Jorge Juan, *David Alfaro Siqueiros*, Mexico: Editorial Espartaco, S.A., 1959

234 De Michelli, Mario, *I Maestri del Colore: Siqueiros*, Milan: Fratelli Fabbri Editori, 1967
 Siqueiros, Milan: Fratelli Fabbri Editori, 1968
 Siqueiros, New York: Harry N. Abrams, 1970
 Fernández, Justino, *El Arte Moderno en México. Breve Historia*, Mexico: Editorial Porrúa e Hijos, 1937
 Arte Moderno y Contemporáneo de México, (UNAM- Instituto de Investigaciones Estéticas) Mexico: Imprenta Universitaria, 1952
 Arte Mexicano de sus Orígenes a Nuestros Días, Mexico: Editorial Porrúa, S.A., 1958
 Gual, Enrique, *Siqueiros*, Mexico: Galeria de Arte Misrachi, 1965
 Siqueiros, Mexico: Anáhuac Compañía Editorial S.A., 1967
 Siqueiros, David Alfaro, *El Muralismo en México*, Mexico: Ediciones Mexicanas, S.A., 1950 (Enciclopedia Mexicana de Arte, núm. 8)
 Cómo se Pinta un Mural, Mexico: Ediciones Mexicanas S.A., 1951
 Arte Público, Mexico, no publisher's imprint, 1954
 Carta Abierta a los Pinteros, Escultores y Grabadores Soviéticos, Mexico, 1954
 A un Joven Pinto Mexicano, Mexico: Empresas Editoriales, S.A., 1967
 Cuarta Etapa del Muralismo en México, Mexico: Galeria de Arte Misrachi, 1968
 El Nuevo Realismo Mexicano. Integración Plástica, Mexico: UNAM-Dirección de Difusión Cultural, 1960
 Art and Revolution, London: Lawrence & Wishart, 1975
 Me Ilamaban el Coronelazo: Memorias, Mexico: Grijalbo, 1977
 Scher'er Garcia, Julio, *La Piel y la Entraña (Siqueiros)*, Mexico: Biblioteca Era, 1965
 Stein, Philip, *The Mexican Murals: Including a Selected List of Murals and their Locations*, Mexico: Editur, S.A. (undated)
 Suarez, Orlando S., *Inventario del Muralismo Mexicano: Sigle VIIac /1968*, Mexico: UNAM-Dirección de Difusión Cultural, 1972
 Tibol, Raquel, *Siqueiros, Introductor de Realidades*, Mexico: UNAM-Dirección General de Publicacinoes, 1961
 Historia General del Arte Mexicano, Epoca Moderna y Contemporánea, Mexico: Editorial Hermes, 1963
 David Alfaro Siqueiros, Buenos Aires: Editorial Codez, S.A., 1965
 David Alfaro Siqueiros, Dresden: Verlag der Kunst, 1966

David Alfaro Siqueiros, Mexico: Empresas Editoriales, 1969
Siqueiros Vida y Obra, Mexico: Secrearia de Obras y Servicios, 1973
Orozco, Rivera, Siqueiros, Tamayo, Mexico: Fondo de Cultura Económica, 1974
Textos de David Alfaro Siqueiros, Mexico: Fondo de Cultura Económica, 1974
UNAM, Angélica Arsenal (ed.), *Vida y Obra de David Alfaro Siqueiros: Juicios Críicos*, Mexico: Fondo de Cultura Económica, 1975

ARTICLES

Siqueiros, David Alfaro, 'Tres Ilamamientos de orientación actual a los pintores y escultores de la nueva generación de América', Barcelona: Revista Vida Americana, 1921
 'Manifesto del sindicato de obreros técnicos, pintores y escultores', Mexico: El Machete, March 1924
 'En el orden burgués reinante hay que buscar la causa de la decadencia arquitectóica contemporánea', Mexico: Periódico El Machete, May 1924
 'Qué es Ejercicio Plástico y cómo fue realizado', Buenos Aires: Folleto, 1933
 'Muerte al invasor', Mexico: Revista HOY, 1941
 'No hay más ruta que la nuestra', Mexico: Secretaría de Educación Pública, 1945
 'Hacia una nueva plástica integral', Mexico: Revista Espacios, September 1948
 'La Crítica del arte como pretexto literario', Mexico: Revista Artes de México, 4, 1948
 'Mi experiencia en el muralismo exterior', Mexico: Excélsior, March 1956
 'Mi respuesta: la historia de una insidia', Mexico: Ediciones Arte Público, 1960
 'La trácala. Mi réplica a un gobierno fiscal-juez', Mexico: 1962
 'Vigencia del Movimiento plástico mexicano contemporáneo', Mexico: Rivista de la Universidad de México, 4, 1966
 'Hacia la transformación de las artes plásticas', en Raquel Tibol, Mexico: Cuadernos de Arquitectura, 20, 1968

CATALOGUE

Siqueiros. Exposicíon Retrospectiva, Mexico: UNAM-Museo Universitario de Ciencias y Arte, 1967

INDEX

Picture acknowledgments

22	Bob Schalkwijk, Mexico City
32, 34	Bob Schalkwijk, Mexico City
35	Gruppo Editoriale Fabbri, Bompiani, Sonzogno, Etas S.P.A. Milan
37	Bob Schalkwijk, Mexico City
40 to 48	Bob Schalkwijk, Mexico City
51	Desmond Rochfort
52 to 81	Bob Schalkwijk, Mexico City
82	Commissioned by the Trustees of Dartmouth College, Hanover, New Hampshire, USA
85 to 92	Bob Schalkwijk, Mexico City
94 above	Bob Schalkwijk, Mexico City
94 below	Desmond Rochfort
95 to 98	Bob Schalkwijk, Mexico City
99 both	The New School for Social Research, New York
100	Pomona College, Claremont, California
101	Commissioned by the Trustees of Dartmouth College, Hanover, New Hampshire, USA
102 all	Courtesy of Laurence P. Hurlbert, Middleton, Wisconsin
103 to 110	Commissioned by the Trustees of Dartmouth College, Hanover, New Hampshire, USA
111 to 120	Bob Schalkwijk, Mexico City
124	Stock Exchange Tower Associates, San Francisco
125 and back jacket	San Francisco Art Institute (photographer David Wakefield)
127 all	© The Detroit Institute of Arts, Founders Society Purchase, Edsel B. Ford Fund and Gift of Edsel B. Ford
128, 129	The Detroit Institute of Arts
131, 132	Lucienne Bloch Dimitroff, Gualala, California and Laurance P. Hurlbert, Middleton, Wisconsin Lucienne Bloch Dimitroff
133 to 144	Bob Schalkwijk, Mexico City
147 both	Siqueiros Archives, Mexico City
149, 151	Siqueiros Archives, Mexico City
153, 154	Bob Schalkwijk, Mexico City
155 both	Siqueiros Archives, Mexico City
156, 157	Bob Schalkwijk, Mexico City
158 both	Courtesy of Laurence P. Hurlbert, Middleton, Wisconsin
160	Bob Schalkwijk, Mexico City
163, 164	Bob Schalkwijk, Mexico City
165	Desmond Rochfort
166 to 172	Bob Schalkwijk, Mexico City
173	Dirk Bakker, Detroit Institute of Art
174 above left	Bob Schalkwijk, Mexico City
174 below	Bob Schalkwijk, Mexico City
175 to 181	Bob Schalkwijk, Mexico City
182, 183	Manuel Alvarez Bravo/Bob Schalkwijk, Mexico City
184	Bob Schalkwijk, Mexico City
186	Gruppo Editoriale Fabbri, Bompiani, Sonzogno, Etas S.P.A. Milan
188	Siqueiros Archives, Mexico City
189 above	Desmond Rochfort
189 below	Siqueiros Archives, Mexico City
190	Bob Schalkwijk, Mexico City
191 all	Siqueiros Archives, Mexico City
192	Bob Schalkwijk, Mexico City
193 all	Siqueiros Archives, Mexico City
194–195	Bob Schalkwijk, Mexico City
196 to 203 above	Desmond Rochfort
203 below	Siqueiros Archives, Mexico City
204	Desmond Rochfort
205 both	Siqueiros Archives, Mexico City
206	Desmond Rochfort
207 above	Gruppo Editoriale Fabbri, Bompiani, Sonzogno, Etas S.P.A. Milan
207 below	Siqueiros Archives, Mexico City
208	Bob Schalkwijk, Mexico City
208 to 209	Bob Schalkwijk, Mexico City
210 above	Bob Schalkwijk, Mexico City
210 below both	Siqueiros Archives, Mexico City
211	Bob Schalkwijk, Mexico City
213 all	Desmond Rochfort
214 all	Siqueiros Archives, Mexico City
215 to 217	Bob Schalkwijk, Mexico City